APPROPRIATION AS PRACTICE

Studies of the Americas
edited by
James Dunkerley
Institute for the Study of the Americas
University of London
School of Advanced Study

Titles in this series are multi-disciplinary studies of aspects of the societies of the hemisphere, particularly in the areas of politics, economics, history, anthropology, sociology and the environment. The series covers a comparative perspective across the Americas, including Canada and the Caribbean as well as the USA and Latin America.

Titles in this series published by Palgrave Macmillan:
Cuba's Military 1990–2005: Revolutionary Soldiers during Counter-Revolutionary Times
 By Hal C. Klepak
The Judicialization of Politics in Latin America
 Edited by Rachel Sieder, Line Schjolden, and Alan Angell
Latin America: A New Interpretation
 By Laurence Whitehead
Appropriation as Practice: Art and Identity in Argentina
 By Arnd Schneider
America and Enlightenment Constitutionalism
 Edited by Gary McDowell and Jonathan O'Neill
Vargas and Brazil: New Perspectives
 By Jens R. Hentschke
Caribbean Land and Development Revisited
 By Jean Besson and Janet Momsen

Appropriation as Practice

Art and Identity in Argentina

Arnd Schneider

First published in 2006 by
PALGRAVE MACMILLAN™
175 Fifth Avenue, New York, N.Y. 10010 and
Houndmills, Basingstoke, Hampshire, England RG21 6XS
Companies and representatives throughout the world.

PALGRAVE MACMILLAN is the global academic imprint of the Palgrave Macmillan division of St. Martin's Press, LLC and of Palgrave Macmillan Ltd. Macmillan® is a registered trademark in the United States, United Kingdom and other countries. Palgrave is a registered trademark in the European Union and other countries.

ISBN-13: 978–1–4039–7314–6
ISBN-10: 1–4039–7314–8

Library of Congress Cataloging-in-Publication Data

Schneider, Arnd, 1960–
 Appropriation as practice : art and identity in Argentina / Arnd Schneider.
 p. cm.—(Studies of the Americas)
 Revision of the author's thesis (Habilitation)—University of Hamburg, 2004.
 Includes bibliographical references and index.
 ISBN 1–4039–7314–8
 1. Art, Argentine—20th century. 2. Identity (Psychology) in art. 3. Art and society—Argentina—History—20th century. 4. Indian art—Argentina—Influence.
 I. Title. II. Series.

N6635.S36 2006
709.82′0904—dc22 2005056469

A catalogue record for this book is available from the British Library.

Design by Newgen Imaging Systems (P) Ltd., Chennai, India.

First edition: July 2006

10 9 8 7 6 5 4 3 2 1

Printed in the United States of America.

Curiositas enim experiendi incitatum facit Super Danielem, 14, 15
Albertus Magnus (ca. 1193–1280)

Contents

List of Figures

All photos: Arnd Schneider, unless otherwise indicated.

Acknowledgments

This book had first been submitted, in slightly different form, as a thesis of *Habilitation* (*Habilitationsschrift*), and was accepted by the University of Hamburg on January 9, 2006. My first thanks goes to my thesis advisor Waltraud Kokot, professor of anthropology at the Institute for Social Anthropology, for her unreserved support for this project. Fieldwork and writing-up of the manuscript were supported by a generous grant in aid and a three-year Senior Research Fellowship (*Habilitationsstipendium*) from the Deutsche Forschungsgemeinschaft/DFG (German Research Council), 1999–2002 (grant no. SCHN 622/1–4). I am also grateful to the University of East London (UEL) for having granted unpaid leave of absence, 1999–2002. Special grants from both DFG and UEL enabled me to digitize a voluminous slide collection pertaining to this project, without which the production of this richly illustrated volume would have been much more cumbersome. A further grant from UEL provided a subsidy toward the publication of illustrations, and a sabbatical for semester A 2005/2006 was used for the final revision of the manuscript.

In Argentina, my thanks go above all to my indefatigable friend Julio Sánchez in Buenos Aires who, during my first fieldwork in Argentina (1988–1999) and a follow-up visit in 1993, introduced me to the work of two artists who were inspired by indigenous cultures, namely Alfredo Portillos and Anahí Caceres. Although I was occupied with Italian migrations at the time (Schneider 2000), their work and that of other metropolitan Western artists who reference indigenous cultures and encroach upon the anthropological discourse and practice of fieldwork were to become my main subject of research since (Schneider 1993, 1996). Julio remained a most valuable guide to the Argentine art world throughout my research stays.

The book is the result of a year's fieldwork in 1999–2000 and a follow-up visit in 2001/2002. I thank the artists, critics, gallery owners, museum curators, and many others who helped me during these periods with their time for interviews, conversations, studio visits, and viewing of private collections. They would be too many to list, yet all of them contributed invaluably to the research effort. I would like to thank personally, however, Javier Olivera and Teresa Pereda, whose friendship and generosity enabled me to accompany

them on two quite different "artistic journeys": a film shoot in Patagonia (see chapter six) and an artistic field trip to Jujuy in the Argentine Andes (chapter seven). Mirta Marziali provided a most hospitable atmosphere in her pottery workshop, on which a good part of chapter 4 is based, and so did Bernardo and Norma Di Vruno.

Readers of this volume were very supportive of the project, and I am grateful for their suggestions, which helped improve the manuscript. In particular, I would like to thank Tony Robben, one of the readers who revealed his identity. I am also immensely grateful to Vivian Schelling who read the entire manuscript, and made very valuable suggestions. Friends and colleagues who read and discussed individual chapters include Peter Flügel, Jonathan Friedman, Stuart Morgan, and Chris Wright (chapter two), John Cowpertwait (chapter three), Amanda Hopkinson and Norma Schenke (chapter five), Joshua Appignanesi, Amanda Grimshaw and Amanda Ravetz (chaper six), and Barbara Göbel (chapter seven).

I also remember many conversations and epistolary exchanges on the topic of Argentine identity with the late, and much missed, Eduardo Archetti.

My thanks also go to James Dunkerley for offering this book a home in his series of the Institute of the Studies of the Americas, and Gabriella Pearce, my editor at Palgrave, for seeing the manuscript through to final publication.

Furthermore, I am grateful to all institutions and private persons who have aided me in my research and made visual and written materials available to me (often waiving or reducing fees for copyright permissions for which there was no separate budget).

I also like to thank hosts and audiences at the following institutions and venues to whom I have presented ideas over the years for their stimulating discussion; University College, London (Susanne Küchler); St Antony's College, Oxford (Herminho Martins); the University of East London; City and Guilds of London Art School (Helen Wilkes); The New School for Social Research, New York (Aleksandra Mir, Vera Zolberg); the University of Texas, Austin (Mari Carmen Ramírez); the University of Colorado, Boulder (Donna Goldstein); the State University of New York at New Paltz (Rimer Cardillo); Universidad Nacional Autónoma de México (UNAM), Mexico City (Natividad Guitérrez); the Academy of Sciences, Ljubljana (Kristina Toplak), Instituto Nacional de Antropología, Buenos Aires (Catalina Saugy); the Universities of Copenhagen and Vienna (EASA Conferences 2002 and 2004, Barbara Keifenheim, Thomas Fillitz, Maruška Svašek, Barbara Wolbert, Helena Wulff), the University of Rome "Roma III" (Camilla Catarrulla), the University of Bremen (Dorle Dracklé), and the University of Hamburg (Waltraud Kokot).

Note on Photographs, Translations, and Anonymity of Interview Partners

All photographs and translations are mine, unless otherwise indicated. Every reasonable effort has been made to trace and acknowledge the ownership of

the copyrighted material. Any errors that may have occurred are inadvertent, and will be corrected in subsequent editions, provided notification is sent to the author.

In order to preserve the anonymity of interview partners, in some cases proper names, places and circumstances have been changed.

Chapter One

Introduction: The Paradoxes of Identity in Argentina

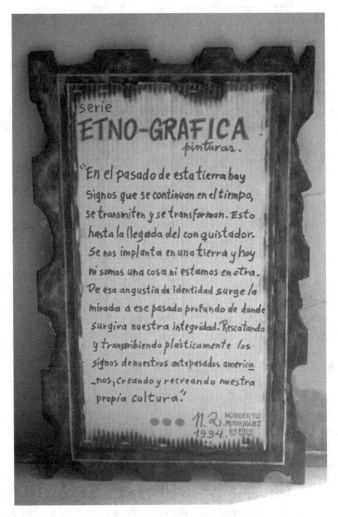

Figure 1 *Norberto Rodríguez,* Opening statement of the *Series "ETNO—GRAFICA,"* 1994, by permission of the artist. Photo: Arnd Schneider.

Series ETNO—GRAFICA paintings.

In the past of this soil there are signs that are continued throughout time, that are transmitted and transformed; that is, till the arrival of the conqueror. We are implanted into a land and today we are not one thing or the other. From this anguish of identity emerges our gaze to that profound past from where our integrity will arise. Reclaiming and transcribing in plastic terms the signs of our American ancestors, creating and recreating our proper culture.

11.2.1994 Norberto Rodríguez

The Arguments of This Book: Art, Identity, and Appropriation

This study starts from a paradox. What motivates artists in a nation largely made up of descendants of European immigrants to occupy themselves with indigenous art, both of their own country and of other parts of Latin America?

For artists in Argentina the choice is less than obvious. The country's cultural elite, over a considerable historical period and with few exceptions, such as the writer Ricardo Rojas (on whom more later on), favoured the import of European models of culture over native ones or those from other Latin American countries.

Of course, in a way, the question posed is also a self-reflexive one: what motivates anthropologists, we might ask, the majority of whom are still of European or North American extraction (or at least trained in the Northern hemisphere), to study the "Other"? Whilst I must leave aside the broader implications to those investigating the epistemological foundations of anthropology, I shall return in my discussion of methodology and theory to specific ramifications of this argument, namely the issues of *practice* and *appropriation*. Here, I just wish to outline the main concerns of this study.

This book aims to contribute to the current debate on globalization and more precisely to the question of how "traffic in culture" (Marcus/Myers 1995) is practised and experienced by artists in Argentina. It wishes to illuminate this question through a number of case studies set in the specific regional ethnographic context of contemporary Argentina and, in particular, its capital city, Buenos Aires. The main motivations for this study are a number of dissatisfactions with the scope and explanatory depth of theories of globalization, and with studies in the anthropology of art. These are set out in the second chapter.

Argentina was chosen as the field of study for a number of reasons. A case is made in this book to understand the traffic in cultural symbols across cultural boundaries as constructed, and yet rooted in the experiences and practices of the artists involved and other players in the art world. The specific issue investigated is the appropriation of indigenous cultures by mostly nonindigenous artists. Argentina is not an obvious choice for this enterprise: there is not and

there has not been a legitimizing national ideology for such appropriations. Appropriating choices among artists have to be deliberately constructed. This is in stark contrast to countries such as Mexico, Peru, or Ecuador, in which nationalist projects provided legitimate and hegemonic discourses for the assimilation or incorporation of indigenous societies into the nation state—at least since the Mexican Revolution.[1]

When I started my research, most people I talked to said that artists who appropriate indigenous cultures did not exist in Argentina, and were curious why I would not study Peru or Mexico, where apparently I would find more obvious examples. I will come back to this denial of the indigenous in Argentina, which has to be interpreted as part of a particular identity construction, of how the Argentine art world conceives of being "international" by directing itself toward Europe and North America. The fact that I was told that the subject I was researching did not exist is significant, as it hinted to a wider ideology of denial. I return to the deliberate disinterest in indigenous topics, or even its straightforward negation later. Here it suffices to mention that the historical context for this phenomenon is the still-dominant ideology of the melting pot (*crisol de razas*), within which Argentina is understood as a nation of European immigrants and their descendants.

To focus on artists in the Southern Cone presents a particular challenge to scholars studying identity and new configurations of indigenous artistic expressions in Latin America. This is because constructions of identity are not voiced in the idiom of presumed biological descent, but in terms of geographical and cultural belonging. This amounts to an inclusive form of identity construction that is defined by practices of cultural acquisition and not by discourses on origins. In fact, it is opposed to the latter and presents a potential threat to those constructions of identity that base themselves on presumed biological roots. This inclusive form of identity acquisition or construction is similar to learning a new language, or adopting elements from another culture, without claiming any biological descent from its bearers. Students of ethnicity are familiar with the example of Catalan identity, which in contrast with Basque identity, for instance, is not based primarily on descent, but on the acquisition and display of certain identity markers, such as language, food, and familiarity with history and geography in Catalonia (Woolard 1988). In Argentina (and possibly elsewhere) the inclusive form of new identity constructions, however, also has an overbearing side to its character. Because they are not based on descent, and indeed are often developed in opposition to descent (in the first instance one's own European, Old World descent), these new constructions of identity are also implicitly (and sometimes explicitly) disrespectful to those claiming descent from indigenous people—in other words, the present-day indigenous people of Argentina. The arbitrariness, or wilful creation, of new identities freed from traditions based on descent contrasts with indigenous constructions holding a belief in presumed descent. The latter are, of course, no less arbitrary, but are ordered according to different parameters, usually claims to biological descent and of belonging to a particular territory.

It has to be added that constructing a new identity based on indigenous cultures (and not indigenous descent) also involves practices of appropriation relating to *time*, that is, Pre-Columbian and indigenous history, and *space*, through archaeological excavations and, historically, the land-taking process.

Yet the two positions, on the one hand that of those basing a new Latin American identity on indigenous cultures, and on the other hand that of those claiming descent from indigenous groups, are not mutually exclusive or irreconcilable. During my research, I came across a number of indigenous artists who were exhibiting at the Buenos Aires international art fair *Arte BA*, and who consciously claimed their space in the national and international "white" universe of the art world, and sought a dialogue, rather than confrontation, with those appropriating indigenous cultures. I also interviewed a number of artists who are descended from Europeans and for whom the issue of appropriation was an ethically problematic one.

In the last two sections of this chapter, I return to the historic changes of identity formation in Argentina, and how these are expressed in the changed economic climate at the turn of the new millennium.

A Multifocal Approach

People rather than the objects they make are the subject of this study. In this sense, my approach is informed by Alfred Gell's (1998) fundamental insight that art objects have a social agency in society, that is, the way in which they are used and interpreted in social relations makes them meaningful. Hence, one of the main concerns of this study is to focus on the process of artistic creation, and not primarily on the finished artworks, or for that matter on their reception.

This book then is located at the intersection between the anthropology of art, urban anthropology, and studies of ethnicity/identity and globalization. In the anthropology of art, the preoccupation with contemporary art is a relatively recent phenomenon, as is for urban anthropology the study of cultural production in the metropolitan centers of global networks of cross-cultural communication (for recent examples, see García Canclini 1998, 2000; also Plattner 1996). A number of recent anthropological studies also have started to investigate the spatial geographies of symbolic power in Latin American cities, and how their global encapsulation is experienced and interpreted by different social groups of urban actors (Freeman 2001, Guano 2002, Wildner 2003a, 2003b).

The main objective of this book is to explore the processes of appropriation of indigenous cultures and investigate the underlying ideological framework within the wider context of art production in Buenos Aires. Howard Becker (1982) introduced the useful concept of "art world" to the sociology of art, which understands art as a cooperative, multilayered process between a number of individuals (producers, mediators, and recipients), institutions, and art objects, not just as the result of a creative act by a single individual, commonly denominated "the artist." A peripheral art world in global terms,

the Buenos Aires art world is hierarchically structured by a gallery and museum circuit, art schools, art critics, individual artists, and the art-consuming public. The question then becomes: How is the international art system symbolically legitimized by the gallery and museum circuit in Argentina, as well as by art schools (i.e., the places in which artists acquire their specific "cultural capital," as well as practical skills)?

As regards individual artists, a further question is whether any emerging patterns in the process of appropriation are influenced by access to economic resources, communication, and power (in the gallery circuit, at international art fairs and auctions, the making of reputations in journals and newspapers).

Empirically, my fieldwork (for methodology see Appendix I) has tried to map out and follow the social relations between these constituent elements of the art world, focusing particularly on production and mediation, and rather less on reception of art works and practices. The results of this are presented in chapter 3.

Research on appropriation of indigenous cultures focused on the role of artists in a process of cultural conversion and identity construction, that is, how presumed local forms are imported into an international framework. How does appropriation actually work, and what does its processual character tell us more generally about phenomena of cultural change and culture contact? Arguably, this terminology is now out-of-date, but what has been suggested in its place, Appadurai's (1996) "- scapes," for example, does not solve the problem of cultural difference either; it merely lifts it onto another plane. Which are the points at which cultures meet in a global world? To answer these questions, it would be a step forward if we could establish a certain logic to the process of appropriation and selection from supposedly "infinite" cultural material. Artists have often been regarded as bricoleurs, combining and recombining elements from the most diverse cultural sources. One of the principal points this book makes is that the appropriating strategies of artists are positioned at nodal points in a global network of cultural flows, in which specific indigenous discourses are converted into an idiom that is receptive to international consumption.[2]

Hence the important issue tackled in this volume is the degree to which artists assume a mediating role in the process of cultural globalization. Some of my previous research in Uruguay, Ecuador, and Mexico suggests that they may be conceived of as brokers between local cultural practices (themselves affected by globalization), and global circuits of information (increasingly interconnected, and impregnated with local practices) of the international art world (Schneider 1999, 2000c, 2004a). For instance, artists like the Uruguayans Carlos Capelán and Rimer Cardillo work from Santiago de Compostela, Spain (previously from Lund, Sweden, and Costa Rica) and New York respectively. They make references to global anthropological discourses (in the case of Capelán), and to indigenous cultures in Uruguay and Ecuador (in the case of Cardillo) (Schneider 2000c, 2004e). Their work is exhibited internationally, but occasionally also in their home country, where art critics and art historians[3] both mediate international artists to a local public and provide an international gateway for a few local artists.

Thus chapters 4 through 7 have a specific focus on how appropriative strategies are deployed, such as the taking of motifs/symbols from secondary sources (e.g., from books and other previous researches by anthropologists and archaeologists), and through direct contact with the members of indigenous cultures (in a less systematized way, but similar in principle to anthropological fieldwork).

In addition, this book explores the underlying rationale of category formations, that is, how definitional categories (often based on binary oppositions of exclusion/inclusion) are formed and dissolved in the process of globalization. For instance, one of the crucial questions is how "indigenous" is defined by artists. Another important area for research is how, in a process of reconversion (adaptation to local contexts)[4] and conversion (import into global networks), symbols can change both their forms and meanings.

Argentina: Creole Identities

This chapter opened with a brief quote from the artist Norberto Rodríguez (cf. Fig.1), who established a specific discourse about identity for Argentine artists: being uprooted and transplanted "Europeans," they cannot look back to Europe, but have to find their new cultural roots in Latin America, through the appropriation of contemporary and ancient (Pre-Columbian) cultures. Such discourse is not new and stands in a tradition of those favouring native and "indigenous" cultural models (over imported "European" ones favoured by the political elite), as advocated for example by the writer Ricardo Rojas, on whom more later on in this section.

More generally, we have to situate such constructions of identities by artists in this book in the context of identity constructions in contemporary Argentina. To this end I give in the following section a brief overview of the formation of ethnic and class identities in Argentina, with special emphasis on Buenos Aires and the littoral provinces, which were most affected by European migration.

In the eyes of European, North American, and, most importantly, other Latin American observers, Argentina is perceived as a European immigrant country and Buenos Aires as the "Paris of South America." This perception is shared as a self-image by many Argentines, especially by those in the coastal provinces, who wish to portray themselves as Europeans in South America. However, rather than taking such stereotypes at face-value this section contends that Argentine concepts of the self, as an admixture of indigenous, Spanish colonial, and European immigrant influences, are made in the New World—they are, in fact, *Creole*. In the Hispanic world, to be a Creole (*criollo*) meant, originally and in its most narrow sense, being born to Spaniards in the "New" World,[5] and more inclusive definitions would encompass every person born in the Americas, to Old World parents; "hence there are white and black Creoles and Creole animals, but not Creole Indians."[6] In Argentina there exist two fundamental notions of *criollo*, one being upper-class and presuming unbroken descent from colonial Spaniards,

and the other being egalitarian, referring to descendants from colonial Spaniards and indigenous people. I discuss the difference between the two further on in this book.

Here it is important to point out that, generally, Argentine writers and philosophers, such as Sarmiento and Alberdi, privileged the European point of view over any autochthonous traditions. However, there were also other voices, and one of them, the Argentine writer and essayist Ricardo Rojas, had been a major influence on the artists featured in this book. In his programmatic book, "Eurindia" (published in 1924), Rojas tried to vindicate Argentine native traditions. He contrasted Argentina's indigenous and Creole traditions with what he termed the "exotic" European tradition. European traditions appear "exotic" because they are imported from far away and are fundamentally alien to the Argentine soil. Rojas deliberately conflates the categories of indigenous and Creole to arrive at the conclusion that in Argentina the "European civilisers" were of "exotic provenance," not so the indigenous people (Rojas 1993 [1924]: 12). The fact remains that Rojas inverts the customary gaze of the European observer (for whom Indians would be "exotic"), by putting Europeans into the role of the exotic other (what Jean Franco termed the "exoticism of cosmopolitan life," Franco 1970: 103), from the viewpoint of indigenous and Creole Argentines. However, Rojas assumes this position as a member of Argentina's urban and cosmopolitan elite. Rojas also promoted an "American aesthetic" and advocated the foundation of an "Institute of Decorative Arts," which would dedicate itself to the study and applied practice of indigenous art and archaeology, adapting it to the necessities of modern industrial production and technology (Rojas 1958 [1930], Fiadone 2001: 11).

Artists working with appropriation of indigenous cultures were also influenced by the philosopher and anthropologist Rodolfo Kusch (1922–1979) and the anthropologist Guillermo Magrassi (1936–1989). In his writings, Kusch opposed the *porteños* (inhabitants of Buenos Aires) to the indigenous population of the interior, and warned the European population that with time they had to "transform our European fiction into a cruelly autochthonous reality," as the *caudillos* of the nineteenth century also demanded (Kusch 2000: 22). Inspired partly by Heidegger and Husserl, Kusch also contemplated the opposition between *ser* (in Spanish, *to be* in the essential sense) and *estar* (in Spanish, *to be* in terms of spatial-temporal circumstances). He attributed the *ser* to the European conceptions of self, and the *estar* to indigenous conceptions (Bordas de Rojas Paz 1997: 47–73). Kusch also worked as a fieldworker, documenting popular culture in the Argentine North West and in Bolivia.

In our interviews, many artists also mention Rudolfo Kusch's daughter, María Florencia Kusch, a renowned archaeologist, whose classes they had attended at the University of Buenos Aires or whom they had collaborated with on specific projects. During the 1970s and 1980s, Guillermo Magrassi, on the other hand, gathered anthropologists and artists around him, promoted interdisciplinary projects (such as with the artist Miguel Biazzi,

see Biazzi/Magrassi 1996), and taught anthropology and Pre-Columbian art at the art school "Ernesto de la Cárcova." Magrassi also directed the Centro de Estudios de Antropología (CEA) and Asociación Iberoamericana de Estudios Antropológicos y Sociales (AIDEAS), which were private research and teaching centers.

Buenos Aires: Old and New Migrations

The ethnographic context for this study is the city of Buenos Aires, Argentina's capital. The majority of the research was carried out there, and even where research consisted in accompanying artists on field trips or production visits to the Andean province of Jujuy, or to Neuquén in Patagonia, the preparatory research and contacts were established in Buenos Aires (see Appendix *A Note on Methodology, or the Challenge of Artistic Practices*). This is the reason why a basic understanding of the formation of identities in this city is an essential background and context for the artists analyzed in this book.

The inhabitants of Buenos Aires, irrespective of their specific individual descent, generally conceive of themselves as descendants of Europeans. Since the nineteenth century this constructed identity has served to mark out differences vis-à-vis indigenous people, descendants from colonial Spaniards and indigenous people (*criollos*), and African slaves. During the last few decades there has been increasing immigration from Argentina's neighbouring countries (Chile, Bolivia, Peru, Paraguay, and Uruguay—less so from Brazil). These new immigrants are not yet accepted fully as *porteños*.

Since the end of the last military dictatorship, *el proceso*, in 1983 there have been new possibilities in civic society to express identities, among descendants of Europeans, among Creoles (a category that is discussed in more detail further on), and among indigenous people. This period of the last two decades also provided new opportunities for artists working with appropriations from indigenous cultures. The majority of those descending from Europeans perceive the immigration from neighbouring countries as an indication of Buenos Aires, and Argentina in general, becoming ever more Latin American. According to this point of view, Buenos Aires is increasingly showing characteristics of other Latin American cities (such as shanty towns, more "indigenous-looking" people), which are contrasted with Buenos Aires' European immigrant past and self-image as the "Paris of South America." On the other hand, there is also a growing (albeit still comparatively small) number of Argentines who, especially in the cultural field, are seeking to break with their European past and want to assume a new Latin American identity. Many artists featured in this book share this point of view.

The important thing to bear in mind here is that both the notion of *porteños* as inhabitants of Buenos Aires and descendants of Europeans, and more recent shifts of identities toward Latin America, are constructed in the New World.

Porteño, as other Argentine identity markers, is by definition a Creole concept, and in the rest of this section I explain why Argentina is best understood as a Creole nation (as I have argued earlier, Schneider 1998). This

might sound surprising, since Argentines from the end of the nineteenth century and for most of the twentieth century have taken the melting pot (*crisol de razas*) as the basis for their identity construction. After massive, mainly European, migration between 1880 and 1930, and once more after World War II till the early 1950s, Argentina was seen as a European immigrant nation. It received more immigrants than Canada and Australia, and was second only to the United States in the volume of immigration of European origin. In terms of the relative proportion of immigrants versus pre-immigration population it was second to none. However, scholars such as Germani (1955, 1970) have argued that, in contrast with Australia and the North American immigrant experience, in Argentina a genuine melting pot arose out of the fusion of immigrants of different origin, rather than a result of ethnic segregation (see also Schneider 2000b). Germani (1975: 119–145) was also among the first to analyze the impact of internal migrations (i.e., from the rural parts of the Province of Buenos Aires and other provinces) on the social composition of the metropolis, and how this contributed to the rise of Peronism in the early 1940s. Internal migration was caused by a need for cheap, unqualified labor in industry and the service sector, which after 1930 could not be satisfied by transoceanic migration. The majority of internal migrants were farm-hands and day-laborers (*peones*), descendants of colonial Spaniards and indigenous people who in Buenos Aires were derogatively labeled *cabecitas negras* (little black heads), a racist term implying the superiority of the European-descended population. Thus the category *porteño*, designating the inhabitants of the *port* city of Buenos Aires, is part of that wider ideology of the melting pot. Everybody who is an inhabitant of Buenos Aires, speaks the dialect *lunfardo*, and shares the basic premises of the symbolic universe of the city is called a *porteño* (Schneider 1995, 2000a).

However, despite these categories conveying an apparent sameness, such as for instance, the Argentine version of the melting pot (*crisol de razas*), we have to examine critically who is included and who is excluded by these ideological constructs. Not everybody "melted" in the same way, and we shall see that the melting pot, far from being egalitarian, changed its connotations historically and always entailed hierarchical distinctions between desired, less desired, and undesired immigrants.

As we shall see it is against the more general assumptions of a melting pot of European peoples that the artists in this book are rebeling against with their appropriations of indigenous cultures, substituting the melting pot with a new paradigm of constructed roots in Latin America.

Difference and Sameness

This section thus challenges some commonly held assumptions about the creation of difference in Argentina. Whilst we do not deny the unquestionable European influence upon these processes, they fundamentally resulted in "American" concepts, created in the New World. Even though some denominations of European origin, in the form of racial and ethnic categories, might

persist, they have been transformed into something else. The models generated in Europe have been reconstructed into categories with new meaning in Argentina.[7]

It follows from this that discourses of difference and sameness in Argentina (as in other "white" settler societies, and to some degree, other Latin American countries) are hybrid discourses.[8] Ultimately, they come out of the experience of Europeans with indigenous peoples. We know that encounters of perceived radical difference produce discourses of fictive purity, which are really constructions of alterative self-identities.[9] When, after 1879, Indians had been almost extinguished in Argentina (in fact there is some argument amongst historians as to how comprehensive this "genocide" was, Quijada 2000, 2002) and the remainder pushed into marginal reservations, Europeans of different immigrant origins and subsequent waves of migration, and Creoles, had to negotiate national identities. We shall see further on in this chapter that essentializing concepts such as Creole (*criollo*) are the result of this new hybrid situation.

In the late nineteenth century, the Creole elite that had promoted immigration tried to "assimilate" Europeans to an imagined Argentine culture with Hispanic and Creole values, whilst also proclaiming to "Europeanize" the rural Creoles. However, they only partly succeeded, and a new hybrid culture, incorporating elements of the European immigrants, resulted from mass immigration. In fact, the urban population of European and other overseas descent in Argentina became in a wider sense as much "Creole" as those who denominated themselves as *criollos*. If we substitute in the standard definitions for Creole (introduced in the previous section), "Spanish" origins with "European," that is, "born to Spaniards (or rather Europeans) in the New World," we obtain an exact characterization of the population of the provinces of the littoral. For even if self-definitions insist on a presumed European character, that is, Europeanness as expressed in building styles, food consumption, and language influences, such notions are entirely New World constructs, and therefore *Creole*. In fact, in provincial towns of the Argentine littoral, such as Paraná, Creole carries this wider meaning and encompasses the descendants of all Europeans not only of Spaniards.[10] Even in Buenos Aires, *criollo* became synonymous with having acquired an Argentine identity. Furthermore, in the context of developing sports activities in metropolitan Buenos Aires, *criollo* denoted the particular "Argentine" way of playing, for example, soccer, as contrasted with an earlier style practised by the English immigrants, who had introduced the game to Argentina and dominated it till 1913. By contrast, upper-class polo remained (and remains) dominated by Anglo-Argentine players, whilst acquiring an Argentine *criollo* style as distinct from that of polo played in England.[11]

Thus in Argentina, the term "Creole" (*criollo*) conveys different meanings. In its upper-class notion used by the *familias tradicionales* (traditional families), creolism disguises a contradiction in terms. Here, the term presupposes "pure" and unbroken descent from Spanish colonial families, although, in fact, during the nineteenth century there was frequent intermarriage of

upper-class Creoles with new European arrivals, especially, Scottish, Irish, German, Basque, and French.[12] Before independence, lower-class colonial Spaniards in rural areas had mixed with Indians and Africans for generations.[13] During colonial times, in the vice-regal capital Buenos Aires, distinctions between Creoles and Spaniards were important for positions of power and influence in the bureaucracy, and played a part in the stratification of the merchant class. After independence in 1812, class distinctions remained, expressing a fundamental division between the politically and economically powerful, who would also determine the norms of proper behavior, the *gente decente*, and the "rest," the *gente de pueblo*.[14] However, amongst the elite, political change and an essentially hybrid origin had produced a new discourse of Creole purity. Therefore, we have to examine in the first instance the Argentine notions of the term *criollo* more carefully, in order to distinguish it from more generalized meanings.

As explained before, in the Hispanic world, to be a Creole (*criollo*) meant, originally and in its most narrow sense, being born to Spaniards in the "New" World. In Argentina, however, because of mass immigration, Creole is used primarily in two rather different ways, the distinguishing element being social class. Therefore, in the Argentine case, Creole became a socially stratified term.

In the first, "egalitarian," sense of its meaning in Argentine usage, *criollo* denotes anybody (and by extension any habit or custom, such as "Creole cuisine" *comida criolla*) supposed to be of mixed Spanish colonial and indigenous origin, and from the interior provinces less influenced by recent European immigration, as opposed to the littoral. Descendants of Europeans and other recent immigrants who constitute the majority of the population in the littoral use the term in a depreciative way, implying backwardness, rural habits, and little education as opposed to their own supposedly more sophisticated way of life. It can also be used in a neutral or more positive way to denote traditional ways of Argentine life relating to the rural culture of the pampas and its inhabitants the *gauchos* (as opposed to European *gringos*), the epitomizing of this way of life in the epic novel *Martín Fierro* (by José Hernández), and its popularization in the gaucho-figure *Juan Moreira*.[15] Furthermore, *criollo* would denote descendants of Europeans, especially in rural areas of Argentina, who in their habits and customs have become so indistinguishable from those descending from Spaniards and Indians that in fact they have become Creoles or creolized (*acriollados*).[16] In addition, those identifying strongly with Creole traditions would oppose them to imported European ways, in which case Creole becomes a counter-discourse, and a means to distinguish oneself from more recent European immigrants. This is similar to what Ricardo Rojas had in mind when he suggested that *Europeans* should be regarded as the "exotic other" in Argentina, not Indians or Creoles. Europeans who can become Creoles are another indicator that the meaning of the categories in our scheme is not hermetically sealed, and that to some degree people can move between them and assume new identities. Moreover, it shows that what I term the egalitarian notion *criollo* is a culturally

constructed category, and not based on an ideology of descent (however fictive or putative) as among the upper classes. In this sense, the egalitarian and inclusive meaning of *criollo* is similar to *porteño*, denoting any inhabitant of the port city of Buenos Aires.

In 2000, on my way to an artist's studio in *La Boca*, the old Italian neighbourhood, I met three elderly men sitting on the benches of a little square. One of them told me, "I am ninety-years old," and when I asked him, "Where are you from" he answered, "I am the son of Italians." "From where?" I went on to ask. "From Palermo, Sicily," he replied. "And did you speak Italian at home?" "No, I was a small boy (*yo era pibe*); we spoke in *criollo*" (here meaning Argentine Spanish—the usual expression is *castellano*). This is symptomatic of how *criollo* has become synonymous with Argentine, and in this case even *porteño*.

In Buenos Aires, and the littoral provinces more generally, *criollo* can acquire a negative meaning not only because it designates people and their habits as from the interior, but also because it often refers to poor immigrants from these areas who have become more visible since the internal migrations after 1936, as explained at the beginning of this section. In this case, *criollo* is bound up with socially constructed racial categories that are used in a derogatory fashion, such as *morocho* (dark skinned), or *cabecita negra* (little black head).

The second and more restricted, almost exclusive, meaning of *criollo* in contemporary Buenos Aires refers to the upper classes of supposed colonial Spanish, or at least early independence, origin prior to mass immigration: the *familias tradicionales* are also the *familias criollas*, that is, those who have upper-class Creole surnames. An example of this ideology persisting in contemporary Buenos Aires are the frequent visits by members to the library of the upper-class Jockey Club and its *Instituto Argentino de Ciencias Genealógicas*[17] in search for genealogical records purporting their old ancestry from Spanish Creole families. A former librarian of the Jockey Club told me that the club's president once commented thus on those researching their ancestry: "What are they looking for in the Viceroyalty? At that time they were all thieves!" (*¿Que buscan en el virreinato? ¡ Eran solo ladrones!*). Ernesto "Che" Guevara de la Serna (whose father's full name was Ernesto Guevara Lynch) when traveling in Ireland wrote an ironic postcard to his father in 1964: "Dear Pop, With the anchor down and the boat in port I'm in this green Ireland of your ancestors. When they found out, the television came to ask me about the Lynch genealogy, but, in case they were horse thieves or something, I didn't say much. Happy holidays. We're waiting for you. Ernesto. (December 18, 1964)."[18] The background to this is that Irish families (similar to Che Guevara's Irish side of the family) had married into upper-middle- and upper-class Creole *familias tradicionales*,[19] thus leaving behind their rather humble origins. Amongst upper-class families of Creole or partly Creole origin, *criollo* descent and traditions are seen as an ulterior means of distinguishing themselves from nouveaux riches families of more recent immigration that lack a rural land-owner background (such as industrialists, for example). For instance, Italian immigrants and descendants of

Italians, even if they are very well off, are looked down upon by the *familias tradicionales* because they represent generically the massive immigration of unskilled, illiterate immigrants at the beginning of the century. In my earlier research on Italian immigrants I came across the son of a wealthy Italian immigrant who had invested his fortunes from import business into a rural estate, and married into one of the *familias tradicionales*. His mother-in-law apparently commented to her daughter (his future wife): "Well, if an Italian is good enough for you, you can go on seeing him . . ."

The examples show quite clearly that some Argentines might not perceive of themselves as Creoles, yet they are, as descendants of Europeans, other overseas immigrants, Indians, and Africans, the products of "American" (i.e., New World) historical destinies. It is precisely these new constructions of identity, through the appropriation of indigenous cultures (as deliberate acts of creolization), that the artists I discuss in this book are engaged in.

Argentina in the 1990s and Beyond: From Economic Bonanza to Despair

In the 1990s and at the beginning of the new millennium, Argentina was a country profoundly shaken in its assumptions about identity. An already fragile self-confidence was further challenged with the most recent economic and political crisis in 2001/2002.[20]

These events succeeded ten years of comparative economic stability under the Menem administration. Emblematic of Argentina's changed economic climate in the 1990s, representative for the new consumer tastes of the young, upwardly mobile, and a bold statement by big investors—thus *porteños* perceived the development of the Puerto Madero, Buenos Aires' port (first built in 1898), through which many of the country's imports and exports, including millions of immigrants, had passed. The port had been derelict and hardly used for decades, and investors seized upon the opportunity in the early 1990s: Warehouses were turned into lofts, with the lower floors converted into upmarket shops and restaurants, and the docksides into walking malls, an attempt to emulate redevelopments at London's Docklands, Hamburg's Speicherstadt, and many other port areas around the world. The flamboyant Puerto Madero development was seen as progress by *porteños*, and as a sign of Argentina's changed fortunes after the economic debacle of the Alfonsín administration. It also signified Argentina's subordinate insertion into the hegemony of neo-liberal globalization of the 1990s, providing the illusion that the first world belonged to *porteños* (Guano 2002). On various visits during the 1990s, I was taken by friends on guided tours of the area. More recently in 1999–2000, the Spanish architect Santiago Calatrava was commissioned to build a swinging footbridge across one of the docks, resembling the inverted keel of a ship (see figure 2). Again, this new construction was pointed out to me as landmark of the new future-oriented, "modern" Buenos Aires, and I was criticized sometimes for my lack of enthusiasm and for my apparent nostalgia for old buildings, immigrant cafés, and museums.

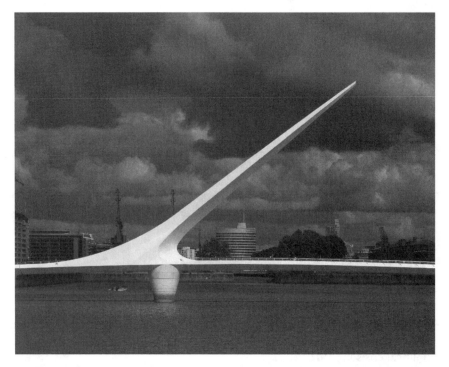

Figure 2 Santiago Calatrava (architect and engineer), *Puente de la Mujer*, Buenos Aires, 1999–2000. © Alan Karchmer, Architectural Photographer.

The great retrospective of Argentine twentieth-century art *Siglo XX Argentina Arte y Cultura* held in the *Centro Cultural Recoleta* in 2000 praised the redevelopment of the Puerto Madero area as a veritable "reconquest of the River [Plate]," in fact, hailed it as the most important urban development since the 1930s, giving new impetus to the south of the city, which had been neglected for decades (Petrina 2000: 180, 182). What, then, did *porteños* regard as fundamentally changed since my first extended fieldwork in 1988–1989?

Of course 1989 also was the year in which President Raúl Alfonsín had to end his mandate six months ahead of time, and was succeeded by newly elected Carlos Saúl Menem. Alfonsín is credited by most Argentines and foreign observers with the return to democracy and setting up the important Truth Commission, CONADEP (Comisión Nacional Sobre la Desaparición de Personas), which under the chairmanship of writer Ernesto Sabato published its report *Nunca Más*. Alfonsín had left his mark of distinction on the political history of Argentina to chair its first democratic government after the dark reign of the last military dictatorship *el proceso* (short for *El Proceso de la Reorganización Nacional*).[21] However, in economic terms, his government had a much less enviable record. In particular, the last period in 1988/1989 was characterized by hyperinflation, and eventually led to Alfonsín's early resignation.

The new Menem government pegged the Argentine Peso to the U.S. Dollar at an exchange rate of 1 : 1. Having stabilized the currency and made the country attractive to foreign investors, the first five years of Menem's government were judged by most observers as a relative economic success— at least according to traditional liberal economics—that prevailed in the 1980s and 1990s (Heymann/Kosacoff 2000). Large parts of state-owned enterprises were privatized (especially in the telecommunications and energy sectors) with huge profits for foreign investors. Argentines, however, quickly learned that this meant higher prices at home, and soon telephone calls within Argentina were among the most expensive in the world. I often heard statements such as, "acá nos robaron; ya no nos queda nada" (here they robbed us; we are left with nothing), indicating the degree of despair and rage at what was perceived as economic imperialism by the first world. Free-market economics also meant less protected markets, especially within the Mercosur, where Brazil—after having devalued its currency—was flooding the Argentine market with comparatively cheap manufactured goods. During Menem's presidency, Argentina underwent an unprecedented period of deindustrialization. The result was the closure of many Argentine factories and rising unemployment (up to 18 percent), and poverty levels which by October 2002 (under the substantially unchanged economic politics of the de la Rúa government) meant that 54.3 percent of the population in Greater Buenos Aires was living below the official poverty line (Epstein 2003: 16). However, stabilization of the currency meant, at least for those who earned some surplus money, that this could now be saved in bank accounts in Argentina (and not abroad), where deposits could be held in Pesos or Dollars. For the first time in many years, middle-class Argentines, and in fact everybody who had not lost jobs or businesses, started to believe in the economic policies of their government. High inflation rates and a currency at the mercy of speculating with a fluctuating exchange rate were seen as a thing of the past.

Observers and analysts of the art market also perceived Argentina as an underdeveloped market, but one with good chances for future growth, and helped by the stable currency. As late as 2001, and shortly before the tragic political and economic events of December 2001, one economic observer concluded his analysis of the Argentine art market in highly optimistic language, seeing "great potential" for this market and future gains by investing in contemporary art (Golonbek 2001: 127).

Artists in Argentina are often in precarious economic situations in which artistic work has to be complemented by teaching and other jobs not related to the arts. However, artists too could benefit to some degree from the new monetary stability, as money from sales of their work (even when prices were modest), prizes, awards, and government scholarships had some "real" value and could be saved, invested, or used to meet living and material costs, as well as allow more foreign travel. Gallery owners also profited from the Menem period, which saw a new young professional class, as well as new fortunes emerging—a perceived target market for new Argentine art. A more detailed examination of this phenomenon is presented in chapter 3.

Yet as one observer put it, there were also changes in the characteristics of collectors in the 1990s that were linked to the new economic cycle. In contrast with the 1970s and 1980s (when institutions, such as banks and insurance companies, and a few outstanding private collectors, such as Jorge and Marion Helft, dominated collecting), the 1990s were characterized by a new group of professionals who had made their money (in some cases, fortunes) in that period, and who were especially attracted to contemporary art—rather than to more conservative and established genres (cf. also our discussion in chapter 3; and Telesca 2000: 202–203).

For art critics and writers, as for other comparable professions, economic stability and a fixed rate of exchange against the Dollar also implied that their fees were paid in hard currency and, more often than in the past, on time. As one critic expressed it in a conversation with me, "money was circulating," and the "chain of payments" was functioning.

The cultural developments during the Menem years (1989–1999) are complex and no attempt is made here to treat them comprehensively. In terms of state spending on the arts, Argentina still lagged behind others, notably Brazil. Overall, Argentina spends little of its national budget on culture, an estimated 0.22 percent in 2000, compared to UNESCO's recommendation of 1 percent and Germany, for example, spending 2.5 percent (Golonbek 2001: 102). Single institutions, such as the *Museo Nacional de Bellas Artes* (MNBA) would still receive substantial contributions (about $3.5 million in 1999; cf. Golonbek 2001: 66), but they were nothing compared to the acquisition budgets of the prime institutions in Europe and North America. The 1990s had also seen some resurgent international interest in one of Argentina's prime cultural exports since the 1920s, the *Tango*, which in turn led also to renewed interest in this dance form by young people at home.[22] Argentine cinema, too, made new strides, with a host of young directors leaving behind the more politically informed films of opposition and exile (epitomized by Fernando "Pino" Solanas and others), and taking up the challenges by a more unorthodox narrative cinema, and new ways of directing, embodied in international cinema by, for example, Quentin Tarantino (and his emblematic film *Pulp Fiction*) and the Dogme group around Lars von Trier.

However, whilst the return to democracy in the 1980s had seen some interest in *lo nuestro*,[23] that is, emphasis on Latin American indigenous cultures and folklore by an urban middle class (artists, fashion designers, musicians), the 1990s were more directed at achieving globalization, access to Internet, cyber-culture, and other international trends and technologies, thereby aiming to establish Argentina in the global circuit of traffic in culture.

Occasionally, government agencies did promote the arts of indigenous and Pre-Columbian Argentina, as, for instance, when the collection of Pre-Columbian art of the Italo-Argentine Di Tella family was donated to the *Museo Nacional de Bellas Artes*, or when the same museum hosted a show of Mexican Zapotec art in 2000.[24] In 1998, the *Feria del Sol*, a fair of crafts and artisanship (on which more in chapter 3), also received a subsidy of $30,000

from the *Fondo Nacional de las Artes* (FNA), the main national organization sponsoring the arts (Fondo Nacional de las Artes 1998: 20–21). An image of a woman weaver with her loom appeared on the cover of the FNA's annual report for 1998. The FNA helped organize a show of the contemporary art of Argentina's north-western provinces (*Arte del Noroeste Argentino*, Centro Cultural Recoleta/Museo Sivori, 1998), and the FNA has established a category of folklore within which it awards competitive prizes (Fondo Nacional de las Artes 1998: 63, 52).

The already mentioned exhibition by the *Centro Cultural Recoleta* on Argentine art and culture in the twentieth century highlights a certain resurgence in nativist and folkloric themes in the democratic period since 1983 (when these themes could once more be openly discussed), but is now also linked to globalization, and a wider (i.e., global) interest in ethnic arts. Thus, as Blanca Rébori wants to affirm in her short catalogue entry on "Folklore," the "concept has lost its character of immobility and conservatism" (Rébori 2000: 190).

Overall, however, the impression given by most of my interviewees was that there did not exist a coherent policy to promote indigenous art or art inspired by indigenous cultures, and private collectors often lamented in the interviews that there was no museum of Pre-Columbian art in Buenos Aires, and bureaucratic obstacles to the establishment of a private museum or foundation were considerable.

One collector of Pre-Columbian art gave the following reply to my question of whether he did not want to convert his private collection into a public museum:

> To found a museum is one of my objectives. Here, the state has cared for this topic rather little, in contrast with Peru and Mexico, where these initiatives represent an important source for generating money. The archaeology of Pre-Columbian art, for its important museums, and for its important archaeological sites, was promoted by the state because it is an important source for tourism. In Argentina, it was not perceived from this point of view. The topic is less than secondary, it was tertiary for all the different governments we had here. I have not seen even a minimal effort in developing an interest in these cultures, and finding a way to promote research on this topic. To the contrary, here one always looked to Europe, or in recent years, to the United States—regarding culture, mainly to Europe. In my primary and secondary school studies they only mentioned the Inca. We studied the Romans, the Egyptians, and everything about European culture—much more than we learned about the culture of our America (*nuestra América*).

Another collector articulated his views on art in the following way:

> When I looked at the quantity of pieces I gathered in forty years, I thought I should create a museum, a foundation. In my CV I present it as "social art" I think creating a museum and giving it to the public is a social act. That's why I am working to show Pre-Columbian art to the public. That's one of my ideas of being an artist.

A patronage-law bill, fostering tax incentives for private participation in cultural projects, was in its final approval phase in 2001. In Brazil and Chile, similar laws already exist and have been applied with some success. In Argentina it is planned to establish a fund with the *Fondo Nacional de las Artes* (Golonbek 2001: 110–111).[25]

Conclusions

This chapter sets the scene to the understanding of why European-descended artists construct new discourses of identity based on acts of appropriation from indigenous cultures as acquired "roots" that are not based on descent. Fundamentally, the discourses by these artists insert themselves into a tradition of Creole ideologies, mixing indigenous and European elements, which are shaped in the "New World" even if they continue to have "Old World" (European) referents, as explained in this chapter. An introduction has also been provided to the range of methodologies and main themes of this book, through which the issue of appropriation and new identity constructions are explored. The artists who are discussed in this book are situated against the background of recent Argentine political and economic history of the last two decades.

In the first decade of the new millennium the prospects for Argentine artists remain mixed. Substantial new initiatives, such as the building of the *Museo de Arte Latinoamericano Buenos Aires—Colección Costantini* (MALBA) by the private-collector/millionaire Eduardo Costantini, indicate that future activities are to be expected from the private sector rather than from the largely discredited state institutions. As if any further proof were needed, the deep economic and political crisis into which Argentina plunged at the end of 2001 provided more evidence that state institutions were bankrupt, and many of them are perceived by ordinary Argentines as corrupt and run by functionaries just for their own interest. This more complicated and confused situation, however, seems to open new chances for artists and galleries contesting the traditional frameworks, both in terms of power and ideology.

This book demonstrates, after a more theoretical discussion on appropriation in the following chapter, how artists develop specific strategies of appropriation in order to reposition themselves in terms of identity vis-à-vis the dominant ideologies of melting pot and immigrant nations, which were reviewed in previous sections. There might even be a case for arguing that it was precisely Argentina's overwhelming experience with immigration that has led to a greater predisposition and flexibility in constructing new identities.

Chapter Two

Theoretical Foundations: On Appropriation and Culture Change

Introduction

The purpose of this chapter is to establish the concept of "appropriation" as the main theoretical paradigm of this book. It will be argued that appropriation is the most suitable notion to understand the work and practices of the artists under discussion.

The focus on appropriation, as an individual strategy and practice, is required in order to recalibrate theories of globalization and hybridization, which do not sufficiently focus on individual practices.

I first discuss definitions of appropriation, and then explore its role in relation to theories of culture change and globalization. I then advocate a new meaning of appropriation as hermeneutic practice, and finally discuss it in relation to globalization and hybridization in Latin America.

This chapter advocates a reconceptualization of appropriation in order to provide a better understanding of global art practices. In the first instance, I suggest we have to consider the relation of appropriation to cultural change. Early twentieth-century theories of cultural change and cultural contact (in German speaking anthropology, in the United States and in Britain) were clearly interested in the "migration" of particular elements (symbolic and material) across cultural boundaries,[1] but suffered overall from a holistic view of bounded cultures. Recent theories of cultural globalization, on the other hand, do not pay sufficient attention to the individual actors (as opposed to groups of individuals) in cross-cultural contact. Hybridization, creolization, transculturation, and other concepts focus more generically on mixtures of different cultural practices in entire societies or groups of individuals, but less on individual strategies. This chapter suggests that we might think of cultures as open systems in which individual actors negotiate access to and traffic in symbolic elements which have no fixed meaning.[2]

This chapter then critically discusses the concept of appropriation and evaluates the usefulness of applying the term appropriation in the analysis of

cross-cultural communication in a global world. Specifically, the discussion is of relevance to contemporary art practices that involve the appropriation of ideas, symbols, and artefacts from other cultures. In the Argentine context, which will occupy us in the following empirical chapters of this book, appropriation is a strategy of identity construction. Said otherwise, through the incorporation of new elements, inspired by indigenous cultures, artists change their own identity.

The focus of this book is on the visual arts, yet the discussion of appropriation has important implications for studies of diasporas in the process of globalization, since these involve particular conceptualizations of identity, authorship, and ownership of cultural and intellectual property.[3]

I am also interested in more general terms in the processes of cultural transmission,[4] cultural exchange, and recognition of otherness,[5] which, I argue, become operative through appropriation by individual artists. Thus my approach aims to shift the traditional units of analysis in anthropology, namely from whole "groups of individuals" and bounded cultures (the traditional emphasis of anthropology and of the anthropology of art) to the individual producers of artistic works and their role in the process of globalization, as well as, generally, cross-cultural contacts. In fact, artists are conceived of here as an "interface" in this process, nodal points in the global system that provide "entry into other cultures" (Hannerz 1996: 39–42). As Hannerz puts it succinctly:

> The real significance of the growth of transnational cultures, one might indeed argue, is often not the new cultural experience that they themselves can offer people—for its frequently rather restricted in scope and depth—but their mediating possibilities. The transnational cultures provide points of entry into other territorial cultures. (Hannerz 1992: 251)

Defining Appropriation

I first comment on the term appropriation in contemporary art practices, and then suggest a hermeneutic approach to understand its role in processes of cultural change and globalization. Appropriation as a more general social, material, and symbolic practice, of course, extends beyond the production of artworks and also involves the appropriation of space (in the city,[6] for example, through studio and gallery spaces and the social networks of the art world—as explained in more detail in chapter 3, and through travel for artistic projects [chapters 6 and 7]). We can also think of appropriation in relation to historical time, such as when the pre-Columbian indigenous people of Argentina are claimed to be cultural ancestors for contemporary Argentines with a new Latin American identity (as opposed to imported European models), a view held by many artists discussed in this book and one that has been referred to in chapter 1 and taken up again in chapters 4 to 8.

Here, however, in order to clarify issues of terminology, this discussion relates in the first instance to the production of artworks. In art history,

appropriation in the narrow sense has been defined as "[T]he direct duplication, copying or incorporation of an image (painting, photograph, etc.) by another artist who represents it in a different context, thus completely altering its meaning and questioning notions of originality and authenticity" (Thames and Hudson Dictionary of Art and Artists, Stangos 1994:19). "Originality" and "authenticity," of course, are notions central to the Western canon of art since the Renaissance. In more recent times, appropriation is sometimes characterized more frankly, as a practice by which "an artist may 'steal' another pre-existing image and sign it as his/her own," whereas "reappropriation connotes 'stealing' an image, symbol, or statement from outside the realm of art" (The Bullfinch Pocket Dictionary of Art Terms, Diamond 1992: no page numbering). In terms of the Western legal notion of individual property, artistic appropriation implies an infringement of copyright, as Coombe points out:

> It is important to note here that the law assigns works a category and a degree of protection at the time of origin, not at shifting points of public reception. Hence, an artistic work that copies the work of another, regardless of the social critique or political point the artist believes she is making, is a copyright infringement and remains one even if the artworld comes to regard the work/copy as an authentic masterpiece. (Coombe 1993: 257, cf. also Coombe 1998)

The late Latin *appropriare*, "to make one's own," (deriving from *proprius*, "one's own") is at the root of subsequent applications of the term and also surfaces in debates on the return of "cultural property," in which the political implications of cultural appropriation, both of tangibles (such as the Elgin Marbles) and of intangibles (i.e., "intellectual" and "spiritual" property) have been discussed at some length.[7]

Appropriation, copying,[8] or even citation and reference to the work of previous artists are established practices throughout the history of art (with obviously changing connotations according to the historical period), but they have become particularly salient to "(post)modern" art practices, which, as Rosalind Krauss highlights, challenge traditional Western notions of exclusive authorship and any accepted supremacy of the original (high) over its copy (low) (1989: 8–10; also Schwartz 1996). In contrast, Benjamin Buchloh has characterized the strategies of appropriation and montage in twentieth century modern art as "allegorical procedures" (1982: 46), implying obvious changes of meaning in the process. On the other hand, appropriation for many Latin American and other "Third World" artists prolongs and extends the experience of the original, whilst also investing it with new meaning,[9] and serves as a strategy for identity construction. This bears some resemblance to the original Roman understanding in, for example, in the appropriation of Greek art, where the practice had more of a symbolically transformative character, rather than simply copying (cf. Krauss 1989: 10).

Consequently, there is no "original," after all. As Friedman (1997, 1999) variously argued, cultures are always impure, consisting of heterogeneous

elements ab initio. There is, so to say, nothing *before* hybridity; in fact, the term is probably misleading, as it presupposes a transition from pure elements, which, through a blending process, become impure, or hybrid. For want of a better term, "originary syncretism" has been proposed by Amselle (1998: 1). It captures well the dilemma of the underlying terminological contradictions between "originary" and "syncretism" (as syncretism, like hybridity, presupposes an earlier nonsyncretic state), and tries to dispel any notion of a reified original state, or homogenous culture.

Arguably, in a more general sense most cultural practice is appropriation, in that it is part of a continuum (both historical and spatial) of all human endeavor in this respect—an assertion not alien to the politically and culturally "disenfranchised" in contemporary societies, as the following quote, which comes from a member of *Group Material*, an arts collective based on New York's Lower East Side, shows:

> Well, let's take this supposedly theoretical ideal of "appropriation." With the high school kids that I teach, there is an intrinsic knowledge about appropriation, because for them in a sense, all cultural production has to be stolen. White culture historically never let you proclaim the culture that you had. It's not talked about, it's not taught, it's not on TV. And even within a group of young artists—for graffiti writers, to bite something and make it your own is a sign of greatness. Tap dancers build whole repertoires of stolen steps. There's the idea within folk culture of how imagery gets communicated, appropriated, and turned into new imagery. (in an interview by Critical Art Ensemble 1998: 29)

It is clear from this quote and worth mentioning again that artistic practices of appropriation go beyond strategies that are inherent to the artworks themselves—in fact, they are intrinsically linked to contested spaces of identity construction. Once they occupy public spaces (as in graffiti art, murals, but also with gallery spaces), they also appropriate spaces that are arenas of contest, as Wildner (2003a, b) has recently shown with her work on the public square *Zócalo* in the center of Mexico City which has become a focus for competing symbolic claims by a variety of social groups.

In what follows, I adopt an extended definition of cultural appropriation "as the taking—from a culture that is not one's own—of intellectual property, cultural expressions or artefacts, history and ways of knowledge," (Ziff/Rao 1997: 1, citing the Resolution of the Writers' Union of Canada, 1992). The problem with such a definition for many artists is that they appropriate cultures that at the same time are and are *not* regarded as their own. In fact, the construction of new identities by these artists often evokes ancestral ties to indigenous cultures, either by presumed biological and/or cultural descent and belonging (even for artists of European descent), as well as ties to the international, still largely Westernized art canon mediated by the "art world" (Becker 1982).[10]

A further issue is that the parameters used in the above definitions are problematic, because meanings of appropriation and "culture" are shifting

according to context; especially since the latter has lost its exclusive definition as a bounded system of shared values and artefacts (or material representations) of a social group. Also, as has been pointed out in debates on cultural appropriation, those claiming a particular culture as their own, and thus challenging the appropriation of elements of that culture by others, often use themselves ethnocentric constructs of culture as an unchanging phenomenon, expressing what Coombe calls "possessive individualism" (that objects, tangible or intangible, belong to individuals) (Coombe 1993: 253). Thus, operating with rigid notions of cultures at both ends of the continuum between "origin" and "copy" leaves appropriation in a straitjacket of cultural essentialism.

Could then appropriation be reestablished as a concept to conceive of the brokering practices between different (and coexisting) cultural contexts by visual artists (and others, in a variety of cultural domains such as music, fashion, and cuisine)? Obviously, such a reinstatement of appropriation would have to account for the social and political dynamics involved. A crucial question is, who appropriates what, where, and from whom. This implies a situating of appropriating practices in different power relations, which would go beyond the more formal approaches in art history in which appropriation has been defined as the taking out of one context and establishing of a new one. Consequently, there would be a shift in emphasis toward social practice and agency as advocated by some recent writing in the anthropology of art (Gell 1998, Pinney and Thomas 2001). This, in turn, could account both for how cultural forms become diasporic (and change their meanings), and how the actors involved are often themselves in a diaspora in relation to their cultures of origin.

Appropriation, Cultural Change, and Globalization

The effects of globalization are not new, of course, nor is their study—as Sidney Mintz (1995, 1998) frequently reminds us. It is therefore useful to revisit critically some historical antecedents of present concerns with the processes of cross-cultural contact and globalization (see also Gingrich and Fox 2002). This chapter later returns to the discussion on globalization with specific reference to Argentina, and to Latin America more generally.

It is well known that the American variety of cultural anthropology (starting with Boas and Kroeber) as well as cognate attempts by early twentieth-century German and Austrian anthropology (cf. Lowie 1937, Harris 1968, Mühlmann 1984, Gingrich 2002: 230) were eager to investigate cultural difference and culture change. Of course, the models then proposed of "cultural circles" (*Kulturkreislehre*) and "culture areas" have long been superseded, as has been the idea of bounded, homogenous cultures. What is of interest here is the fact that terms such as appropriation, *Aneignung* in German—although rarely used explicitly—were conceptualized through ideas of cultural contact and the exchange of artefacts and belief systems between cultures (and their constitutive elements, such as symbols). However, a problem of the early

diffusionists, especially German and Austrian ones (such as Fritz Graebner and Father Wilhelm Schmidt) was that they conceived of culture change as a rather mechanical process. As Thurnwald pointed out in his critique of Graebner:

> From the old so-called "evolutionary" point of view this concept [i.e., *Kulturkreislehre*; A.S.] differed in that it assumed particular cultural centers and points of diffusion. However, how this transference was realized and what effect it had psycho-sociologically, was not the preoccupation of Graebner in his book "Methode der Ethnologie." For him, transfers were realized mechanically, like transferring a piece from one museum case to another. (Thurnwald 1931: 11; my translation)

It is rather uncanny, and not without irony, that Thurnwald[11] should refer to the museum, a principal site of appropriation in late nineteenth- and early twentieth-century (colonial) anthropology—the practices and continuing sites of representation of which have been much critiqued by both discursive writing and visual artists' installations.[12]

In early and mid-twentieth-century anthropology, cultures were conceived as wholes, that is, the symbolic representations and material manifestations of bounded "groups of individuals," as a famous memorandum on acculturation by Herskovits, Redfield, and Linton stated in 1936. As such, models of cultural change and acculturation left little room for the consideration of the individual in society, a problem that I contend persists till the present in anthropology, and especially the anthropology of art (see below, and Schneider 1996), despite the processual and constructed understanding of culture many studies in anthropology now adopt, following for example Barth (1970, 1989) and Hannerz (1992).[13]

Early twentieth-century studies of acculturation (which, in the United States, were promoted by Herskovits, Redfield, Beals, and in Germany, for instance by Thurnwald) or culture contact (in the British Commonwealth), of course, were not questioning the colonial politics of cultural appropriation and, on the whole, were complicit with colonialism.[14] The conceptual interest was in the dynamics of cultural change as a result of increasing contact between cultures, usually between non-Western cultures that had come into contact with Europeans and, less often, between non-Western cultures themselves. Criticism of the holistic culture concept and the neglect of the individual was voiced already by Bateson ([1936], 1973) in his rejoinder to the memorandum by Herskovits, Redfield, and Linton (1936) mentioned above, when he suggested studying acculturation in relation to the individual child, calling this process "enculturation." The overall neglect of the individual was not remedied by "culture and personality studies" either, in which individuals were simply conceived of as representatives of their culture (e.g., performing to patterns, according to Benedict 1934, or to a metaphysical "superorganic," according to Kroeber 1917, or being moved by "Paideuma," that is empathic emotion, according to Frobenius[15]).

Before Structuralism's ahistorical approach to culture, anthropologists of the 1920s to 1940s in Germany, Austria, and the United States were still

partly informed by the broader schemes of earlier cultural evolutionists and diffusionists. They were particularly interested in studying, through participant observation, cultural change and culture contact as processes of cultural borrowing (*kulturelle Entlehnung*[16]), and more specifically, appropriation, even "piratical acculturation," that is, appropriation through warfare—which some evolutionists saw as the earliest form of culture (ex)change (cf. McGee 1898).[17]

To sum up, these early approaches ultimately aimed at uncovering the laws, rules, or at least a logic of culture change—the kind of grand theory of which the late twentieth century, understandably, had become suspicious (see also Gingrich and Fox 2002: 4–5). Of course, with the above I do not pretend to have exhausted the discussion on early twentieth-century diffusionism in relation to appropriation and culture change, which would merit a separate study.

Nevertheless, it is curious and perhaps symptomatic that current concerns with cultural hybridization—despite attempts by Hannerz (1992, 1996), and Thomas (1991, 1999) for instance—have not yet led to a similar theorization of the actual, material processes of cultural change within the global system. As yet there has been no comprehensive attempt by postmodernists and post-structuralists to reveal the logic, laws, or mechanics of global cultural processes (supposing that there are certain regularities)[18]—which might compare in scope and breadth with the older acculturation paradigms.

Regarding future research, we have to ask further whether processes of cultural change in a global setting are essentially distinct from those between "single" cultures previously investigated through paradigms of acculturation or culture contact, or whether the rate of change simply accelerates, or becomes qualitatively different, and now functions according to other parameters than in the past. Finally, the status and usefulness of cross-cultural comparisons as indicators of globalization have to be assessed and contrasted with the superseded notions of acculturation.[19]

Appropriation as Hermeneutic Procedure

The point here is not to revive the antiquated theories of acculturation and culture change of the early twentieth century, but to reconnect with the interest in appropriation, and focus on individual practices, that mediate or broker between different cultural levels in the process of globalization.

For anthropology, it is important to develop a proper concept of appropriation, one that takes into account (a) the "original"[20] context of an artefact and its producers; (b) the artefact itself; and (c) the appropriating person, or agent. Such a concept has to retain, from a hermeneutic point of view, the "understanding" or "comprehending" nature of the appropriating act. At the same time, it has to reinstall the intentions of the "original" producer, whilst giving justice to the artefact. From a purely hermeneutic point of view the aspiration for such an encompassing concept probably must remain unfulfilled.

Thus Ricoeur, one of the few contemporary philosophers who has specifically written about appropriation, points out:

> An interpretation is not authentic unless it culminates in some form of appropriation (Aneignung) if by that term we understand the process by which one makes one's own (eigen) what was initially other or alien (fremd). (1981: 178; German terms in original)

Appropriation is opposed to "distanciation" by Ricoeur, but its practice does not mean taking simply possession of the other. To the contrary, the term implies in the first instance the dispossession of the narcissistic ego, in order to engender a new self-understanding, not a mere congeniality with the other (Ricoeur 1981: 191–193).[21]

> Relinquishment is a fundamental moment of appropriation and distinguishes it from any form of "taking possession." (Ricoeur 1981: 191)

Yet anthropology, which owes by its very nature (encompassing ethnographic research and cultural analysis), to the producing, "originating" cultures, cannot stop here. Anthropology cannot privilege, as during its colonial past, the appropriating practices of the powerful, nor can it just stop at the artefact and its interpretations, similar to what hermeneutic philosophers do with "texts." Somehow, anthropology must find a way to reveal, as social and cultural relations, the actual mediating process, which, via objects, artefacts, ideas, language, takes place between culturally *different* social actors. Of course, in an ideal speech, or for that matter, social or political, situation, with perfectly equal individuals, Hegel's old assertion would still hold, that through marking out or defining personal property (as well as taking spiritually possession of it), the individual as a person endowed with individual will is constituted, and that it is precisely through transfer of property that two individuals manifest their free will (one to give, or to transfer, and the other to take, or to appropriate).[22] The problem here is (as not only Marx realized) that despite the fundamental equality of the exchange relation itself, people in such transactions are *not* equal, which is both true for transactions within societies, and between societies. Anthropology then has to develop a concept of appropriation that takes account of the inherent inequality in transactions, as in cultural transactions (versus economic transactions[23]), and yet to allow for the possibility, following partly Riceour, of "understanding" by appropriating.[24] The latter is for the reason that concepts of appropriation have all too often focused exclusively on the economic and legal aspects of appropriation,[25] even when discussing cultural change, thus neglecting the possibility of understanding in the hermeneutic sense, that is, changing oneself as a result of interpreting the other's artefact (or any other cultural manifestation).

Conversely, when in an unequal relationship, from the viewpoint of the "other" appropriation appears as alienation. In the history of philosophy,

especially with Hegel and Marx, this has been a much discussed concept. Here, however, alienation is useful because it restores to the "appropriated" a status as experiential subject, albeit less powerful than the appropriating agent. Alienation also has implications for movements of cultural resistance, for example, among indigenous people, in which appropriation is contrasted with "cultural autonomy," the right to determine the disposal over one's own cultural traditions (cf. Todd 1990: 24). This is especially the case in post-colonial societies in which the appropriating and reinterpreting practices of artists are expressed as claims against the unequal power relations in the world-system.

How then can we develop a concept of appropriation that comprehends the process linking artists, artefacts (and their original producers), and the new artworks resulting from the appropriative process? One possibility is to introduce a concept of "agency" as Gell (1998) has done, focusing thus on actors, rather than objects of art. Although Gell does not specifically focus on appropriation, one could construct a model that takes account of the intentionalities of the actors involved, and the functions artefacts and artworks (or parts of these, symbols, etc.) perform within their respective social context. Yet with this procedure we would not have really explained the transformative aspect, manifested in the final artwork (including incorporated symbols of other cultures, and so forth) as a result of the appropriative process, nor the change induced by the artist into the art world, or more generally his or her society.

Therefore, let us return for a moment to the hermeneutic approach. I suggest developing a concept of appropriation based on understanding the other (or the other's products, artefacts), that is, appropriation as a practice and experience of "learning," similar to what Paternosto (1999: 22; 2005) has outlined (albeit only in preliminary form) for the work of contemporary abstract artists inspired by ancient Latin American art.

Following this line of reasoning, we would arrive at a concept which reconciles the element of agency with the element of "understanding." This might also resolve a rather formalist contradiction in the classic canon that poised an inferior practice of appropriation (implying copying) against the superior idea of creativity (implying the originating genius).[26] Now, concerning contemporary art, we can still ask what the "original" intentions were of those from whom artists appropriate, without falling into a simple trap of assumed "dialogue" (what obviously Ricoeur's concept of appropriation is not about). What would have to be restored is the intentionality of the other, by giving it its proper voice, and, as such, de-alienating it from the act of appropriation.[27] However, allowing or giving a space or voice to somebody is already problematic, since it implies a patronizing attitude and a vantage point of superior power. Maybe we should substitute these verbs of imposing agency with "listening" to the other in the first instance, or just "speaking nearby," as Trinh T. Minh-ha (1994) has suggested.

So far, the anthropology of art has not sufficiently investigated and theorized appropriation as a major feature of culture change. For instance,

the term is conspicuously absent from most subject indexes, including Gell (1998). One exception is Marcus and Myers (1995), who suggest that appropriation

> ... concerns the art world's ideology, discursive practices, or microtechnologies for assimilating difference (other cultural materials) in various ways. Such an assimilation of difference is generally accomplished by stripping cultural materials of their original context, or using representations of an original context in such a way as to allow for an embedding of this influence within the activities and interests of producing art. (1995: 33)

Thomas (1999: 141) also calls for a theorization of the term, but is more occupied with the politics implied in Australian "white" settler art appropriating Aboriginal culture. Writings in the field of visual anthropology, despite having evocative titles, such as "Appropriating Images" (Tomaselli 1996), have not theorized appropriation either.

Thus the way forward, as I suggested earlier in this book, is to conceptualize appropriation as one of the principal practices underlying any culture contact or exchange, and therefore of any dialogical situation of "understanding" each "other."[28] This aspect of appropriation has to do with the essential elements of difference that mark out the degrees of divergence and convergence between cultures, and the "alterative" processes of re-cognizing such differences. Boon pointed to the process of "how cultures, perfectly commonsensical from within, nevertheless flirt with their own 'alternities,' gain critical self-distance, formulate complex (rather than simply reactionary) perspectives on others, embrace negativities, confront (even admire) what they themselves are *not*" (Boon 1982: 19, his italics).

Appropriation needs cognitive difference (even and especially when it arises out of sameness, Harrison 1999b: 239). However, historically speaking, appropriation has occurred frequently in situations of real power differences in which, as Barkan and Bush (1995: 13) point out, "[a]ppropriating the non-Western in a Western context always underlines the subjective agency of the West, and the unequal passivity of the other."

Conversely, it is precisely in its own appropriations of the West that the non-West becomes the active historical agent in this "alterative" encounter, one which subverts and deconstructs the ideological terrain of its present and former colonial masters (one only has to think here of such classic works as Julius Lip's *The Savage hits back*,[29] or Jean Rouch's films, for example, *Les maîtres fous*, 1953). It is in these instances that the alienating aspect of appropriation is contested, and an attempt is made to transcend what remains, in terms of dialogical exchange, a dissymmetry of power and representation.[30] In situations of economic dependency and restricted access to international art markets, appropriation can develop a dynamic *sui generis*, as Camnitzer highlighted in his analysis of Cuban art (1994: 302). Appropriation in Cuba is both a historically well-established practice, based on the experience of cultural syncretism, and a practice that can work in

several directions, including appropriations from past and present indigenous and African cultures in Cuba, as well as from international art. In practical terms, appropriation also resignifies imported elements, and often uses them as replacements in aesthetic solutions, where specific parts, elements, or ingredients have not been available locally.[31]

Appropriation in its broader cultural sense (coupled with cognate terms such as adoption or assimilation) is of interest here, as it is through this strategy and its mechanisms and techniques, of which appropriation within contemporary art constitutes a special case, that symbols and artefacts currently migrate not only from one culture to another, but in the context of globalization (i.e., in a globalized art market/"art world") also become available on a world-wide scale (undergoing a concomitant process of commodification and recontextualization, cf. Appadurai 1996 and Thomas 1991). As mentioned before, appropriation in its formal sense means a taking out of one context and putting into another, yet the extended meaning I have been advocating sees it as a hermeneutic procedure that, consequently, implies not only that cultural elements are invested with new signification but also that those who appropriate are transformed, and ultimately construct and assume new identities. As Thomas commented wryly on the early asymmetrical exchanges between Europeans and indigenous peoples in the Pacific: "To say that black bottles were given does not tell us what was received" (Thomas 1991: 108). More recently, Thomas has further pointed to appropriation as a two-way process, and its inherent "unstable duality" between rejection and acceptance of both giving to and taking from the other (Thomas 2001: 139, 150).

One effect of the appropriation of European (Western) elements in non-Western contexts is often the subversion of their "original" meaning, a process that can be confusing to a Western observer, as there is an inclination (in the West) to take familiar terms at face-value, especially when analytical categories, such as hybridization, syncretism, imitation, and copying, all make reference to the supposed existence and validity of an original form from which secondary meaning can be derived. Gombrich (1966: 83–88) suggested that subsequent stylistic categories of art (like Classic, Romanesque, Gothic) basically mask two essentialist categories; the classical and the non-classical, which were used as exclusive terms to distinguish between "us" and "them"—or by extension, I would argue, between tradition and innovation, "originals" and derivations. Friedman (1999) similarly has deconstructed the concept of hybridity as a masked essentialism.[32] The point is that, arguably, there is no "original" after all; any notion of a composite original can only be arrived at through the study of the distribution, or epidemiology, of its many variants.[33] Whilst undoubtedly one part of human creativity is capable of creating ex novo, another part continuously recomposes, realigns, and rejoins old elements, slightly altering them to create new forms, sometimes in almost endless variations on one form (as in Kubler's notion of "series," 1962: 53–54). Within postcolonial discourse such a subversion of meaning is a more general feature, where peripheral, "third world" cultural practices assert

their right to appropriate and reinterpret cultural artefacts from the center,[34] as a claim of postcolonial societies against the uneven "power geometry to the processes of globalization" (Inda and Rosaldo 2001: 13). Appadurai (1996: 32) has spoken of "indiginization" in this context, but I prefer the term appropriation, as it does not carry the reifying undertone ("the indigenous") of the receiving end, and can be used by any group or individual however their identity is constituted, whether they are Western or non-Western.

Globalization and Hybridization in the Latin American Context

We have now seen how appropriation can be used to understand better the mechanisms of globalization and provide a new dimension to the idea of hybridization. Appropriation is seen here as a strategy and social practice of understanding—in the hermeneutic sense—the other, and a means to identity construction. The emphasis is on individual practices of intercultural transfer, and the social agency of the artists involved.

These insights can help us understand better the workings of hybridization and creolization in Latin America, discussed below.

In the Latin American context, the symbolic recontextualization of European artefacts and ideas from colonial expansion to the more recent process of globalization has been debated under a variety of terms, ranging from "transculturation" (Ortiz 1947),[35] "syncretism," "*mestizaje*," the (neo-) Baroque (Echeverría 1994, Gruzinski 2002) to "cultural reconversion" (Radcliffe/Westwood 1996: 21), and "diglossia" (Lienhard 1997).[36] Thus for Ortiz, transculturation referred to how both European and African cultures were transformed in the Cuban colonial and postcolonial experience to form a new national identity. *Mestizaje*, for instance in Ecuador (Radcliffe/Westwood 1996, Schneider 2004a), and in Mexico (Gutiérrez 1999) is an ideology that proclaims the mixture of Spanish (and other European) cultures with indigenous ones to form a new national culture. The Baroque and neo-Baroque have been introduced to account both for how the European genre of the Baroque, transplanted to the Hispanic Americas, was able to integrate a great variety cultural forms, of Spanish (and other European origin), African, and indigenous influences during the colonial period, and how, more recently, a new hybrid form, the neo-Baroque accommodates the variety of cultural expressions in postmodern times. However, the term is used more as a conceptual device than in an art historical sense, and for the postcolonial period the neo-Baroque allows for a simultaneous diversity of cultural expressions of different origins, as a kind of cultural syncretism (Echeverría, 1994, Gruzinski 1991, 2002: 21–22). Cultural reconversion refers to the process by which foreign elements are resignified with local meaning (Radcliffe/Westwood 1996: 21); a good example would be the small Eiffel Tower statue I once saw in a house near the Argentine pilgrim center of Luján, with an inscription "*recuerdo de Luján*" (souvenir from Luján). The original reference to Paris was now completely localized because

as descendants of Europeans Argentines could effectively appropriate any cultural symbol from their ancestral homes and invest it with new, local meaning (Schneider 1998c). Diglossia, a term from sociolinguistics, according to Lienhard "refers to the coexistence of two linguistic norms of unequal social prestige at the heart of a social formation." (Lienhard 1997: 197), with for example, Spanish representing power and prestige, and Quechua representing subaltern status in the Andes. Lienhard argues that such linguistic divides, a result of the colonial order, are also typical of cultural difference in places in which asymmetrical relationships, for example between catholic and indigenous religious practices, coexist. Extending on Lienhard, I should add, one might also think in the present age of globalization not only of two strata in a hierarchical relationship, as implied by di-glossia, but several, and similar to hetero-glossia, much as Bakhtin (1981) used this term to refer to different cultural and social levels within spoken languages.

It is clear from the above that appropriation, through incorporation of diverse cultural material, plays an integral and vital part in the processes of identity construction. In Latin America, globalization has meant the coexistence of regionally and locally varied and stratified discourses on culture (mixing variously elements of pre-Columbian, Iberian Colonial, African, European immigrant, and North American mass culture) (Blum 2001, Gruzinski 2002, Sieder 2002, Wade 2003). Yet whilst globalization has linked, economically and culturally, geographically distant parts of the world, it has not homogenized culture on a global scale (as both Marxist and modernization paradigms predicted).[37] Postmodern theories, with their emphasis on difference, have argued for an understanding of Latin American identities in their own right, not just as appendices of European expansion, or direct offspring of the pre-Columbian other.[38] Whilst these new approaches attempt to apply the concept of alterity to Latin America, it should be noted that there is a long and continuing genealogy of vindicating otherness from Europeans within Latin America, namely through the idea of "creolization." As explained in the previous chapter, to be a Creole (*criollo*) originally just meant being born to Spanish parents in the "New" World, whereas more inclusive definitions could encompass anybody born in the Americas. But even the earliest sixteenth-century definitions (for example by Juan Lopez de Velasco and Bernardino Sahagún, cf. Arrom 1959: 11–17) pointed out that these New World "creatures" were different in their behavior, customs, and culture from Spaniards in Spain. In linguistics the term creolization has been successfully applied to New World transformations of Old World languages, and understands these, once they are grammatically standardized (and thus cease to be "pidgins"), as languages in their own right (see Morse 1988: 159). In a wider sense then, creolization means the making native of elements from other cultures through a regional blending process. Arguably, it was the Caribbean where creolization achieved its strongest expression, resulting in a new multicultural system amongst imported peoples (Mintz 1995). In the present, some writers, for example Hannerz (1992) and Caplan (1995), use the term creolization to characterize the establishment of a

"global ecumene" of cultures (cf. Hannerz 1992: 217–267). However, if creolization places a certain emphasis on distinctive otherness it still retains an underlying discourse about Old World origins, which, historically, are undeniable, as suggested in chapter 1 with the application of the concept to the formation of identities in nineteenth- and twentieth-century Argentina.

Conversely, the concept of hybridization, as applied by Nestor García Canclini (1993b, 1995 [1986]), highlights the difference and variation resulting from cultural miscegenation rather than a focus on origins as a way of understanding contemporary cultural production and discourses of identity in Latin America. Canclini, who has worked on craft production in rural Mexico, the mass media, and on identities in the city of Tijuana, on the border with California, starts from the fundamental contention that capitalist modernization does not necessarily destroy traditional cultures, "it can also appropriate them, restructure them, reorganise the meaning and function of their objects, beliefs, and practices" (García Canclini 1993a: viii). The result is the coexistence of numerous traditions displaying varying degrees of modernity (García Canclini 1992: 32). Dissatisfied with older concepts that conceived of cultures as rather homogenous and bounded phenomena, García Canclini has consequently employed the concept of the hybrid (1989: 15) or processes of hybridization (1993b: 79–80, also Canevacci 1993b, 1995a) to analyze the heterogeneous multiplicity of cultural practices in contemporary Latin America. However, behind the heterogeneity and globalization of symbolic practices still lie unequally distributed economic resources (García Canclini 1993a: 8), notably the ownership and control of the means of production. Similarly, we have to conceive of postmodernity in Latin America as a "series of conditions" (Yúdice 1992: 6), rather than one new and homogenous metadiscourse. Postmodernity as a plural experience is also behind the idea of locating alterity in Latin American discourses on identity and culture. Assuming a continuous process of appropriation and rejection, alterity denies the notion of an uncontaminated cultural core (Yúdice 1992: 8), thus refuting the simple contrapositions between American and European, native and alien, original and copy, indigenous and imported. This critique can also be used to view hybridization critically, along similar lines as those suggested by Friedman (1999) referred to earlier in this chapter.

What then are the motives for the appropriations of indigenous cultures among urban Latin American artists?

For the Latin American artists who feature in this book the question is fundamentally one of identity, when after the demise of modernist projects they ask: "What can we do with our origins?" as García Canclini puts it (1989: 109, also 1995b: 425). Thus origins or roots are not conceived as something essential and unchanging, but rather as those elements of history/culture (pre-Columbian, colonial, and contemporary) that had been marginalized in the modernist discourses about the state and nation, that prevailed for the last and much of this century. In fact, these elements are the primary material, a quarry of fragments, from which the artistic bricoleurs set out to work with.

Urban artists in Latin America then, epitomize one of the paradoxes of globalization, to be locally rooted and yet globally sited.

Conclusions

It is precisely at this juncture, the construction of new identities in an urban context, that the appropriating practices of Argentine (and other Latin American artists) are located.

To summarize at this point, appropriation, I have suggested, is more than one-to-one transferral; its hermeneutic potential implies a resignification of meaning, against the background of a structural imbalance between what (or who) is appropriated, and what (or who) is alienated. A revised concept of appropriation is also advocated, in order to do justice to individual actors in the global context, individual agency having been neglected both by earlier paradigms of culture change, and by more recent theories of globalization, and the anthropology of art. The emphasis on social agency has to be contextualized by the transformative act of appropriation, which, as outlined above, is better understood as a hermeneutic practice.

This is to say that explanations for the choices of appropriations will have to be sought by investigating the interplay between changing definitions or conceptualization of cultural traditions and nationhood to individual identity claims. Inasmuch as appropriation implies incorporation of new cultural material, it also effects the artists' own identities. Whilst any time-scale must be necessarily relative, and remain historically and situationally specific, there will be always a "before" and "after" in the appropriation process through which artists' identities change. It is at the intersection of collective and individual constructions of identities that the recognition of otherness operates, which, as pointed out in the beginning of the chapter, is vital to the appropriation process itself.

In the following chapter we see how appropriating strategies by artists are situated in the Buenos Aires art world. A "thick description" of the art world is provided, and the role of its different players (artists, critics, gallery owners) explained. In particular, the relation of the Buenos Aires art world to the international art world will be elucidated, in order to situate it in the global context.

Chapter Three

The Buenos Aires Art World: Sites of Appropriation

Introduction

In this chapter I examine the Buenos Aires art world as a specific example of a site of artistic production, where "indigenous" and local art forms are transformed and inserted into a global context. Ethnographic sites have now become a theoretical and practical preoccupation for artists, theoreticians of art, and anthropologists working on the border crossings between art and anthropology (see Coles 2000, Schneider/Wright 2006). Also, in this chapter I aim to explore the notions of "Western," "Latin American" and "indigenous" art as they are conceptualized by the participating urban actors, such as artists, critics, gallery owners, and museum curators.

Buenos Aires: A "Peripheral" Art World?

The term "art world" (Howard Becker 1982) refers to the collaborative effort involved in producing works of art in contemporary complex societies. Works of art are not the work of the single genius, but always entail the cooperation of others in the artistic process, ranging from rather few, in some visual arts, to large numbers of people, for instance, in opera and cinema production. By extension, an art world in any given society (global, regional, or local) or city consists of the whole ensemble of social actors and institutions that produce art, as well as the art-consuming public and the art works themselves.[1]

In the international art world Buenos Aires occupies a peripheral position with respect to the centers: New York, and—not in any order—Paris, London, Cologne/Düsseldorf, as well as other major European cities. In global terms then, Buenos Aires can be characterized as a local art world, assuming a position comparable to that of St. Louis within the United States, as studied by Stuart Plattner (1996).[2]

The comparison, however, is only valid up to a point. Buenos Aires, capital of one of Latin America's largest countries, is itself a regional center from

which peripheral relations extend to other Argentine cities, such as Córdoba and Rosario, as well as regional capital cities, which it surpasses quantitatively in terms of cultural and artistic production, such as Montevideo (Uruguay), Asunción (Paraguay), and even Santiago (Chile). It thus plays an important role as a regional bridgehead to global markets in Latin American art. Arguably, in Latin America, Buenos Aires occupies what one might describe as a "good second division position," surpassed only by Mexico City, São Paulo, and probably Bogotá for the volume of sales, as well as Havanna (which hosts an important Latin American art biannual) in terms of exhibitions.

However, whilst the above picture is correct for the total volume of art traffic and relative importance of cities in Latin America, in terms of collecting, Argentina occupies a prime position. According to the American magazine *Artsnews* (which publishes every year a list of the 200 most important collectors), Argentina has five collectors at the international level. It occupies the seventh position internationally (sharing it with Spain, Italy, and the Netherlands) ahead of other Latin American countries (Golonbek 2001: 69).

In fact, the problem with rankings of cities and countries is that they can only be seen to describe a partial picture, not the total volume of communication networks, and the traffic of information and commerce. Although it is true that the majority of actions is carried out along these power lines, individuals, that is gallery owners, curators, and artists might develop their own relations with the global art world, bypassing the local center in Argentina or other "third world" countries. However, such direct relations require a higher input in terms of cultural capital (knowledge about the center) and economic capital (investment in travel and technology) than in the center, in which both certain institutions of the local art world, and agents or agencies from the global art world can take on some of these functions. It is certainly true that the Internet is now increasingly used by artists to establish contacts and to promote their work. However, despite the few Internet sites dedicated to contemporary art (such as www.arteuna.com—on which more in chapter 8) and Internet galleries (such us www.latinarte.com—on which more later on), successful sales and exhibition projects still depend on personal, face-to-face, contacts.

Thus for an artist resident in a provincial city in Argentina, in order to get national recognition, it is vital to have his or her work shown and reviewed in Buenos Aires.[3] Furthermore, in order to get international recognition of the work, it would be crucial to be represented by one of the few galleries in Buenos Aires that operate internationally. This is not to say that very occasionally an artist might not establish direct contacts with the center, for example by living for a period abroad, or attract those specialized in Latin American art to visit a provincial city, but this would be the exception. For example, in Mexico, Oaxaca has established itself as an important center of contemporary art outside Mexico city (as has Monterrey), and in Ecuador, Cuenca similarly has developed its own art world, distinct from that of Quito and Guyaquil, furthered also by the promotion of an international Latin American biannual art exhibition.

After a short initial period of fieldwork, and having consulted with artists, art critics, and gallery owners, it was a comparatively simple task for me to work out the hierarchies of the Buenos Aires art world. One can list a number of public institutions in order of importance, headed by the National Fine Arts Museum (Museo Nacional de Bellas Artes) and followed by the Recoleta Cultural Centre (Centro Cultural Recoleta) and the Modern Art Museum (Museo de Arte Moderno), the Centro Cultural Borges, the Centro Cultural San Martín, the Palais de Glace, and private institutions, such as the Museum of Latin American Art Buenos Aires—Costantini collection (Museo de Arte Latinoamericano Buenos Aires—Colección Costantini—MALBA),[4] Fundación Klemm, Fundación PROA,[5] Espacio Gieso, as well as exhibition spaces of foreign agencies, such as the Spanish Institute for International Cultural Co-Operation (ICI) and the German Goethe Institute. Then there are other museums that occasionally would also host contemporary arts events, such as the Museum of Decorative Art (Museo de Arte Decorativo) and the Museo Sivori. The list of galleries working with contemporary art would be topped by the Ruth Benzacar Gallery, operating since the early 1960s, as well as others of international renown, such as the Rubbers and Diana Loewenstein galleries.

As far as artists are concerned, very few, such as Antonio Berni (1905—1981) and Guillermo Kuitca (born 1961), fetched up to several hundred-thousand Dollars at international auctions in the late 1990s, with a dozen to twenty artists being internationally present but commanding much lower prices (between $10,000 to 100,000). In terms of prices, this level represents a considerable rise compared with the previous decade, when even Berni had a reference value of only $33,000, with the end of the decade seeing prices rising, and an untitled painting of Guillermo Kuitca's obtaining a listed price of $80,000 to 100,000 in Christie's Latin American Sale in New York in 1998 (Christie's 1990: 124, Golonbek 2001: 120–122).

With institutions of art education one can similarly compile a list, starting with the Escuela Nacional de Bellas Artes "Pridiliano Pueyrredón," the National Art Academy "Ernesto de La Cárcova," and the National Art School "Belgrano." A list of the prime institutions that fund the arts comprises the National Arts Fund (Fondo Nacional de las Artes) and the private Fundación Antorchas, as well as a number of other private institutions that sponsor competitive prizes, such as the "Premio Fortabat" (by the Fortabat cement company), and prizes awarded by various Argentine and foreign banks (see also Appendix II).

I should point out that the above list, obviously, refers to the time of fieldwork, 2000–2001, and is, of course, not complete with regard to galleries, the number and composition of which also fluctuates greatly with the ups and downs of the Argentine economy. Furthermore, for anthropologists, such lists are only a starting point. What is of interest to us is how people interpret and make use of these structures and institutions, and how they contest existing hierarchies. The directory of Buenos Aires galleries published as part of a Latin American art guide by the art magazine *Arte al Día* lists

sixty-nine galleries (Directorio de Arte Latinoamericano 2000: 18). However, some less well-established galleries are not mentioned. For example, according to Golonbek (2001: 123), a list of galleries dealing with young and emerging artists would also include a "young," alternative gallery called GARA, on which more later on.

This point is also of particular relevance for artists working on indigenous topics, many of whom feel marginalized or not represented at all by the main art institutions listed above. In fact, those artists working with indigenous topics, while they would not dispute the hierarchy and power relations in the contemporary art world of the "official" list presented above, would rank institutions differently, and add others to it, reflecting more their specific interests.

However, this does not mean that there exists a second, parallel art world for those working with indigenous topics. Rather than there being a separate "art world" for such artists, the ranking of institutions is different, and there are certain areas of overlap. Also, parallel efforts exist in the form of private *talleres*, meaning both artist's studio and workshop (based on subscription or individual payment), in which students would learn from a particular artist, who would often also hold some poorly paid official position at a university or art school. The following are the main institutions where artists working with appropriations of indigenous cultures find their work and represented. Museums and cultural institutes: San Martín Cultural Centre (Centro Cultural San Martín), *Instituto Nacional de Antropología y Pensamiento Latinoamericano (INAPL)* National Anthropology Institute (Etnographic Museum), *Museo Etnográfico*, luis Perlotti Museum (Museo Luis Perlotti). In addition, the anthropologist Guillermo Magrassi (who died in 1989) directed a number of private research and teaching centers in the 1980s, in which many artists feature in this book participated, such as: Centro de Estudios de Antropología (CEA) and Asociacióu Iberoamericana de Estudios Antropológicos y Sociales (AIDEAS) (see also Appendix II).

There are no art galleries specializing exclusively in contemporary art inspired by indigenous cultures. Such work is to be found either in contemporary art galleries, or if deemed closer to craft, in shops selling craft and ethnic arts from Argentina's indigenous people, or reproductions of their work. A number of such shops are to be found in the neighbourhoods of San Telmo and Palermo Viejo, as well as on and around Florida Street in the center of Buenos Aires.

For a city of 3 million inhabitants in its federal district (Capital Federal), or 12 million, including the Greater Buenos Aires area, the metropolis has a relatively small and personalized art world, which a few institutions dominate, as I have outlined above. In the words of one young artist, "There are only two or three institutions which count and have money." In a situation of scarce and unevenly distributed resources, compounded by public underfunding, artists have to get personalized access to resources. This means they have to know and socialize with directors and curators of museums and galleries, art critics, and fellow artists. The usual public arenas for such socializing are

openings, award ceremonies, public lectures, and art fairs. Besides these public channels there exist more private social contacts, consisting in personal visits to museums, galleries, and critics, and vice versa to artists' studios.

The other means of access to public exhibition spaces is purely economic—and in this sense different from the public grant systems in the United States or Europe, as I explain below. Given the chronic under- or nonfunding of public institutions such as museums and cultural centers, artists have to come up with sponsorship, or in many cases, self-finance, in order to secure an exhibition.[6] As an artist explained to me, rooms and even more so, halls in the MNBA, depending on size, cost several thousand pesos (equivalent to U.S. dollars till the end of 2001), a fact that was common knowledge. "If you bring the money, the director will exhibit your work," was a frequent assertion I often heard by artists about the MNBA. However, apart from securing finance, there must also be a criterion of selection. Whilst officially there are panels and competitions, many artists allege that personal contacts play a role, as well as the taste and preferences of the museum directors. Typical for such complaints is a letter to the editor of the art journal *Arte al Día*.

> With respect to the Biannual of Sacred Art 2000, I feel particularly hurt for two reasons: (1) my work was rejected . . ., (2) Of 111 chosen artists, 27% were also selected in the last biannual.
>
> Five of the artists who won prizes, also received prizes in the last biannual; of the remaining, many are already established artists.
>
> Without any desire to depreciate anybody, I feel it is pathetic what happens to art in Argentina: I have the impression that the artists are selected by a "rule of thumb," that is by the thumbs of a few, the majority remain outside the circle (or square) [*círculo o cuadrado*]. It would not be that serious if this was only the case with the Biannual of Sacred Art, but the same thing happens with all the important awards.[7]

There are several strategies to react to, or come to terms with being outside the "circle" (an expression used by several artists and critics I spoke to), that is, the perceived center of power or gravitiy in which decisions are made in the Buenos Aires art world. One of these would be to show work in alternative, fringe exhibition spaces, another is to form one's own following, or schools. In chapter 4, I present a number of such examples, namely Mirzia Marziali's ceramics workshop, and the classes in Pre-columbian design held by Professor Sondereguer at the architecture faculty of Buenos Aires University.

Artists working with topics related to indigenous cultures said that they are precluded from showing in these most prestigious exhibition spaces because their work was not en vogue with the director of the MNBA (in 1999/2000) and other shakers-and-movers of the art world who would only follow the latest trends from North America and Europe.

When probed on this, museum directors and curators, however, insisted—as might be expected—that their only criterion is quality (as Jorge Glusberg, the director of the MNBA in 1999/2000, explained to me[8]), and that they

see a vibrant Argentine contemporary art scene from which the best can compete with international artists.

With a few exceptions, such as Alejandro Puente (figure 3), César Paternosto, and to a certain degree Alfredo Portillos (figure 4) and Teresa Pereda (see chapter 7), most Argentine artists working with appropriations of indigenous topics do not have an international art market. Rather, they constitute a minority within the art world of Buenos Aires.

Argentine art finds itself caught in a dilemma that can be summed up as follows. In the international art world Latin American art is perceived as exotic, with folkloric and indigenous influences (and to this ideal artists wanting to be succesful subsequently have to perform). On the other hand, there are the aspirations of Argentina's own artists, in their majority, to emulate the latest trends from New York or Paris. Orly Benzacar, from the top Buenos Aires gallery Galería Benzacar, also made this point in our interview: "The 'First World' still ignores us, although that's changing with globalization."

The globalization of the art world, and the internationalization of postmodern approaches also meant that Argentine artists now have to adopt these trends if they want to have success, or to be recognized as artists in the first place. Yet the problem, as with older European styles (or fashions), is that when Argentine artists do perform to the stylistic requirements of the center they are still not perceived as equals because of their provenance and because their work is perceived to be second rate, or of imitating character, with respect to trends created in the center.

In 1961, on the occasion of the opening of Argentine art at the Arts Council in Britain, Rafael Squiru, the then director of the Museum of

Figure 3 Alejandro Puente, *sin título* (feathers), 1986. Courtesy of the artist.

Figure 4 Alejandro Portillos, *Altar Latinoamericano*, 2000. By permission of the artist. Photo: Arnd Schneider.

Modern Art in Buenos Aires, made a point about belonging to the "Western" tradition and still being different.

> We belong to Western Culture, even if the books don't say so; even if we are different (we hope to be at least subtly different) . . . For us London or

Edinburgh, Paris or Madrid, Florence or Rome, are not exotic places; they were built by our ancestors and we claim them as part of ourselves. Not to understand this means refusing to understand our art. (Squiru 1961: no page numbering)

In such a scenario, Argentine artists intending to work with references to indigenous cultures find themselves on the one hand not representing "typical" Argentine culture (which is largely identified with European heritage and Spanish colonialism), and thus get little promotion at a national level, and on the other hand expose themselves to accusations of trying to be different from the majority of local artists, and just wanting to establish a market niche for themselves.

The Meaning of Art in Buenos Aires

How then is this art world conceived of and used, interpreted, and made to function by different social actors? In order to answer this question and to give an idea of the hierarchies and social etiquette in the Buenos Aires art world, I analyze a number of events I attended in 1999/2000, each of them symptomatic for a particular sector of the art world.

I first describe three events I attended at established art institutions already mentioned in the previous section.[9] I then describe and analyze how artists are represented by galleries, focusing on, for example, what commissions they take, how they establish an international market, and the role of collectors. Next, I focus on small, new galleries that have arisen because young artists felt they were not represented fully by the established galleries.

Finally, I analyze the position of artists who perceive themselves as working outside the established circuit (such as Alberto Delmonte, Silvia della Maddalena, and Juan Maffi).

The Art World Celebrates an
Honorable Member

Right at the beginning of my fieldwork, in October 1999, I attended a party given in the honor of one of Argentina's foremost art critics, Fermín Fèvre (1939–2005). The party was held at the Centro Cultural Borges, a cultural center opened in the 1990s in memory of Argentina's most famous writer on one of the new shopping malls on Florida Street, Galerías del Pacífico. This and many other shopping malls that opened during the 1990s are some of the most visible examples of the consumer oriented neo-liberal economics and noveaux riches tastes of the Menem years, which I have referred to in chapter one.

I went to the party with a friend of mine, a young art critic. According to him, almost all the rank and file of the Buenos Aires art world were present, with very few names missing. My diary entry, left in the ethnographic present, provides a good impression of the event:

The fiesta is quite exclusive and my friend has to smuggle me past the guard, since I do not have an invitation. Fermín Fèvre, together with Jorge Lopez

Anaya (another important critic and art historian), Jorge Glusberg (the director of the MNBA in 1999/2000), and Marcelo Pacheco (a critic and art historian), is one of the prime art critics of Argentina. A lot of people from the art world have assembled: gallery owners, artists, and critics. Champagne from Mendoza is served, then starters, turkey with spiced rice, ice cream, and, finally, a tower-shaped birthday cake. A duo of Tango dancers offers an excellent performance. Then two tenors and a soprano from the Teatro Colón sing some Italian *arias* and Spanish *zarzuletas*. The texts are printed on a handout (for us to sing the refrain from), but many people seem to know the melodies by heart.

An Awards Ceremony

On another occasion (again reported from my diary below), I went to the award ceremony for the Fondo Nacional de las Artes (FNA), the Argentine arts council that awards scholarship, prizes, and awards, as well as sponsors the arts more generally through exhibition grants and grants for publication.

In the evening, I go with a friend of mine who teaches art history, and two of his art class friends, to the Premio del Fondo Nacional de las Artes (presided over by Amalia Fortabat[10]) where Alfredo Portillos gets the first prize in *artes plásticas* (worth $10,000). The event takes place in the Museo de Arte Decorativo.

Most of the guests are dressed formally, the reception hall is full and we have to stand at the back. On the podium, to the left, are the prize winners, then those who confer the prizes, presided over by Amalia Fortabat, and the judges to the right. It is a rather long ceremony, in which most of the honored, especially those from music, theatre, and film, also show or recite one of their works (for example, the Tango poet Horacio Ferrer recites his famous Tango lyrics "Balada para un loco").

By contrast, Alfred Portillos is short and succinct, proclaiming: "*arte es vida, y vida es arte*" (art is life, and life is art), and "*arte es una iniciación*" (art is an initiation).

Afterwards, there is quite a sumptuous reception with champagne and cocktail refreshments. It is curious that this takes place in one of the exhibition rooms of the museums, with furniture clearly marked "*no tocar*" (don't touch), but people nevertheless leave napkins and glasses, etc. on top of the museum exhibits. A woman artist who works on indigenous themes is also there. I ask her about the art world, and she says that it is very small, and everybody knows everybody else here.

Later we congratulate Portillos who invites us to his flat for drinks. I also meet some artists from FOSA, an avantgarde performance group constituted by former students of Portillos. We take a taxi and at Portillos's we have *sandwiches de miga*, the very thin sandwiches (available with a myriad of toppings) typical of Buenos Aires, and more champagne. We raise a toast to him, and everybody in this small circle of friends and relatives (his brother and son are there, too) seems to be happy. It's very hot, and, after some time, my friend and I decide to leave.

A Publicity Event at the Home of a Gallery Owner

A reception at the home of gallery owner Ruth Benzacar, gave insight into both the "old," more established art world (represented by Benzacar herself and some artists), as well as younger people from the visual arts and arts criticism.

I go to Ruth Benzacar's *asado* (barbecue).[11] Despite the fact that it was held indoors (*asados* are usually outdoor events), it was so billed by an old friend of mine, Federico, who organizes arts events and has invited me. I try to get a bottle of wine in the local supermarket in San Telmo, but there are long queues of people. Then I take the 59 bus to Santa Fe Avenue and try again to get some wine, but in one shop it costs $5.90 (exorbitant!), whereas another large wine merchant's is closed during the siesta. I get some flowers for $3. That will do, as nobody brings anything to these events, anyway.

Everything takes place in one of those enormous flats on Talcuahano Street in the city center. Federico, who has organized the event, welcomes me, with Maria, his business partner, standing by his side. I leave my flowers with one of the maidens. Ruth Benzacar, of course, stands right at the center and recognizes me, and I greet her. It is an enormous flat, from what I can gather, of at least 200 square metres. All the walls, especially, along the long corridor toward the back, are hung with paintings, mainly Argentine, Antonio Berni, Oscar Bony, and so forth—of her own and other artists, representing the who's who of Argentine modern art. The rooms are painted in strikingly extravagant colors: green and red, for example.

I am surprised to see mainly young people, art critics, and also some artists, many journalists, among them a young art critic from *La Nación*. The latter found the collection of Beson (a contemporary art collector on whom more later in this chapter), which we visited the other day, very interesting, and liked their house from the inside, but not the outside. Beson, according to him, came across as very bold, and his wife more charming, although that was a formality. I talk to a group of young people, among them a journalist from the *Buenos Aires Herald* (the English language daily), and two artists. I explain my project to them. We talk about everything, for instance, the art world in Mexico. The journalist previously lived in New York where she found people more segregated than in Buenos Aires; African Americans keep really apart, she claims. "The melting pot in the United States is a complete myth," she says, "I didn't see much of that." Wine, champagne, and little starters (such as olives, and eggs) are served.

Then Oscar Bony (1941–2002), one of Argentina's foremost contemporary artists, arrives: "What are you doing here?," he asks me with a certain briskness. He is always intrigued, and slightly surprised, by my presence at all these art events. Then it is off to the main meal in the enormous room adjacent to the cocktail event. First, Spanish tortilla with salad, and then paella are served—not exactly *asado*, but very good. I speak to an artist from the Belgrano neighborhood who is a draughtsman mainly, but also writes for an economic affairs newspaper. He tells me, "Something interesting will happen; just fashion will begin to distinguish itself from talent." He thinks there are some interesting new artists in Argentina. He traveled to Mexico where there was some perception of Argentines as being bold and arrogant (the general perception in Latin America). He said Benzacar had a fantastic collection in her house; Berni would

sell very well (in fact, he is the second-highest quoted Argentine artist after Kuitca). Then Bony tells me of his invitation to Slovenia, where they are going to recreate his landmark work "La Familia Obrera" (original installation/performance with a workers' family in the Instituto di Tella Gallery in 1968).[12] I speak briefly to the guy from the Spanish Institute for International Cultural Co-Operation (ICI), then to Federico, my initial contact for this event, and then I go. Before I leave, I say good-bye to Ruth Benzacar and envisage interviewing her in March.[13]

The Significance of the Three Events

The birthday party for critic Fermín Fèvre was the celebration of an eminent member of the Buenos Aires art world, and at the same time served, as did other similar events, as a "stage" for those who count in that art world to show themselves. The place chosen for the occasion, the Centro Cultural Borges, occupies a position in the upper strata of the Buenos Aires art world, and the cost for organizing the event, rent, food, and hiring entertainers must have been considerable.[14] The cultural program with the two tenors from the *Colón* Opera House at the center, at once embodied the wish to emulate the international music world ("The Three Tenors") as well as paying homage, through the muscial program, to Argentina's Italian and Spanish immigrant heritage.

The awards ceremony of the Fondo Nacional de la Artes was an event of national importance, which again assembled an important number of players of the art world, but also many people who came upon invitation of the prize winners, including younger people (such as their students). For the artist known to me, Alfredo Portillos, the $10,000 awarded represented a substantial sum, which allowed him to carry out new projects, apart from meeting living costs. The reception, or rather informal gathering, at his modest flat after the event contrasted sharply with the formal style of the awards ceremony and lavish reception afterwards.

The gathering at the home of Argentina's prime gallery owner, Ruth Benzacar, was intended to bring together younger and older artists, but also young mediators from the art world, such as journalists, critics, and exhibition curators. Although a private home, the luxury flat was itself practically a gallery or small museum with works from Argentina's main modern and contemporary artists on display. And of course, as Orly Benzacar, the daughter and heir to the gallery, recounted to me later, the origins of the gallery lay in dealing from home, as *marchand en chambre*, although from a different address.

Gallery Owners: Creating Markets and "Educating" Collectors

Gallery owners in Buenos Aires frequently mentioned that the market for contemporary art is very small and new in comparison with New York, European cities, and even other Latin American cities. Curators and gallery owners from galleries that are now among the most important in the contemporary art market, like the late Ruth Benzacar, and her daughter Orly,

were keen to point out that they had to create or invent an interest in contemporary art. "There was no culture in contemporary art—we had to invent it," Orly Benzacar said, and she went on:

> "Although Buenos Aires is a big city, it doesn't have the number of galleries comparable cities in other parts of the world host. Buenos Aires should have more galleries."
>
> *A.S. Do you refer to North America and European cities, or also to São Paulo and Mexico City, for example?*
>
> "Yes, even other Latin American metropolises. Galleries which are important (*de peso*) which are representing what's going on in a city. Here in Buenos Aires we are very few—apart from us, there are not many more." (Orly Benzacar, interview, 29/07/2000)

A Mexican woman who had insight into the gallery scene in Mexico City said to me once: "Here people have to learn to collect" (*acá la gente tiene que aprender coleccionar*). A young female artist who had experience of working in Mexico City also found the Buenos Aires gallery circuit very provincial. She was completely disillusioned with the art market in Buenos Aires, which does not "function" well, when compared to Mexico and the galleries over there which offered their artists better deals and promoted them better. Galleries in Buenos Aires would take very high commissions. (e.g., the top galleries 70 percent, others 50 percent, sometimes one can negotiate 40 percent). However, an art critic of whom I enquired about this two days later said "*no es cierto*" (it is not for sure), Benzacar would charge 50 percent, the others 30 percent. In his recent assessment of the Argentine art market, Golonbek (2001: 11–14), too, regards the Argentine art market as insufficiently developed. He attributes this situation primarily to cultural factors (i.e., the specific tastes of collectors—on which more in the next section), rather than economic ones.

On Collecting

The history of collecting art in Argentina is intertwined with the country's social and economic history. Traditionally, a pursuit of the landholding upper classes, it has also become an activity for those who made their fortunes in industry, and more recently during the short boom of the 1990s, in service industries and privatized state firms. Moreover, the history of collecting reflects the ideological preferences of those indulging in it. It is an expression of their taste and symbolic universe, not only relating to their class position, but also to those who set tastes for them: galleries and critics.

Traditionally, the upper classes have collected colonial art, or more recent Argentine art depicting life in the countryside (e.g., Molina Campos). Buenos Aires has also a few workshops, renowned in Latin America, for restoring colonial art. The social critique of painters from the twentieth century, such as Antonio Berni, or the surrealism of Xul Solar (1887–1963), is to be found among more open-minded collectors, but would not form part of the inventories of the *familias tradicionales*, upper-class families claiming descent

from Spanish colonialists. The gallery Zurbarán, named after the seventeenth-century Spanish painter, is the principal Buenos Aires gallery catering to traditional tastes. According to art historian Marcelo Pacheco,[15] several phases can be distinguished in the social history of collecting art in Argentina. In the eighteenth century, there had been a prehistory of collecting among merchants and traders in colonial Buenos Aires, who would have landscapes and still lifes, as well as religious pieces, in their houses. Collecting writ large really starts with Manuel de Guerrico who returned from Europe to Argentina in 1852, specializing in European painting from the fifteenth to seventeenth centuries. With Argentina's economic rise in the 1870s, collecting also became fashionable among the economic elite. As with earlier collections, the taste was European, now including eighteenth and nineteenth centuries, and the whole range of genres; but Argentine art was largely excluded. In the twentieth century the pattern diversified, with specialist collections in French art (the preferred taste), as well as Spanish. Other collectors would focus on Old Masters, and others again—a minority—on established modernists of the twentieth century, such Picasso, De Chirico, and even abstract expressionists from North America. Slowly, Argentine art also aroused the interest of collectors, but traditional topics, such as the countryside, the pampas, and the old city of Buenos Aires, *la gran aldea*, were preferred over contemporary topics and experimental approaches, for example, by the surrealist Xul Solar—thus reflecting the extreme conservatism of Argentine collectors. Arguably, the cultural tastes of the Argentine upper class have been mainly conservative, remaining fixated on European "Old Masters" and Spanish colonial art. There is no history of them supporting what was considered avant-garde or modern art in any specific historical period of the nineteenth or twentieth centuries, as was the case in the United States.

It is only in the 1980s, with collectors such as Marion and Jorge Helft, who become interested in contemporary art, both international and Argentine, as well as open up their collections to the public, that contemporary Argentine art is finally represented among Argentine collectors.

Another, new generation, of collectors starting in, the 1990s is a reflection of the new economic phase of neo-liberalism, which (other than deepening the class divide and creating more poor people) also created some nouveaux riches, who are keen to acquire cultural capital.

The majority of collectors are people who made money from their businesses and now want to embellish their living rooms and acquire "culture" because as noveaux riches they do not have original cultural or social capital.[16] The most recent ones are products of 1990s' neo-liberal policies of the Menem government.[17] Most collections are strictly private, but some are open to the public by appointment (like the collection of Jorge Helft in San Telmo). Eduardo Costantini has now made his collection available to the public in a purpose-built museum, the *Museo de Arte Latinoamericano de Buenos Aires* (MALBA). I visited the MALBA on my return visit to Argentina at the end of 2001, and was impressed by its imposing modern design. A huge electric staircase leads up from the entrance hall and bookshop to the first floor, where the collection is on display and also temporary exhibitions are held (figure 5).

Figure 5 Entry Hall, MALBA, Buenos Aires. Photo: Arnd Schneider.

In Argentina, it is not a simple affair to convert a private collection into a public museum, as some collectors of Pre-Columbian art pointed out to me who saw the state and bureaucracy placing many obstacles in their way (see also chapter 1).

According to Golonbek (2001: 70—72), the contemporary art market of Argentina can be divided into three main categories: "Modern," "classic contemporary" and "contemporary." Modern works are those by established early to mid-twentieth-century painters of Argentina (Xul Solar, Lino Enea Spilimbergo, Antonio Berni), classic contemporary works are by an already established artistic generation (Luis Benedit, Felipe Noé, Guillermo Kuitca), and contemporary works are by those who recently made a break in the art world. The latter category can be further split up into young artists and emerging artists.

Overall, artists whose work is informed by indigenous cultures occupy a rather marginal position in the art market. Only two artists, Alejandro Puente and César Paternosto, are mentioned by Golonbek's investor guide under the rubric of geometric abstract art, but without mention of their Pre-Columbian themes (Golonbek 2001: 77), though indirect reference is also made to the *Escuela del Sur/Ojo del Rio* promoted by Alberto Delmonte (on whom more later on).

Golonbek sees the Argentine art market as still underdeveloped, with potential for future growth. If only 1 percent of the upper to upper-middle income strata (10 percent) would invest in art of $10,000 per year, this could add another 4,000 collectors (Golonbek 2001: 131). In his categorization of collectors, however, the conservative type prevails, both in terms of taste (exceptions confirm the rule), and in terms of doing business (most use the phone, or send agents to auctions, rather than using e-commerce).

It is not that money, or important collectors, do not exist in Argentina, in fact they both do. *Artnews*' survey of the 200 most important collectors found five Argentines collecting international art and also national art. This ranks Argentina in seventh place, on a par with Spain, Italy, and the Netherlands, and within Latin America ahead of Brazil and Mexico (Golonbek 2001: 69). However, Golonbek (ibid.) points out that in relation to Latin America, the *Artnews* list fails to mention important activities in Venezuela, Brazil, and, one might add, Mexico and Columbia.

An example of Argentina's new generation of collectors is Claudio Beson, one of the important new collectors of contemporary art. After some networking, I got an invitation to visit him in the exclusive northern neighborhood of Acassuso—the diary extract below gives an idea of the world I entered that evening.

I buy some flowers (quite expensive at $12) for the evening with Beson, as part of which I expect a meal. His wife had said that she would prepare some food.

At five minutes to eight the chauffeur waits for me. We drive to Acassuso in an air-conditioned car. This is an incredible drive; I had forgotten how rich the *zona norte* is. Past Olivos, it seems only to consist of expensive restaurants,

ice-cream parlors, beer halls, McDonald's restaurants, and showrooms for Mercedes and Harley Davidsons. How easy and predictable tastes are!—even and especially with the upper classes and the nouveaux riches. We pass by San Isidro Cathedral, which is beautiful, and some colonial houses, and then enter Accasuso. Long, fenced houses and estates later, we eventually arrive at Beson's home. There is a huge wall with an entry door and the house set to the back. The *mucama* (maid) opens the door. Beson and his wife Vera come down the stairs in the company of a young journalist from *La Nación* whom I had met at the Pasaje Bollini bar. A guided tour through the house follows. Nice light shines through the windows of this very modern house. Beson has a fine collection, especially Brazilian and Argentine: Antonio Berni, Víctor Grippo, Gonzalo Fonseca, Cildo Meireiles, Ana Mendieta, Gabriel Orozco, Nicola Constantini (at whose opening at the MNBA we met the previous day, of course), Benedit, some German contemporary artists. Vera, his wife, talks to me quite a lot (she has to, since there is no food, just cheese and crackers). My central faux-pas, which hopefully goes unnoticed, is when I say that it is laudable for people in their position to collect rather than to invest into other things, for example a yacht, at which she just points out of the window, and says, "Oh, we have one as well." And now I can see the moorings dimly lit behind the garden (the yacht club Acassuso, the members of which actually employ an art critic to teach them about contemporary art). Later, we have a tour of the garden and everything is much clearer. Beson's wife interrogates herself about identity. Once she had a French boyfriend who was unimpressed with the *familias tradicionales* (the Argentine elite), and she remasked further to me:

"I'm Bougeville, and and my Belgian ancestors built some railways here and then married to old Spanish colonial families, and I feel Argentine, but for example my maid, is Mapuche from Rio Negro. Here it's very difficult to build an identity. The Argentines, who are they? It's not a strong identity." (*Acá cuesta mucho construir la identidad, las raices. ¿Los Argentinos que son? No es una identidad fuerte*).

Beson is very proud of his collection, and several times he points out how much he likes a particular picture.

Then some other people come, and it is obvious that dinner will not be served for me, but instead their chauffeur will take me home. He has been once in Europe, thirty years ago, in Germany and Italy. Germany he found very strange because it is so orderly, and in Milan there is chaos like here. He lost his work and his savings during the period of hyper-inflation of the last Alfonsin government in 1989, and since has worked as Beson's driver. The neighborhoods in Greater Buenos Aires have become dangerous. "The northern zone is an island of wealth in Argentina," he says, providing an appropriate epitaph to the evening.

The visit to Beson's home was remarkable in several respects. As I do not usually frequent people of his class background in my daily life (although I had contacts with the upper classes during my earlier fieldwork), my expectations were also different from what I was to experience. From Beson and his wife's point of view, the invitation was somehow granted as a benefit. Me, and a young journalist from a Buenos Aires daily, were of the party. Of course, our function was not to be critical, but to say nice things and praise

the collector's taste and the quality of his collection. Their socially distanced behavior made clear that this was a business encounter, in which the visitors should feel comfortable, but where the line to a more private, friendly relationship would not be crossed.

A New Gallery: Making a Difference or Reproducing Old Patterns?

I have already mentioned the established patterns of the Buenos Aires art world, consisting of a few dominant institutions, listed earlier in this chapter. More recently, young gallery owners in Buenos Aires, in their twenties to forties, have realized that there is a small but growing market in contemporary art that is bigger than that satisfied by the established galleries. GARA, in the trendy neighbourhood of Palermo Viejo, is one such gallery, founded in 1996 by Cecilia Garavaglia. Her aim is to show young artists, both from Buenos Aires and other cities, for example, Rosario. The trends they represent are mostly postmodern, including multimedia installations, rather than traditional painting and sculpture.

To the outside observer most of the art exhibited does not seem to have a specific reference to Argentina at first glance, and could have been produced anywhere in the world.

Yet such a position privileges the wrong point of view, namely that from the "old" center. It is especially interesting to understand what international art means in the Argentine context, and what claims to belong to the international art world have been made from a local position. GARA's presentation in a special insert of the left-wing Buenos Aires daily, *Pagina 12* (which was also distributed at the Spanish art fair ARCO in Madrid) in February 2000 is very revealing in this respect:

GARA ART GALLERY: Argentine Contemporary Art

Gara starts as a project of building up a way of spreading the work of young artists. From this persperctive, GARA was constantly convoking those artistic proposals which, due to its experimental characteristics, could not be placed in a conventional gallery.

It is situated in Palermo neighbourhood, an emerging, progressist and intellectual area of Buenos Aires. Both the proposal and the environment started to convoke critics, artists, poets, architects, designers, an heterogeneous public willing to observe and discuss about these new rising pieces of art.

This place meant an alternative for new expressions, which in response to the visibility achieved, were becoming more and more familiar in the local artistic community.

This political move, carried out intuitively but methodically, allowed a new vector to be drawn in the symbolic geography of the artistic map of Buenos Aires. Our hope today is to continue with this task but in an international context, spreading the works of the new generation of Argentine artists.

Director: Cecilia Garavaglia[18] (ungrammatical English version in the original).

The ambition is clearly to promote a new initiative outside the established circuit, and at the same time trying to insert the gallery into the international art market. So, whilst at present GARA is still a marginal, yet up-and-coming, gallery, with time it might well become more established.

Friday 28 April 2000

In the morning, I go to GARA in Palermo Viejo to meet Cecilia Garavaglia. She has been to the international art fair ARCO, Madrid this year for the first time. GARA is one of only three Argentine galleries present there: Ruth Benzacar and Diana Loewenstein, are the others. She says that it was very successful and she has sold well. She says she can't help me much, since she doesn't specialize in artists usually who make references to indigenous cultures. The only one who comes to her mind is Javier Olivera, the film director who also paints.[19] She takes 30% commission when she sells, others take 40–50%. She works with people who could also show their art elsewhere and yet it is recognisable as being from Argentina/Buenos Aires, for example, with site-specific work. There was one artist who has worked on the rubbish bins of Buenos Aires. She then invites me to look at the portfolios artists had sent her.

GARA, though still an outsider gallery, is gaining status fast, which is clearly indicated by the fact that it is one of only three Argentine galleries represented at the international art fair ARCO in Madrid (in the previous year, 1999, there had been only two, Benzacar and Der Brucke, plus the Fondo Nacional de las Artes[20]). Although not mentioned yet in the *artealdía* directory of Latin American art, GARA is already listed in Golonbek's "Argentine Contemporary Art Market Investment Guide," as "representing young emerging artists" (2001: 123).

Thus to open a gallery with mainly postmodern contemporary artists in a fashionable neighborhood in Buenos Aires is symptomatic of the restricted circle and class status of such art production, which does not have an urban hinterland comparable to that of New York's SoHo,[21] London's West End galleries, or new and up-and-coming East End studios, or where the urban culture of entire neighborhoods is dominated by contemporary arts.

Contemporary international art is not a way of life in Buenos Aires, except for the very few who can afford it. Other artists who live in economically precarious situations in Greater Buenos Aires were not aware of the latest international trends and, in any case, saw little relevance of these to the political and cultural situation in Argentina. They were more interested in working on *lo nuestro* (literally, "ours"), meaning a cultural identity that had not yet been subsumed under the varnish of international language. However, this is only one part of the story. The new international diversity indeed has enabled local formal solutions, as aesthetic choices, to enter postmodern discourses about the art object, so that in Mexico, for example, artiststs like Abrahám Cruzvillegas combine postmodern approaches with work in indigenous communities.[22]

Argentine examples for this trend are Eduardo Molinari and Azul Blaseotto (who were suggested to me by GARA's owners), who executed a series of paintings based on a journey to Tilcara in Jujuy. One of GARA's gallery owners also

told me that she wanted to live in Jujuy and write about it. This is indicative of the complexity of producing art in Argentina, where the postmodern is not just a repetition of international styles, but is mixed with local contents.

The Art Fair ARTE BA

A good opportunity to observe the Buenos Aires art world in a condensed fashion and gauge its engagement with the global art world is the international art fair "Arte BA," which has been held once a year since 1992. Arte BA exhibits work from over eighty galleries (eighty five in 2000), mainly from Argentina, but also from Uruguay (three), Paraguay (one), Chile (two), Brazil (five), Bolivia (one), Columbia (one), Spain (three), Mexico (one), Cuba (one), the United States (four—three of them specializing in Latin American art), and Germany (two), as well as forty foundations, institutions, banks, and auction houses (mainly Argentine, but two from Brazil and one each from Italy, France, Uruguay, and Spain).[23]

The following description of Arte BA, compiled from a number of diary entries and left in the ethnographic present, aims to provide insight into the different coexisting levels (indigenous, national, and international) of the Buenos Aires art world.

ARTE BA is held in the *Rural*[24] in Palermo which I remember from my first fieldwork in Argentina in 1988/89, when I visited a book fair and the famous agricultural exhibition. On my first visit, at the entrance, I ask for the Press Office, but the guards don't know anything. Then I pass through and, miracously, Miriam appears (whom I had met in January at Ruth Benzacar's reception), and very kindly provides me with a pass. I want to see the talk by Nicolás García Uriburu, Eduardo Costantini and others on the launch of the internet site www.latinarte.com, but the place is absolutely packed, and I can just take one photograph. One woman representative of the web gallery promises me the video, I should talk to a certain Victoria in an hour's time (when the talk is over). I then walk around, and see quite a few institutions represented with their stalls, among them, Academia de Bellas Artes, Instituto de Cultura Indígena (with Mapuche silversmith Silvia Rinque, and director Juan Namuncurá—there are lots of people at their showroom), Arte Precolumbino, Cecilia de Torres representing Torres García and the *Escuela del Sur*, and GARA [figure 6].

At Latinarte.com. I talk to Alicia who says they mainly put Argentine painters on the web, shows me the website, the son of collector Jorge Helft is one of the founding executives. They have categories for "indigenous," "established masters," "individual new artists," and so forth.

Arte BA is quite a big event: there are about 90 galleries, 50 institutions, 12 publishers represented—some of which are from Uruguay and Brazil. The whole aesthetic display and lay-out of the event is very modern: white rectangular showrooms dominate (the exception is Instituto de Cultura Indígena which has an all-black showroom), it is well organized, and yet a familiar atmosphere prevails. I run into lots of people I know by now. International, contemporary art seems to dominate, but there are also those selling more "Latin American"-looking art, Cecilia de Torres for example.

Figure 6 Cecilia de Torres gallery, New York, at Arte BA, 2000. Photo: Arnd Schneider.

The Instituto de Cultura Indígena participated for the first time and was offered a stall for free. But I ask myself whether this was this just a politically correct gesture, or is indigenous art now taken more seriously?

The public is middle class and above, their tastes are not only reflected by the art on display, but also by the stylish cafes and the restaurant, which could be found anywhere in the Western world, coupled with an animated Latin or Italian atmosphere, typical of Buenos Aires. Quite a few people are interested in the Instituto de Arte Indígena, as well as reproductions of Pre-Columbian art.

I go for a second visit the to the Arte BA fair. It is late afternoon, everybody is very busy. I try to arrange the interview with the latinarte.com people, but they are in a business meeting.

I also pass by the Instituto de Cultura Indígena. Lots of people are there. I speak to Angélica Quilodran (whom I have met yesterday), and who shows me her etchings on display. I finally persuade her to go for a coffee plus interview. She is from Villa Regina (Province of Río Negro), and her father is Mapuche (her family is originally from Temuco, Chile). She tells me how she had traveled with her father to Temuco, where she spoke to the grandmother who told her about the family's history. But her father does not speak Mapuche any longer. Also, she suffered discrimination in her youth, sometimes they would say "*la india*" (depreciative for "indigenous woman") at school. It's only now that I am looking for my roots, she says. On her mother's side, they are Spaniards. She is really happy to be in Buenos Aires at Arte BA, where she meets lots of new people, and makes useful contacts. In General Roca, where she went to art school, she knows other artists who work with indigenous themes. She had proposed to Juan Namuncurá to organize an exhibition at the Instituto de Cultura Indígena, but he said they are not indigenous (they don't have the right surnames). She is rather open-minded about this, and when we discuss the topic, she agrees with me, that it would be interesting to have a joint

exhibition and discussion. She wants to send me photographs of her works, or through the Institute. As yesterday, there are lots of people interested in the silverworks of Silvia Rinke, and some deals are done. Yesterday, an elderly man approached her and bought a wrist band, also introduced some elderly ladies who wear exclusive cloths and make-up—I think, they must be upper class. I think, some *estancieros* (land owners) like the idea of Mapuche art (and possibly other indigenous art), somehow incorporating, what has been destroyed or lost (this is also, after all, the idea or fantasy of the museum in the West).

I meet another artist, Silvia, who tells me that apart form her artwork she does also bijoutierie, *joyas* (jewellery) to sell in the Palais de Glace. By contrast, her other works, that is, sculptures of large dimensions, are difficult to sell. Sculptors, she thinks, have a particular culture as "makers"; artisans, by contrast work in groups, different from the hermetically closed off painter. She is actually a good example of an artist (in this case, a sculptor) who has to work as an artisan, too, in order to secure an income.

I am just thinking about Arte BA as a village—actually quite suitable for an ethnographic study the art world of BA, although it's only a selection, of course.

On the following day, I go again to Arte BA. The first news I get is very sad, Ruth Benzacar, eminent and foremost gallery owner of Buenos Aires, has died overnight. Most people I speak to are shocked and taken aback by the sad news. I pass by the stall of the gallery and say some words of condolences to the man attending (not sure, if he is a family member).

I pass by the stall of the Tucumán artists I met yesterday, his name is Guillermo Rodríguez and I invite him for interview which he gladly accepts— we have a very good conversation. Later, at latinarte.com they are busier, but Victoria nevertheless, accepts a short interview. One of the owners of Nicolas Helft, the son of the art collector Jorge Helft is too busy for a full-length interview. Also, he does not answer my question of who the investors are (from the United States, maybe?), apparently this is a "business secret."

I also see one woman who has a designer poncho with "Pre-Columbian" patterns (figure 7). However, little interest is aroused by this since there was a fashion of this also in the 70s. I cannot say that people take special notice of this. As it is, of course, only a small minority amongst the exhibitors who dress with references to the indigenous: basically those artists exhibiting at the Instituto de Cultura Indígena, and Guillermo Rodríguez and Quiroga from Tucumán. As mentioned already, this is symptomatic of the minority status in public life of indigenous art and art inspired by indigenous people.

Teresa Pereda, whom I meet later, says: "You see, there are very few people here who make reference to the indigenous in their work—in another Latin American country this would be different."

On my last visit to Arte BA, the following day, I speak to the people of the Instituto Indígena. Juan Namuncurá says, "we are alive" (*somos vivos, lo nuestro es vivo*) and further comments on the guys in the opposite stall who sell "Argentine Indigenous Sculpture" (*Escultura Indígena Argentina*), that is reproductions based on Argentine Pre-Columbian art,: "That's not same, they make copies" [figure 8].

Arte BA was a well-attended and lively event, and surely one of the annual highlights of the Argentine art world. At the same time it serves as an important

Figure 7 A woman with a poncho at Arte BA, 2000. Photo: Arnd Schneider.

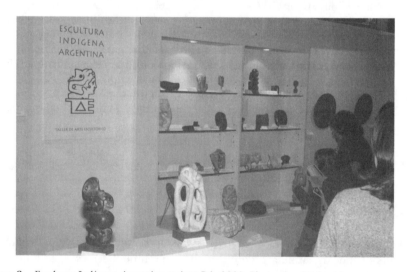

Figure 8 *Escultura Indígena Argentina* at Arte BA, 2000. Photo: Arnd Schneider.

showpiece of Argentine art; the public is mainly Argentine, despite a number of international exhibitors. Traditional and expected tastes, that is, those supported by the main galleries dominate. But one can also discern a certain presence of indigenous topics, both with the Instituto de Cultura Indígena and other artists working on indigenous topics, such as Guillermo Rodríguez from Tucumán. Arte BA was also an opportunity for people to cross-cut boundaries. This is exactly what artists of the Instituto de Cultura Indígena appreciated, as this was their first opportunity to show themselves, and also network in the "official" art world. Through the proximity, and restriction of space, it is easier for people to get in touch, which is precisely the advantage of fairs, as compared to separated and distant galleries, institutions, and artists' studios in a city.

There was a clear intention of the indigenous artists wanting to be different, as they chose black for their stall, setting them off from, and arguably resisting the dominating "white" (in more than one sense) of the rest of the displays. It was also curious to see upper-class, land-holding people buying silver jewellery from Silvia Rinque, the Mapuche jeweller and silver-smith represented by the Instituto de Cultura Indígena. There is probably a deeper discourse at work here, where land-owners, whose immediate ances-tors pushed the Indians off the land and into reservations, somehow want to incorporate what has been lost. A number of landholding upper-class fam-ilies have important collections of colonial and indigenous ponchos and silver jewellery, which are now being documented and made available to the public.[25]

Feria del Sol: Artisan's Show-Case or Indigenous Artists' Place of Difference?

I have already pointed out that for those working with indigenous topics there is no "separate" art world, just a different set of institutions and prior-ities. One of these is the *Feria del Sol* (Sun Fair), billed as an "encounter with our heritage" (*un encuentro con lo nuestro*), held once a year, showing the work of artisans and craftsmen. However, whilst the event is largely domi-nated by crafts, it is overall heterogeneous and includes, for example, also fashion designers, such as Manuela Raisjide, who takes her inspirations from indigenous designs. Artists from various indigenous communities are also present (such as Mapuche from Patagonia and the M'bya-Guaraní from Misiones). The display of items follows a more rustic style than at Arte BA, where a wide a variety of products or objects are on display, from home-made marmalade to artistic fashion design, to art objects made by the indigenous communities.[26]

It is also curious to note that here indigenous artists actually "make" their art in front of the public, whereas at Arte BA they only exhibit (figure 9), somehow and possibly unintentionally alluding to those older traditions in which indigenous artists and artisans had to "perform" in front of white audi-ences, in live dioramas in museums and at world fairs.

The Economics of Recession and the Art Market

The influence of the faltering economy of Argentina can be gathered from reports on auctions. Commenting on auctions in the month of July 2000, Gualdoni Basualdo, in the column "art market" of the monthly art journal *artealdía* writes:

THE UPS AND DOWNS OF THE AUCTIONS REFLECT THE INSTABILITY OF THE MARKET PLACE

. . . [A]nd then it was the turn of Saráchaga[27] which. . . . presented an auction with three focal points: a good assortment of Argentine paintings, an interesting collection of colonial and Creole[28] silverware, and a part of the library of Mrs. Elisa Peña.[29] *The results of the sale are evidence of the economic adjustment the country is experiencing.* Only in this way can one explain that important works by Quinquela Martín,[30] Larrañaga[31] and other artists remained unsold, which the auction house had presented with very reasonable asking prices.[32] [my italics]

However, according to Golonbek (2001: 118) selling and buying at auctions is an increasingly important activitiy of the Argentine art market. In 2000 there were about 1,500 transactions at auctions, which represented an increase of about 20 percent from previous year.

At the end of 2001, when the country plunged into a deep economic and political crisis, prospects for the art world, however, also seemed gloomy. My fieldwork almost came to an end, with several people in the art world, including gallery owners, too busy to look after their business transactions and having no time to spare for interview.

Secondary Circuits to the Established Contemporary Art World

I have already mentioned that save for a few exceptions, such as Alejandro Puente, César Paternosto, and Teresa Pereda, most artists working with appropriations of indigenous cultures in Buenos Aires find it difficult to establish their subject on the national and international art market.

Norberto Rodríguez, for example, unlike the above artists, works outside the established circuits of the central Buenos Aires art world. He lives in Quilmes, in the Southern suburbs of Greater Buenos Aires. The son of Spanish immigrants, Rodríguez combines an interest in his immigrant past, with the appropriation and reevaluation of indigenous themes.

His series "Etnográfica," which I presented at the beginning of the first chapter, is programmatic, as he reclaims an "indigenous" past and present in Argentina from the vantage point of an uprooted descendant of Spanish immigrants.

Rodríguez was brought up in Quilmes, and has had shows at the municipality, but he is under no illusion about the art world of Buenos Aires and remains at a distance from it. Although he has frequented the main art

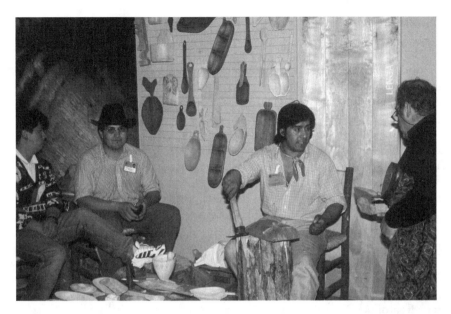

Figure 9 Artisans from the M'Bya Guaraní community, 8ª Feria del Sol, 2000. Photo: Arnd Schneider.

schools listed at the beginning of this chapter (i.e., Belgrano, Pueyrredón, Cárcova), he is rather reluctant to join a gallery, even if he were offered one. "One has to see if they like the work," he replied to my question on this point, "for me, making art is more a question of life than exhibiting."

Rodríguez has chosen to stay outside the established circuit, where he feels his type of art, based on indigenous topics, is not appreciated. He decided instead to use a secondary circuit of his home town Quilmes in Greater Buenos Aires, where the local university has bought some of his works, and where he had an exhibition at the municipality. The cultural capital (Bourdieu 1987) acquired in various art schools, and through contacts with a number of prominent teachers, such as the late anthropologist Guillermo Magrassi and the archaeologist Florencia Kusch, in this case is employed locally rather than on a national or international level.

Likewise, the group *Ojo del Río* around the painter Alberto Delmonte[33] was critical of the actual exhibition practices of Buenos Aires' main art institutions, the MNBA, the Museo de Arte Moderno, and the Centro Cultural Recoleta. These institutions, according to Delmonte, are run very autocratically, which is why he preferred to stay outside (however, in 2005, after an earlier change of director-ship, Delmonte had a major retrospective at the MNBA). In our interview, Delmonte also mentioned that he was very disappointed with the current state of art teaching at the national academy of art, Ernesto de la Cárcova, and that he would not accept students from there anymore, "who don't know how to paint." According to Delmonte, in the 1980s there had been a resurgent interest in indigenous topics, and his group

of artists, *Ojo del Río* (founded in 1989), had a good public response to their exhibitions.

His student Silvia della Maddalena explained to me in our interview that despite the group's common ideologies, it was difficult to act together (for joint projects, exhibitions, and so forth), as members frequently disagreed. In 1999/2000 Silvia taught in Delmonte's workshop. The students knew what to expect, she said, that is, an abstract, geometric painting style, inspired by indigenous cultures, in the tradition of Uruguayan painter Joaquín Torres García (1847–1949) and his famous workshop,[34] and Argentine painter Leónidas Gambartes (1909–1963). However, when the members and students of the workshop talked about this, they still meant and interpreted different things—even if they are interested in the same style of painting. It was very difficult, Sylvia, suggested, to form a new "school" or "tradition."

Juan Maffi, a sculptor, had been trying for several years to promote and teach a kind of art different from that usually seen in mainstream institutions, which (according to him and others, for example, those around Alberto Delmonte) were following just the latest international trend. In Maffi's *taller* (studio) students are encouraged to make field trips, especially to the countryside around Buenos Aires (*pampa*), and to work with found materials, both natural and man-made. In our interview, he said that he had realized some time ago that he could not wait for official institutions to support him, but had to create "his own space," in order to make his art (and that of his students) happen (figure 10).

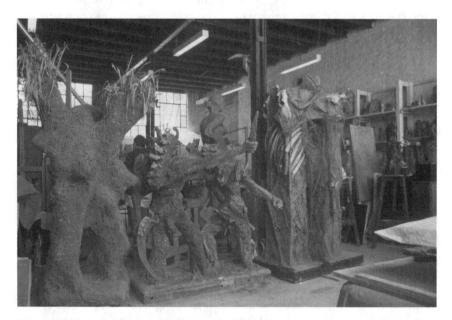

Figure 10 A view of Juan Maffi's studio, 2000; including in the sculptures *El duelo* (centre; cement and bones) and *El hombre toro* (right; adobe, branches, and bones). By permission of the artist. Photo: Arnd Schneider.

Conclusion

In this chapter several topics have been addressed. We have seen on the one hand that the traditional center-periphery model of the international art world can be challenged in various ways in a "third world" country like Argentina. The challenges are made both by individual artists who feel they are not represented by the main art institutions (such as the *Ojo del Río* group and Juan Maffi's workshop), but also by galleries, such as GARA, who want to establish themselves outside the established circuit, yet aim to be represented internationally.

In terms of identity, Argentine art's old fixation with Europe has been substituted by a focus on the international art world, the only parameter for an artist to be successful. Appropriations of the indigenous, in this context, can only receive attention if they are expressed in idioms recognized by the international art world. The periphery can be "original," but it is much harder to establish trends or fashions that would have relevance beyond a local or regional center. As one of the young guests at the private reception of the Ruth Benzacar gallery said, he expected "something interesting to happen, beyond the current fashion."

In economic terms, we have also seen how volatile the Argentine art market is and how much it depends on the ups and downs of the economy, a fact highlighted by the recent collapse of the Argentine economy in 2001. This being much more the case than in the so-called first world, and further compounded by the fact that Argentina does not at present feature any "surprise" or long-established artist whose work would command millions (rather than thousands) of dollars on the international art market (where, of course, prices do not exactly follow the development of the economy).

The next chapter provides a detailed description and analysis of the ceramics workshop of Mirta Marziali and the actual material working processes of the approriation, forming part of what I have called the secondary circuit of artists sinspired by indigenous cultures in the Buenos Aires art world.

Chapter Four

Copy and Creation: Potters, Graphic Designers, Textile Artists

Introduction

This chapter provides an application of the theoretical concerns I have developed in chapter two. We have seen that culture change, in fact the development of any culture, inevitably involves the appropriation or borrowing from *other* cultural systems. Yet there seems to remain a paradox: the entire terminology of appropriative strategies, such as "copy," "recreation," "imitation," "fake," and "appropriation" itself, make reference to the presumed authenticity of an original. The original embodies somehow the essence, the irreducible singularity of the specific artefact, work of art, or more generally, cultural form or expression. Within Western thought this concept is applied not only to the Western tradition, but also to non-Western cultures. Ultimately, such an understanding of creativity, as being singular and unique, is rooted in the Western conception of the individual, that is, as a bounded, autonomous person. The critique of this concept from within anthropology was built both on work on specific ethnographic areas, such as Melanesia and Amazonia, and recent parallel work in Western societies.[1]

In this chapter, I intend to explore the empirical context of appropriation in the practices of potters, draughtsmen, and women, and graphic and textile designers in Buenos Aires. In particular, I investigate how the "original" is constructed and conceived of in the first place, and then recreated and transformed through various strategies and techniques of appropriation. Both strategies and techniques I call "technologies of appropriation" and expand on this in the conclusion. Three main examples have been chosen for participant observation, each of them illuminating different issues of the appropriating process.

First, I focus on the potter's workshop and teaching class of Mirta Marziali (*Taller de Cerámica Precolumbina*), then on the classes of Pre-Columbian design of Professor César Sondereguer in the faculty of architecture of the University of Buenos Aires (*Diseño Precolumbino*), and, finally, the textile workshops and classes of an adult arts and-craft school in *Haedo*, a neighborhood

of the Municipality of Morón in the Province of Buenos Aires (*Escuela Taller Municipal de Artes y Artesanías Folclóricas de Morón.*).

In the concluding part of the chapter, I argue that rather than dealing with copies of pristine originals as conceived of by the social actors or "appropriating agents," the social actors themselves create the "original" and endow it with new meaning through their appropriating work and social interaction.

The "original" then is constructed in a process, which is at the same time discursive and practical, and encompasses both "original" source and "copy." This is how the recognition of otherness operates, by including the "original" source perceived and researched by the actors *and* the new creation, or what they call "copy." Thus new meaning is bestowed onto the original through the copy and recreation process.

Mirta Marziali's "Taller de Cerámica Precolumbina"

I had met Mirta Marziali a few days after my arrival in the autumn of 1999 at the National Institute of Anthropology[2] in the neighborhood of *Belgrano*. An extract from my diary entry for October 15, 1999 illustrates how my expectations clashed with what I encountered.

In the daily *La Nación* I had discovered a little note about "Amerindia," an exhibition of "recreations" of Pre-Columbian ceramics in the *Museo de Antropoplogía y Pensamiento Latinoamericano*. I phone in order to find out if these were "original" pieces, "recreations" or "contemporary art." The lady on the telephone tells me that these are pieces from the *taller*, or workshop of Mirta Marziali, a potter, and nine of her students. I am quite expectant and hope to find contemporary art pieces.

The special exhibition is on the first floor. My disappointment, or I should say, rather, surprise is immediate. In fact these are "copies," recreations of Pre-Columbian art, by the students of Mirta Marziali's workshop. I then have a chance to speak to her, and she explains to me that she is inspired by Pre-Columbian art. She also teaches as an assistant to Prof. César Sondereguer who offers a program of "Latin American Aesthetics" at the University of Buenos Aires, and whom she promises to introduce to me, which in fact she does later in the evening.

In our conversation, Mirta Marziali stresses that, in order to understand "Amerindian art," one has to start from recreations. Only from there can one develop freer forms which are still inspired by Pre-Columbian aesthetics, such as her own calendar "discs" at the entrance of the exhibition [figure 11]. This is obviously a topic I wish to explore, of how through recreation and abstraction, interpretation is arrived at.

My own gut reactions to this exhibition are quite instructive about how we, in the West, conventionally conceive of creativity and more generally, artistic activity: as an unique act of creating originals. Other practices are relegated to inferior statuses of copy, imitation, repetition, and are often ascribed to craft production, as opposed to Fine Art. This view seems to have been shared by César Sondereguer. As Mirta later told me, he considered the exhibition pieces as mere "copies," embodying no creativity. Mirta vehemently protested this

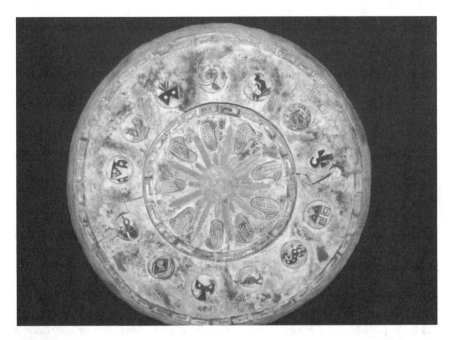

Figure 11 Mirta Marziali, *Calendario*, ceramic sculpture, 1999. By permission of the artist. Photo: Arnd Schneider.

view, when one of her students said that they were just doing reproductions, she replied: "We are not doing reproductions here, one cannot see the back of the ceramics on the photographs reproduced in books. One always has to put some creativity and imagination!"

Participating in Mirta Maziali's workshop, with time made me realize that "copies" were as much created as unique and individual pieces, as the "originals" had been by the makers of the ceramics in Pre-Columbian cultures. In fact, the originals only acquired meaning for the participants of the workshop through their copying and recreation practices. As outlined in chapter two, creation here is understood as a process of hermeneutic interpretation, in which appropriation of "other" cultural symbols or forms involves a learning attitude.

Mirta had invited me to come to the workshop, an offer I readily took up. I usually traveled on the *subte*, the Buenos Aires underground, to *Once* railway station and then onwards by train to *Villa Luro*. The middle-class neighborhood of *Villa Luro* is the location of Mirta Marziali's pottery workshop. The area lies still within the bounds of the federal capital district and near *Liniers*, which till the middle of the twentieth century was home to cattle markets and enormous abbatoirs. Train rides were revealing on the now harsh social differences of Argentina. Whereas the trains of the northern wealthier suburbs would have mainly middle-class passengers on them, to the West and South the impoverished and the poor predominated, and, on my

journey, I could see from the window graffiti with political slogans protesting against the payment of foreign debt.

Initially, I just planned to come a few times, in order to interview participants and observe the working process, as well as making photographs. In the following, I describe in some detail the functioning of the workshop, and how the participants selected their motifs and forms and arrived at the ceramic forms and final artefacts. Eventually, however, I realized that in order to gain a deeper understanding of the processes of appropriation, I had to participate, which I did (over a period of five months) and made a pot inspired by Pre-Columbian cultures in Argentina.

It is still a minority of anthropologists who *participate* in the material processes of artistic creation in the societies they observe. Although there are some notable exceptions to this rule (for example, Guss 1989, Moeran 1990), the majority of those studying artisans and artists, whilst giving very detailed descriptions and analyses, do not participate or learn the material processes themselves, or if they do, such practical involvement is not the primary concern of their writing. In one of the classic early studies on pottery, by Franz Boas' student Ruth Bunzel, "The Pueblo Potter" (1972 [1929]), the anthropologist "learned to make pottery in two different villages, trying as far as possible to conform to the native standards. Methods of instruction, criticism of their work and especially emphasis in teaching provide some of the most interesting and valuable material." (Bunzel 1972: 2) Whilst Bunzel's remains an insightful and, for its time, innovative study of pottery and creativity among the Pueblo, her own experiences are not taken up in the main text. Archaeologists also have been experimenting for a long time, with what Robert Ascher (1961: 795) has called "imitative experiment," that is, the experimental replication of archaeological artefacts, in order to gain an understanding of their manufacture.[3]

One of the problems with working as an anthropologist is that one is often not trained to do practical things, to engage with the material culture of the people one is living with. In my case, I had a family background in art appreciation and practice (my father being a sculptor and arts teacher and my mother having trained as a fashion designer), but I never took to the practical side myself. Thus apart from exercise-level executions of artworks in school classes, and, some early adolescent ceramics class, I had no particular practical preparation. During my fieldwork, I was relatively cautious to engage practically, though I was tempted on occasions, such as in the workshop of contemporary artist Juan Maffi and his students, who had been out in the pampas doing installations and land art. In another case, given my previous experience as a freelance TV producer and interests in visual anthropology, I found it easier to participate. This was the shooting of the feature film *El Camino*, where I accompanied the film crew for ten days to Patagonia and helped with the casting of Mapuche extras (cf. chapter six).

So it took me a while in Buenos Aires before I felt confident enough to enlist myself in Mirta Marziali's pottery workshop.

The Students

During the time of my fieldwork, Mirta ran her workshop twice a week, on Wednesday and Saturday afternoons. She charged $70 per semester, but often this was reduced, according to the economic possibilities of the participants. Afternoons were extremely informal. Mirta would arrive at about 3pm, unlock the door, lift the blinds, and prepare the workshop by laying out clay and small potter's-wheels on the table. Half an hour later, the first students would arrive. Mirta kept the door locked (a sign of the changed security situation in Buenos Aires); so when unlocking, everybody, inevitably, got a personal and warm welcome from her. Always, somebody would have brought some cake from a bakery, and Mirta would prepare maté, which then was drunk communally from the gourd (*mate*) with a metal straw (*bombilla*), and sometimes tea or coffee were offered as well. Whilst participants started unpacking their unfinished pieces from the shelves, on which they were kept in plastic covers to keep them wet, prepared their tools and work places, they would also start talking about the week's events in their daily lives, or even about politics.

The participants who, except for one man in his forties, were all women, came from a variety of middle-class backgrounds, and had been frequenting the workshop for different lengths of time.

Marcela López was the "oldest" member of the workshop; she had been coming for ten years. She always wanted to make Pre-Columbian pottery, and, when walking through the neighborhood, had noticed Mirta's workshop by chance. Some time ago, she carried out an experiment with Mirta of how to apply *al fresco* painting to Mexican vases.[4] Even after she had finished several courses with Mirta, she continued to come to the workshop. More recently, she had also been traveling with Mirta and her husband to Peru to visit Cuzco and Machu Pichu. As we shall see in chapters six and seven, travel is one of the technologies of appropriation and a significant element in the activities of artists appropriating indigenous cultures, and is also practiced by some of the members of this workshop.

The other participants had frequented the workshop for varying lengths of time, between two months and two years. Emma, who was in her early thirties, had been coming to the workshop for about two years. For her, the workshop activity was a kind of therapy to help her with some psychological problems. Florencia, also in her thirties, and a mother of two, ran a travel agency, and had been coming to the workshop for about two years. Gaby in her early forties, came with her five-year-old daughter to the workshop. Claudia, thirty, had already done a ceramics course elsewhere, but now wanted to learn more about Pre-Columbian pottery as part of her search for identity.

Valentina, twenty-one years old, and the youngest of the workshop members, had just started with the workshop. After a first failed attempt, she had now chosen with Mirta's help a Peruvian vase as a model for her own vase, which, on my first visit to the workshop, she brushed with stone to give a particular structure to the color, and then incised ornaments with dark

lines. Mirta corrected her work and asked her: "Why don't you use the potter's disc?"

I say more about the teacher–student relationship later on.

Practical Work and Theoretical Classes

The majority of sessions was practice-based, that is, participants worked on their pieces, but once in a term Mirta offered theoretical classes by giving lectures with slides on Pre-Columbian ceramic cultures. Special emphasis was put on the different pottery techniques, such as forming the vessel from clay "sausages" (*chorizos*), polishing, painting, varnishing, and firing the clay.

Mirta was particularly keen that her students first learn and understand the "cultural forms," that is, indigenous motifs and symbols, as well as the different shapes of vessels, before they were allowed to develop their own creativity.

Though each piece was different, the process toward its creation and final realization followed usually the same pattern. First, students chose a vessel type or form, and one or more motifs for its ornamentation or decoration. Sometimes, this could be done later, after the blank had been finished and before the first firing. The inspiration for form and decoration was sought, almost without exception, from the books on Pre-Columbian cultures that Mirta kept in her workshop.[5] Occasionally, participants might themselves bring illustrations and suggest a piece, or they used recollections from pieces they had seen in collections, of which they would have taken notes and photos. According to their capabilities, and how far advanced they were in the course, participants would generally choose something feasible for them to realize—with Mirta always being the last instance, to advise them on the practicability of the proposed piece.

What were the criteria for the selection of a particular piece, or specific motifs? Some participants might just flick through the books in the studio and find a specific piece particularly attractive, others might have an idea of a piece already. Some were already interested in a specific culture, such as Moche (Peru), or one of the ancient Mexican cultures. Whereas some of the participants would chose a freer approximation to the "original," others were keen to achieve an exact, verisimilar copy (see figure 12).

For instance, Mario Ansotegui, who had taken classes with Mirta Marziali in the past and in 1999/2000, and was the treasurer of the friends of the *Instituto Nacional de Antropología y Pensamiento Latinoamericano*, went to great length to study and master the pottery techniques of ancient Mexico. A retired engineer for the Ford Motor Company, he was in touch with scholars and consulted bibliography on the Internet, and had made several trips to Mexico, where he met master potters to observe and learn the process in situ. When he showed me his studio during our conversation, he was a fervent advocate of copying and reproducing the originals as faithfully as possible.

In the workshop the adoption of a particular vessel type, and the appropriation of ornaments and decorations, followed regular patterns, but was

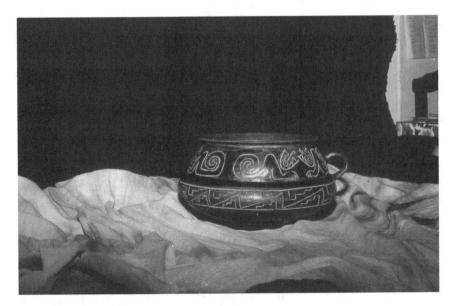

Figure 12 Vessel burnt with oxygen reduction technique and with incised feline motifs. Exact copy of Pre-Columbian designs (Aguada culture, NE Argentina). Potter: Marcela López. By permission of the artist/Mirta Marziali studio. Photo: Arnd Schneider.

not necessarily predictable, as significant variations occurred with respect to the sources (I deliberately avoid the term "original"). First, the vessel, pot, or sculpture was usually altered in its size. This is, as far as size can be judged from the illustrations, since older books rarely indicate exact size measures, and more recent European or American publications are expensive and difficult to obtain in Argentina. Second, certain elements from the primary source, such as handles, the opening, etc., might be slightly changed, omitted, or altogether different elements might be added, to accommodate for a simpler vessel. This was because the apprentice potter in the workshop had not yet mastered the relevant technique, or in order to include new elements to the taste of the creator. Arguably, where most liberty with the sources was taken and often deliberately hybrid elements were introduced was with the addition or combination of new elements decorating the piece.

Thus, for instance, a vessel the form of which was based on the Aguada culture of North West Argentina could be decorated with a motif from the Cienaga culture, also from North West Argentina. However, certain explicit rules applied, which were even verbalized: for example, elements from very distant and disparate cultures (for instance, from Peru and Mexico) were thought not to combine well. Nevertheless, the criteria for allowed combinations remained extremely arbitrary.

Once the type of vessel is chosen, work on the form begins. If the participant had no previous experience of pottery and ceramics, Mirta would show how to make clay rolls and help with cutting the ground of the vessel. The difficulty, as any new hobby potter will realize, is to make round and even clay

rolls. These then have to be laid in circles one over the other, which, in case of a round vessel open at the top, have to be a little bit shifted in respect to the previous one, so as to achieve the round form. This, in fact, is one of the simplest and most ancient techniques of pottery to achieve a round form without a potter's disk.[6]

When writing about how I learned this technique in Mirta's workshop, it still evokes a distinct tactile memory of how actually the soft clay is worked and formed, and how I filled the spaces in between layers of roll with a watery clay mixture. Also, working with clay evoked even older memories, when, as a youngster, I used to go to a ceramics course at a youth centre in Hanover, Germany. And whilst I am writing this, an even more ancient memory surfaces, connected to an artefact that I still treasure and that has survived many moves and relocations during my life: an ashtray I made as a four-year-old boy in the local *école maternelle* (primary school) when I was living with my parents in Paris.

The Process of Appropriation

An important element in delineating the field of appropriation is the instruction classes offered by Mirta about once a term. I shall advance some description of these classes below (taken from my diary entry).

May 24, 2001

In today's class, Mirta shows some slides in order to familiarize us with the morphology of the different pottery styles and forms, such as vessels, sculptured vessels, and urns. Mirta explains that the first ceramic culture was Valdivia, in Ecuador, around 3200 BC. Red and white clay was used, also moulds, and open earth ovens, for five-hour burns. Burning with oxygen, as well as oxygen reducing burn, resulting in black pottery, was used, for example, in Chavín in ancient Peru. The Teotihuacán culture of Mexico knew tripod vessels, and fresco and tempera techniques. The Mixtecs instead used a form of coating and painting their ceramics with slip.[7] This coat was then polished with the inner stem of the corn plant. There are two main techniques to apply ornaments, either by scratching (*esgrafiar*) into the slip after the first burn, so as to obtain a different color for the ornaments, or by incision into the crude clay. Mirta concluded her lecture by highlighting that in Peru, Chavín de Huantar was the "mother culture" of Paracas, and the Nazca culture was characterized by idealistic deities, whereas the Moche had a more "realist" ceramic art.

Mirta here followed Sondereguer's scheme, who has classified Pre-Columbian art into broad stylistic categories, but based principally on the western canon, on which more in the next section (Sondereguer 1997). When Mirta spoke about the fret step of Tiwanaku (Lake Titicaca), one woman said, "Ah, this is like the Roman meander" and Mirta replied vehemently, "No, this is *ours*, it's not Roman!" (¡*No este es nuestra, no es romana!*). Somehow this exchange of opinion between the two women epitomizes vividly a paradox in contemporary Argentina, of being influenced by European paradigms and yet claiming indigenous traditions as their own.

Finally, Mirta talked about the Pre-Columbian cultures in North West of Argentina, Aguada (the culture I had chosen for my vessel), and Cienaga. Then the lecture continued on sculpture vases from Colima (Mexico), high and low relief techniques, and the Peruvian Nazca who knew sixteen colors for glazing. Potters of the Chimú (Peru) and Condorhuasi cultures preferred to model from a block of clay. Then some examples of urns from the Mexican Zapotecs and the Argentine Santa María culture were shown.

This was an interesting class for me, as I got insight into how the background knowledge to the practical work is provided to the students—basically in front-to-back traditional teaching, and affording clear distinctions between different techniques and styles—an approach which students, however, seemed to enjoy. After the lecture, I continued to work on my vessel, but making the initial clay "sausages" was the problem, the rest seemed to be easier. The ladies worked away, on this occasion there was not so much conversation, they just talked about propolis, that is the bee's secretion which is considered antiseptic and very popular as a homeopathic drug in Argentina, but they referred to some instances where it had been tampered with and some people died of it.

Choosing Form and Motif for My Piece

I had seen superb examples of the ceramics from the Argentine North West in the collection of Nicolás García Uriburu (Colección Nicolás García Uriburu 1999), and had interviewed Alberto Rex González, the doyen of Argentine archaeology, and a specialist on Argentine Pre-Columbian cultures. Later, I would see huge amounts of them lingering on dusty shelves in the deposit of the National History Museum in La Plata.

So I was drawn to the La Aguada culture (ca. 500 to 900 AD) with its simple and plain, in fact, almost monotone aesthetics of black ceramics with white incisions, the dark color achieved through oxygen reduction in the last firing. This is what I intended to chose as inspiration for my own piece (figure 13).

Working on the Object

Mirta and I selected a simple La Aguada vessel which I quite liked. First, I had to make clay "sausages," then cut a floor for the vessel, and eventually, use a knife to correct the size in order to arrive at even borders. In the workshop artificial aids, such as pen holders and small potter's-wheels (desk versions) were employed, which obviously were not available to Pre-Columbian cultures. Then the handles were added, again from two "sausages." Finally, this was followed by incising the ornaments.

June 7, 2000

Today, the task is to clean the vessel, also around the handles, and then to choose a motif for ornamentation, from the Aguada culture. However, in the

Figure 13 The vessel in the making, and source for decorative motif. Photo: Arnd Schneider.

end I feel more attracted to a feline "dragon" from the Cienaga culture. I recalled that in her lectures Mirta had referred to Quiroga/Ibarra's (1971) suggestion of "draconic" cultures. But she had also criticized that assumption, insisting that in the Pre-Columbian art of Argentina there were no dragons—which are from European mythology, after all—just felines. The other motif I select is a female feline from the Aguada culture. When I start with the incision, it is actually not as easy as I thought, and the proportions come out rather differently than in the original source. But then it is not a pure copy, and maybe I will not use all the lines of the drawing, anyway. I note that in the source book by Albuerne/Diaz y Zárate (1999: 139, 145; cf. figure 24) all the lines are parallel, because they used a computer program, whereas in the pictures of the real Aguada vases, they are drawn freely, and therefore irregular. Mirta agrees with me, and says there are different approaches to recreation. One, she said, "is to make exact copies, as Mario Ansotegui does, who tries to make exact 'copies' [of Mexican vessels], the approach of a chemist," she summarized, "exactly the same mind set as my husband who is a public accountant."

Artists working with archaeological source books lamented in our conversations that technical descriptions and visual depictions of Pre-Columbian pottery in archaeological publications are often inadequate. As Alejandro Fiadone (Fiadone 2001: 20–23) pointed out recently, "transcriptions" (as drawings) of ceramic patterns in book or article format are presented as plane and thus are necessarily distorted, nor can the volume of ceramics be represented adequately on two-dimensional paper, whereas in fact in much of ceramics the surface is curved (figure 14).

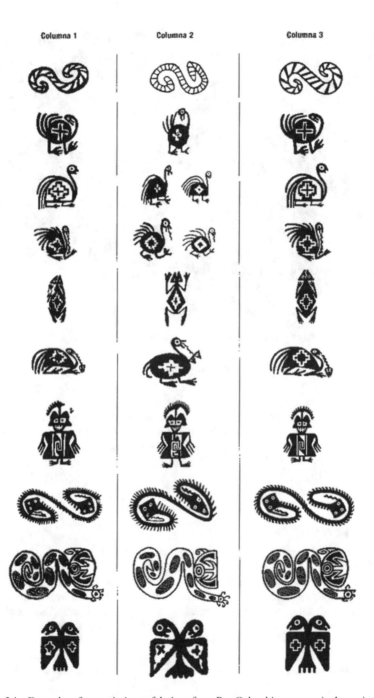

Figure 14 Examples of transcriptions of designs from Pre-Columbian pottery in Argentina, by Alejandro Fiadone. Reproduced from Fiadone (2001: 22), courtesy of Alejandro Fiadone and La Marca Editora, Buenos Aires.

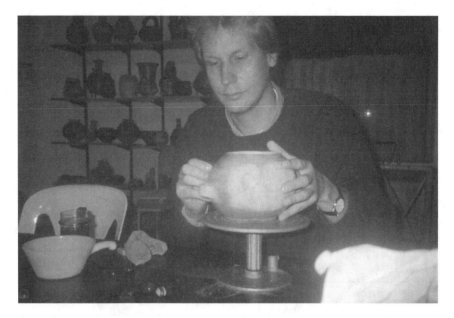

Figure 15 Polishing the vessel. Photo: Mirta Marziali.

Dry and Polish

June 14, 2000

Over the next few weeks my piece first has to dry, and then to be polished. I frantically finish the incisions, because during the a planned field-trip away from Buenos Aires the vessel will have to dry, in order to be polished later. I continue my polishing work, with sand paper and stone[8] which I find really boring [figure 15].

Oxygen Reduction

August 12, 2000

I go to Mirta Marziali's workshop in the afternoon, in order to see how my piece will be burned with the oxygen-reduction technique—a procedure to be performed on the pavement in front of the workshop! It is ready and with a huge pair of pliers Mirta takes it out of the oven. She then puts into a large tin with sawdust, outside on street, provoking a steep flame, I jump back, and so does Marta (later, I think, this is not so safe, after all) [figure 16]. She covers the tin with a lid to reduce the atmosphere, suffocating the oxygen, and when it comes out the piece it is just beautiful! The incisions are clearly visible. My job now is to clean it with a brush. Next week I will paint the incisions white.

Filling Incisions with White Paint

August 16, 2000

My piece has to be cleaned, and I apply white slip (kaolin), a rather fulfilling activity after the boring polishing, a few weeks back [figure 17].

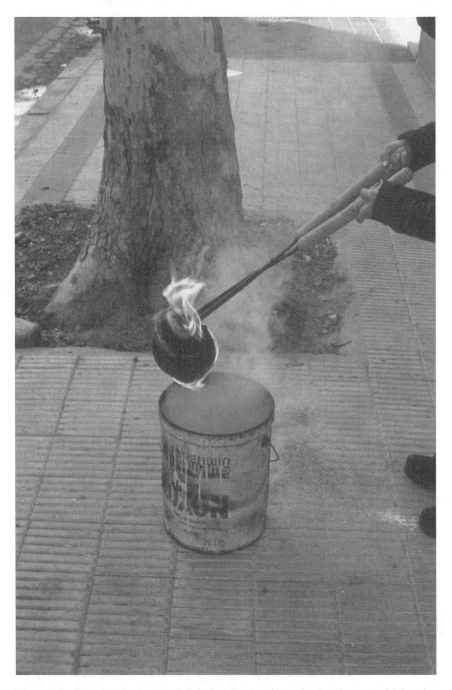

Figure 16 Oxygen reduction: putting the burning vessel into the tin. Photo: Arnd Schneider.

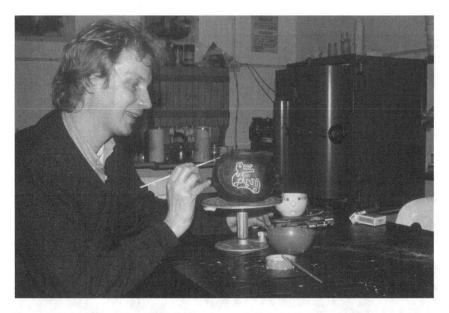

Figure 17 Applying white slip (kaolin) to the vessel. Photo: Mirta Marziali.

The Discursive Web of the Workshop:
The Construction of Meaning Beyond Ceramics

Whilst working a variety of material techniques a great range of social interaction and discourse took place, and a considerable variety of topics were discussed among the participants of the workshop.

For example, when speaking about her family, Mirta told of her valiant daughters, who are not intimidated by men and once kicked and hit back when they were approached untowardly.

The other women all commented positively and jokingly how I now had started my practical class. While I was working on the handles of my vessel, Mirta and the other women explained to me the meaning of *gato* (literally "cat," but here it means "high-class prostitute"). The topic came up because of the pop star Shakira, Antonio de la Rúa's (the then president, Fernando de la Rúa's son) Colombian girlfriend, a relationship that according to the women in the workshop was a "fake" to cover up de la Rúa Jr.'s homosexual affair with an Argentine politician. But according to other friends of mine this version was actually not true.

When I cleaned the vessel around the handles, the conversation was about "tax evasion," and I claimed there was rather a lot of it in Argentina. But Mirta replied quickly: it happens because people have no money. She told me of the work of her husband who is a public accountant. I should note that people, in contrast with Europe and the United States, study a lot here at night, and this is, she said, because they work during the day. Her first husband got up at four in the morning, studied till six and then went to work,

and slept a short siesta in the afternoon, but sometimes, when there were exams, had no time for even that. We also commented on the fact that men do not like to iron, and I told the group (all women as always, except for one guy who used to join in the afternoon) that men pass on various recipes amongst themselves, of how to dry cloths without ironing, for example by putting a shirt on a hanger. Whereupon the women laughed, and said I should pass those recipes on to them.

Often my opinion was invited on current political and economic issues, and the workshop participants wanted to know how I saw things from a European perspective. Social interaction in the workshop, however, was not only *verbal*, but also entailed the sharing of the maté gourd, eating of cakes, and the warm embraces upon arrival and departure. Interaction thus was also *practical-*, *material*, and *sensual*, by working together in the workshop. Although usually participants did not work jointly on a specific piece, comments were passed on each others' pieces, and advice given. However, it was always Mirta, *la profesora*, who was the last instance of judgment, and from her position of authority and experience would materially intervene into the working process of a particular student and make material corrections.

These and other descriptions of my attendance of the workshop make it quite clear that the workshop obviously was not just about pottery, but family and gender roles, politics, and economics were often discussed in conversations. The material practices are therefore directly interwoven with the fabric of social relations of everyday life.

The Motifs for Participation

All of the participants of the workshops had a genuine interest in Pre-Columbian ceramics. There were, however, also other motivations. Some of these were to mix with other women and spend time outside the home. For instance, for one woman who had psychological problems, going to the workshop was also occupational therapy.

What are the criteria of evaluation for the pieces? The main criteria were truthfulness (verisimilitude) to the "original" source, mastery of technical execution, and the finishing of the completed piece. There did not seem to have been an explicit discussion about the content of these pieces, whether they would truly embody, in an almost metaphysical sense, the "spirit" of the culture from which they were taken. However, such assumptions were made implicitly when actually making the pieces. Yet I thought when they stood on the shelves that they looked sometimes a bit lifeless.[9] Nor was there much discussion about the appropriation process, and the ethics of taking motifs from other cultures. However, both Mirta and Marcela López, the most senior student, spoke with great respect about the indigenous people they had met during their recent trip to Peru.

There were, however, obvious preferences for cultures which were perceived as being culturally and geographically nearer: Argentine Pre-Columbian and Andean cultures, rather than those from Columbia, Brazil or Mexico. Somehow,

there was a concept that these were the legitimate ancestors of the young Argentine nation state, as was clearly expressed with Mirta's insistence that the fret step in Pre-Columbian art was *not* Roman but "*ours.*"[10]

Teaching Appropriation: César Sondereguer's Classes in Pre-Columbian Design

Since at least the 1980s, César Sondereguer, an architect by training, has developed a special interest in the aesthetics of Pre-Columbian cultures. As mentioned in the previous section, I had met Sondereguer right at the beginning of my fieldwork at the opening of the exhibition of pieces from Mirta's workshop. I then had the opportunity, over the course of six weeks, to observe a number of the classes Sondereguer and his assistants taught to graphic-and-textile design students in the architecture faculty of the University of Buenos Aires.

What makes Sondereguer's approach so different is the emphasis on practice (the practice of appropriation), with exercise-based executions of the appropriation of Pre-Columbian elements. He argues that there is a common aesthetic to all Amerindian cultures, and that they can be divided into simple stylistic categories (Sondereguer 1997). The primary ones are figurative (naturalist or abstract), abstract (figurative or geometric), and concrete, and the secondary or what he calls "co-participating expressive styles" are purist, baroque, expressionist, and super-realist (more on this below). Such categories are clearly disputable when applied to ancient American art, and even some of Sondereguers collaborators did not entirely agree with his approach. However, the considerable number of his published books, and his teaching of Pre-Columbian design in the architecture faculty of the University of Buenos Aires had the effect that he reaches a relatively large public, and allowed him to create a significant following for his project. In the following, I describe and analyze some of Professor Sondereguer's classes.

Tuesday, November 9, 1999

In the morning I meet Luis Massa, one of Prof. Sondereguer's assistants at *Barrancas de Belgrano* train station and we drive to the Architecture Faculty. When we arrive at the car park for lecturers, Luis says, "Here *we* have to pay," referring to the parking tickets, "although they don't pay me." He points to the large posters in the "politicized" entrance hall, specifically one of them, commemorating the *desaparecidos* (the "disappeared" during Argentina's military dictatorship, 1976–1983). On the second floor of the Architecture Faculty a large seminar room with view to the river and domestic airport "Jorge Newberry" is where the students of the degree programs in "Industrial Graphic Design" and "Textile Graphic Design" meet.

I have come to observe the course "Pre-Columbian Design." The chair, professor César Sondereguer is there, as well as an assistant, Luis Rosales, and two ladies—one, Viviana, is correcting students' work, the other helps Luis Massa. We first have a look at some of the works in the textile class, taught by Luis Massa. Here, the task is to develop from a Pre-Columbian form (which the

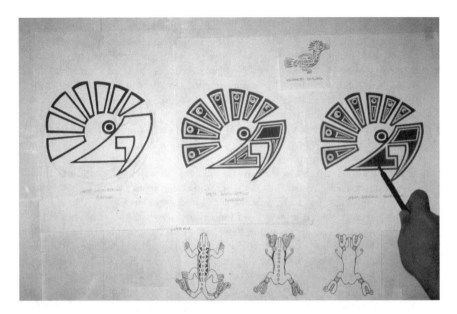

Figure 18 Stylistic variations and the correcting hand of the lecturer. Photo: Arnd Schneider.

students chose), a variation, which can be developed into a textile pattern. A further challenge consists in choosing colors whose contrasts maintain the plasticity, dimensionality and form of the original motif, or even of the black and white line variation. "Errors" consist in choosing the "wrong" colors and compositions, that is those which make disappear, or unrecognizably alter the original dimensions of the motif. Thus, where in the original line drawing, a jaguar, a bird, or a head are clearly schematized and distinguished, with "wrong" color choices and combinations, an indistinct, nonfigurative, and undesired pattern of lines might evolve [figure 18].

In graphic design, I observe the lecturer correcting student projects which have to be finalized for next week. The challenge here was to develop several variations on one motif by changing its style, according to the classifications in Sondereguer's books. For example, transforming motifs from "purist" and "abstract" styles into "figurative" and "baroque" styles.

That these categories are western is a problem, I think, and something I had mentioned before to Sondereguer. But he starts from an idealist base of metaphysics, and what he conceives as the norms of European art history which he then applies to all the art of the Americas.

The corrections regard specially the difficulties students have, not so much with style, but with perspective, and reduction, since with a few lines Pre-Columbian peoples were often able to schematize a particular object, or animal. One student has problems drawing the teeth of a large feline correctly (inside-out, instead of outside-in). Having asked teachers and students for permission, I take photographs.

I then speak to a few students about their experience. They are all in the third year of their degree (that is effectively in their fourth after a one-year

foundation course), and will graduate next year. They say, it is very difficult to find work now, but maybe there will be some opportunities in advertising, graphic design, and textile design. Some of them have worked part-time as designers, whereas others obviously worked just in odd-jobs for the money. The students find Sondereguer's book very didactic, and easy to handle. They enjoy the course, but are rather vague when I ask them whether they want to specialize in Pre-Columbian art.

I ask myself whether their subject is something appropriated, or something they consider of their own culture? Probably, the former.

Next time I am around, it is the deadline for students to hand in their works. The students have to show their works and write a short justification of their chosen approach. The assessment takes a long time from 10.00–12.30. I take photographs and afterwards I interview two groups of students.

In the interview the students said that whilst they had liberty to choose the motifs, they still had to apply Sondereguer's stylistic scheme. Also, since his textbooks were in black and white, they had freedom with the choice of colours which they were encouraged to research from other sources. One student of textile design explained to me, "You have to realise that colours change in contact with other colours. Red with turquoise, because they are complementary, will be in a continuous fight. But red with yellow or orange, they will be closer to each other on the colour scale. . . . We also try to maintain the original colour scale of the culture we study (and from which we take)."

On the other hand, students appreciated the stylistic preconceptions as useful didactic tools, because they came without previous knowledge of Pre-Columbian cultures. Yet they were aware that the stylistic categories are "theirs" (i.e. from Sondereguer's publications), and not of the original artists. As one student put it, "surely, they did not think about everything we study today. They recognised [stylistic] differences, but they did not put [our] names to it."

The classes provided interesting insight into how Pre-Columbian cultures are *practically* appropriated into the realm of contemporary art and design. After one class, Sondereguer told me that he is very upset as they want to obstruct his course higher up in the University hierarchy. The university authorities even stipulated that this should be a course without exams (which is exactly what he did, he just introduced non-graded assessments). He is not a full professor, but has associate status and now wanted to win a competition (*concurso*), but apparently he had many enemies. In his rage he said, "The anthropologists hate me and the archaeologists hate me, and both don't know anything about art." On this occasion, Luis Massa gave us a lift to the *Museo de Bellas Artes*, where Sondereguer wanted to buy a catalogue of the exhibition on the Zapotecs which I had visited the week before,[11] but it was already sold old. Sondereguer told me with delight how well his own books sell. He first thought they would not sell, but they sell so well that he even had to recede from his plea to the publisher to lower the price. Sondereguer is doing well on royalties (but badly on his university salary, for untenured university professors it can be as little as $120 per month). We took the bus to *San Telmo*, the neighborhood where we both live, and he talked the whole way, insisting how misunderstood he is in his own country, and that especially anthropologists and archaeologists do not like what he writes about art, but he was hoping for some recognition from abroad.

Graphic Design and the Design of New Identities

One concern of graphic designers who appropriate indigenous motifs is the faithful appreciation of the original. We have already mentioned Fiadone (2001) earlier in this chapter, making the point that visual interpretations and representations by archaeologists are often insufficient. This more technical preoccupation, however, is part of a larger discourse on identity, that is to say an Argentine identity based on indigenous aesthetics. The intellectual ancestors of this project are, foremost, Ricardo Rojas (whom we have referred to in chapter one) and a number of other Argentine writers, archaeologists, and architects.[12]

Identity is also the concern of Irene Albuerne, draughtswoman, illustrator, and designer and Vilma Diaz y Zárate, whom I interviewed on their book *Diseños Indígenas Argentinos* (Albuerne/Diaz y Zárate 1999) from which I took inspiration for the decorative motif when making the vessel in Mirta Marziali's pottery workshop. Their preoccupation with indigenous cultures is intertwined with Argentina's political history. After the interview, I asked them about the *el proceso*, the recent military dictatorship (1976–1983). During this period, Irene did not go into exile but lived a self-imposed censorship, designing only European and "neutral" tapestries, as the military discriminated against everything indigenous. In our conversation, she said she did not know what was going on, or people she asked denied having knowledge of human rights abuses. Vilma was more critical. Once she saw a Ford Falcon (infamous for raids by secret military personnel), and how people came out and shot a young man on the street. She went to the United States in 1977 to study anthropology.

Both women think now is a new time for identity formation in Argentina, expressed by a renewed interest in indigenous art, music, and the reappropriation and resignification of images, which apparently is also taking place in Rock music. They see this as diametrically opposed to the imposed nationalism during the *el proceso* period, and had no sympathy for the euphoria for the Soccer World Cup 1978, and the Malvinas War 1982, when the military government instigated national fervor. In our conversation they also mentioned badges launched in a publicity campaign by the military government and bearing the inscription *"los argentinos somos derechos y humanos"* ("We Argentines are righteous and human," a pun on *derechos humanos*, human rights). Not long ago, Irene saw one in a shop, already yellowed by long exposure to light.

On the occasion of our interview, Irene sported a long dress with indigenous patterns, possibly inspired by the Aguada culture (though I did not see the "signature"–she usually put the name of the culture on her designs). She definitely perceived a growing interest in indigenous themes, especially amongst younger people; her nieces appreciated her dresses and wore some of them, and likewise the elder daughter of Vilma. In the past, the girls might have said about clothes inspired by indigenous cultures, "Oh, Mummy, what horrible things you are wearing," or something of the sort.

This renewed interest, obviously, is also tied to global developments and the current fashion in ethnic arts world-wide, as is demonstrated by the many Buenos Aires boutiques selling international fashion and, for instance, in 1999/2000 included "ethnic" oriental caps, then fashionable throughout the Western world.

The "Escuela Taller Municipal de Artes y Artesanías Folclóricas de Morón"

As a final example of the creative processes involved in the appropriation of indigenous cultures, I discuss the work of the *Escuela Taller Municipal de Artes y Artesanías Folclóricas de Morón* (in the following *Escuela Taller*).

Luis Massa, one of the lecturers in Pre-Columbian textile designs on Sondereguer's course, suggested to me to get in touch with Bernardo and Nora di Vruno, brother and sister respectively, who in 1984 had founded the *Escuela Taller*. The school is a unique project in Argentina to offer Pre-Columbian, and to a lesser extent contemporary indigenous and folkloric, craft techniques to adult and mature students. During the course of my fieldwork, the school's sessions were run on Monday and Thursday evenings from 6 to 9 pm.

The state primary school "Hipólito Yrigoyen"[13] provided rooms and storage facilities for this evening school. It is situated in Haedo, a neighborhood of the municipality of Morón in Greater Buenos Aires. Teaching is divided between the music courses, headed by Bernardo di Vruno, and the crafts and textile classes, primarily of different weaving and knitting techniques, using a variety of looms, headed by Elsa Manjarín. Nora di Vruno, who also teaches music, is the overall coordinator of the evening school.

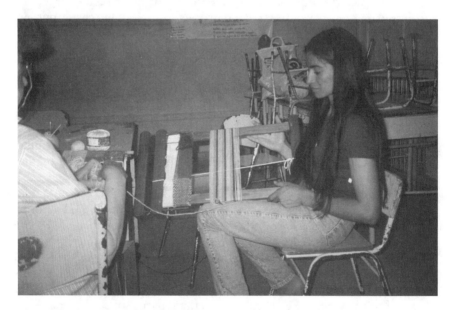

Figure 19 A student working at the Creole loom. Photo: Arnd Schneider.

Courses were run in the following principal subjects. In the textile section, these included gauze, macramé, *ñanduty*,[14] lace, tapestry, woven fabrics, archaeological textiles, plaited fabrics, knitting, Creole loom (see figure 19).

The music division offered the following subjects: *quena* (indigenous flute, Quechua term), *pincullo* (a type of *quena*), *charango* (small, five-stringed guitar), guitar, *sicu* band (pan flute band),[15] folkloric percussion, and musical literacy.

Practical subjects in both divisions were complemented by theoretical classes in the history of Pre-Columbian art.

The Students

The students, in their great majority women, were mostly Argentines of European descent. A number of them came from the neighborhood of Haedo, some of them from other towns in Greater Buenos Aires, for example, Hurlingham, and the rest from the capital district. The age distribution ranged from early twenties to people in their sixties.

The teachers were intrigued by my interest in the subject and yet a bit surprised that I wanted to observe the classes and take photographs. However, they freely admitted me into their classes. I explained that I was doing research on Pre-Columbian and contemporary indigenous cultures and how and why these were adopted by "white" Argentines. With people's consent I took photographs and this also provided an opportunity to engage in conversations with them. I noticed a certain hierarchy among teachers. For instance, one of them, Haydée, was quite reluctant to give me an interview, because she felt I should first talk to Elsa Manjarín, the head of the section of textiles and crafts, who also worked at the La Plata Museum of Natural History. Although very well trained, Haydée felt she could not contribute anything authoritative on the subject.

The students were keen to know what I would do with the photographs and I explained that I would use them in a book and in lectures. I also promised that I would give a talk at the school on my research and show them the slides I had taken, which eventually I did at the end of my fieldwork.

As mentioned, the majority of students—as most Argentines—were of European descent. However, there was Rosalía, a *Colla* (or *Kolla*)[16] woman from the northwestern province of Salta who was particularly interested that the results of my research would be made available to them, and was also very pleased when I finally gave the talk. She wanted to see the slides (but not necessarily have prints) I had taken of her at the loom and my description of it, so that she could correct me, and thus was able to ensure that I had the right version of the weaving techniques and meaning of patterns (figure 20).

The teachers and students were very welcoming to me, interested in my research, and also in my opinion about Argentine and world affairs. They were clearly aware that they represented a minority in Argentine culture, as people are usually rather indifferent to indigenous or folkloric cultures, and were intrigued by the fact that a foreigner should be interested in them.

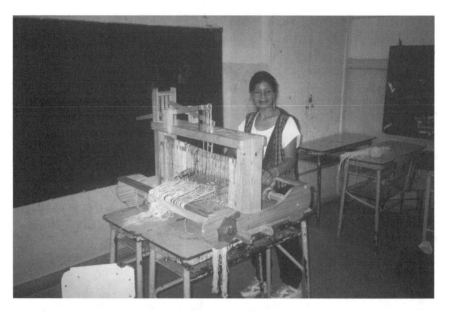

Figure 20 Rosalía at her loom. Photo: Arnd Schneider.

I was invited to a number of public events of the school, including the end-of-year party and a fashion show, and I accompanied the music students to an evening concert they gave in another school in Haedo. Based on my diary entries, I describe the events below.

November 25, 1999

Tonight the *Escuela Taller*'s music group has been invited to play a concert in a nearby school. The school's hall is full, it is a graduation ceremony, and I take some photos. The band is dressed in white shirts and *chalecos* (waist coats). They perform a variety of Andean folklore pieces, both from Argentina and elsewhere. The Argentine flag, and that of the indigenous people are swung during the performance. The indigenous flag showed a pattern of colored squares, representing the Inca empire *Twantinsuyu* (with its four provinces, *Chinchasuyu, Kuntisuyu, Antisuyu* and *Kullasuya*—the last including present-day NW Argentina) [figure 21].

Bernardo's sister announces the show and says that one should appreciate this music as something "*lo nuestro, Argentino*," not something exotic (belonging, for example, to Peru or Bolivia).

On the way out Bernardo shouts jokingly "*indios*" at some of his companions who pack up their instruments.

Bernardo's branding of his musicians as "*indios*" amounts to an explicit acknowledgement of the process of appropriation: through their practices, these mostly European descended Argentines become urban "Indians," aspiring to emulate and recreate the arts and music of indigenous people from Argentina

Figure 21 Waving the indigenous flag. Photo: Arnd Schneider.

and other Latin American countries, and searching for a new Latin American identity.

December 4, 2000

In the evening, I go via train to the fiesta of the *Escuela Taller*. A thunderstorm is about to start, I arrive just in time to hear the first piece of young people playing traditional instruments. Lot's of people have come, and the hall is full. In the entrance hall an exhibition of traditional crafts is displayed. The textile teachers are all dressed up and are expecting their students' "cat-walk."

I take many photographs. People ask me again and again whether I would sell them. This expectation is raised by other professional photographers and video makers who interview me and, after the event sell the video for $20. After that there is the cat-walk, more music by the band and great finale, with flag waving, including the indigenous flag waved by Rosalia from Salta. In the entrance hall there is also a stall for a support project for the *Wichí*, indigenous people from the lowlands of Salta Province. The show closes at about 12.30 am.

Monday, December 13, 1999

This time, Nora di Vruno gives me a lift. During the journey, she tells me of the moving experience her father had when he traveled to Enna, Sicily, to visit the village of his forefathers. He found the house and also the birth records in the parish archive and could confirm the name, Di Vruno, not Di Bruno (as I and many people first assume). Nora seems to be more moved by her Sicilian ancestry than Bernardo, and is amused to hear that I told a friend in Palermo,

Sicily, that Buenos Aires has a neighborhood called "Palermo." I hadn't realized that this is the farewell Christmas celebration at the school, and once I arrive the lady whose class I attended first gives me, as to all the other students, a copy of Alfonsina Storni's poem on Buenos Aires (*A Buenos Aires*), and her own thoughts, on how the mixed identity of the *porteños* should also value the interior of the country and indigenous cultures. In another class they have made a wonderful tapestry, inspired by the Paracas culture. Later it is exhibited in the main hall.

April 27, 2000

When I meet Norma and Bernardo again we welcome each other warmly, and I tell them of my travels to Patagonia with Javier Olivera (the director of *El Camino*, cf. chapter six). When I mention Rubén Patagonia (an indigenous musician and actor—a protagonist in the film *El Camino*), they are rather sceptical, especially Bernardo. "I know all the *talleres* (workshops) of the folklore movement from the 70s," and there are some white people who really assume this cultural form, they have almost become "Indians," such as one *rubio* (blonde guy) playing music, and then there are some others (like Ruben Patagonia, but he doesn't say so) who are Indians, but really stage this too boldly. Norma agrees, and she has seen Rubén in the folk festival in Cosquin, where he was shouting "*Mari Mari*."[17] "I know the meaning of these words, but he is using them too boldly, and maybe the audience is not prepared to believe him," she says.

Arriving at the school, people recognize me and greet me warmly, an indication they remember me and have accepted my presence. "Are you back?" "Are you doing a course here now?" they ask me. I am joining the class of Haydée. I assist there for quite a while. There is one "new" guy—really a third year student, who picked up weaving very quickly and talented last year. All the others are women, as is the majority at the school.

Then Rosalia (the *Colla* woman from Salta) appears, and asks me quite bluntly, "What happened to the photographs you had taken earlier?" "We have to see what he has taken from us," she continues. Hers, is of course, a very legitimate request, expressing similar concerns as the people I had been photographing in North West Argentina as part of Teresa Pereda's expedition (see chapter seven). I explain that I am not printing photographs but make slides, but that we can arrange for a slide showing, since they have the projectors and Rosalia is happy with that. She has brought about five varieties of corn, as well as nuts from Salta, and explains their different uses and how to prepare them. Especially, Haydée is stunned by the way *mote* (peeled, cooked corn) is prepared: the seeds are boiled with lime or ash. She had tried vain to soak them (like beans) for hours and boiled them, but the peel would not go off.

I show the little woven tapestry which I bought from Leleia Aigo, the old *lonko's* (chief's) daughter in Ruka Choroi, the Mapuche reservation in Patagonia I have been visiting with the film crew of *El Camino* (see chapter six). At the *Escuela Taller* they all like it. However, I have to explain that it is not "traditional"; the *Pehuén*,[18] other symbols, and the specific choice of colors were not used by the Mapuche in the past. They much admire the quality of the wool, which is "original" (*de ellos*, literally, "theirs").

Nevertheless, Haydée and Elsa Manjarín (who joins later), disqualify the cloth as a "recreation" for tourists, with its yellow pattern on red ground

not following in color and even technique the old black and white Mapuche style.

The immediate classification of the Mapuche cloth as not traditional also shows the power of white society, through specialists and their institutions, to authenticate indigenous cultures. It is somehow as if the whites judge what is truly indigenous, and what is not, measuring it against the standards of "traditional" indigenous cultures kept, again by whites, in museums. In this view there is little space for modern recreations, or new creations not based on "traditional" motifs.

Then I join Elsa Manjarín's class, where she has Rosalia explain again, and in much detail, the different uses of the several varieties of corn. Rosalia also tells us that corn flour is used in a little pot, to find out whether it will be raining or not (according whether it sticks to the pot or not). We then look at the masks of the North-West Coast Indians: Tlingit, Kwakiutl and so forth. Manjarín explains well the *potlatch*, but is very severe and almost piqued, when I make reference to the Boas collections in New York and Lévi-Strauss's book "Way of the Masks." Maybe she found her authority challenged by an outsider, a "European," who has access to better information, libraries, films and so forth.

September 18, 2000

Nora soon arrives and we set off for the school. The students are curious about my research and Nora explains the program to me: there will be classes till 7.30 and then I'm supposed to show the slides. I tell Bernardo that I know Maki, the Peruvian who offers classes in Quechua philosophy in downtown Buenos Aires at the Tinkunaku centre, and he asks me what I think of him. I reply that I find he is a serious person, but cannot comment on his musical knowledge and *quena* playing [figure 22].

At the school people recognize me: "You are here again?," "Where were you?-," they ask. Then I visit various classes and they are very proud to point out to me the waist looms which I hadn't yet seen, as well as other new creations. Graciela Suárez, Elsa Manjarín and Haydée Zebrak, as well as another teacher of Czech descent are there. Then everybody assembles in the main hall, Nora has positioned a slide projector there, everybody is expectant and I give my talk. Of course, the work from the school and the festivities is known, but I am able to identify some pieces.

The real discussion begins when I show the pictures from Gaby Herbstein— the Buenos Aires fashion photographer who had made a calendar having her models pose as indigenous women (see chapter five). Elsa Manjarín and Graciela Suárez find this quite controversial, arguing that these are not true representations, but some people from the audience say that they express artistic creativity, and that we are now living in an age of globalization. They mostly disagree with Herbstein's choice of nonindigenous models.

Then we have a discussion of globalization, of which everybody seems to be afraid of. But in the end, they seem to agree with me that globalization does not mean, despite economic differences, the total erasure of local cultures and differences, and that there is a great potential for resistance—something under-scored by a young guy, wearing his hair in dreadlocks, and his girlfriend who sit next to me.

Afterwards, several people ask for my card and address in Europe, some want to leave and then contact me, once they are in Italy or Spain.

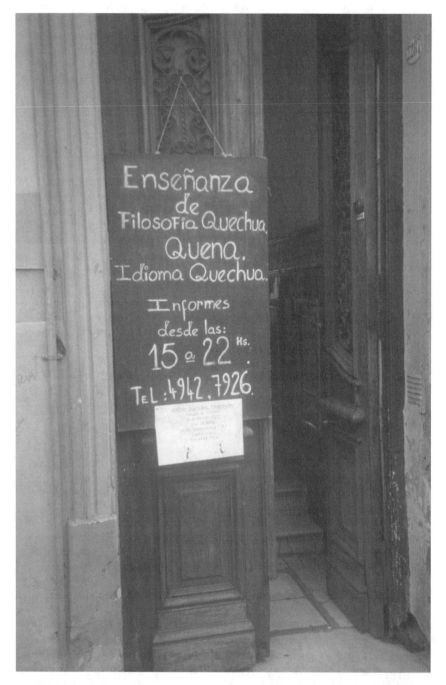

Figure 22 An advertisement for classes in Quechua philosophy and language, and *quena* flute. Independencia neighborhood, Buenos Aires. Photo: Arnd Schneider.

Conclusions: Appropriating Agents and
Technologies of Appropriation

This chapter has shown the practical processes of appropriating indigenous cultures in the urban context of Buenos Aires, both through strategies and material techniques—what I have called technologies of appropriation. I have also argued in favor of the participation of the anthropologist in artistic working practices, in order to gain deeper understanding of cultural processes and the material workings of appropriation.

We have seen that in Mirta Marziali's workshop, ceramic activity serves as a route for new identity constructions. At the same time, ceramic activity does not exist isolated from other realms of social life. Rather creative processes are woven into the social fabric of everyday life, as shown by the numerous examples of conversations around topics from politics and economics, gender and the family.

We have also observed in the analysis of practices and discourses in the workshop, how, in a very practical way, recreations or "copies" are in fact second originals, in the sense of newly created originals, even if they make reference to a previous form by their creators. This works both at the process of perception, or apperception, of the incomplete form "at source" (i.e., books, photographs), which is often insufficiently documented in archaeology sources, and at the level of the practical execution of works in which new elements, deviating from the "original," are introduced. This, in fact, poignantly demonstrates our point made in chapter two that there are no "originals" after all, just variations and interpretations on a previously documented source.

In the case of the classes in indigenous design offered by Professor Sondereguer and his staff at the architecture faculty of Buenos Aires University, we find a more schematic approach to appropriation, which starts from rather rigid Western stylistic categories which are then applied to Pre-Columbian cultures. Creativity here appears much more directed and channeled through preconceived stylistic categories than in the ceramics workshop. Students only had the initial choice of a motif (which then had to be varied according to the stylistic categories), and with respect to color in the textile design class. Although further research would need to be carried out on this, it is fair to surmise that copying of representative examples from the canon of Western painting, from the Renaissance to early modernist art (e.g., Cubism), in Western art schools in Argentina (and elsewhere) that follow a classic art academy approach is not fundamentally different from Sondereguer's method in regard to Pre-Columbian cultures: after all he is using Western stylistic categories in the first place.

In the adult evening school classes of the *Escuela Taller* the primary objective is the teaching of indigenous crafts, and to impart knowledge on indigenous arts and crafts. Consequently, for the students the main motivation is to learn the techniques pertinent to various crafts, and to achieve mastery and completion in executing them. As in the ceramics workshop, the strategies of appropriation, and the creativity they entail, range from direct copying to

mixing symbols of different origin in one piece, to developing new forms based on the inspiration of indigenous forms. An important aspect of the school, less prominent in the other two examples, is the performative and public character of the works. There are frequent gatherings and public events not only in the school, but also in other venues, in which the staff and students show their work. Music being an important part of the curriculum helps of course this performative side of the work (which would merit a separate assessment beyond the scope of this book), as it does to a certain degree the work with textiles, which can be shown publicly in similar ways to a fashion show.

Strategies coupled with the physical techniques of appropriation together constitute the technologies of appropriation, such as copy, travel, physical acquisition of objects (in collections), and performance, and are all used to create new meanings and contexts for the "original" objects, which can only be understood jointly with their new material interpretations.[19] Implicit in the technologies of appropriation is also their hermeneutic potential, that is, the learning process underlying the artistic practices when dealing with indigenous cultures—in fact, a "knowledge in doing" as Minar/Crown (2001: 375) termed it. At the same time, appropriation is rarely rationalized as a problematic procedure by the appropriating agents (i.e., the artists), as entailing ethical dilemmas and differences in power between those who appropriate and those who are appropriated, whether of past or present cultures.

In all three cases, ceramics workshop, design class, and evening school, appropriation is linked to the construction of identity. The creative processes we have analyzed imply the search of a new Latin American identity, verbalized as *lo nuestro* ("ours"), that is not based on biological descent, but on new cultural capital, obtained in different areas of practical and theoretical skills acquisition. Although this will require more research, appropriation from indigenous sources, through a process of copying informed by a canon of stylistic categories, is not substantially different from the travels by Argentine artists to museums and galleries, and the copying of and "appropriating" works of the Western tradition. Arguably, these artists see the Western tradition as much a part of their heritage as the indigenizing artists wish to construct a new tradition from the Amerindian cultures. However, it would be too simple to speak just of a parallel process of appropriation, with indigenizing artists here (a minority), and Western inspired artists there (the majority), in the contemporary Argentine art world. Whilst such a distinction can initially prove useful, sometimes more than one discourse collapses in the work of one person, or the biography of an artist is characterized by both approaches during various career stages.

There remain, in any case, the ethical implications of appropriation in the construction of new Latin American identities when they are based on stereotypes of the indigenous, and these occupy us further in the following chapter.

Chapter Five

Fashionable Savages: Photographic Representations of the Indigenous

Introduction

In this chapter I am going to explore the complex ways in which indigenous people are visually represented in contemporary Argentina. I intend to demonstrate how these representations use certain stereotypes, which reflect more generally ideas about gender and the nation-state. Encounters between Europeans and their descendants and indigenous people in Argentina, in colonial and postcolonial times (before and after 1812), are the result of a historical process, which I outline briefly in the first section of the chapter.

I then suggest how these encounters—which entailed visual representations—were framed within ideas about gender and the nation-state. In the main section of the chapter I analyze the calendar *Huellas* ("Traces") produced for the year 2000 by the Argentine fashion photographer Gaby Herbstein.

However, at the same time as stereotypes of indigenous people are constructed within Argentine society, they are never fixed, but in flux and negotiated by different actors. Thus, in our example, indigenous people themselves (as political activists, consultants to the project, and artisans), the photographer and her production crew, as well as other commentators, and consultants (for instance, anthropologists and nongovernmental organizations) were all involved in the production of the calendar and, when interviewed, gave different interpretations to the process.

Hence the aim of this chapter is to show that there are no simple ways of understanding representations of indigenous people in contemporary Argentina, for example, by opposing indigenous versus nonindigenous representations. Rather, the important issues have to do with the political and gender perspectives of the participants, and how they conceive of the nation.

A first-hand look at the calendar probably would classify its images as sexist and idealized (in fact, as fabricated images of Indians), and that is exactly what some commentators did when I showed them the calendar. But such a critique would be stopping short of understanding why these images

have been produced and set up in particular way, and what their meaning is in contemporary Argentine society.

Extinction and Excotism: Representing
Indigenous People in Argentina

A comprehensive history of the visual representation of indigenous people in Argentina remains yet to be written, and would have to encompass both religious and secular art, as well photography since the second part of the nineteenth century.[1] Visual representations accompanied the growing marginalization of indigenous people on the territory that is now Argentina. Starting in the sixteenth century, the Spanish colonization subjugated indigenous populations of the Inca empire in the North West, and displaced many of them (for example, the Quilmes Indians of Tucumán).[2] Yet, overall, the Spaniards were not numerous and militarily strong enough to extinguish the mainly nomadic, hunter-gatherer aboriginal populations in the South and the North East. From 1610, in Paraguay and Brazil, and the north-eastern part of Argentina (today's province of Misiones) Jesuit missionaries were setting up *reducciones*, settling Guaraní Indians, converting them to Christianity, and teaching them arts and sciences (these utopian projects came to an end with the expulsion of the Jesuits from Spain and Portugal in 1767/1768).

In the Province of Buenos Aires, Indian experienced raids into their territory (both for military and economic reasons—the south of the Province of Buenos Aires harbors important salt deposits), and responded with incursions into settled areas (so-called *malones*). After contact, Indians had adopted the horse from the Spaniards and large amounts of cattle. Thus, in some ways similar to what happened on the North American prairies, in the pampas the livelihood and mode of subsistence changed. Hunter-gatherers and horticulturalists turned into cattle nomads. Raids on Spanish farmsteads and frontier posts provided not only highly praised cattle and horses (which after first Spanish settlements had also multiplied in the wild), but occasionally also women.[3] In fact, the proverbial female captive (*la cautiva*) became an established motif in the literature and painting about this period.[4] As Laura Malosetti Costa has shown, the white defenseless woman "raped" by a dark and ferocious Indian on a horse symbolized the fight of "civilization" against "barbarism," promoted in letters and politics by D.F. Sarmiento, and in the arts by painters such as Enrique Carlos Pellegrini and Johan Moritz Rugendas.[5] As Malosetti Costa rightly points out, the motif of *la cautiva* inverts the factual relations of power and politics in the Pampas: it is not the white man who takes the Indian's land, but the Indian who takes the white man's most precious possession, that is, his woman. Therefore, the white colonists are justified to wage war against the Indians.[6] The topos is, of course, much older and dates back to the seventeenth century and the chronicle *La Argentina Manuscrita* by Ruy Díaz de Guzmán, and to the figure of Lucía Miranda, wife of the Capitán Sebastián Hurtado at the fortress of

Sancti Spiritu, who was kidnapped ("raped" in the now obsolete sense of rapine or seizure) by the Timbú cacique Mangoré. Indians (not the whites) are portrayed as the real usurpers and in turn, retribution and the conquest itself are justified.[7] As Malosetti Costa highlights, the image of *la cautiva* was an erotic one. Two configurations dominate paintings and literature: the "captured" woman, and the woman as prisoner, hostage to the desires of her new indigenous master. The question of "race" of the indigenous other is linked to the stereotype of gender: a woman is only valued when she is white (and Indians and whites are contrasted strongly in the paintings of the period).[8]

This pattern of part-friendly, part-hostile coexistence, marked both by treaties and commercial relations, as well as sporadic military engagement would continue even after Argentina's independence in 1812. Calfucurá, a powerful chief of the Mapuche Indians who had crossed into the pampas since the eighteenth century,[9] was recognized as the real counterpart to established power in Buenos Aires, and was as such also represented in painting, for instance, when negotiating with the authorities.[10] The turning point came in the 1870s when the Argentine state, instigated by economic interests (read: greed for agricultural land on the fertile pampas), decided to extend its internal frontier forward. The Campaign of the Desert (*Campaña del Desierto*) pushed the Mapuche Indians (who since the eighteenth century had crossed from Chile into Argentina) southwards onto marginal lands in Patagonia. Many were killed, others had to flee across the Andes to Chile, others again survived precariously on Patagonian reservations, or in captivity and small settlements in the province of Buenos Aires. Though Argentine elites had disputed the status of Indians before the desert campaign, after its conclusion it was clear that indigenous people would only occupy marginal positions in society.[11]

The Campaign of the Desert was documented by the photographer Pozzo who accompanied the troops. Lithographs provided the conceptual basis for the composition of portrait photographs of Indians, pretending a kind of authenticity when photographed in groups, families or, more rarely as individuals.[12] The majority were group or family portraits, with generic titles such as "Pampa Indians" or "Toba Family" (figure 23). There are only few examples where individuals have been identified[13]—corresponding to the Eurocentric stereotype of simple, socially undifferentiated tribal societies.

The Italian photographer Benito Panunzi, on the other hand, took photographs of Indians who were visiting Buenos Aires between 1862 and 1864, that is, before the Campaign of the Desert. Among his works we find individual portraits, for example, of Casimiro Biguá and his son, yet these were carefully arranged studio photographs. After the desert campaign it was Pozzo who photographed the defeated cacique Pincén as a wild "tiger of the pampas." More than a century later, coincidentally, a descendant, Luis Pincén, will be involved in the calendar project *Huellas*—the subject of this chapter. To achieve this image of the Indian as "wild beast," Pozzo asked Pincén to dress in the studio as he imagined he would have done with his fellow Indians on

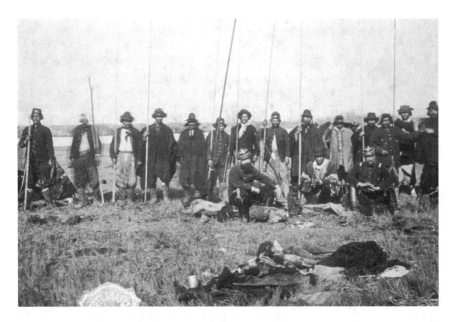

Figure 23 Antonio Pozzo. *Linares y sus hombres* (Linares and his men). 1879. Museo Mitre, Buenos Aires. Shown as part of *No entregar Carhue al Huinca*, RES, 2000. Courtesy of the artist.

the pampas, that is, with spear and *boleadoras* (the lassos with stone balls, later also adopted by the gauchos). As Marta Penhos points out, these paraphernalia were "artificial and verisimilar" objects at the same time.[14] It seems that two types of photographs prevailed: the ones that portrayed Indians out of context, and others which tried to artificially recreate or reenact the supposed "natural" surroundings.

As described further on, Gaby Herbstein's calendar stands in the tradition of the latter model of nineteenth-century photography (see also Edwards 1992, 2001).

There has been relatively little research on policies and attitudes toward indigenous people in twentieth-century Argentina.[15] As mentioned at the beginning of this book, genocidal campaigns against Indians continued into this century, and after the near extinction of Tierra del Fuego natives,[16] it was only in 1936 that the last resistance of Toba and Pilagá Indians was broken in the Chaco.[17] By 1930 Argentine society had also experienced its first military coup, and military governments (interrupted by short civilian intervals) would dominate Argentine politics till the early 1980s. The last military government (*el proceso*, 1976–1983) made between 20,000 and 30,000 of its citizens disappear and was also particularly repressive toward Indians, slum dwellers, and other marginal groups. During the current democratic period (Alfonsín, Menem, De la Rúa, Duhalde, Kirchner governments), Indian rights became more acknowledged (importantly, Law 23.303 was passed in 1989, which aims to regulate land rights and set up a National Institute of

Indigenous Affairs, INAI).[18] Since the 1980s there is also a resurgent cultural interest in indigenous cultures, their folklore, arts and crafts, coupled with more serious research in anthropology and archaeology (which were closed during the military dictatorship). It is estimated that presently there are about 300,000–500,000 indigenous people in Argentina.[19]

In contemporary Argentina, democracy coupled with pronounced economic decline provided the framework for a revived interest in Latin American cultures and native peoples, further enhanced by growing international contacts with other Latin American countries, and more generally characterized by a now globalized exchange of ideas and artefacts. This configuration provides the background to the case study I now discuss in more detail.

Contentious Images

I have chosen the example of Gaby Herbstein's calendar 2000 "Huellas," because on the one hand it demonstrates well the controversial issues surrounding the contemporary representation of indigenous cultures. On the other hand, and beyond its strictly Argentine context, it also points to old (and new) white fantasies of "playing" or staging Indians, ranging from white actors playing Indian characters in cinema, white novelists, such as the German Karl May, who never left Europe, writing countless novels with Indian heroes (with a fictional Apache called "Winnetou," represented in film by a French actor Pierre Brice), European and North American children playing hide-and-seek varieties of Cowboys and Indians (often inspired by TV serials such as "Bonanza" in the 1960s and its many successors), and even anarchist leftists in German and Italian cities of the mid-1970s calling themselves "urban Indians."

During my fieldwork in Buenos Aires in 1999/2000, I had the opportunity to see the exhibition "Huellas" accompanying the calendar in the shopping mall "Abasto" in the homonymous middle-class neighborhood, associated with classic tango bars.

I interviewed the producers and other people involved, as well as outside commentators. I first came across Herbstein's work through the Mapuche silversmith Silvia Rinque, whom I interviewed for my research on contemporary arts and indigenous cultures in Buenos Aires. Silvia Rinque was one of the indigenous consultants to Herbstein's project, and provided silver jewelery for the model who was to represent the Mapuche woman in the calendar. I shall return to her opinion about the project later.

The socioeconomic context of Herbstein's work, which is situated in the commercial fashion and advertising world, makes it different to that of mainly noncommercial artistic photographers (though they might double occasionally in commercial projects, too). Each year the Herbstein studio produces a calendar with "its" models, around a particular theme (for example, in 1999 the zodiac was chosen), which then is distributed free to a specific and exclusive clientele. Thus for the year 2000 calendar, the holders of Diners Card were selected.

The structure and lay-out of the calendar is straightforward: on large-format pages (48 × 64 cms, images 42 × 56 cms), one fashion model represents one indigenous group for each month. Starting with January, the indigenous groups are, Toba, Wichí, Chané, Guaraní, Techuelche, Mapuche, Yámana, Kolla, Diaguita, Huarpe, Abipón, and Selk'nam. Small captions give a brief summary of the cosmovision of the indigenous group. The front page depicts the same model used for the Toba, but in a different image. Photographs were shot with a professional stills camera, and models and paraphernalia were arranged in a studio set up. The second page features historical photographs and drawings of indigenous people.[20] In the centre of the page a text, entitled "Huellas," spells out the ideological program of the calendar:

TRACES ("HUELLAS")

At the gateway of the year 2000
The traces are the essence of a search.
Not of the past. Not of history but of ourselves.
Of a culture. Of many cultures.
Of the same [culture]. That of our ancestors.

Their traces remain.
Their way of thinking, of clothing themselves remains
To tell us how they were before the arrival of the *conquistadores*.
Their cloths are not a fig-leaf.
Nor a fruit of modesty,
But rather an aesthetic expression
Of the simple union with nature.
They noticed that the human body
Is little adorned
And took feathers from the birds,
From the trees fruits and flowers.

That's how they dressed, that's how they lived.
These are their traces.
We need to encounter them to encounter ourselves.
And begin again.

I return to this text later in the chapter. At the end of the calendar, four supplementary pages give information about the research and production of the calendar, credits for the collaborators, and the bibliography consulted. The first of these pages complements the display of archival photos at the beginning of the calendar, and shows small photographs documenting Gaby Herbstein and her crew's travel to various indigenous communities in Argentina, as well as backstage photos from the studio set. The central part of the page lists all the credits of this huge production (a video was also produced), as well as numerous sponsors for technical equipment, such as SONY, and the opening event of the exhibition of the photographs of the calendar in the shopping mall "Abasto," including multinationals Coca-Cola, Bacardi, Fernet-Branca, and Johnny Walker, and Argentine brewery Quilmes.[21]

A large "cast" of models, modeling agencies (those Gaby Herbstein works with usually), and support staff is mentioned, for the calendar, exhibition, and production of an accompanying video.

The indigenous consultants are thanked (with their tribal affiliations in brackets), as well as various anthropologists and NGOs that cooperated. The project also enlisted support of the United Nations, which allowed it to use its emblem during the "International Year of Peace" in 2000. Sergio Guzmán Castellano, the general coordinator of the Buenos Aires office of the United Nations explained the motivation for this move: "the beautiful images revalorize the splendour of these [indigenous] peoples who understood peace as an art to live in harmony with the wisdom of nature."[22]

The back page features a text, entitled *Presencias* ("Presences") by Carlos Martínez Sarasola, an Argentine anthropologist who was a consultant to the project, and is author of a standard work on Argentine Indians,[23] as well as director of an NGO *Fundación desde América*. The main message of the text is that despite ignorance, silence, and wilful obliteration by other Argentines (not least through repressions and genocidal military campaigns), about half a million indigenous people in over 600 communities continue to exist, and are "present" in Argentina. Maybe, this text rather than the mystical "Huellas" (belying the somewhat naïve approach of its authors) should have been placed at the beginning of the calendar.

Another NGO, *Fundación Arte y Esperanza* (linked to the Catholic Church), which works on nonprofit projects with indigenous artisans, is also credited. I interviewed both Martínez Sarasola, as well as Mercedes Homps of the *Fundación Arte y Esperanza*, who both said they had been initially supportive of the project but later found the idea of professional models rather than indigenous women being used disconcerting and inappropriate to the topic.

The lower part of that back-page shows a group photo of all the indigenous consultants on the project with their tribal affiliations. Amongst the indigenous consultants, I interviewed Luis Pincén (Tehuelche), Silvia Rinque (Mapuche), and Georgelina Duarte (Mbyá-Guaraní).

The next of the supplementary pages presents small, contact-size photos for the twelve indigenous groups featured in the calendar, and short summaries of their history and present situation. The photos are a mixture of close-ups, and others from the same models and sets used for the main section of calendar. At the bottom of the page an extensive bibliography on indigenous people is quoted.[24] The back to this page features once more publicity on Gaby Herbstein's photographic studio and the naked upper body of a model painted and dressed up as an indigenous woman.

Intentions and Reactions

I interviewed Gaby Herbstein and her art director Julieta Garavaglia (who also runs the new art gallery GARA; see chapter three) in the modern Herbstein photographic studios in Buenos Aires' upper-middle-class northern neighborhood Palermo Viejo in February 2000.

In our conversation they explained their approach:

Gaby Herbstein:

Julieta and I had been working together on the previous calendar, and we fancied work on origins. We spent almost a year in doing the research, because this hadn't been done before. . . . We were not taught at school about indigenous people . . . We searched a lot in books, consulting reports of the *conquistadores*, as well as libraries, ethnographic museums, and private collections. Imagine, me doing that as a granddaughter of an English "conqueror" who came here to build the railways.

Julieta Garavaglia:

Gaby is a fashion photographer—so it had to do with fashion, we were not going to photograph indigenous people. It's not documentary work. We also contacted indigenous people who told us about traditions transmitted by their grandparents. We contacted Silvia, on her silverwork. And we travelled. We went to a Wichí community in Salta for a week and looked how they lived and worked.

Also, most of the dresses and accessories were made by indigenous people. The idea was to show how they dressed before the arrival of the Spaniards. That was the purest form. Then everything changed, the colonists came who clothed them, because before that the Indians were almost naked.

Basically, we wanted to retrieve the origin of the Argentines.

Gaby Herbstein:

This is really part of our history. The other thing is we wanted to give back to the Indians what they never obtained, dignity. They were always the *cabecitas negras*,[25] the disdained people. Theirs was a culture which was disdained.

What has fashion to do with the indigenous people? If only the indigenous people were fashionable! Well, to some degree we achieved this. There was a lot of press coverage, the people were interested in seeing the models. You know, beauty is something very important here in Argentina. So to show to the young people, attract their attention through the models so that they become interested in our culture is a way of entry, to get the topic across. The United Nations thought it was a good idea that through the calendar we could reach large numbers of young people, and that it was a good way to transmit our culture.

The people from the anthropology world were looking at us with suspicion: "What do you got do with it?," they asked us. For them, the world of advertising and fashion is frivolous and artificial. There was some resistance to our research, we had some trouble getting access to information.

The indigenous people asked us: Why not indigenous models?

First, we only had selected two ethnic groups, not all of the present ones. For example, the Abipones and Yámanas already disappeared (so we *had* to use models for them). Also, it wasn't our idea . . . [to document indigenous cultures], but to show the link between fashion and indigenous people and their culture. This means that fashion gives back to the indigenous people their dignity and shows their culture. The idea was to find among the models those which most resembled indigenous people.

It was an indirect way to get the attention of young people. If I have a photograph of a Mapuche woman, it's just another photograph. But a model *representing* a Mapuche is different.

However, Silvia Rinque was opposed to this and said, "I will find you a very beautiful Mapuche girl," yet when she saw our model she was very satisfied.

We invited the indigenous people on the set. They didn't understand much of the set design and the posture of the models but they helped us with telling us their myths. So every model we told a little bit of the story she was representing in the photo.

Gaby Herbstein and Julieta Garavaglia told me that their idea was to recreate the atmosphere of the turn-of-the-century photographs they found in the archives. That was the reason why they used sepia colors, and studio set-ups (for example, the jaguar). They also were inspired by the photographer of North American Indians Edward C. Curtis (who was famous for staged photography).[26]

Gaby Herbstein:

"We didn't shoot them as savages, but with the aesthetic of the era" and "We didn't invent it, it existed [adornments, animals, tattoos]. We wanted to represent and reconstruct."

However, even in our conversation, there was no hint at taking these historical photographs critically for what they were: representations of vanquished savages taken by the victors, often for "scientific" purposes, such as those of physical anthropology. Yet by adopting—even partly—the aesthetic of this era without any critical distance, one becomes complicit with its methods, unknowingly or not. For instance, no attempt was made to enter the different discourses about Indians that were made in the photographic oeuvres of Panunzi and Pozzo, as pointed out in the second section of the chapter. Not only was the aura of historical photographs just artificially recreated (in fact, uncritically copied), but also the wealth of possible postures and gestures for the historical period was not taken into account.

But what were indigenous people themselves thinking of the production of the calendar and the final result?

I first turn to the testimony of Luis Pincén (a descendant of the Indian cacique Pincén, of the Tehuelche-Mapuche). In our interview, Pincén described to me the history of his family: the persecution and refuge of the cacique Pincén,[27] his ancestor, and then his own background as a biology teacher in Argentine schools and member of the *Fundación desde America*. Within the politically heterogeneous movement of indigenous people in Argentina, Pincén occupies a moderate position. He thinks that promoting the indigenous cause can be achieved through cooperation with whites, and is against what he calls "reverse racism" (that is, the rejection of whites by Indians).

When we spoke about the calendar, Pincén was generally positive about it, as he saw this enterprise as a chance to promote the indigenous cause:

> Gaby Herbstein came to us (i.e. the *Fundación desde America*), investigating, searching for material, very respectfully. The idea was hers (and of her art director), and from the beginning I found it interesting to have a different viewpoint. We thought we had to co-operate and help. The idea was that the calendar would not be completely anthropological and would show some aesthetics, the glamour of indigenous women.
>
> For me it was very important to re-evaluate, and vindicate the beauty of the dark indigenous woman (*morocha*). [In Argentina and elsewhere] the stereotypes of beauty are very strong among women who are the most attached to fashion. We always criticize the fashion world as superficial . . . but for a work contrary to these stereotypes to speak about indigenous women, their dress, their beauty, to offer interesting elements which are never made public. So could this "fashion machine" not be used in our favour?

Luis Pincén admitted that there was some criticism:

> Some said it wasn't real, it did not truly represent our people—but nobody has the absolute truth.
>
> For example, the lizard on top of the head of the Toba was put there because it has to do with the cosmology of the Toba [figure 24]. What happens, is that 98% of Toba are actually converted to evangelical pentecostal churches—so what can these Toba say on their mythology, even if they live in their community? With the new religion they will negate their culture.

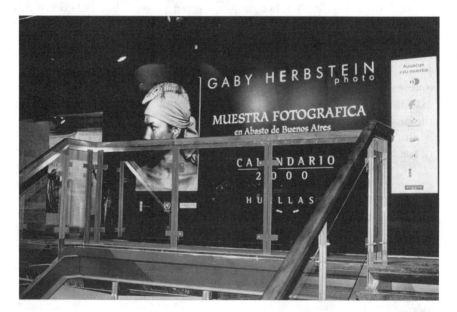

Figure 24 Exhibition of Gaby Herbstein's calendar *Huellas*, Abasto shopping mall, Buenos Aires, 2000. By permission of Gaby Herbstein Studio. Photo: Arnd Schneider.

I really would have liked the models to be indigenous girls, there are beautiful ones. However, when I observed the shooting from the "backstage" I had to realise, they had to use models.

Somebody professional had to do this, because to prepare the photos takes a lot of time. The girl representing the Diaguita stayed for six hours till they finished the make-up and then four our five hours to pose. Such a thing a professional has to do not a common woman. When the Colla woman posed, they prepared her for four hours, and then she spent another four hours on the photographic set in uncomfortable positions. Also, Herbstein assured us that she would chose models with "indigenous" features.

One wonders, however, why Luis Pincén emphasized the beauty and the glamour of indigenous women, and yet justified Herbstein's decision to use fashion models. Was this beauty something indigenous women could achieve on their own, or only through being represented by nonindigenous models, imbued with the aesthetic ideals of Western advertising? (figure 25).

Silvia Rinque, a Mapuche silversmith, who also cooperated with the production of the calendar, did not agree with Pincén's position and actually felt that he had betrayed the indigenous cause. Rinque made all the silver jewelery for the Mapuche "model," advised on the dress, and insisted on the way she would appear (the reader will recall that Herbstein and Garavaglia had to convince her of a white model being used). But she still had substantial reservations, especially about the other photographs which she found sexually too explicit (such as the Yámana model, holding a large fish on her shoulders). However, she was very happy—as she said, "at least 90%,"—with her work

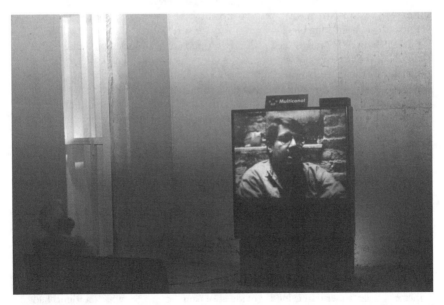

Figure 25 Luis Pincén interviewed in the video accompanying the exhibition. Photo: Arnd Schneider.

and the representation of the Mapuche woman ("I did not want that one sees the legs and the arms"), but strongly disagreed with the choice of professional models.

> "We asked for, in fact we demanded indigenous models, but she responded, 'So, for the Abipones (an extinct indigenous group) whom shall I select?' Well, she should have selected another indigenous group. But these are all professional, very fashionable models (*sumamente fashion*)."

Another significant point Silvia Rinque was making had to do with the issues of indigenous rights and the appropriation indigenous crafts and artefacts (and by extension, symbols, myths, and traditions). Whilst she was paid for her work and could adorn the model representing the "Mapuche" woman with her silver jewelery (which, however, she just lent to Gaby Herbstein), she was not credited as "Silvia Rinque, Mapuche silversmith and jewelerer," but just as "Silvia Rinque, Mapuche." As she emphasized, crediting her profession would have helped her get more commissions and enhance the diffusion of her work. Her resigned summary comment was, "The calendar went only half way of what we indigenous people wanted."

Finally, I also met Jorgelina Duarte of the Mbyá-Guaraní. My diary entry for that meeting gives an idea of the mixed attitude of Jorgelina toward the calendar.

Friday, January 28, 2000

In the morning I meet Jorgelina Duarte, Silvia Rinque's Guaraní friend and collaborator on the "Huellas" catalogue by Gaby Herbstein. She lives in Entre Rios Street and I have to travel two stops by the metro and then walk down Entre Rios about four blocks. I am not quite sure which neighborhood this is but it gets very "popular" and quite ugly, opposite her block I see large buildings, *Obras Sanitarias de la Nación* (the state waterworks), and Colegio Carlos Pellegrini (the once famous high school—now it looks more like an evening school). I arrive at the building and have to take the elevator, and then end of a dark and dirty corridor. I find the apartment. Very small, it is laid out across two levels. Jorgelina welcomes me, her sister visiting with her brother from Misiones Province, and her young boy, are also there. We talk about the calendar. She says it was controversial, since the indigenous people didn't have full say, and the photographer (Gaby Herbstein) did not chose indigenous models.

At the same time, Jorgelina is somehow proud of the calendar and has hung it up on the wall of her flat. She likes the Mapuche, Guaraní (figure 26), Colla pictures, but disagrees with the juicier, exotic, erotic images of Toba, Wichí (figure 27) ("This is a woman like an animal, they would not have dressed like this for hunting and gathering!" she says), Yámana, Apibón (figure 28). "This is against the sense of decency of indigenous women," she comments). She likes the Guaraní picture, but says that the facial painting is Guaraní-Tupí (i.e., of the Brazilian group), not of the Argentine Mbyá-Guaraní. In contrast, she shows me pictures from a German calendar made about ten years ago, which a friend had copied for her and which she shows in school projects. The calendar depicts members of the Guaraní community, their houses, and some activity, a mixture of ethnographic documentation and "happy," smiling indigenous people.

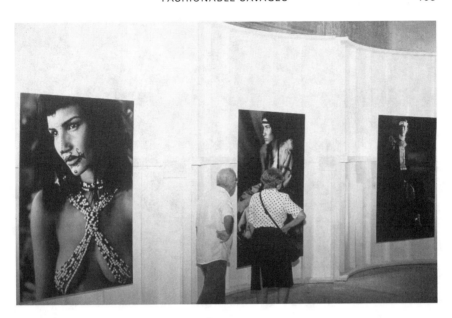

Figure 26 Exhibition *Huellas*, Buenos Aires, 2000. By permission of Gaby Herbstein Studio. Photo: Arnd Schneider.

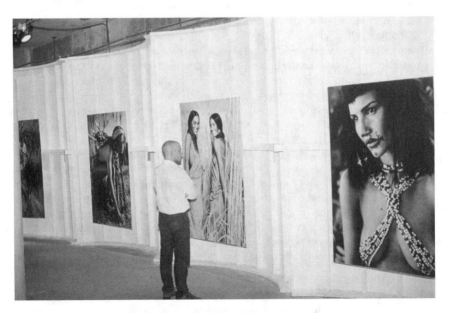

Figure 27 Exhibition *Huellas*, Buenos Aires, 2000. By permission of Gaby Herbstein Studio. Photo: Arnd Schneider.

Promotion of the Guaraní cause is her main activity in Buenos Aires. She has just come back from some holidays in the *comunidad* (community) to promote awareness about the Guaraní, and to sell craft. Her grandfather is the cacique of the *comunidad*. She shows me some documents on how they have been trying

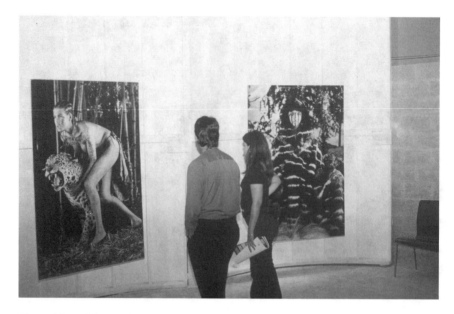

Figure 28 Exhibition *Huellas*, Buenos Aires, 2000. By permission of Gaby Herbstein Studio. Photo: Arnd Schneider.

for some time to promote clean drinking water for the community. It costs about 200, 000 pesos [equivalent to U.S.$200,000 in 2000], but maybe less, a construction firm working for the provincial government, will take its slice. She goes over and over again the file and can't understand where it's being blocked. They don't know yet the new local members pf the provincial assembly, for which there had been recent elections. Also, there are competing indigenous organizations in Misiones, and foundations who receive money from Luxembourg. "But," she says, the money doesn't reach the indigenous community!" We then have *tereré*, the cold maté with ice cubes and fruit juice, drunk in Misiones and Paraguay where it is also offered with herbs.

Her husband comes back; he works as a cleaner and maintenance guy faraway in the province of Buenos Aires, and in the northern suburb of Belgrano. But the money is not enough; the rent alone is $250. They have the telephone barred for outgoing calls, and his mother is helping them with money, "*si no, no alcanza*" (otherwise it would not be enough), Jorgelina says. I make a photocopy from an article of the *El Territorio* paper from Misiones, reporting on Guaraní protests. Jorgelina wants me to phone Silvia Rinque to ask her to call her back.

Conclusion: Conquering New Ancestors

In order to understand the full context of Gaby Herbstein's and Julieta Garavaglia's intentions when planning, researching, and producing the calendar, it is useful to return to an assertion that they made in the "Huellas" text I referred to earlier, and also in the interview. Their main interest is in "origins," that is, wanting to show how indigenous people lived before the

arrival of the Spaniards, in short, showing the "origins of the Argentines." Here, we find the key to their motivations, and in fact those of much current indigenist discourse in Argentina, that is, by people in the arts who appropriate and interpret indigenous cultures. Basically, this line of thought claims that indigenous preconquest populations are the ancestors of contemporary Argentines, when in fact at the time no nation-state existed and since then most of the indigenous people have been extinguished. Moreover, reference is made to prehistoric Indians, not contemporary ones, whose existence both as representers (in this case as models) and represented is denied—except for the small format documentary photographs on the supplementary pages. One might also ask: ancestors to whom? Most Argentines are descendants of Europeans, and constructing such a "new," but in fact, very old, ancestry to indigenous people albeit as historical fossils, is obviously different from the dominant nationalist projects, which would establish identity of the nation state on two quite different pillars. The first of these bring independence, including a glorious colonial past for the upper-class Spanish "Creole" families, but obliterating the indigenous and African contribution to the lower-class *criollos*.[28] The second pillar of the nation-state consisted in the later modernization through European migration, though this concept was stratified according to the provenance of immigrants, Northerners were eventually preferred over Southerners. It seems that indigenist discourse almost succeeds in inverting the old proverb (often retold to me by *porteños*), according to which Mexicans descended from the Aztecs, Peruvians from the Incas, and Argentines from the ships, that is by actually substituting Mapuche—or other indigenous populations—for "ships." The original proverb and the new "indigenism" also point to a kind of envy at other Latin American countries' ancestral cultures, and the lack of it is seen as the main reason why Argentines would have such a fragile national identity. In fact, already in the late nineteenth and early twentieth centuries some sectors of the Argentine literary and political elite constructed (and construed) Indians as ancestors of the nation-state; one prominent example for this is the writer Ricardo Rojas, as pointed out in the first chapter.[29]

A second part in Herbstein's and Garavaglia's explication concerns their artistic ideals and concepts of beauty, such as those gained from working with professional models (rather than indigenous women) and keeping apparently to an "aesthetic of the era." The explicit aim is to make indigenous people fashionable, and thereby "sell" them to a young, white fashion-oriented public. The ideal of beauty is that promoted by the international fashion world: young, slim, almost anorexic, long-legged girls. However, Pincén shared this ideal, which is the dominant and hegemonic one in Argentina, and was delighted to see beautiful fashion models dressed up as Indians, thus giving "glamour" and "beauty" to indigenous women. One wonders, however, whether the blonde ideal of Argentine society which is ubiquitous in advertising and on the streets with many women wearing dyed blonde hair (*platinizada* "platinized," being the popular euphemism for it), has not just been replaced by darker colors through the sepia tinting, but no aesthetic

specific to or originated by indigenous people is promoted, with the exception of the Mapuche representation, perhaps. Finally, the short texts accompanying the images offering mythological extracts often are not matched by the actual depictions. Thus the Selk'nam women is too obviously a "white" tame fashion model, where the text speaks of "There was a time in which *krech*, the moon, and the women dominated the world. They terrorised men representing different spirits till one day the men rebelled and there was a big fight . . ." Other texts are more revealing, such as the quote from Charles Darwin, who despised of the Yámana since they knew no property, but this is mismatched by the accompanying photo showing a nude model with a fish.

What kind of indigenous women are represented in the calendar? Using fashion models undoubtedly sends a strong message about beauty and eroticism on the one hand which corresponds to stereotypes in Argentine society. On the other hand, dressing models up as imagined turn-of-the-century Indians, and producing sepia prints has two effects: first, Indians are once more portrayed as museum pieces, pertaining to a pristine past before the arrival of Europeans. Thus the photographs become complicit with turn-of-the-century ideas about savage Indians. Second, as women they become objects of desire for a white public.

Thus there seems to operate a double negation in the work of Herbstein and Garavaglia. Indians not only are not shown in their present conditions (except for some small documentary photos on the trip to indigenous communities), but contemporary Indians are also denied representing their own past, because indigenous models were not employed. As such the photos correspond to a "white" and widespread Argentine fantasy about Indians as extinct, living mostly as savages in the past. They also correspond to a reverse perception of indigenous women as more sensual, closer to nature, and sexually less inhibited than their European counterparts. Somehow, indigenous women curiously occupy here the position their male companions (who are absent in the calendar) had in the fantasies and actual encounters of Europeans: as amazon-like warriors who capture and spellbind the male and female gaze, while at the same time being the *cautivas* of male desires.[30]

That these desires are not the exclusive domain of white *porteños* is shown by the statement of Pincén, who emphasized the concept of beauty in indigenous women. But has the fashion industry and the beauty ideal (or rather ideology) it promotes really been used to the advantage of indigenous people, as Pincén hoped it would? Most of the reactions from the press seem to speak a different language. Very little understanding of presumed political and cultural message to rehabilitate Indians in the minds of Argentine mainstream society is to be found there. Rather, one finds platitudes about fashion, beauty, exoticist stereotypes, with titles such as "Sexy Almanac,"[31] "The presenter of Petete [a television character and a fashion model] is a tigress,"[32] "María, a VIP Indian,"[33] and one paper even asking "Which were the most elegant tribes?" Other papers, of the "light" variety, were obviously more interested in reporting on the presence of the rich and famous at the launch of the calendar, than on the content ("The Sabatinis at a photographic show" [accompanied by photos of former tennis star Gabriela Sabatini, her brother Osvaldo, and his wife, the

actress Catherine Fulop],[34] "Let's go for a walk" [on Catherine Fulop and Osvaldo Sabatini attending the exhibition launching the calendar],[35] "How beautiful are you, Cathy!" [on Catherine Fulop attending the event].[36] A few other papers did some more serious reporting, mentioning the idea and intentions of the calendar, archival research and visit to indigenous communities, support by the United Nations, the work of Mapuche silversmith Silvia Rinque, and the controversy about using white professional models rather than indigenous women.[37] *La Nación* was probably the only paper which ironically lamented, ". . . pity that they [the indigenous people] were not shown in the photos, because they are not as fashionable as the models."[38]

The authors of the calendar maintained that they were faithful to the archival photographs they located through their research. Yet it was precisely in the historical context of extinction and subjugation, anthropological research and experiments, that the original photographs were shot, reflecting the evolutionist and racist ideology of their era.[39] Thus shooting studio photographs today with reference to archival photos without criticizing and contextualizing them for what they are, the contemporary photographs become complicit with the historical intentions, as pointed out earlier in this chapter. This is not say that Herbstein and her team shared the ideology at the end of the nineteenth and in the early twentieth century about Indians. To the contrary, they were led, in their own words, by intentions of "vindicating Indians," of conferring "dignity" to them, and of making them "fashionable."

For instance, in the exhibition in the "Abasto" shopping mall, the central display at the entrance showed the images from the calendar in smaller format, accompanied by a statement from the cacique Cangapol (figure 29).

Figure 29 Exhibition *Huellas*, Buenos Aires, 2000. By permission of Gaby Herbstein Studio. Photo: Arnd Schneider.

Figure 30 *No entregar Carhue al Huinca*, RES, Buenos Aires. Courtesy of the artist.

However, in the calendar, their intentions remain far from being unequiv-
ocal, to the point of being open to misinterpretation, and thus serving the
opposite purpose, which is clearly evidenced by the reception in the press. In
fact, quite different approaches are explored by Argentine artists, and I can
only mention here in passing the work of contemporary photographers and
artists, such as RES (figure 30) and Lionel Luna.

Indigenous people, obviously, have to speak for themselves. Yet it is note-
worthy that in the statements by Luis Pincén and Silvia Rinque, whilst the
latter was critical of the project, the enhanced publicity for the Indian cause
in Argentina was valued as positive.

When I showed the calendar to Argentine friends, I obtained mixed
reactions. On the one hand, there were those who would quickly identify it
as a superficial enterprise of the fashion world, whilst acknowledging the
technical and aesthetic quality of the photos. Others would say, "These are
just fashion photos, they have nothing to do with Indians." There were also
those who were immediately impressed by the quality of the images, and put
them in their context as studio photos by a fashion photographer, using
famous models without having any documentary pretensions about contem-
porary Indians.

From observing visitors on several visits to the "Huellas" exhibition in the
Abasto shopping mall, I could discern that they were all white middle- or
upper-middle-class *porteños*, some of them reacting with surprise to the pic-
tures, others with curiosity and being intrigued by the topic. One has to add
that it is not a common sight to see in Buenos Aires large displays of indige-
nous people, even if they are of an artificial nature. Usually, the large

billboards on the central avenue *Avenida 9 de Julio* and other downtown avenues are used for advertising aereolines, computers, and fashion, or, during election periods, political parties.

In some way, it is therefore commercially courageous to bring indigenous people into the public sphere, in what is the political, economic, and cultural center of the country, which has always marginalized indigenous people. But eventually such a move also pays off commercially. As Herbstein mentioned in the interview, once companies had heard of the calendar project and had seen the successful launch, they too wanted to use indigenous people for their advertising campaigns. Hence Herbstein studios designed an advertising campaign for a cigarette company, featuring the members of the only indigenous Rugby team of the country, Guaraní players from the Chaco. In November 1999, there had been a conference on indigenous people (the second of its kind) at the San Martín cultural center (see also figure 67 in chapter eight). However, in terms of public display, that is, the part visible to outside passers-by, there were only a few handicraft stalls, confirming probably the image *porteños* had of indigenous people anyway. That is to say, people dressed in folkloric costumes, and selling arts and crafts, such as flutes, wrist bands, and little statues.

The discussion of the "Huellas" exhibition and calendar also illuminates issues of the public perception of the "other" in Buenos Aires. Whilst this issue merits further research, towns in the province of Buenos Aires, and more so in Patagonia, often seem to have monuments commemorating the "past" indigenous population, but there are to my knowledge no such public places of remembrance in the city of Buenos Aires.

Certainly, the calendar also represents an appropriation of the indigenous body. By posing as indigenous women, the models actually get into the skin of an imaginary indigenous "other" who is not allowed to represent herself (other than to decorate the skin of white women with her accessories). Thus these images occupy a public space in Buenos Aires that has been left vacant since the Spanish Conquest. Only captive Indians, Creole descendants, and, more recently, indigenous immigrants from Peru, Bolivia, and Paraguay would represent this conceptual space at the bottom of society.

There is yet another form of appropriation, when Gaby Herbstein and Julieta Garavaglia speak of Indians as the origin of "us" Argentines. Here, the idea (or ideology) of the nation-state subsumes Indians as its ancestors. This is problematic, both historically, because it was the Argentine nation-state that defeated the last indigenous resistance, and politically in the present, because indigenous communities in Argentina are seeking their right to self-determination. Similar to what has been achieved in the North American context, some indigenous leaders conceive of their communities as "nations" and want autonomy from Buenos Aires coupled with far-reaching rights over their territories, if not independence. As demonstrated throughout this book, the paradox of claiming indigenous "ancestry" in terms of history, culture, and territory for a new concept of the Argentine nation-state is also to be found in many variations among other visual artists. However, some artists

are also aware of the problematic nature of their constructs and reflect on their own role as "whites," or nonindigenous people, in the appropriation process.[40] It is noteworthy that those who do claim biological ancestry, that is, present-day indigenous people, are rarely or only partially involved in the appropriation process, indicating the continuing dominance and hegemony of the non-indigenous section of society, as underscored by the present example.

Having returned to London from fieldwork in Argentina, I showed the calendar to Norma Schenke, an Argentine artist working toward an MPhil at the London College of Printing, and doing research into the representation of indigenous people in Argentine photography of the nineteenth century. In our discussion, she made the valid point that despite the noble intentions of the producers, the calendar results again in the discrimination of indigenous people by imposing European models of beauty.

Thus it could be questioned whether the production of the calendar does not stem from a patronizing attitude, when Herbstein and Garavaglia pretend to restore to indigenous people their dignity. The issue is whether such dignity would not have been achieved better through their more active participation.

Herbstein's work is possibly best described as an aestheticizing and ideal-izing approach to the representation of the indigenous, dictated by the presumed parameters of the fashion world, which are primarily commercial ones. A different kind of approach probably would take a second step, in order to achieve a more aesthetically fragmented representation (including notions of the "ugly," and "realist," according to fashion ideals), and express a reflexive critique of the status quo of indigenous people in Argentina (both past and present). In different contexts, the fashion house *Benetton* has been an example for an aesthetically more complex proposition, challenging traditional concepts of beauty and taking up politically controversial issues. However, *Benetton* too has aroused controversy with its approach and prac-tices; for instance, in Argentina its policy of enclosing large areas of land for sheep farms in Patagonia is contested by the local Mapuche (see, for example, www.mapuche.nl/english/benetton0304.htm).

Returning to the opening remarks, we can conclude that in this calendar, stereotypes of beauty of the urban Argentine society, and *porteño* society in particular, are transposed to staged indigenous women (by white fashion models). The nation-state (or Gaby Herbstein's understanding of it) has now not only appropriated the indigenous space of the present, but also indige-nous people of past generations, thus achieving a colonization of the others' history. People who in Eric Wolf's terms were, from the Western vantage point, "People without history"[41] (in fact, they had their own history, though this was denied by the West), now become inextricably part of *our* history.

In the following two chapters, we analyze artists' projects that did involve not just the representation of indigenous peoples, but actually involved them in substantial ways in the process of artistic production.

Chapter Six

Setting up Roots: On the Set of a Cinema Movie in a Mapuche Reservation

Prelude

One common sense of cinema is that of an extreme, hyper-real construction of reality. Field sites do not seem to escape this fate, and in due course become locations, and in turn locations become sites of fieldwork.

Rather than existing as two discreet entities, field sites as observed "reality" here, and locations as the places of scripted "fictions" there, both are site specific, constructed realities. From an analytic point of view, and considering the roles of anthropologist and director in their creative interventions into local realities, the ethnographic research design is comparable to the script, as is the shoot, with its creative derivation from and interpretation of the script, comparable to the interpretative interaction of the anthropologist with his or her research subjects during fieldwork. However, in terms of declared aims, there still appears to be a main difference in that one is about fabricating fantasies (cinema) and the other is about fact-finding (ethnography). Whilst they might differ in their aims, both the practice and writing of ethnography strive for truth values and verisimilar representations, and so do many genres of cinema (though not all).

In this sense, both field sites and locations are constructed realities, or "hyper real."[1] Field sites and locations are also to some degree interchangeable, and seem to move in and out of each other, depending on which group of "actors," for example, artists, ethnographers, cinematographers interacts within them.

It so happened that my first site of fieldwork in Sicily, the mountain village of Sutera,[2] the year after I had left in 1985, would become one of the many locations for Michael Cimino's *The Sicilian*, starring Christopher Lambert (1987). After the enormous trucks from Rome's dream factory *Cinecittà*, hardly fitting into the village square, had left, and I returned the following summer, people proudly would point out to me how the village had been transformed during the shooting, façades had been painted, and locals had

Figure 31 Salvatore "Totò" Marino on the set of *The Sicilian* (Michael Cimino, 1987) in Sutera, Central Sicily, 1986. Photo: Nino di Prima.

participated as extras. One take featured the shoemaker Totò, repairing shoes on his stool in the *piazza*. When I saw the finished film, there was just a glimpse of him (figure 31), cut indiscriminately against scenes from other unnamed villages in Sicily.

So what was the motive of pride, participation, and comment for local people in the film became just one of many generic picturesque shots, without any local reference. People whose life-worlds and environments have become locations—even and especially when the story is based on specific historical events or characters (on the bandit Giuliano[3] in the case of *The Sicilian*)—are usually aware of cinema's quality to transform the local into a generalized impersonal discourse, dictated by script, commercial interests, and the tastes of the supposed audience (in this case, primarily American and European).

Therefore, quite different expectations are raised when a director promises the people of the location more than just a cursory view, or generic representation, of their place, but puts forward the real name and selects them as the main location, as was the case of *El Camino*, shot in the Patagonian town of Aluminé. In a way, sensations were evoked for local people to feel they had become the chosen ones!

Introduction

The subject of this chapter is the recent production of an Argentine feature film (*El Camino*, 105 mins., Javier Olivera, 2000), shot in part in a Mapuche

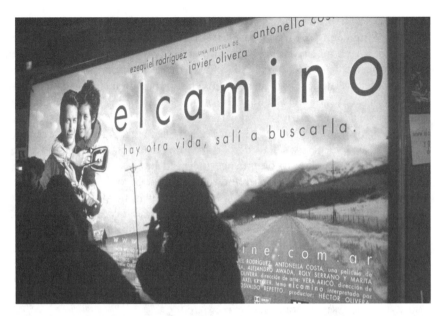

Figure 32 Illuminated billboard of *El Camino* when it was released in Buenos Aires in 2000.
Photo: Arnd Schneider.

reservation and a neighboring town in Patagonia. The issues I want to
address are complex, and include the perspectives of the film-crew, villagers,
and indigenous people. The intricate web of politics and ethics of representa-
tion that are involved in the practical preparation and execution of shooting
in a reservation of indigenous people in Argentina is my principal concern. I
also address the political agenda, or "indigenism" of the movie, that is, the
explicit aims as they were spelled out to me in meetings and interviews with
the director. Thus the main emphasis here is on the production process, and
especially shooting, rather than the finished film, which was screened in
Buenos Aires and other parts of the country. I shall also address the issue of
how, as an anthropologist, I became complicit with the film crew, which I had
intended to "observe," and how I intervened partly in the production
process.

Research was carried out in April 2000, accompanying the director, Javier
Olivera, and the film-crew in Patagonia for ten days. Originally, I had
approached Olivera in his capacity as a painter who incorporates indigenous
symbols into his works, and from that first encounter the opportunity arose
to also follow his film project, *El Camino* (figure 32).

The Film and Its Background

The Story Line

El Camino is a "road movie," incorporating also elements of the thriller
genre with a fast-moving story, and trying to appeal to a young public in

Argentina. The protagonist, Manuel, in his early twenties, is a pensive, good-looking young man from a well-to-do Buenos Aires neighborhood. He never got to know his father, but a funeral notice for his grandfather in the provincial town of Azul makes him drive there on his motorbike, hoping to encounter his father. The father remains elusive, but an uncle tells Manuel to search for him in Aluminé (Neuquén Province, Patagonia). On his motorbike, our hero starts a long trip through the Province of Buenos Aires. On the journey many things happen: Manuel falls in love with a young woman, Caro, but also witnesses a murder of a young man in police custody; he manages to escape, only to be pursued in a wild hunt by the assassin police officer. Manuel arrives in Aluminé and reunites with Caro, and then visits the Mapuche reservation of Ruca Choroi. His father, an anthropologist, is absent in Germany, but Casimiro, a Mapuche and good friend of his father, shows him the house, and a workshop his father has set up with the Mapuche on the reservation. Meanwhile, Ferraro, the corrupt police officer, has arrived, searches for Manuel in the reservation, and threatens to kill him. Yet his attempt is failed by a number of unarmed Mapuche, who encircle him and persuade him to put down the gun. Eventually, Manuel gives evidence in a court, and the assassin policeman is convicted.

The Film's Agenda

The film's director, Javier Olivera, son of the renowned Argentine director Héctor Olivera (best known for his *La Patagonia Rebelde*, 1974) had already made documentaries for the National Institute of Indigenous Affairs and one feature film (*El visitante*, 1999), based on the story of a veteran from the Falklands/Malvinas War.

In *El Camino*, Olivera's aim was to show, as he expressed in various conversations, "another reality," that is contemporary indigenous people, and to open the eyes of a largely "white," European-descended inhabitants of Buenos Aires and the coastal provinces. Although not called *indigenismo* in Argentina (as in Mexico or Peru) his motifs were akin to these ideologies in that he sought to vindicate indigenous otherness from the perspective of the white or Creole (*criollo*) population.

After the end of the desert campaign in 1871, in which the Argentine Army took the territories south of Buenos Aires and in Patagonia, the resistance of the Mapuche had been broken. Indigenous people were pushed into reservations, resettled, and above all, marginalized, geographically, economically, and, of course, culturally.[4] In the construction of the nation-state there was no symbolical space for indigenous people—or for that matter, for the few remaining African Argentines.[5] Much mythologized in Argentine arts and literature, even for the *gaucho* a partly indigenous past or present was rarely acknowledged. Like a number of Argentine visual artists, film directors, such as Olivera, then stand in a minority tradition of artists, who search for "roots" inspired by past and present indigenous cultures, and who try to convey a political message of cultural resistance. Sometimes this is paraphrased

as a resistance against North American influences and globalization. Yet theirs is a construction, or appropriation,[6] from the viewpoint of the urban, "white" *porteños*, the inhabitants of Buenos Aires. It is not the perspective of indigenous people themselves. Nor is it the approach of indigenous ethnic leaders of whom some, like Juan Namuncurá (a musician and director of the foundation *Instituto de Cultura Indígena* in Buenos Aires, who was also present at the art fair *Arte BA*, see chapter three), were very critical of the film, or the few indigenous established artists, such as the Mapuche singer Pichi Malen, and other visual artists who claim descent from Mapuche, such as the video-maker Paula Coliqueo.

The film had several objectives. First, it was planned as a commercial project.[7] Then there was also the attempt to combine the separate and mutually alien worlds of upper-middle-class "white" Buenos Aires with the interior, the Province of Buenos Aires and the "South," that is, Patagonia. But more importantly, the film aimed to include indigenous people in Patagonia into the narrative who have traditionally been excluded from mainstream culture in Argentina. An analysis of the script and the finished film would have to ask how these images were fabricated, what kind of stereotypes of indigenous people the film conveyed, and how they were received by the audience. Above all, it would have to put the question of whether in fact indigenous people were once more just used as a picturesque background.

Here, however, the main emphasis is on the actual process of fabrication of reality during the shooting process, ethnography off screen as it was observed first-hand. Of course, the film was also constructed in pre- and postproduction, yet I had little opportunity to witness these parts of the process (apart from a few interviews with some production executives and editors).

On Location

By the time I reached the film crew in northern Patagonia in early April 2000, they had been traveling by bus and car through the Province of Buenos Aires for about two weeks.

They were just finishing a shoot by a small river, an intimate love scene between protagonists Manuel and Caro before we headed for Aluminé, following a dirt road via Zapala across the Patagonian plateau and the Pre-Cordillera, which precedes the Andes proper, in the gentle environs of the National Park Lanín (receiving its name from the extinct volcano over-towering it near the Chilean border). This area is known amongst Argentines for its forests of *Pehuén* (araucaria or monkey puzzle tree, an ancient conifer), and one of the largest Mapuche reservations in the country, Ruca Choroi (meaning the "Singing Parrot"). The crew was booked into a huge Alpine style hotel at the outskirts of the village of Aluminé, Neuquén Province. From there a small gravel road, after 20 kilometers, leads to Ruca Choroi. At the entrance to the reservation there is a primary school, and Catholic nuns run a mission and a radio station.

Our schedule was first to shoot some scenes in the town of Aluminé, outdoor shots, street scenes (the arrival of the female protagonist Caro at the bus station), and indoors, in the supposed house of the father of Manuel, shown to Manuel by the father's best friend, the Mapuche Casimiro.

Obviously, the story of the making of this film can be told from different vantage points, and in the presentation of my material I attempt to represent the agendas and expectations of the different groups and individuals involved, these being the film crew, the villagers of Aluminé, and the indigenous people of Ruca Choroi.

The Crew

What were the crew's expectations of shooting in the Mapuche reservation? The crew[8] clearly perceived a difference to the earlier part of the shoot in the Province of Buenos Aires, and the final part of the film, set in and around the reservation. During travel in the bus, on the way to the reservation, crew members were highly expectant about this final part of the journey. I remember the second director's assistant pondering the question, "How will they [i.e., the indigenous people] receive us?" This contrasted with the producer's verdict that the trip to the Indian reservation was wholly unnecessary, and that the final part of the story could have equally been shot elsewhere, for example, in the province of Buenos Aires. The assistant producer, a young woman in her twenties, on the other hand, wondered about the "authenticity" of the Indians she was to encounter, as she expected them to be "fake" and "dressed up" for tourists.

However, the principal concept used by members of the film crew to describe their intended rapport with the Mapuche, or more generally their attitude toward them, was *respect*. Respect for people in a completely different social and cultural situation, coupled, in some cases, with an admiration for the natural beauty of their territory and their customs. It has to be emphasized that a sense of guilt for the historic land-taking process of indigenous territories arguably underlies this concept of respect—a trope familiar from other settler societies.[9] However, apart from the director, assistant director, and possibly some others, few were aware that this was also another historically loaded encounter, between the victors and the vanquished.

The crew also had a specific perception of the production schedule. In terms of evolving linear time, there was the incessant unfolding of the production schedule, ranging from idea, script-writing, casting, shooting, postproduction (editing), to screening. The film, too, had its own development of time, which in disjointed, fragmented installments was woven into the production process. It is well known that shooting and editing are diachronic events with respect to the final film time. This means scenes are not shot in their temporal sequence, but according to the necessities of production and, in fact, instances abound where directors depart from script and production schedule during a shoot. The knowledge of the script of *El Camino* and, even more so, of the detailed storyboard, or the precise shooting

schedule varied with professional position (e.g., director, assistant director, camera man), yet even technicians and drivers knew and had internalized the master narrative, that is, the story-line of the film, and were able to indicate to me the position of individual scenes. Thus, apart from the real-time and practical day-to-day challenges of the production (shooting), people would also live, more or less consciously, in "film-time," that is, the unfolding of the story-line. This feeling of a second, subconscious (or, perhaps even overarching) temporal discourse, was enhanced by the fact that the film's protagonists, Manuel, Caro, Casimiro (actors Ezequiel Rodríguez, Antonella Costa, and Rubén Patagonia, respectively) traveled in the same bus as technical personnel and socialized with everybody. Filmic reality was not only "out there" to be shot (as in a documentary), but also constantly within the consciousness and life of actors and others, outside shooting time—and contributed sometimes to a tense atmosphere, and the sense of being, at least temporarily, bound by the same predicament.

The Villagers of Aluminé

A different narrative of the film shoot was obtained from the villagers of Aluminé. Aluminé is a small town, aspiring to grow as a tourist center in a remote part of Argentina, offering hiking and wild-water holidays. The villagers' interests and expectations became very clear during a reception which was organized for director Javier Olivera in the great hall of the hotel. The mayor was present, as well as several councilors and representatives of the local tourist board. In their speeches they welcomed Olivera's choice of location, saying that it would provide an opportunity to make Aluminé and its natural and tourist attractions known to a wider public, in Argentina and abroad. The emphasis was on nature and ecological and adventure tourism, which already provides a livelihood to many villagers, and are perceived as areas of future growth.

Olivera was especially praised for his decision of mentioning in the film the real name of Aluminé, not just using Patagonian landscapes as fictional background settings. In that encounter Olivera was polite, praising the villagers for their cooperation, and avoiding controversial topics—obviously, he did not want to endanger the smooth running of the shoot.

In fact, in the speeches of the representatives from Aluminé no mention was made of the Mapuche of Ruca Choroi, or the conflicts surrounding their occupation of lands in the area of Pulmarí. In the discussion, it fell to me to ask the delicate question about the nature of the interaction the villagers and the indigenous community at Ruca Choroi. People replied rather hesitantly, saying that Aluminé should be known as much for its nature reserves as for its indigenous reservation—the indigenous people had become another ornament of the local flora and a tourist attraction, they were not regarded as people who had legitimate rights and their own voice.

As regards the day-to-day contacts between the Mapuche of the reservation and the villagers of Aluminé, they are mostly reduced to practical issues, such as the need to visit the hospital (there is a nurse for less serious cases on

the reservation), and having to deal with the municipality. Most affairs, however, are regulated internally through the indigenous council. People from the reservation also go to Aluminé to buy goods, or visit relatives living in the city. A number of Mapuche also live in the town of Aluminé, although they are considered by those on the reservation as having lost their traditional ways, including language. For the villagers, on other hand, dealing with the Mapuche is primarily an economic relationship, of selling goods on the reservation, and being called out to do repair jobs at the school.

The Mapuche of Ruca Choroi

When writing about the Mapuche of Ruca Choroi, I should point out that I visited their reservation as the anthropologist of the film crew (wishing to study the process of film production) *not* as an ethnographer of the Mapuche. Although I had briefly stayed with the Mapuche of another reservation, Anecón Grande, in the Province of Rio Negro, in 1989 and had contemplated doing research on economic and political relations in that reservation, I could not claim any special familiarity with their culture, and less so with Ruca Choroi. My position was substantially different from that of an anthropologist who would have had long-term stationary fieldwork experience. His or her experience would have been different from mine, for example, in seeing the around thirty-people strong film crew arrive on the reservation.

The Mapuche, consequently, perceived me as part of the crew. Yet crew members were asking me, "What are you doing here?" as *they* assumed that as an anthropologist I had come with them for the opportunity to visit a reservation, that is to study the Mapuche, *not* them. De facto, I was, however, part of the film crew and participated ad honorem in some production activities, such as helping the assistant director, Aldo Romero, in casting extras (figures 33 and 34).

So yet another narrative of the film shoot was provided by the indigenous Mapuche from the reservation of Ruca Choroi, telling me of preproduction meetings with the director, their experiences of and participation in the actual shooting, and expectations about the postproduction period when they were hoping for a screening of the film on the reservation as promised by Javier Olivera. He kept his promise and the film was shown there in spring 2001.

So, what were the expectations of the Mapuche of the film? When shooting started, not all the people on the reservation actually knew about the film. The motivation to participate was mostly economic, as there are very few opportunities for paid work in Ruca Choroi or in Aluminé—the marginalized economy of the Mapuche is based on a few cattle, and the nuts of the monkey puzzle tree (*araucaria* or *pehuén*). For participating in *El Camino*, extras were paid $15 a day. The agreement was reached after long and protracted talks with the indigenous council headed by the elected chief (or *lonko*), and only after the support of the traditional *lonko* by descent, in this case Amaranto Aigo [infact, the Mapuche group of Ruka Choroi still calls themselves *Aigo* after Amaranto Aigo's descent group], had been won.[10]

Figures 33 and 34 Aldo Romero (Assistant Director) casting Mapuche extras, and preparing reminder notes for extras to present themselves for a shoot. Photos: Arnd Schneider.

The idealistic agenda of the film remained an abstract entity for the Mapuche, as did the entire story, especially since they had not seen the first part shot in Buenos Aires and the Province of Buenos Aires. However, they were very keen to ensure that their own image, as "modern," not "backward" indigenous people would be portrayed. Also, elderly people would remember the shooting of the documentary *Araucanos de* Ruca Choroi by Jorge Prelorán (1971, re-released as *Damacio Caitruz*)[11] which did involve the

whole community. According to accounts given to me, when Prelorán later showed the film on the reservation the response was overall favorable, but people disagreed with the inclusion of a funerary scene that went against their religious sentiments.

The Mapuche I spoke to were keen to point out that they should be portrayed as they live today, as "modern" indigenous people, not as "backward Indians," in at worst demeaning, but often just romanticized images still held by mainstream Argentine society. One charge leveled against the film crew, as against tourists who visit the reservation, was that the "white" people just take photos away and make money. Coming as complete outsiders to the reservation, and invading it with unfamiliar technical apparatus and production schedules, met a reaction of both curiosity and indifference.

The Mapuche see themselves as the rightful communal owners not only of their settlement of Ruca Choroi, but also of the grazing grounds in nearby Pulmarí, which they have occupied from the *cooperación*, a military institution that holds land in the area. The Mapuche are well aware that their lands, historically speaking, are territories of retreat, marginal places they had been forced into after the defeat in the "Campaign of the Desert" in the 1870s. Their claim for land in this area acquires then a double-significance, not only to obtain land to survive with their livestock, but also as a symbolical act of resistance vis-à-vis those, that is the military representing the "white" nation-state, who stole their homeland in the province of Buenos Aires more than a hundred years ago.

Impersonating Fiction

Last but not least, in this account there are personae who fabricate this particular narrative, that is myself, a visiting anthropologist, officially not participating in the film, but occasionally helping out, for instance when casting indigenous extras. It is perhaps one of the creative dilemmas of fieldwork with artists that anthropologists, still trained to Malinowskian parameters (as I was at the London School of Economics in the 1980s), try to take more of an observer's than a participating role in artistic activities. Whilst anthropologists have often been consultants to documentary film-makers and practice visual anthropology themselves, as regards the visual arts they have confined themselves mostly to observation and interviewing.[12]

There were also others who uncannily impersonated some characters from the film. For instance, there was Damián Petronca, a young man from Greater Buenos Aires, who in a search for soul-finding and self-discovery had followed on a hitch-hiking journey indigenous Rock-musician Rubén Patagonia, acting as Casimiro in the film. Just like Manuel in the film, Damián would come for enlightenment of his alienated urban existence to the South. Had I also a double? The protagonist Manuel's father, an anthropologist, was absent in Germany, at a conference or for fund-raising— another strange coincidence perhaps, but Javier Olivera had written the script before knowing me.

Shooting and Representation

In the following, I wish to concentrate on the problematic and complex interaction between local people, indigenous people, and film crew, exemplified by a few specific episodes.

With each of these episodes I wish to highlight certain aspects that I think are crucial for the understanding of this feature film production and its impact on the local community: (a) with respect to the reaction of onlookers and their own filming and photographing of the shooting (which consisted of the automated, almost ritualized repetition of scenes), (b) the participation of indigenous extras, experiencing the invasive, unfamiliar presence of technical equipment, and repetition of simple actions. Finally, as regards the representation of indigenous people in this feature film, I have also selected (c) one episode to demonstrate the constructed nature of "Indianness."

Scene 1: Shooting and Onlooking

For one particular scene (a reunion between Manuel and Caro) a camera track and dolly had to be mounted on a road junction near the village square of Aluminé, and about 150 spectators had to stand back—amongst them Luis Martínez, a school teacher, who had taught for many years in Ruca Choroi, and Sergio (figure 35), an extra who had to drive a car in a later scene (in which he brings back Manuel and Caro from the reservation to the bus station).

The scene was typical for the formalized, almost ritualized shooting of sequences after the scene or stage is set up (lightning, sound, camera): consisting

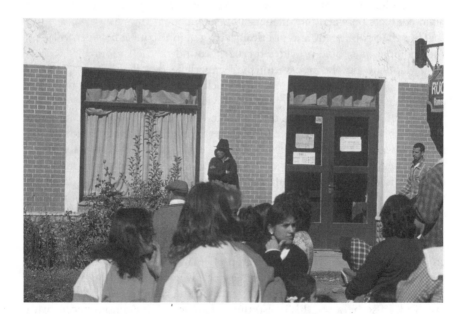

Figure 35 Sergio leaning against the wall. Photo: Arnd Schneider.

first of a rehearsal, and then of shooting the several sequences repeatedly till the director, in accordance with his cameraman and sound engineer, was satisfied. Sometimes, the rehearsal was split into actors' rehearsal (just acting and dialogue) then camera rehearsal (to find the best camera positions and moves), and, finally, the two together. The assistant director gave the command "*¡silencio!*" (silence), directed both at onlookers and crew, followed by the director's commands for camera and sound, the second assistants announcing scene and take numbers with the clapperboard, and then the director's "*¡acción!*" (action), prompting play by the actors, and finally, ending it all with "*¡corte!*" (cut). This procedure was repeated till the director was satisfied, and for the onlookers was perhaps the most intriguing and amusing part of cinema in the making, that is the seemingly endless repetition, waiting, and watching, somehow recalling those sensations when one winds back a film or, more likely, a video.

Multiple Representations

The film crew were not the only ones having cameras at their disposition. People in the on-looking crowd would take photographs and shoot their own videos. Unfortunately, I did not get the opportunity to look at these videos or photographs.

However, I did have a chance to visit the municipal TV station, where journalists were keen to show me around, and interviewed me and also other members of the film crew. Jacqueline Vallejos, who was the producer of the TV program, talked to me about the history of the station, founded recently, the dependence on political forces of the day in the village, and the latent and open conflicts between the villagers and Mapuche.

Thus the problematic and politically charged intercourse between villagers and indigenous people provides the background to the shooting of scenes. The Mapuche on the reservation had experienced stills photography and video used by tourists and journalists (including TV crews), but they were completely unfamiliar with large-scale movie production.

Whilst, in journalistic and documentary film and video, scenes are also sometimes staged and even large parts of the script and shooting "fictionalized" in docu-drama, the theatrical, staged process of scripted, fictional cinema (as opposed to those varieties of cinema that use documentary elements), I contend, is still significantly different, in that, during the shooting, takes are repeated many times over, and shooting itself is planned down to the most minute details. This is even the case with very short scenes that in the final cut occupy only a few seconds.

To the indigenous extras, however, the extraordinary length to which the crew went in order to accomplish particular scenes must have seemed extremely tedious if not redundant, especially when familiar daily routine activities, such as cutting vegetables (the next example, see below), were involved. In some ways, this is also the experience of indigenous people with professional large documentary crews who had to obey the "dictates of filming" as Jeffery/Jeffery (2000: 158) point out in their analysis of an Open University

documentary shoot in Northern India, with some of their description resembling closely what I had observed in Ruca Choroi.

> Villagers were hustled into place, scenes set up and shot—and then the film-crew usually moved straight to the next location. . . . We worked as energetically as the rest of the crew at crowd control, barring the way and pushing people back, silencing bystanders while the tape was running . . . (Jeffery/Jeffery 2000: 158)

Scene 2: Mapuche Woman Cutting Vegetables

The second issue of unfamiliarity for the Mapuche and others who experience feature film-making for the first time, is the large and extremely lavish technical equipment for a fully scripted 35 mm feature film production. Lighting, reflector boards, extended boom microphones, and electricity generators are much more invasive than a small stills or video camera. Michael Taussig (1993: 31–32), following Walter Benjamin, and Christina Lammer (2002b) have both spoken of such visual procedures as quasi-surgical operations—where the equipment almost assumes the function of surgical instruments in a operating theatre in which "truth" has to be extracted.

One can sense from the startled, almost frightened expression of the woman how she must have felt. Surely, the shooting for this scene must have seemed to her an endless repetition of a familiar daily task. The invasion of unfamiliar technical equipment, such as light meter, boom microphones, and reflectors is clearly visible. For those unfamiliar with movie production, it might be shocking and surprising that an apparently lengthy and cumbersome procedure will result in only a very short scene in the final movie—but in fact small "insert" scenes can take as much time to shoot as long scenes (figures 36–39).

Figure 36 Aldo Romero (Assistant Director) explains to a Mapuche woman how to cut vegetable. Photo: Arnd Schneider.

Figures 37 and 38 Final preparations are made for a scene. Photos: Arnd Schneider.

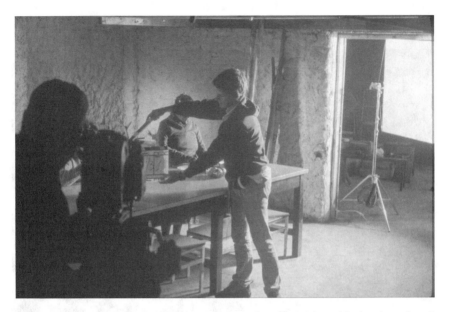

Figure 39 The third assistant director announces the take number with the clapperboard. Photo: Arnd Schneider.

Scene 3: Getting the Beat

Here Casimiro beats the *kultrún*, the ritual instrument drum of the Mapuche culture, used in the "*rogativas*" (rogations), and the *ngillatun* or *kamaruka* ceremony in February.

However, the particular *kultrún* used on this occasion was painted by the director with four crossed lines, indicating the four directions or cardinal points. This he thought was more authentic than the "blank" offered by the Mapuche of the reservation.[13]

This scene is arguably also the most revealing about the character of con-structed "Indianness" in the film. For instance, when shooting this scene, Casimiro was unable to beat the drum and sing at the same time. This meant that Javier Olivera, the director, had to beat the drum. What we see then in the film is an indigenous actor, Rubén Patagonia, playing and singing, whilst on the soundtrack we hear actually Javier Olivera drumming the *kultrún*. This, to me, seems to be symptomatic for the film's split representation of "indianness" between authenticity and staged event, where in fact an urban indigenous Rock musician and actor and with no local connections to Ruka Choroi and a white film director from Buenos Aires impose their "Indianness" onto the film.

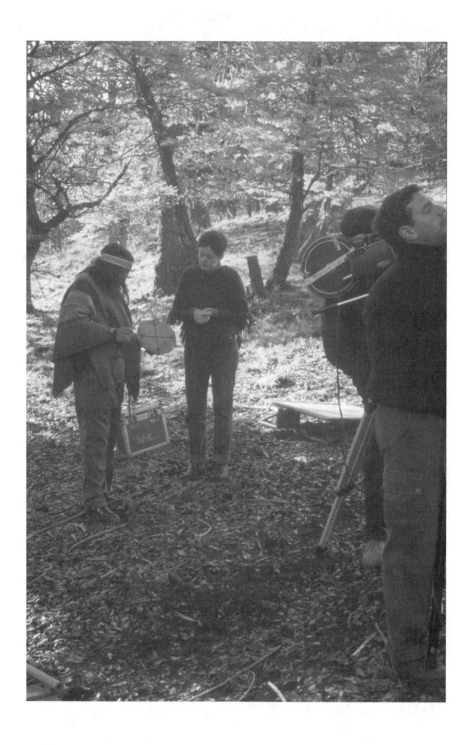

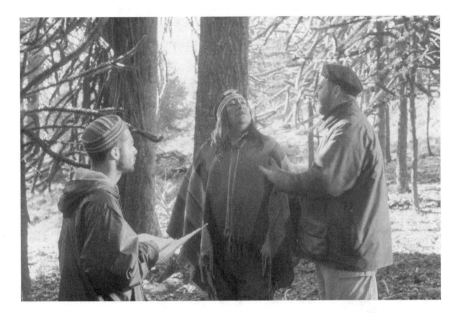

Figures 40 and 41 Rubén Patagonia practicing the *kultrún*, with the artistic director, Vera Arcó, standing to his right (figure 40). Javier Olivera indicates the beat to Rubén Patagonia. The second assistant director, Federico D'Auria, holds the script (figure 41). Photos: Arnd Schneider.

Who is Indian or Whose Indian?

At the end of this section one might also ask provocatively who were the "real Indians," if any, in this film and its production?

At the very beginning of the shoot—and early in the film—there was Sergio, a Mapuche from the reservation, who was asked to drive an old *Torino* (an Argentine car of the 1970s) to fetch protagonists Manuel and Caro from the bus station and bring them to the reservation. In between shoots, one would see him as a withdrawn observer. I wonder what it all meant to him, but did not dare to speak to him (see figure 35 above).

Perhaps, those Mapuche on the reservation into whose modest houses Rubén Patagonia and I had been invited to share *maté*[14]—with city-based Rubén looking for the genuine native experience, were "real Indians"? Yet the Mapuche in this encounter were insisting that *they* were modern, and that they had dressed like Rubén in the past but not anymore, thus voicing quite unveiled criticism of Rubén's claim to authenticity, and more generally of the representation of indigenous people in the film.

Or perhaps the twisted story of Damián Petronca represented yet other, but equally "real," "Indians"? He was a young uprooted man from Greater Buenos Aires, looking for spirituality, who had hitch-hiked all the way to Ruka Choroi to meet his idol Rubén Patagonia, whom he had got to know in an earlier live concert on the periphery of Argentina's capital. When he took on Rubén's clothes and played the *quena*, the indigenous flute, his

Figure 42 Rubén Patagonia with a Mapuche man who had invited him and the author to his house to drink *mate*. Photo: Arnd Schneider.

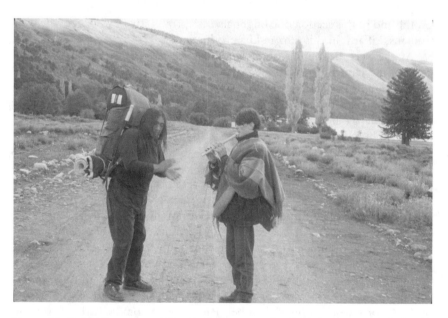

Figure 43 Rubén Patagonia and Damián Petronca, wearing Rubén's poncho and playing his *quena* flute. Photo: Arnd Schneider.

dream must have come true to be near the indigenous roots of his idol—and yet they are already the acquired cultural paraphernalia of an urban musician and actor. In this *off-scene* life-embedded performance, it is now Damián Petronca who has come to embody the "Indian" of this shooting trip, constructing, borrowing, and reappropriating elements, searching for roots and making them his own.

Conclusion

There have been a number of movements in cinema, such as Italian Neo-Realism, Cinema Verité in France, and Direct Cinema in the United States, that have sought a close, document-like representation of reality, where the cast included lay-actors, and which used real settings and authentic dialogue. Yet there still remain some differences, with documentary (which in its journalistic versions is often interview-based with real people), and even docudrama, which entails re-enactments by professional actors. There are many genres of cinema, and with some of them the border toward the documentary can be porous in both directions, yet mainstream commercial cinema is still fundamentally different in scope and in terms of production: it is produced for the big screen, there is a fictional story line (although it can be based on real events), and professional actors are used. Traditionally shot on 35 mm (occasionally 16 mm) this is increasingly changing with new digital formats, the crew is much larger (although this can differ widely from production to production) than with a documentary or reporting crew. The boundaries between fiction film and documentary have become very fluid—not least with recent productions of indigenous cinema, such as "*Atanarjuat—The fast runner*" (Canada 2000) by Inuit film-maker Zacharias Kunuk.[15]

All of these genres, despite their different pretensions, are in the business of constructing reality, or making fiction. Films with an indigenist agenda, such as *El Camino* are yet another instance of this. At their best, such films offer what Jean Fisher has called "dramatized ethnography" where indigenous people are presented as "neither *irrationally* savage nor sentimentally noble" (Fisher 1991: 32).

Whilst *El Camino* was a low-budget film and did not have the ambitions, artistically or commercially, to compete in the same league as, for instance, Kevin Costner's *Dances With Wolves*, it is worth remembering some observations that were made by critics on that latter epic, portraying a U.S. soldier "going native" among the Lakota. Jean Fisher, whilst giving some credit to the films artistic achievements, sees in *Dances With Wolves* yet again native Americans as an idealized other, and the glorification of the individual heroic soldier, coupled with nostalgia for a lost community, which is irretrievably in the past, whilst failing to comment on the present life in North American reservations (Fisher 1991: 30, 33, 39). Ward Churchill, a native American, acknowledges that Costner, for the first time in Hollywood's history, cast indigenous people not just as extras but actors, representing human beings with real "motifs" and "emotions" (Churchill 1992: 244). Yet, as Fisher, he

also laments that the film fails to engage with the squalor and political and economic issues surrounding contemporary reservations (ibid: 246).

Unlike *Dances with Wolves*, *El Camino* is, of course, set in the present, and partly on a contemporary indigenous reservation. In the latter part of its narrative it centers on an encounter between a "wise Indian" Casimiro and "a young man from Buenos Aires," Manuel, on the run from a police officer and his family past. The encounter is an idealized one, especially the portrayal of Indian spirituality. Yet as the director, Javier Olivera, explained that the idea was to portray indigenous reality to a white public in urban Argentina. However, this portrayal functions more according to the stereotypes held by white, if well-meaning, intellectuals such as Olivera, than it affords a voice to present-day indigenous communities in Argentina.

This is beyond the scope of this book, but further analysis of the finished film would also have to evaluate it within a tradition of Argentine cinematic production depicting its indigenous others, such as *El Último Malón* (Alcides Greca, Argentina, 1917), *La Guerra Gaucha* (Lucas Demare, Argentina, 1942), or *La Nave de los Locos* (Ricardo Wullicher, Argentina, 1995).

An ethnography of feature film-making then will have to ask difficult questions of such productions, apart from giving insight into artistic processes—comparable to those researches enquiring into theatre, dance, and performance more generally. And, like these, it will also have to gauge the practical implications of these fields for anthropology.

Whilst anthropologists and visual anthropologists have looked at the finished products of cinema, that is, films, little ethnographic research has been carried out on the production process of feature film-making itself. Hortense Powdermaker's early study, *Hollywood: the Dream Factory: An Anthropologist looks at the Movie-Makers* (1950), remains still one of the exceptions (although it contains little documentation of her fieldwork on the sets), another one being Roger Silverstone's ethnography of a BBC documentary, on which he commented:

> I had to treat this small society in some way as anthropologically strange, question even the most obvious and familiar parts of their routine. (Silverstone 1985: 200)

In ethnographic terms then, cinema is a special case of an artistic production site, which like others (dance, theatre, music, visual arts) can be open to ethnographic, participatory research in sociology[16] and anthropology. It constitutes, in fact, an "Art World" (1982) of its own, the title of Howard Becker's fundamental study, although he did not discuss cinema specifically. Cinematic production would merit further comparative research, because of its manageable size (at least in medium-sized productions), the closed and continuous working together of people over a period of time (division of labor, and the almost ritualized process of shooting), its mediating qualities in terms of the finished product (artistic idea, public reception, and critical writing), and its global diffusion.

The anthropologist's role, however, as in other ethnographic sites, is one of reflexive implication with his research subjects, and depending on the subject of the film and the degree of participation, one of creative intervention. Feature film-making, documentary film-making, and arguably, anthropological fieldwork as well, can all be considered interventions into local realities, which rely on collaborations with local people, with the aim to produce "fictions" or narratives of different kinds directed at specific audiences—films, documentaries, or ethnographic monographs.

As suggested in my opening prelude, cinema and ethnography both contain hyper-real additions to and second representations of reality (much as contemporary art's 1970s super-realist painters and sculptors drew our attention to these processes; see note 1), even if they create scenarios with different aims and for different purposes.

We have seen in this chapter how feature film production, at least on the set, and because of its specific, almost ritualized working practices, leads to a kind of alienation from the surrounding reality, in this case from the indigenous people of Ruka Choroi, the very subject the director wishes to introduce into the film. A self-focused crew, involved with routinized requirements of shooting, is largely cut-off from any meaningful dialogue with indigenous people, which could impact on the film-making process. The Mapuche, on the other hand, participate as rather passive extras, experiencing the shoot as an intrusion of alien technical procedures. Of course, there is conversation, token granting of visual agency (for example, through a now ubiquitous gesture used by reflexive film-makers of handing over of the stills camera; in one scene to Mapuche children), and some exchange of opinion. However, both the economic inequalities, where the Mapuche find it tempting and necessary to grant access to the reservation and to participate as extras, and the constraints of pre-scripted feature film-making, mean that during the shoot the relations between crew and Mapuche remained problematic.

In the case of *El Camino*, attempts at dialogue with the indigenous "Other" was largely restricted to the preproduction process (Javier Olivera discussions of the project with the Mapuche elders) and the postrelease phase, when in early 2001 the director went back to the reservation to show the film.[17]

Chapter Seven

Practices of Artistic Fieldwork and Representation: The Case of Teresa Pereda's *Bajo el Nombre de San Juan*

Introduction

In this chapter I continue to explore artistic practices of appropriation and creation. Here the emphasis is on the "research" strategies artists employ in the appropriation of indigenous cultures. I focus on the work of one particular artist, Teresa Pereda, whose project *Bajo el Nombre de San Juan* I followed over a period of six months during my fieldwork in 1999/2000.

Before I discuss the project in more detail below, I want to provide a brief introduction to what I mean by "artistic fieldwork" in relation to such projects. Fieldwork, despite the many criticisms leveled against it, still remains *the* method of defining anthropology with respect to neighboring disciplines, such as sociology, cultural studies, or history. When I use the term fieldwork in connection with artistic practices, I do so in reference to those practices of artistic research that include travel, the appropriation of cultural sites (in a symbolic and practical sense), and direct contact with local populations.

There are significant antecedents to such fieldwork practices in the history of modern and contemporary art, which I have discussed at some length elsewhere (Schneider 1993, 1996, Schneider and Wright 2006).[1] Here it will suffice to point out the main characteristics of "artistic fieldwork" and the specific problems it involves. In contrast with anthropologists, and with few exceptions, such as famously Paul Gauguin (and more recently, Nikolaus Lang, cf. Lang 1991), artists stay for comparatively shorter periods in the "field" or their site of cultural appropriation. Whereas anthropologists would aim to learn the local language as a matter of course, artists do not necessarily put a primary emphasis on acquiring language skills during travel. Artists' methods of recording their impressions during travel, historically, have included the drawn and written diary, the sketchbook in a range of media, and more recently, photography, film, video, and, in the case of those

interested in first-hand accounts of people (such as Teresa Pereda), the tape recorder.

The main difference between artists and anthropologists is that the latter work with what they hold to be established and standardized methodologies and theoretical paradigms, whereas artists' approaches seem to be more idiosyncratic and individual. This at least is the received wisdom from a scientific or social-science point of view. However, artists acquire their skills in art world institutions, and arguably work from certain standardized paradigms within any given period, just that the forms of expression seem more idiosyncratic and individualistic to the outside, anthropological observer.

Inspired by Native Spaces:
The Work of Teresa Pereda

I had interviewed the Teresa Pereda in Buenos Aires, visited her Buenos Aires studio[2] and also went with her to gallery openings of other artists. During the time of my fieldwork, Teresa was working on her project *Bajo el Nombre de Juan*. She invited me to accompany herself, her husband, and a photographer on the second research trip connected with this project.

Teresa Pereda obtained a degree in Art History from the University of Buenos Aires (UBA) and trained as a painter at the studios of Estela Pereda (her mother), Ana Eckell and Néstor Cruz, who are well-recognized Argentine painters. By the 1990s, she had established a significant track-record of national and international group and solo exhibitions. Yet in the Buenos Aires art world Teresa felt marginalized because of her interest in indigenous topics. "They think of me always as the 'Teresa who paints little Indians,' " she once told me. On the same occasion, an opening of a retrospective by Alfredo Portillos,[3] she remarked that this artist really would have merited a more prestigious venue, such as the Museo de Bellas Artes, or Centro Cultural Recoleta. As pointed out in chapter three, the art world of Buenos Aires is hierarchically structured not only by institutions, but also in terms of how specific themes and trends take preference over others, and how artists working in the field of indigenous cultures feel effectively marginalized.

Teresa Pereda's work is heavily influenced by direct experiences with indigenous people, mainly the Mapuche in Patagonia (she spent some time of her childhood on a large farm *campo* of her father in Neuquén province). In one of our interviews she explained to me how the deeper motivations for her work were influenced by her upbringing.

> For a long time, I grew up far away from here, not in the cities. I have now lived for twenty years in Lincoln [in the Province of Buenos Aires], and when I was little I lived in the Andes of Neuquén Province. My life has always been marked by travel, because one had to go to the cities to study. Inside of me, I always had this dichotomy: land vs. city. . . . I was always preoccupied, in this coming and

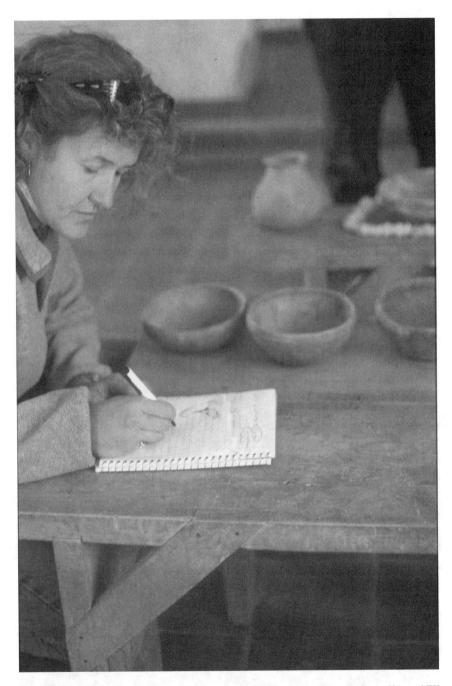

Figure 44 Teresa Pereda transcribing patterns from Chicha pottery, Javi Chico, NW Argentina. Photo: Arnd Schneider.

going to the city, with how little conscience or knowledge people had in the big city of Buenos Aires of the rest of the country. . . .

The other dichotomy was produced by this enormous European migration we experienced relatively recently. Because this migration was numerically much larger than the original population it created really a different country, imposing itself on the existing one. . . . I think a great fissure was created. Argentina is different from the rest of Latin America, and the Argentines feel different within Latin America. Take, for example, "race": my ancestors were Italian, French, and Spanish. I don't have one drop of Indian blood. My family arrived in 1860 and I have relatives in Europe. My reality is a [typical] Argentine reality. But the indigenous reality, and the reality of *mestizaje* since the 16th century, remained somehow hidden on the other side.

Therefore, I was interested to amalgamate these two worlds in my work, because I am a little bit a daughter of both. I grew up among Mapuche, an indigenous people in Patagonia. When one grew up on a farm (*campo*), the people of the area were indigenous, and during childhood one lived this very naturally. I learned a lot form them.

What I aim at is that my work follows this kind of *mestizaje*. To adopt and re-read the *mestizaje* of my country, not to obliterate as it was done in the past. *Mestizaje* not only is mixture of "races," but it also means maté, poncho, and a series of elements which are completely incorporated into our culture, but we don't know their origin. . . .

I also want the book to be something which enables the two "races" to amalgamate, and does not separate them even more. I think there is an area of ignorance and fear from both sides, and that results in the fact that there are two worlds today which are not sharing.

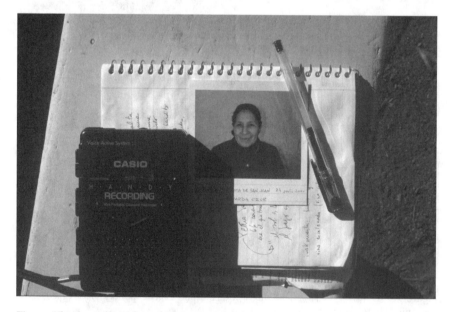

Figure 45 Teresa Pereda's notebook, tape recorder, and a polaroid print of Doña Eduarda. Photo: Arnd Schneider.

In another context, during our travel in the *Puna* (the Andean Highlands), Teresa said to me:

I know that I am white, but maybe being white helps that white people understand better [the indigenous population].

Teresa's works fall into two principal genres, that is paintings, which often depict indigenous symbols or objects and, more recently, artist's books, which are based on longer investigations of indigenous topics, often including travel and fieldwork.[4] It is one such book, *Bajo el Nombre de Juan*, which Teresa Pereda was preparing in 1999/2000, that forms the basis of this chapter.

Conjuring up Indigenous Spaces in Old and New Worlds: *Bajo el Nombre Juan*

The background to Teresa Pereda's book project *Bajo el Nombre de Juan* (Under the name of John) are religious celebrations of the feast of St. John on the 24th of June, in the Catalan Pyrenees in northeast Spain, and in the province of Jujuy in northwest Argentina.

Her idea was to document and artistically rework the tradition of St. John's day celebrations both in an Old World and a New World locality.

When I first met Teresa Pereda, she had completed the Catalan part of her project, and was very enthusiastic about the forthcoming visit to Jujuy. Sponsorship of this part of the project came from the Argentine telephone company *Telefónica*. She showed me her drafts of text passages pertaining to the Catalan part of the project, and explained how she had prepared the trip to Jujuy.

The research phase was divided into two stages, the first of which consisted in contacting people whom Teresa wanted to interview. Later, she would phone or write to them, explaining the purposes of the project. Second, once in the area, the idea was to establish close contact with local people, conduct interviews (with notes and tape recorder), draw sketches of artefacts, and importantly, document the journey photographically, as well as to produce further artistic photographs with the cooperation of a professional photographer.

The Politics of Visual Representations

During the interviews, three to four people took photographs. Primarily, Michel Riehl, a friend of Teresa Pereda and a professional photographer who was employed as the official photographer of the project, would shoot photographs with a variety of still cameras for specific tasks (a Hasselblad, a 35-mm camera and panoramic view camera), and a selection of his photos would be used in Teresa's artist book.[5] Teresa took photos with a small, automatic 35-mm camera, and so did her husband, Rafael, with the same camera. It was also often Rafael who would use the Polaroid camera, the instant prints of which

were given to people immediately. Finally, I was aiming to document this process with two cameras, a small, automatic 35-mm camera and a semi-automatic 35-mm camera.

Although, ideally, I had envisioned for myself a back-stage role, just observing Teresa, Rafael, and Michel at work, in practice I became part of the team, and was also perceived as such by the people we visited. There was no doubt that thus I was inextricably linked to the politics of representation which our project involved (much in the same way as I was part of the film crew of *El Camino*, as seen in the previous chapter).

The ways in which cameras were used in interaction with local people is indicative of the way the representation of the research was set up. Usually, Teresa Pereda would introduce ourselves and then interview the person(s), taking notes in a notebook and recording the interview with a cassette recorder if that was acceptable. During the conversation Rafael and Michel would sometimes be present. After a while—often toward the end of the interview, in order not to upset the interview process—Teresa Pereda would ask the person(s) whether they would object to Michel Riehl taking photographs. They were also promised and given instant photos from the Polaroid camera, the shots taken by Rafael Llorente (figure 46).

In our conception, the idea was to give something "back" to our hosts and interview partners. We were frequently told of the common assumption among local people that outsiders just come, "steal" images, and make money from them. In many parts of the Andean highlands of Argentina, Bolivia and Peru it is now common to ask for money in return for being photographed. However, in general, we were not asked for money, but the polaroid photographs were appreciated. People obviously realized that these were not the same photographs as those we were taking, but it did not matter, nor did it concern us. To paraphrase John L. Jackson Jr.'s remarks on native video making, as gifts our Polaroid photographs possessed the "aura" of the photographers but they were also literally, the receivers' images (Jackson 2004: 40). Whilst for us giving Polaroid prints was a moral compensation for our "taking" of photographs, to them it represented probably a souvenir, a memoir of this event. It was also interesting to note what kind of photographs people wanted of themselves. They had to be socially meaningful, and therefore to include family members and the animals belonging to the household.

Even when there was this "exchange" of giving Polaroid photos for taking other photos as well as more general hospitality, it remained an inevitably unbalanced relation, with us having superior material and economic means at our hands (which is typical of outsiders, tourists, explorers, and government officials visiting this area). Whilst our attitude could try to mitigate the exploitative relationship outsiders have with local populations of the *Puna*, it could not do away with, or contradict, the underlying substantial power differences between "us" and "them," which are at the heart of such relationships. This is not to say that on a human level, we could not entertain deep, and equal, interchanges, spiritually and intellectually, with, for instance, Don Víctor, and his wife Doña Eduarda, and many other people. This would happen independent of educational or economic background.

Figure 46 Rafael Llorente and Doña Xenobia with a Polaroid photograph. In the background, Michel Riehl photographs Doña Xenobia's husband. Javi, NW Argentina. Photo: Arnd Schneider.

The above remarks should remind the reader that equal relationships with interview subjects under these conditions (in the B*una* and elsewhere) remain an idealistic illusion.

Most people felt comfortable with being photographed, after the purpose of the project had been explained to them. Of course, cameras are not unknown and some people even have their own or have used simple cameras at some point. Often they were surprised to see the large and bulky equipment and cameras which Michel Riehl brought with him, but soon realized that this was part of his profession.

I remember one instance where it was impossible for me to take a photograph, however much I would have liked to. It happened after Teresa had interviewed Don Víctor and I wanted to take another shot of Don Víctor just by himself (figure 47). But because he was almost deaf, and because his wife, Doña Eduarda, had just called to serve some coffee, he suddenly rose up, and my opportunity was gone.

Camera and Power

Much has been written about the how the gaze is fortified and multiplied by the camera, the power it evokes, and the weapon-like extension it represents.[6] Bulky professional camera equipment can be intimidating, and appear ostentatious. This, at least, is the received wisdom in postmodern discourse about the media. I am not sure whether it was actually true in Michel Riehl's case. When I looked for the first time at my own slides I took backstage, he indeed appeared well "armed," and some photographic sessions

Figure 47 Teresa Pereda and Don Víctor. Photo: Arnd Schneider.

Figure 48 Michel Riehl taking a picture of Doña Xenobia and her husband. Photo: Arnd Schneider.

I documented would show the photographer as a marksman, waiting to "shoot" his victims (figure 48), and reminded me eerily in their composition if not in their subject, of Francisco Goya's *Third of May [Executions, 1814–15]* or Édouard Manet's *Execution of the Emperor Maximilian [1867]*.

Figure 46 Rafael Llorente and Doña Xenobia with a Polaroid photograph. In the background, Michel Riehl photographs Doña Xenobia's husband. Javi, NW Argentina. Photo: Arnd Schneider.

The above remarks should remind the reader that equal relationships with interview subjects under these conditions (in the B*una* and elsewhere) remain an idealistic illusion.

Most people felt comfortable with being photographed, after the purpose of the project had been explained to them. Of course, cameras are not unknown and some people even have their own or have used simple cameras at some point. Often they were surprised to see the large and bulky equipment and cameras which Michel Riehl brought with him, but soon realized that this was part of his profession.

I remember one instance where it was impossible for me to take a photograph, however much I would have liked to. It happened after Teresa had interviewed Don Víctor and I wanted to take another shot of Don Víctor just by himself (figure 47). But because he was almost deaf, and because his wife, Doña Eduarda, had just called to serve some coffee, he suddenly rose up, and my opportunity was gone.

Camera and Power

Much has been written about the how the gaze is fortified and multiplied by the camera, the power it evokes, and the weapon-like extension it represents.[6] Bulky professional camera equipment can be intimidating, and appear ostentatious. This, at least, is the received wisdom in postmodern discourse about the media. I am not sure whether it was actually true in Michel Riehl's case. When I looked for the first time at my own slides I took backstage, he indeed appeared well "armed," and some photographic sessions

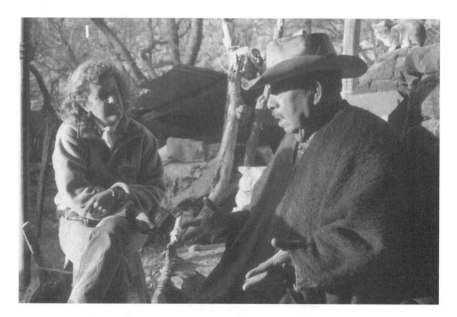

Figure 47 Teresa Pereda and Don Víctor. Photo: Arnd Schneider.

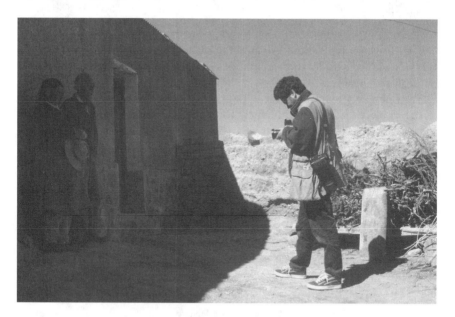

Figure 48 Michel Riehl taking a picture of Doña Xenobia and her husband. Photo: Arnd Schneider.

I documented would show the photographer as a marksman, waiting to "shoot" his victims (figure 48), and reminded me eerily in their composition if not in their subject, of Francisco Goya's *Third of May [Executions, 1814–15]* or Édouard Manet's *Execution of the Emperor Maximilian [1867]*.

But such ad-hoc associations were in *my mind*. Not only were my own photographs framed by these preconceptions, but also local people would not have perceived it that way. For instance, when we were visiting Don Víctor's house, Michel's heavy gear rested on the table (as we have just seen on one of the slides during Teresa's talk). But nobody objected, and it did not in the slightest influence a most animated and amicable conversation with our hosts (figure 49).

On another occasion, during the celebration of St. John's feast, Michel would allow children to peep through his Hasselblad camera, thus making the very instrument of power and curiosity available for inspection (figure 50). In the previous chapter, I explained how this device is now also used by filmmakers, to diffuse ab initio any accusations of political incorrectness. Giving "fictive" visual power to the others thus circumvents admission of the real power difference.

The following example shows how one could also be trapped in one's expectations of events, which become accomplice to later representations. On one occasion, Teresa and I were talking to a man gathering firewood on the hillside below the Church of Tafna. At a certain point, Michel appeared in full gear, three cameras strung across him, and looking *to me* like a stereotypical National Geographic reporter, or somebody on an African safari. I waited anxiously for the moment he would point a camera at the man, Teresa, me, or the whole group. But he just greeted us, passed by sideways, and walked down into the valley, to photograph llamas, grazing near the riverbed. So much for the gaze of the photographer, and whose gaze, after all?

Here it was *me* who desperately *wanted* a picture of Michel pointing his camera at us, preferably with the local man sitting helplessly and bewildered in the middle, the clear victim of our visual desires. Yet it turned out differently.

Figure 49 Michel Riehl, Doña Eduarda, and Don Víctor. Photo: Arnd Schneider.

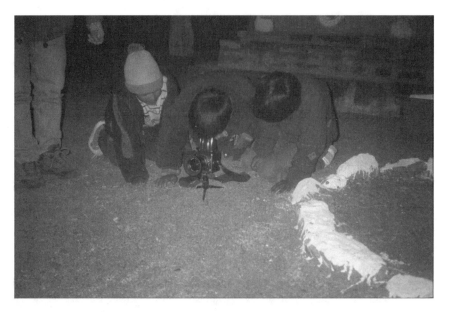

Figure 50 Children looking through Michel Riehl's camera. Photo: Arnd Schneider.

I had become victim of my own agenda, and had to accept that visual agency and representations work differently, and in a more complex manner to the ways described by poststructuralist discourse.

What kind of enhanced (or hidden) agenda did we and our camera(s) carry? Was the camera just an extension of the person, or a medium of interaction and intervention in its own right? I am still sometimes unsure how people felt about our presence and the use of cameras. In one instance, when interviewing Doña Xenobia in Javi, her daughter did not want to be photographed, and ran away or hid behind the door when somebody made an attempt to take a photograph.

Local people can control, to some degree, their own image-production, such as the wooden ornamented house altar, the *misachico*, the representation of saints in the church and during procession, but rarely would they own cameras of which there are very few in use locally. I would assume that ownership patterns change with social class, but further research is needed on this. Clearly, what is called for is a comprehensive study of the visual culture of the people of the B*una*, in the way that Jorge Prelorán studied the image world of the Argentine Andes through his films.[7]

Whilst we were interested in "taking" (pictures, interviews, information), in the interview situations we were treated as guests with an attitude of "giving" on the part of our hosts, who offered drinks and food, such as the dried grapes pictured below (figure 51). Of course, there were also differences between what we thought mattered to people, and what they told us was important to them. Thus, for instance, when I was with Rafael on an

Figure 51 Doña Xenobia's grapes in Javi. Photo: Arnd Schneider.

excursion to an archaeological site near Cochinoca we met a lady with a llama and a tame vicuña (a rarity, as these animals are normally wild). We wanted shots of the woman, but she insisted that she be photographed with both llama and especially vicuña on the Polaroid, as she said, "*con los animalitos*" ("with the animals"), which were her pride and for which she was responsible.

In the rural parts of Jujuy, it is women who look after the *hacienda*, the flock of animals belonging to a household. Men are only asked for heavy tasks, women do the day-to-day work with animals, and the grazing grounds are associated with their names.[8]

As on this occasion, we would sometimes stop people "on the spot" and involve them in conversations, and then take photographs of them. Thus, for example, when meeting a man walking in the B*una*, spinning wool on a hand spindle, we were most intrigued by this ancient technique. We greeted him, and spoke with him till Michel got his camera ready and, with the man's consent, took his photograph, and so did I (figure 52). Yet the whole situation and set-up somehow had been premeditated, in order to get a shot of him. Rafael, meanwhile, would make the obligatory Polaroid photograph, whilst the man was also showing us *his* photograph, a passport-size one he kept with his documents.

A Clash of Expectations:
Indigenous versus Outsiders' Agendas

The problematic and complex negotiation between indigenous expectations and the agenda and practice of Teresa Pereda's team can be illustrated by the encounter with Sixto Vázquez Zuleta, a Colla[9] intellectual and cultural promoter in Humahuaca. Vázquez Zuleta has written several books on the customs of the Humahuaca,[10] as well as short stories and poetry, is the founding director of the Folklore Museum of Humahuaca, and also runs an indigenous radio station. "*Yo soy indio,*" I am Indian, he said proudly at one point of our visit. Teresa Pereda wanted to meet him, in order to get more information about the context of San Juan celebrations, especially the custom of fire-walking and whether there was any connection between this and the ancient Inca rites commemorating the solstice (on June 21), the "Inti Raymi" (the "Sun Feast").[11]

However, because of the late arrival of Teresa Pereda and her crew in Tilcara (they had traveled by car from the province of Buenos Aires), and a diversion of ours to Purmamarca, we arrived late in Humahuaca. Vázquez Zuleta had been expecting us on the previous evening. Teresa Pereda had assumed that the appointment was approximate, and not specific for that evening. Yet, as we learned later, Vázquez Zuleta had had to cancel a dinner with friends. So when we arrived at about noon the next day, he was not available, and a woman in the Folklore Museum who received us told us that he had gone out. We hung about, in a rather subdued way. When Vázquez Zuleta eventually arrived, his attitude toward us was very cold, and he said

Figure 52 A man with a hand spindle in the *Puna*. Photo: Arnd Schneider.

that he had been canceling his engagements for us, and would have very little time for us now. "Five minutes," he said, since he had to look after bricklayers further down the road. Obviously, he was very offended by Teresa Pereda not keeping the appointment, or failing to inform him of our delay. According to Teresa, there was a misunderstanding here, in that she had assumed that this was a kind of open appointment. She admitted to me that it must be upsetting for an indigenous person when a "white" person from Buenos Aires does not honor an appointment. In the end, she persuaded him to show us the museum (we obviously paid the entrance fee of $5). He gave a very committed and detailed tour of the exhibits documenting customs in the Humahuaca area. When I mentioned to him that I was doing research on the "appropriation of indigenous images by 'white' Argentine artists," he commented, "Oh, some time ago some Austrians came here and wanted motifs and symbols for their textile production which I didn't permit, since they did not want to pay any royalties. They just want to steal from the Indians. The same with the pharmaceutical companies, who take knowledge from our shamans. And they even have the guts to patent it! I know, because my father was a traditional healer (*curandero*) from the Junglas region of Bolivia."

This was a stark warning regarding any unwanted appropriation. In fact, coupled with his harsh but understandable reaction toward the missed appointment, it demonstrated that he would not bow to Teresa Pereda's request of more information on the Inti Raymi, the feast of St. John, and the dancers, the *sicuris*, whose paraphernalia (*suri* feathers—the suri is an Andean ostrich) were featured in the museum and whose dance was illustrated by photographs. His father had been a shaman who came from Bolivia, but Vázquez Zuleta remained rather taciturn during our visit to the witchcraft room of the museum. He restricted himself to the essential explanations, and not even my question, of what rosemary (one of the exhibits) was good for, was answered. I had the impression, that though showing us a museum with public exhibits, he must have perceived us as scavenging for information, and having not honored our appointment, we had not earned his respect in the first place.

When I look again at the slides I took in Humahuaca, I realize that in his posture there was also a change implied of traditional roles between whites and indigenous people, or local people and outsiders. Now it was he who did the explaining, and who had ordered the museum. Although this was done according to Western display techniques it followed his criteria. The "museum" in the Americas was, after all, a "Western" import ("collections," of course, also existed in other cultures). But here, Vázquez Zuleta told *us* about *his* culture, not the other way round. This was an indigenous appropriation of white space and hierarchies which, for once, had been inverted.

The Construction of Artistic Evidence: Observing and Participating in St. John's Feast

The aim of this section is not primarily an in-depth description of St. John's Feast in Cochinoca (figure 53). No pretence is made here to double as an

Figure 53 The church in Cochinoca. Photo: Arnd Schneider.

anthropologist who could offer a deep description of the feast and its cultural meaning, informed by long-term fieldwork.[12] Our stay in the area lasted only a week, with time spent in Cochinoca amounting to two-and-a-half days. As in the last chapter, where the principal subject were not the Mapuche of Ruka Choroi, but the film crew's dealings with them, here the focus of this section is on our role in observing and documenting the celebrations, and on our inter-action with local people. I will be occupied with the writing of "our story" (rather than trying to represent the stories of others), and this should shed light on the process of artistic work and the construction of artistic evidence.

We were not the only outsiders to observe the celebrations. There were other people, among them some Argentine tourists, an agricultural expert from Jujuy who was involved with development projects in the area and came to see the livestock show (which was held on the church square), and last but not least, an Argentine anthropologist doing fieldwork further south in the Valley of Humahuaca who was a friend of Don Víctor's son, Ramón, as well as an American couple (who were friends of the anthropologist).

We had established our base in La Quiaca, the Argentine frontier post with Bolivia at an altitude of almost 3,500 metres, from where we explored the ter-ritory to the south (figure 54). We visited Javi, Javi Chico, Tafna, and eventu-ally, Cochinoca. Teresa's aim was to select the most appropriate place in terms of her art project: where celebrations for St. John would take place, including walking on the hot ashes, or fire walking. Javi and Javi Chico celebrated St. John, but there would be no fire walking, whereas Tafna and Cochinoca were the only places were this part of the ceremony was included. However, a

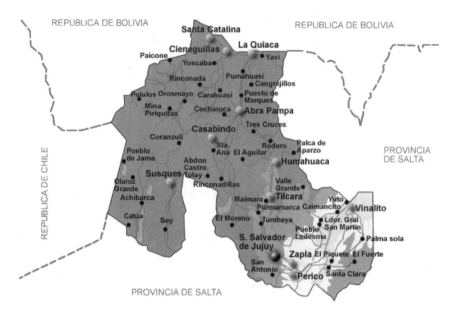

Figure 54 Map of Jujuy Province.
Source: http;//www/facilitarviajes.com.ar/espanol/jujuymapa.htm; 2004.

man who gathered firewood for the event on the hills, just below Tafna's church overlooking the valley, told us that he was expecting not more than a dozen people to attend. So, obviously, the choice was Cochinoca, a little village with approximately eighty inhabitants in 2000,[13] but which once had a much larger population due to its role in colonial times as an entrepôt on the mule route leading to the silver mines of Potosí in today's Bolivia. When we arrived, several men were unloading firewood from a truck for the fire on the village square in front of the church. The whole village and the visitors were going to participate in the celebrations. A small animal fair would be mounted on the sides of the square, showing the best animals, llamas, goats and sheep, some of which wore colourful ribbons, which they had received in a *señalada*, indicating their owner and that they were "married" to another animal. Don Víctor later explained that the animals were exhibited for a competition, and there would be a prize awarded to encourage good breeding.

Initially, we were not sure where we would stay the night, but Doña Eduarda arranged for us to stay in the community center on the outskirts of Cochinoca. This, apart from the school, was one the few nonadobe buildings. The money we would pay for our stay would go to the community. Originally, we had also asked to stay privately with somebody, but there was no space, because most people were expecting friends and relatives for St. John's. However, it also meant that we were placed slightly on the margins and could not observe first-hand how one particular family, for instance, would prepare for the celebrations. Yet our close rapport with Doña Eduarda and Don Víctor

allowed us to get a good insight into the fiesta, albeit just from one perspective, and a privileged one. Don Víctor occupied a central position in the village. A retired agricultural engineer, he was something of a local *caudillo* and influential land-owner, who was also called upon by politicians, as we could observe when a group of members of the Radical Party from Jujuy arrived to campaign for the forthcoming elections. His wife run the only pay phone service in the village, with the telephone box installed in the middle of their living room. Most of the time, Teresa would try to be with Doña Eduarda: as men it would have been more difficult for us to follow her everywhere in the village. We stayed at the house, I interviewed Don Víctor in the sitting room near the fireplace (temperatures in the B*una* fall dramatically at night, as low as −20° C in winter), and we were later joined by Michel, Rafael, and Teresa.

We shared with the villagers a mounting sense of expectation, that was waiting for the priest, who strangely did not arrive on St. John's night.

The statue of St. John was placed at the right-hand corner of the church (figures 55 and 56). In front of it the halved lamb carcasses were placed. Slowly, people began to arrive in the church. I saw what I believed at first were mothers, but in fact were relatively young grandmothers, carrying their grandchildren in a carrier belt on the back. They had come a long way, 10 to 15 kilometers from their rural homes—barefoot. "No wonder they can do the fire walking," I thought. They lit a candle and placed it near the statue of St. John.

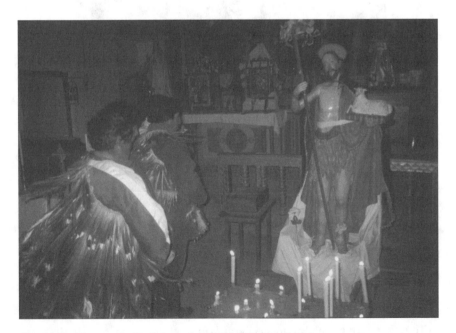

Figure 55 The statue of St. John and two Suri dancers to the left.

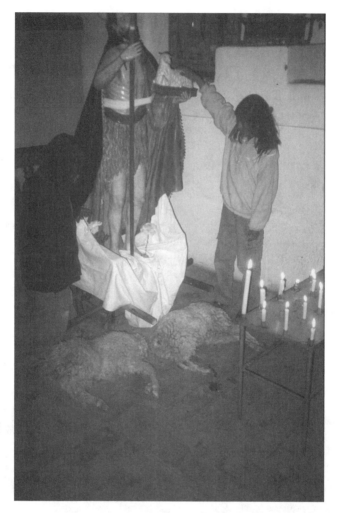

Figure 56 The statue of St. John with halved sheep carcasses laid out in front. Photo: Arnd Schneider.

More people arrived and gradually the rows filled up. People looked at me, and at Teresa and Rafael who stood in the back of the church. I asked for permission to take some photographs of children, and they had no objections. Then Don Concepción started singing, and the rest of the congregation joined in.

Don Concepción blessed St. John with water. Then the *cuarteadoras*, consisting of two women (who later would also perform the rite for the *pachamama*), two girls, and a boy took the lamb carcasses (or *cuartos*—St. John is the protector of sheep and shepherds[14]) (figure 57).

Together with the male dancers (*samilantes*) in their Andean ostrich (*suri*) costumes in front (figure 58), they walked, looking toward the saint's statue and with their backs to the exits, to perform an one-hour dance in front of

Figure 57 The *cuarteadoras*. Photo: Arnd Schneider.

Figure 58 The *samilantes*. Photo: Arnd Schneider.

the main entrance of the church, rocking back and forth, by which the
samilantes held up sticks and crossed their arms, thereby forming a bridge
under which the children and the women with the lamb carcasses walked and
passed in front again. The women and children did this alternating, and also

(like the *samilantes* with their sticks) held up the halved lamb carcasses (the fleshy side pointing forward, and the unshorn outer side backwards), and the other *cuarteadores* walked under them. On the left corner, at the entrance of the church, a man played the *erke* (Quechua) or *corneta* (Spanish), an extremely long alpenhorn-like flute, consisting of an iron tube, three meters long, starting with a lateral mouthpiece, and ending in a cow's horn (cf. Biró de Stern 1967: 320). Another man played a large hand-held drum (*tambor*, or *bombo*). Then a little procession (*misachico*) started, carrying the statue of St. John around the four corners of the plaza and finally back into the church.

As I mentioned, the priest from Abra Pampa, who should have presided over the ceremony did not arrive, so people just went ahead, following Don Concepción who, in the absence of the priest, was their spiritual leader and lay preacher, and guarded both the church and chapel of Santa Barbara. On the following morning, however, the priest had arrived and a larger procession was carried out, passing the four corners of the village, and the *misachico* receiving a blessing on each corner (figure 59).

The celebrations for St. John in Cochinoca were a combination of the dance of *samilantes*[15] with *suri* costumes, and the dance of the *cuarteadoras*, which can also be performed separately. According to Cabezas/Cabezas (1989: 12, 21), the dances have undergone changes, with less elaborate elements characterizing the present. Traditionally, only five to seven men danced as *samilantes*, in a complex dance in pairs of up to fourteen different choreographic parts, the main elements consisting in turning movements imitating the *suri*. Only the last man, called *teque*, dances alone.[16]

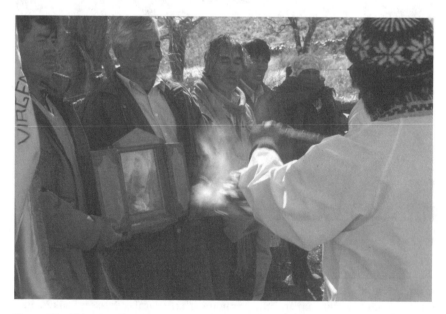

Figure 59 The priest blessing the *misachico*. Photo: Arnd Schneider.

According to Cabezas/Cabezas (1989: 45), the dance of the *cuartos* or *cuarteada*, on the other hand, is a complement to the *misachico* (the procession for a saintly image placed on a little table, or carried around in a box) (Figure 59 above). The dance is carried out in honor of San Santiago or St. John, the protectors of animal flocks. It is practiced in the B*una* and the Quebrada de Humahuaca, and sometimes also associated with other saints, for example, St. Joseph in Abra Pampa (Biró de Stern 1967: 318). It is danced in pairs, which can be formed by men, women, or both. Lamb or sheep are sacrificed and cut in halves (*cuartos*), leaving the outside unshorn, and the inside open and bled dry. These are carried by a pair which takes the animal half by the feet and offers it to the saint during the *misachico*.

Cabezas/Cabezas (1989:45) also mention that the halved lamb carcasses are to be barbecued without salt. However, they do not indicate whether this would happen before or after the dance and *misachico*. According to Biró de Stern (1967: 321), describing the dance of the lamb halves (*baile de los cuartos*) held in January/February for the feast of St. Joseph in Abra Pampa, at the end of the dance the dancers would tear apart the halves, and the dancers and their families would later eat the fractured pieces thus obtained.

In Cochinoca the lamb halves were bled dry, and there were rumors circulating that they would be grilled after the ceremony or on the following day. But for some reason unknown to me this did not happen, or perhaps it did happen and I got no news of it.

Although the priest had not arrived, everything was set for the fire walking. First, however, Doña Eduarda distributed some *ponche*, the alcoholic drink made from milk and strong alcohol, like whiskey or rum. It was freezing on that night and the drink helped people warm up. The fire in front of the plaza calmed down and the fire walking started. Everybody was expectant and excited about who would start the fire walking. There were shouts for the mayor of Cochinoca to come forward. But after about fifteen minutes some women and girls lined up. I heard shouts "¡*Viva San Juan!* ¡*Viva San Juan!*" (Long live St. John! Long live St. John!) and the girls walked across the glowing charcoal. Actually, they walked across quite slowly and steadfastly without any attempt to jump or evade the fire. More and more people lined up, and Don Concepción was among them, as well as an older man with a poncho and the mayor. Some people even went twice, such as Sol Argentina, one of the girls whom Teresa would later use in an interview extract for her artist book. Nobody got hurt or burnt—this was an act of faith as people said.[17] *Ponche* continued to be served for everybody around the fire, as it was bitterly cold. I noticed one of the women with a little baby I had seen earlier in the church. Then people went back into the church and a rite of baptism was performed in front of St. Johns statue, administered by Don Concepción, who poured water on those kneeling in a long double row in front of St. John.

In Search of "Protagonists"

Teresa had contacts in the village through some priests in La Quiaca, and decided that we should visit Don Víctor, who as I mentioned before, was a

former engineer, important landholder, and an important person of respect in the village. Teresa's intention was to find a "protagonist," somebody who, through his or her life-story, could not only illuminate the meaning of the fiesta but also the social and economic conditions of the area. So, during our stay, Teresa interviewed quite a few people, took notes, and shot photographs (with the help of Michel Riehl and her husband, Rafael). Whilst the interviews provided valuable background information, interviews were also carried out, in order to get an idea of who might be a suitable "protagonist." Teresa explained to me that, as in the first part of the work relating to the Catalan Pyrenees, she needed two or three protagonists who would have strong and rich life-histories, "expressive faces," and be at ease to talking to us. Thus both criteria of content (life-history, knowledge of the fiesta and local culture), and aesthetics (expressive faces), would influence her choice.

At times, Teresa sounded gloomy about finding the "right" protagonists. Even when the main celebrations were over, the ashes from the fire walking had been gathered by Teresa and Doña Eduarda to be used in the future art work, Teresa was not sure who would make a strong protagonist. She had second thoughts about Don Víctor (who seemed to be the obvious choice to me) and Doña Eduarda (Teresa also wanted a woman) did not seem to have the time to be interviewed in depth and on her own.

Doña Eduarda had been very busy in welcoming friends and relatives, and with two other women preparing *empanadas*, the traditional Argentine meat pastries, and then for the whole village boiling *ponche* to warm the participants of the feast.

So initially, Teresa reckoned that three of the "candidates" would not make good protagonists: Don Víctor, because he was difficult to understand and too sceptical about the religious aspects of the ceremony; Doña Eduarda, because she lacked charisma; and Don Concepción because he was too much of a catechist (remember he was the lay-preacher in the church, as Cochinoca did not have a resident priest, only a visiting one from Abra Pampa).

There was also a "hidden story," another text to the fiesta, which Teresa was keen to emphasize and find out about, and which people were equally keen to occlude from her, at least partially. At the end of the procession and celebration, following the night of St. John, a few people, amongst them Don Concepción and the female *cuarteadoras*, would gather in the north-western corner of the enclosed churchyard and make an offering ceremony, or *chayada*, to the *Pachamama* (see note 18). Teresa enquired about this, but we were not allowed to enter the churchyard to watch the ceremony or to take photos.

The youngest protagonist, Jorge Olmos, later spoke movingly about the event and Teresa, with his permission, used his statement in her artist book:

> . . . after this wonderful and much loved feast which we all shared, we are going to sprinkle the earth with liquor, we make the *corpacho*.[18] Everybody, following his own feelings makes a little dip, into which we pour a bit of coca leaves, *chicha*[19] and wine, all alcoholic drinks, thanking the Holy Mother Earth the *Pachamama*, who is sacred for us . . .

People co-operated with Teresa and the rest of the team not only by making available time for interviews, opening the doors of their houses, and offering food: physically, too, we could count on their help. One instance of such collaboration was Teresa and Doña Eduarda gathering ashes together at the fireplace in the village square on the morning after the celebrations. The ashes were still hot, so double plastic bags had to be used.

Teresa would use the ashes, together with earth gathered on the road from Abra Pampa to Cochinoca, in her paintings and prints.

Different Agendas and Expectations

So, what characterized Teresa's and our interaction with the people of Cochinoca? We came in as outsiders, not long-term residents in the area, not even as anthropologists residing in the area long-term for research. How did we conceptualize the research, expectations, actual events?

In my conversations with members of the team, I first seemed to sense an attitude similar to that of "explorers on an expedition," who would visit the area quickly, go in, and gather the materials necessary to the project. Yet, in all fairness, this was a product of the nature of the project, the brevity of our stay, and our way of traveling (by 4 × 4-wheel-drive car, rather than on foots by public transport, or on mule back). The team were aware of the limitations this type of travel entailed. Also, as mentioned before, the concept of "respect" was frequently evoked when commenting on local people and their culture.

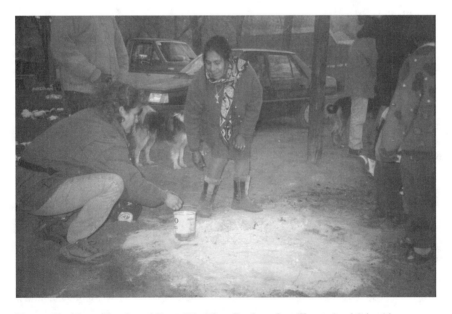

Figure 60 Teresa Pereda and Doña Eduarda collecting ashes. Photo: Arnd Schneider.

What were then the dynamics of our field-trip? I think Teresa's principal attitude was one of "respect." Although the concept was not verbalized as frequently as it had been among Javier Olivera's film crew in Patagonia (see previous chapter), it was nevertheless present, and probably also assumed more naturally, since Teresa had grown up surrounded by indigenous people (see above). As Teresa once said to me in conversation, *hay que hacer las cosas con respeto*, "one has to do things with respect."

Teresa's main approach was to interview people, take notes, and shoot photographs (with the help of Michel Riehl and her husband). Occasionally, however, she would also resort to drawing and making sketches. For instance, when we were in Javi Chico, the custodian of the small church showed us the astounding collection of Pre-Columbian pottery of the local Chicha culture that had been excavated not far from there. Now there are plans to transform a storage house, just opposite the church, into a museum. We placed some of the artefacts on a chair outside in the bright sunlight, and Michel photographed them. Later, inside the church, Teresa took some time to draw, and effectively copied the designs from some of the pottery into her notebook (see also previous figure 44). Before that she had enquired about the significance of the designs.

The Transformation of Artistic Evidence

In this chapter I have been interested mainly in the process of artistic field-work, in the role the artist establishes with her subject, and to a lesser degree with my own role as an anthropologist being at the same time witness to, and part of, that process.

It is in this context that artworks are of interest to me, not as isolated objects on their own. As mentioned before in this book, I see artworks really only as one instance, or one point of materialization, in a long, and drawn out artistic process of preparation, research, evidence gathering, and, finally, also the making of the art object—all characterized by artistic creativity.

When I first visited Teresa Pereda's flat in Buenos Aires, I had seen her paintings and artist's books from the *El libro de las cuatro tierras* (1998) series, which incorporated images of maps, and actual samples of earth gathered on travels from these places (see figures 61, 62 and 63).

Teresa would also use statements from people she had interviewed in her catalogues and artist books. She explained to me the procedure she followed for *El libro de las cuatro tierras*:

> In this book I wanted to represent Argentina as a totality. I selected four geographic areas, which ultimately represent the whole, that is the Pampas, the Littoral, the Desert, and the Andes. Except for the coast, the rest of the country is represented by these four areas. I selected a person of each place whom I went to visit. I specially made the journey to see him or her, having written and told them what my work was about. The contact was always recommended by a

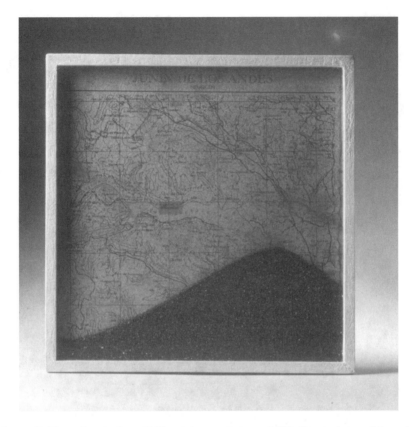

Figure 61 Teresa Pereda, from *El libro de las cuatro tierras*, 1998. By permission of the artist. Photo: Arnd Schneider.

Figure 62 Teresa Pereda, *El libro de las cuatro tierras*, 1998. By permission of the artist. Photo: Arnd Schneider.

158

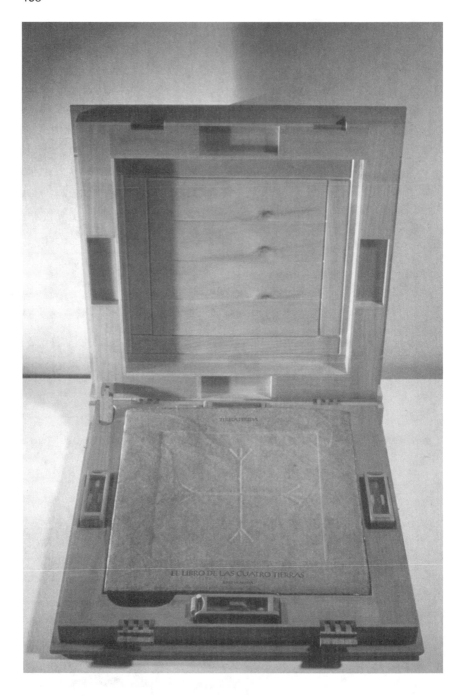

Figure 63 Teresa Pereda, *El libro de las cuatro tierras*, 1998. By permission of the artist.
Photo: Arnd Schneider.

friend who knew the person. [When we met] I asked them to tell me their history and to give me an earth sample from their house. With the earth I made the paper for the book—so it is a book with four different earth samples, which resulted in different shades of colour. And with the histories I made the texts for the book, because I also write the books, and I felt the necessity to write. However, they are not books of essays, but rather of poetry.

The pattern of her methodology becomes clear through these works and also *Bajo el nombre de Juan* (see figure 64). It consists mainly of three phases, or steps. After initial planning, comes first a visit (or more) to the area of research, in which photographs are taken, people are interviewed, some of them more formally (as "protagonists") than others, and physical evidence is taken (usually earth samples, but in the case of *Bajo el nombre de Juan*, also ashes). Then the transformation of artistic evidence in the studio begins. Obviously, there is also the issue of selection of material. From the whole range of evidence gathered, only a small part finds its way into the final art-work, painting or artist book. So, evidently there is an element of artistic choice—not dissimilar to what an anthropologist will finally select from his or her fieldnotes. Teresa's books usually have a mixture of description, interview extracts, poetry, photographs, and explanatory notes and maps in addition to her use of artistic techniques of silk screen printing, and painting (figures 65 and 66).

Figure 64 Proofs for Teresa Pereda, *Bajo el nombre de Juan*, 2001. By permission of the artist. Photo: Arnd Schneider.

160

Figure 65 Teresa Pereda painting with earth. By permission of the artist. Photo: Arnd Schneider.

Figure 66 Teresa Pereda passing earth through a screen. By permission of the artist. Photo: Arnd Schneider.

Conclusion: An Artist Who Emulates the Anthropologist

Teresa Peredas project *Bajo el nombre de Juan*, as those of the other artists mentioned in the introduction to this chapter, throws up larger questions, of how artists are different from anthropologists, what anthropologists can contribute to artistic research (or what their role can be in such projects), and what, more generally, the relation between representation and engagement with one's research location and its people is. To start with, Teresa has a family background in anthropology, as one of her aunts is an anthropologists, and Teresa had been influenced by her writing (and also accompanied her as a child on some of her research). For this project, too, she sought her advice, as she explained:

> The information I had was on Cochinoca, Javi and Tafna. These are the three locations where the celebrations of St. John are most important, according to an anthropologist who researched the area in the 1920s or 1930s. I had this information from my aunt whom I consulted before the trip, in order to see which celebrations to chose. The anthropologist, Felix Coluccio,[20] specialised in folkloric feasts of Argentina, mentioned Cochinoca and Rinconada, but in Rinconada there is no church, that is why I discarded Rinconada.

Although not having a formal training in anthropology, through contact with her aunt, as well as the long interest of her family in Argentine folklore, Teresa has a long-standing, and informed interest in anthropological subjects. Her artworks have mostly focused on these matters. Whilst she is not a professional

anthropologist, it can certainly be said that she emulates anthropologists (and archaeologists) to some degree in her research trips, "excavation" of earth materials, using visual information from her sketchbook, and so forth. However, she then proceeds differently to an anthropologist when using her material evidence, such as earth materials, in her artists' books. Such a procedure would contrast, for example, with an anthropologist collecting material culture for a museum collection. It is important to note that such similarities and differences are best made transparent through direct observation and description of artistic activity as demonstrated in this book, not in abstract statements, informed by rigid disciplinary boundaries. In this sense, my own practice as anthropologist has also been one of participation in the artistic projects of Javier Olivera (chapter 6), and even more so in Teresa's. As outlined in the earlier sections *The Politics of Visual Representation* and *Camera and Power*, the anthropologist is not located in an innocent position as detached observer, but is always ab initio implicated in the agenda of the artistic project and its execution (even if the design might not be of the anthropologist's making). In addition, the anthropological agenda (in my case a certain theoretical disposition as to the functioning of expeditionary photography), also influences perception and interpretation, and becomes enmeshed with the artistic fieldwork project.

This chapter has provided an insight into the difficult process of artistic research and negotiating appropriation of the indigenous in contemporary Argentina. Teresa Pereda's work in some ways is exceptional, in that it seeks the direct contact with indigenous populations. Most artists working with some kind of inspiration from indigenous cultures do not seek direct contact, but get their information through museum collections and second-hand sources, such as books. Whilst few can enjoy the financial independence, and backing by sponsors as for this project of Teresa Pereda's, a great number of them, especially those based in Buenos Aires or other urban centers, can conceivably travel to the "sites" of cultural appropriation (albeit by more modest means). Yet this possibility is only taken up by a minority.

Finally, Teresa's work has to be seen against the background of new formulations of identity within the Argentine nation-state. As is demonstrated in the final chapter, in the present, after the failure of European models of progress as well as melting-pot paradigms of ethnic and national identity, a number of artists (and others) anchor themselves in the contemporary nation-state, especially by appropriating past and present indigenous cultures, and making reference to a wider Latin American identity.

Chapter Eight

The Indiginization of Identity

Introduction

In this book I have been concerned with contemporary Argentine artists and their different technologies (in the sense of material and social practices) of appropriating indigenous cultures. Adopting and adapting cultural forms claimed by "Others," coupled with changed postures of identity, are at the center of such artistic efforts. Whilst appropriation, as expounded in more detail in chapter two, is not a new phenomenon, and in fact is universal to the process of how cultures change, it is now one of the main devices through which globalization is brought about. In this process, I have argued, artists, as individual social and cultural actors, occupy an important role of mediation between local and global levels.

This is a new area of research for anthropology, as in much of the anthropological literature on globalization in Latin America the focus is on communities rather than individuals. Such an emphasis on bounded social groups has its roots in the holistic traditions of anthropology (which continue in recent works on globalization, see Inda and Rosaldo 2001). It also seems to some degree justified by the self-identification of many indigenous people as members of social and symbolic collectivities, even when they are now entangled in the processes of globalization, which can be perceived as a threatening force but also provide new opportunities for resistance (see for example, Nash 2001, on contemporary Maya, and Colloredo-Mansfeld 1999, on the city of Otavalo in Ecuador).

Yet these approaches do not fully capture the experience and practices of individual actors in the globalization process. This is especially the case for urban centers, and the large metropolitan areas, such as Mexico City, São Paulo and Buenos Aires. One notable interdisciplinary exception to the holistic trend, and encompassing both the portrayal of individuals and collectivities, is the recent work on Mexico City by Néstor García-Canclini and his collaborators, focusing on such diverse topics as urban protests, changing living conditions and uses of space in suburban tenement houses, new immigration, and use of mass media (García-Canclini 1998).[1]

Becoming Indigenous: A Third Subject

"Becoming indigenous" in the extended sense of claiming to be native "of Argentina and Latin America" and by assuming an identity based on "indigenous" elements, is not a uniform process among artists. In fact, as seen in this book, it differs from artist to artist, and the same artist may exercise different practices, or technologies of appropriation, during his or her life. "Rooting," that is, leaving old and acquiring and creating new traditions, is probably the best expression for this process. The artists discussed in this book face a dilemma in that they do not perceive themselves any longer as transplanted Europeans, which was the old aspiration for Argentines, and not yet as natives of South America. As one member of the workshop of artist Juan Maffi put it, "We are a *third thing* [or subject]" ("*somos una tercer cosa*").

The choice of the artists, then, is a choice of difference. They have become diasporic in their own country with regard to their European cultures of "origin," and they remain different to the indigenous cultures they partly wish to assimilate.[2]

Outside stereotypes, as much as inside ascriptions define the spaces of identity. In fact, since 1983, as outlined in chapter one, Argentine society has opened up new spaces for identity, by allowing, at least formally in a democracy, various discourses on the nation to coexist. This enables not only descendants of Europeans (the majority of Argentines) to "indigenize" themselves, indigenous people too, become *more* indigenous. For the first time in Argentine history the new constitution of 1994 recognizes in Article 75, Clause 17, "the ethnic and cultural pre-existence of the indigenous peoples," "the juridical person of their communities" and the "possession and property of the lands which they traditionally occupy," as well as demanding to "guarantee the respect for their identity and the right to a bilingual and inter-cultural education" (Constitución de la Nación Argentina 1994: 30). A number of indigenous organizations, such as *Centro Kolla* and *Asociación Indígena de la República Argentina* (AIRA) had demanded these rights for decades (Briones 2005; Lenton/Lorenzetti 2005), and although having different agendas, were also supported by state and church agencies, such as the *Instituto Nacional de Asuntos Indígenas* (INAI) and the *Equipo Nacional de Pastoral Aborigen*. Also, national conferences on indigenous issues are now organized, such as the *Jornadas de las Naciones Originarias* in 1999 (figure 67).

In order to benefit from these new rights (especially when claiming land), one has to be categorized as "indigenous," it is not enough to be a poor "white," "Argentine" or a recent immigrant farmer of Bolivian or Paraguayan origin (Occhipinti 2002: 334). Hence it is understandable that people wish to categorize themselves now in ethnic terms in order to get access to resources (similar to what happens in the "developed" world with entitlements for so-called ethnic minorities). In Latin America, these developments are symptomatic of a more general phenomenon, where over the last two decades, in struggles for scarce resources, political categories have been increasingly substituted by ethnic ones, and indigenous populations have

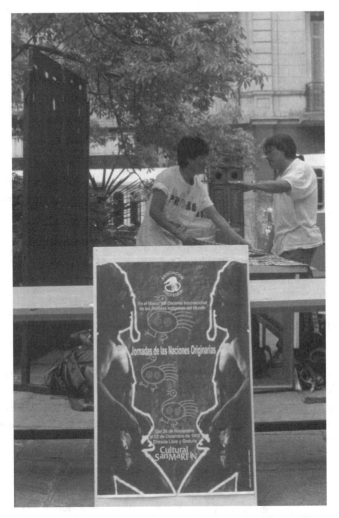

Figure 67 *Jornadas de las Naciones Originarias* 1999, Centro Cultural San Martín. Photo: Arnd Schneider.

achieved growing recognition by the political institutions of nation-states (Albó 1991, Maybury-Lewis 1991, Marzal 1993, Bengoa 2000, Brysk 2000, Blum 2001, Sieder 2002).

For instance, in neighboring Uruguay, where for more than a hundred years there have not been recognized indigenous groups, some present-day inhabitants of Montevideo have formed associations of Charrúa (the last indigenous group, extinguished in the mid-nineteenth century, cf. Pi-Huarte 1993), and even want their blood to be tested to see if they possibly descend from these indigenous people (Cannella 1990: 164). I have delineated elsewhere the reactions of Uruguayan artists to what they perceive as their country's fractured identity (Schneider 2000c).

Among the Argentine artists, as outlined in the introduction and discussed throughout the book, constructions of identity are not based on descent, but on territorial and cultural acquisition, both ideologically and materially through artistic practice (including travel to present-day indigenous groups and archaeological sites) and the collection of objects. Collecting is, of course, another technology of appropriation, and collections of indigenous objects in settler societies are both an expression of material appropriation and an ideology of remorse, in that they claim to represent the otherwise "lost" indigenous cultures and make good, in a moral sense, for the historical land-taking process.[3]

We could now ask why such cultural acquisition, or appropriation, as I have termed this process in chapter two, makes reference to indigenous cultures, and not to some other object of desire for identity? For one, there is an old and established discourse in the West and in fact in a great many cultures around the world of projecting their own utopia onto a golden past age or a foreign culture in which people lived simpler lives and were uncorrupted. Emblematic book titles treating this trope are, for example, the *Past as a foreign country* (Loewenthal 1985), or *Paradise on Earth: Some Thoughts on European Images of Non-European Man* (Baudet 1965). There have been many publications since; among the most significant are Todorov's *The conquest of America and Question of the Other* (1984), and Mason's *Deconstructing America* (1990). Though using different theoretical approaches, they all concur on the main issue, that is the idealization, of noncomplex "tribal" societies by European travelers and observers. At the same time, a discourse on the corrupting, "primitivizing" influence of non-Western societies also exists.

There is in Argentina, of course, also the dominant parallel process of appropriation from Europe, that is during colonial times, from the imperial center, Spain, at the end of the eighteenth century from Englightenment France, and during the nineteenth and twentieth century, mainly from France, Great Britain, Spain, and Italy. Fine arts were no exception in this respect, and recent studies have shown the heavy European impact on art institutions (museums, academies, schools), which included both travel by painters and sculpteres to copy from European collections, as well as from numerous European artworks imported into Argentina.[4]

When they making reference to indigenous cultures, contemporary Argentine artists fall to some degree into the first category (of idealizing indigenous people). However, their expressed attitude is one of "respect"—which was the concept most used when their approach to indigenous cultures was explained to me. At the basis of this conviction lies a concept of indigenous cultures that is in fact an overtly positive, not to say idealized one. Respect means for these artists to appreciate and accept cultural others and their artefacts, yet such appreciation and acceptance is intrinsically linked to the technologies of appropriation, and does not exist for its own sake. It is respect that serves to achieve particular means, intellectual, artistic, and sometimes, also commercial. In addition, as seen in chapters six and seven, on the work of Javier Olivera and Teresa Pereda, respect is also linked to feelings

of guilt for the land-taking and conquering process, and its atonement by (some members of) present-day generations.

We can now ask what the main criteria are for the choice of elements from other cultures? Which elements are taken, and which are discriminated against? For the most part, elements of a presumed "traditional" culture are taken, because these are supposed to be more original or authentic than those which are influenced by modern and post-modern societies. Another preference lies with past, Pre-Columbian cultures, both in Argentina and elsewhere in Latin America. Because the artists make a deliberate choice to sever their cultural ties with Europe, so too the ancestry to the ancient origins of European cultures, that is, the "classic" cultures of the Mediterranean and Middle East is cut off. In interviews, reference was often made to ancient Old World cultures in the curriculum of Argentine higher education institutions and art schools, and contrasted with the parallel omission of Pre-Columbian Cultures. However, in some cases the dividing lines between European ancestry and newly acquired Pre-Columbian, or contemporary indigenous routes are not as clear-cut. For instance, the late Gonzalo Fonseca (whom I had occasion to meet and converse with in New York in 1994 and 1996), combined an interest in Pre-Columbian art with a profound exploration of the ancient cultures of Old World antiquity (cf. Paternosto 2001: 97–98; also Ramírez 1992: 263–266).

In any case, only a few artists seek *direct* contact or, moreover, *dialogue* with contemporary indigenous people, such as film-maker Javier Olivera and visual artist Teresa Pereda, whose work and field-trip to Jujuy I have reviewed in this book. Why would this be the case? As the following section on the painter Andrés Bestard shows, one reason for this is that contemporary indigenous cultures, specially in Argentina, are regarded by the artists as equally "uprooted" as other Argentines of European descent. Thus indigenous people are perceived by the artists as much in need of re-creating their roots as other Argentines—and these roots, by definition, lie in the past.

The painter Bestard studied with anthropologist Guillermo Magrassi and archaeologist Florencia Kusch[5] who also introduced him and others, such as Norberto Rodríguez to indigenous topics, (see chapter one, figure 1, and chapter three). As a draughtsman Bestard also accompanied archaeologists on excavations, and his paintings of this period were inspired by Pre-Columbian rock art and other indigenous influences. More recently, however, he has turned to large paintings of the port of Buenos Aires, both the new and the old Puerto Madero, "as our [European] ancestors would have seen it when they arrived here." Whilst the new port scenes are a result of specific demand by his gallery, and allow him to earn some money, he also sees a connection to how Argentine identity is constructed. In the following longer extract from our interview Bestard explains his search for new roots in Argentina.

Andrés Bestard: The *crisis* we experienced after the Malvinas War [in 1982] also generated a search for identity. The break with Europe, the way they fell on our

back,[6] unsettled the situation for many who had looked constantly towards Europe.

. . .

You had to have almost a funny tension inside you to ward off the image of European art and culture which the teachers were imposing on you in the Academy of Fine Arts. This is why we started to work in a student centre, in order to vindicate another type of image. There, the opportunity arose to make a couple of trips with colleagues from anthropology and ethnobotany, and during these trips to the Chaco I established direct contact with indigenous people.

. . .

A.S. *In the plaza near your studio, here in the neighbourhood of La Boca, I spoke with three old men who told me: "In the past things were better, now the neighbourhood is full of Bolivians."*

Andrés Bestard: They don't realise of course, that they too are descendants of immigrants. In Buenos Aires the arrival of other Latin American immigrants is experienced by the *porteño*, son of European immigrants, as an invasion. You realise, what kind of contradictions this generates? *The invader feels invaded*, now.

. . .

And what I projected onto the indigenous people, thinking that I had completely left behind this stage, was that they had to vindicate their history. Because their history had been completely negated by the white people, but not because it was bad, but because it was not convenient, politically and economically. So, our project was, as teachers and artists, to reconstruct the indigenous past.

The whole project was to reconstruct, through education and art, what we perceived as *ours* (*proprio*), as indigenous of this place, and to restructure art from that vantage point. But with time, and from a more mature point of view, I said to myself: "What I promote here to the outside, and what I tell indigenous people what they should do, I am not applying to myself."

Because, with that false precept which I had, that I was an Argentine who already knew who he was and who had a project for society and nation, I had never asked myself, "Who were my grandparents, where did they come from?" . . . That's what I mean with the *non–identity* of the immigrant.

. . .

So, if you draw that parallel between the indigenous people and the immigrants, you understand that *we are not united by history*. In fact, it confronts us all the time; we are not united by the discourse on Argentine identity. Because who is indigenous is not Argentine but indigenous, and from a specific culture. This is why I wanted this new *project of unity* between immigrants [and descendants of immigrants] and indigenous people. We had to establish a new common platform. But the indigenous people looked at me, as if saying: "Why? *This is not our project*. Our project is to continue being indigenous people."

. . .

It is very difficult to reencounter one's roots in Europe, because of the *great negation* which occurred through the Argentine education system. The crisis which for immigrants and their descendants is conjured up by the image of

Latin America is to some degree this one. The indigenous person does not assume his true being (who he is) because when he says that he is indigenous, he is taken from his place with an attitude of contempt. The Creole (*criollo*), the son of immigrants who was born in America, has no identity either, his identity is in Europe. It is like a kitchen utensil you unplugged, once you do that it has lost its energy. Once you return to your place, you understand that it is not the place where you were born, but where your whole history is.

So, I am a native, indigenous person from Mallorca (*"indígena mallorquín"*). [my emphasis added in Bestard's interview extracts]

Whilst the transparency of his motivations and the self-reflexivity toward the process of appropriation are remarkably explicit in Bestard's account, his concerns are shared by other artists I have interviewed for this book.

Crisis as a Trigger for Identity

For Bestard's generation, in general terms, the search for a new identity starts in a moment of *crisis*. By contrast, younger artists who started their career after 1983 could already benefit from democratic rule, and an openly expressed revalorization of the indigenous past by some artists, such as Bestard (though not necessarily in state education), which had been suppressed under the military dictatorship. For Bestard's generation then the crisis of identity is related to the atrocities of the military dictatorship (1976–1983) and the aftermath of the Malvinas War (1982). Obviously, this is a specific interpretation of the past, and other, more right-wing and conservative sectors of Argentine society will have a different understanding of recent political history. In addition, Peronism, presented the other project for national unity in the postwar period, but it was extremely heterogeneous, both in terms of its politics, and the sections of the population which followed it. Apart from a rather nebulous claim to a "Third Way" (between the superpowers), Peronism did not offer anything specific to those seeking a distinct Latin American identity, and less so for indigenous people.[7] However, it is the perennial theme of an art education dominated by a European cultural model that makes Bestard, and other artists of his generation, look for a "different type of image" which he finds in indigenous people. This is also clearly expressed in a leaflet of the 1991 exhibition *Artistas Plásticos Sudamericanos* in which Bestard participated, "We create our way of work taking the free creation and the free expression as starting point, without foreign patterns, with no imitations" (ungrammatical English in the original).

From Nonidentity to New Identity

In the central part of our interview Bestard spells out that he and his collaborators wanted to "reconstruct" what they perceived as "ours and

indigenous" of Argentina. The reason was that European models of identity, based on descent, had exhausted themselves, and in fact resulted in the "nonidentity" of the immigrants and their descendents. As categories of descent were not an option, new identities are legitimized through claims over territory and history (including Pre-Columbian history), as an appropriation of space and time, which are now labelled and incorporated as "ours and indigenous." This implied further that Bestard and his collaborators also had to find and reconstruct a new "indigenous" image for Argentina's indigenous population, not only for the descendants of immigrants. Theirs was thus an *inclusive* project of creating new roots aiming to overcome the fragmentation of identities that resulted from colonization, independence, repression of the indigenous population, and mass immigration, as revealed in the first chapter. At the same time, the project to homogenize historically disparate identities of descendants of immigrants and indigenous people is also a patronizing one, engineered from the vantage point of the urban-based, "white," European-descended artist. The historic land-taking process thus is paralleled by the incorporation of indigenous culture into a new identity common to both descendants of immigrants *and* indigenous people, rather than the earlier denial of indigenous culture. However, Bestard freely admitted that his and other artists' aspirations to "unite" descendants of immigrants and indigenous people who both, in different ways, had lost their identity, ran into trouble.

Indigenous Identity as Different

This was because indigenous people were insisting on their own destiny. They wanted to "continue to be indigenous" and did not want to be claimed or appropriated by somebody else's agenda. Hence the concept of indigenous is a radically different one when used by native Argentines themselves. The contrast is sharp with artists' and other intellectuals' agendas, which repeat the familiar course of indigenist projects in Latin America (Franco 1970, Marzal 1993, Gutiérrez 1999).

Intriguingly, and as a consequence of both market demand and his renewed reflections on identity, Bestard's art now has come full cycle. His large-scale views of the port of Buenos Aires (as well as transplanting, Argentine flora, such as the OMBÚ tree, into a fictive New York Cityscape), whilst on the one hand playing to the tastes of his collectors, are as much a statement about identity, as were the symbols taken from Argentine prehistoric rock art in earlier paintings (figure 68).

Significantly, at the end of the interview, Bestard resigns his Catalan "indigenousness" to the distant island of Mallorca of his forebears, fully realizing that this, too, can only be an artificial construction of the past.

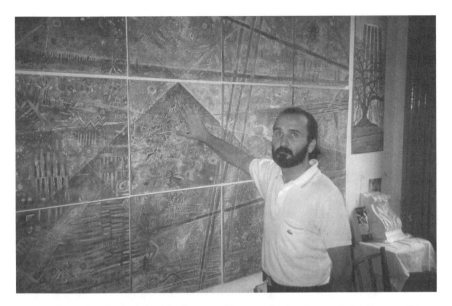

Figure 68 Julio Bestard in his Buenos Aires studio in front of *El Presente Eterno* (250 × 200 cm. sgraffiato technique), 1996 (left), and *Un Ombú en Nueva York* (35 × 90 cm., oil on canvas) 1998 (right). By permission of the artist. Photo: Arnd Schneider.

The Other as a Reservoir for Identity

Whilst the artists covered in this book share Bestard's explanations overall, not all of them are as self-reflexive and self-critical in their practices of appropriation. The cultures of indigenous people, and particular images of them (not to say stereotypes), are regarded as a reservoir for identity. Especially after recent political and economic disasters in Argentina, the Western model of culture has turned into a dead-end for some of the artists, so that they turn away from it to find new sources of inspiration. This repeats somehow the pattern that a *crisis*, be it political (Malvinas War and discrediting of the military dictatorship), economic (hyper-inflation), or cultural (fragmentation of national identity), will trigger or usher forth a search for new identities. Obviously, such a general disenchantment with political, economic, and to some degree also cultural projects for national identity, does not prevent artists, as well as other Argentines, to perfectly feel "Argentine" or rally behind "national" causes in other realms of national life, especially sports, for instance, as followers of the national soccer team (see also Archetti 1999, 2001).

Artists' choices are also framed as individual choices against the global international art world. The dominance of the international, Westernized art world, of course, has been questioned for some time, both from within and without this art world (McClancy 1997). Apart from individual artists, prominent and visible examples of this resistance are also the various biannual art shows held in the so-called Third World, such as the Havana Biannual, the São Paulo Biannual, and the Dakar Biannual, as well as global, multisited

events with a strong emphasis on postcolonial issues, such as the recent Documenta XI.[8] As the artist Anahí Cáceres pointed out to me:

> The resistance to globalisation comes also from people "within" the globalisation process, who work with the media of globalisation. [i.e., the new technologies]

Artists as Mediators: Making Globalization Work

It is precisely the uneven levels of power, and the distribution of different types of knowledge and cultural expertise, that allow artists to become mediators in the process of globalization. The commercial photographer Gaby Herbstein (chapter five), the film-maker Javier Olivera (chapter six), and visual artist Teresa Pereda (chapter seven) are all, in different ways, entangled with their art practices in making globalization work—here understood as the diffusion and transformation of local images and forms of meaning through wider networks of communication.

Artists also increasingly use the internet to communicate their images to a wider, international public. The World Wide Web, of course, creates the illusion of contemporaneousness, geographically and culturally, of distant others—a phenomenon that has been pointed out many times over as a characteristic of postmodernity, or what Harvey (1989) called "time-space compression."

For instance, Ximena Eliçabe, a multimedia artist (working with textiles, feather, video, and computers) feeds images of Argentine indigenous communities and her own works into the Internet, and in this way makes indigenous subjects available to a worldwide audience, albeit dispersed and heterogeneous.

Eliçabe studied at the National Art School Pridiliano Pueyrredón with Alfredo Portillos, whose art draws on indigenous cultures (cf. chapter three). Eliçabe also studied and worked as a teaching assistant with César Sondereguer in the classes of Pre-Columbian design at the architecture, design, and urbanism faculty of Buenos Aires University, reviewed in chapter four. However, for the last few years she has been exploring more independent ways of engaging with indigenous influences, and has drawn her inspirations from a variety of sources. She has visited indigenous communities in Chiapas, Mexico, and in 1996 went to Havana, Cuba, for a workshop on indigenous feather craft with the Bolivian artist Alejandra Bravo. Based on this experience, she created the costumes and performance of *Mantos chamánicos* (Shamanic Coats) in 1996 (figure 69).

Two female dancers are dressed in colourful feather costumes, which Eliçabe assembled using the techniques she had learned from Alejandra Bravo in the Havana workshop. The choice of colors makes general allusions to the feather art of the Indians of the South American lowlands. However, as Eliçabe pointed out in our interview, hers is a work of *synthesis*, not inspired by a particular culture. The choice was more determined by the two characters the costumes had to present, one relating to the spiritual world of the sky and the other to the underworld (represented on their painted faces, by a white and a black eye respectively), rather than by specific ethnographic reference. Eliçabe's approach is further evidence that artists

Figure 69 Ximena Eliçabe *Mantos chamánicos*, 1996. Courtesy of the artist.

Figure 70 Ximena Eliçabe in her Buenos Aires studio. Photo: Arnd Schneider.

mainly follow a synthetic approach, assimilating from many different sources, and are not primarily occupied with singular ethnographic detail.

More recently, Eliçabe has been involved in creating a Website, documenting folk and indigenous crafts of Argentina's interior provinces, such as Catamarca and Jujuy (figure 70).

Research for the Websites and their creation was supported by the *Consejo Federal de Inversiones* (*CFI*), a federal agency which promotes investment in the provinces. The projects by Ximena and her business partner Germán Trench aimed to promote, as they put it, "our autochthonous heritage" (*lo nuestro, lo autóctono*) by sponsoring local artists and artisans, and documenting their work on Websites and making them available to the public. However, their work does not just consist in transferring images of indigenous art and crafts to the Web, but also making computer technology available in the provinces, helping local museums, and organizing art and crafts fairs.

Ximena Eliçabe commented on how she saw the use of multimedia complementing and enhancing artistic practices and the diffusion of knowledge:

> This is why I found it interesting to work with multi-media, including CD Rom, because you can present your work in intuitive ways, and people can search for it in aleatory ways, not just with one way of thinking and a lineal version, but in an intuitive fashion it allows them to access different levels of information according to their interest. It also meant to take advantage of the fascination the new technologies produce.

Ximena's art is informed by global locations, experiences and practices. She is based in Argentina and has travelled to Cuba to participate in a workshop with a Bolivian woman (who lives in Switzerland) to learn a technique by Amazonian Indians to dye feathers. She has travelled with her sister, a photographer who lives in Barcelona, to Chiapas and stayed with EZLN (Ejército Zapatista de Liberación Nacional) rebels and Maya groups and investigated textiles as symbols of rebellion. She also studied with artists and theoreticians of indigenous cultures and their influence in the arts, such as Alfredo Portillos, and with César Sondereguer. Thus she embodies the example of a "global" artist, working from her base in Argentina, cooperating with local artists and theoreticians, adopting a variety of technologies of appropriation (travel, collecting, performance, the Internet), engaging in multisited work, and disseminating local work on a global scale.

Her example is also indicative of a new, younger generation of artists whose political views and actions appear to become more arbitrary and change rapidly with specific projects and circumstances. In addition, political ideologies of class and armed struggle that would have characterized the 1970s are dissolved and substituted with ethnic and identity discourses.

The Transubstantiation of the Indigenous

With the following example I would like to show that an interest in indigenous topics can be pursued in media radically different to those presumed to be "traditional" artistic ones, and is not tied to direct references and one-to-one transferrals of indigenous symbols, and their material representation in conventional media.

Anahí Cáceres has been one of the principal promoters of digital and web art since these new technologies were introduced on a large scale to

Argentina in the 1990s.[9] In 1998, she founded www.arteuna.com, the first
Argentine Website dedicated to art, reviews, literature, and avantgarde music.
Run only by herself and a partner who looks after the technical side, it was
initially completely self-financed and by 2000 had about 16,500 visitors.
More recently, the Website has been sponsored by the Buenos Aires city
government. Cáceres also directs the laboratory for digital art at the art
school Ernesto de la Cárcova. Her background is in fine arts, but she left
painting and other "material" techniques almost entirely in 1995. However,
the art she produces on the computer can also acquire a physical presence, for
example, by being printed on silk screens. [10]

Anahí Cáceres had already an established track record of working with
indigenous cultures. Many of her artworks of the 1980s and early 1990s were
inspired by Mapuche culture, and she had done research on some aspects of
Mapuche ritual. Till 1994, Cáceres used performance, installation, and sculp-
ture to appropriate elements from Mapuche culture, the Araucanian Indians
living in Patagonia and Southern Chile. In her youth, Cáceres lived in Chile,
and again settled in Temuco, Southern Chile for four years, from 1986 to
1990. With her work, especially in the areas of performance and installation,
she intended to throw new light on the ritualistic connotation of art amongst
the Mapuche, and rediscover these for contemporary art. In her published
investigations into the ceremonial and mise-en-scène character of Mapuche
ritual, such as the *Nguillatún*,[11] she sets out her approach, with an innovative
usage of the terms "ceremonial art" and "installation" (Cáceres 1992). On
the one hand, she transposes the term "installation" from contemporary art
to speak about the shamanic performances of the *machi* (shaman) amongst
the Mapuche, and the construction of a *rewe* (a kind of altar, or ritual post[12])
as a ceremonial space, and on the other hand, she applies "ceremonial art" to
characterize her own artworks, for example, in the 1992 series "Kiñekura—
Primera Piedra."[13]

In our conversations (Cáceres 1993, 2000), Anahí Cáceres emphasized
that she understood her installations as private ritual that leaves the realm of
the everyday, and investigates the meaning of objects and their positioning in
space. According to Cáceres, the installation is therefore related to and yet
different from tribal rituals (such as those practised by the Mapuche), which
involve the whole of the community. Since 1994 Cáceres has turned entirely
to digital art and in our interview in 2000 she explained the reasons:

> I see digital art related to engraving, not in terms of the technique or the range
> of engraving, but in offering possibilities of massive dissemination. More than
> anything else, I am interested to work with the internet, because it allows you
> to print artworks with a plotter, make CDs, or show them as videos or in an
> installation. But the internet for me is comparable to the move from an elitist
> art to a democratic art after the invention of the printing press.
>
> . . .
>
> There is still a lot of resistance among artists against digital art. A bit of preju-
> dice, also. Without the smell of turpentine, without the physical contact with
> the material, without making yourself dirty, it's not art! I don't agree. Because

I got myself dirty for 25 years; making engravings, I breathed in acids, and washed off oil paint from my hands, and I can tell you, it's a mess to wash off engraving ink! I know all that. I don't shun it for the digital, it's rather that after having practised all those techniques for many years they facilitate things—even in digital art.

. . .

It was an abrupt change. [In 1994] I stopped exhibiting, and started studying software programmes. I had never touched a keyboard before. I studied by myself, and didn't produce work to exhibit for two years. But I was still around, producing images with the computer.

. . .

A.S. When I first met you in 1993, you made little paper sculptures inspired by Mapuche culture.

Anahí Cáceres: Yes, for *you* my move to digital art must appear as a big change. Many people told me that. However, other people I socialised with during these two years, who saw me continuously, realised that there was the *same theoretical thread* running through my work.

. . .

The theoretical part stayed the same. What changes is the technique to realise a material or an immaterial object. I have texts I wrote on indigenous cultures which speak of the *immateriality of the object*. When I didn't have the computer yet, I tried to reach a synthesis. I was very interested in the use of hand-made paper, wooden branches, and wire. I wanted to see the "digital" structure of the material, not the narrative of fabrication, but the pure language of the material (. . .) the silence of the paper, the silence of the wooden branches, the silence of immateriality [figures 71–74].

. . .

I have Mapuche roots on my father's side, and he researched our family's history in Chile. So, maybe there is an "oedipal" reason for my interest in indigenous cultures, but then it became generalised, detached from my person. It became more universal, detached from specific symbols and signs.

Figure 71 Anahí Cáceres photo of *Yiwe* Malleco, Chile, which was reproduced by Alicia Cáceres for the project YIWE-YIWEb during the residency at Franklin Furnace/Parson Design Center, Performance DCTV, New York, 2001. Courtesy of the artist.

Figure 72 Anahí Cáceres, *Ngillatun*, 1992. Courtesy of the artist.

Figure 73 Anahí Cáceres *El gran quipu*, 1992. Courtesy of the artist.

Figure 74 Anahí Cáceres *Primera Piedra (Energía)*, 1992. Courtesy of the artist.

More recently, Cáceres carried out a virtual performance at the Parson Design Center in New York, where she handled a Mapuche ritual cup, *Yiwe*, with remote sensors (see http://www.arteuna.com/talleres/Caceres/proyecto2001.htm, and figure 71).

To sum up, Anahí Cáceres' work shows powerfully how artists can abstract from a direct transferral of symbols from indigenous cultures, to arrive through digitial art, at a work of synthesis. Even in digital art she finds an original inspiration with her work on indigenous cultures, and her theoretical concerns with the "immateriality" (or spirituality) of the object—though still rooted in the material representation and reproduction of work (via silk screens and other means).[14]

Against Amnesia

My final example in this section is Mónica Girón, who was raised in Patagonia of Swiss parentage and is represented by Buenos Aires' leading gallery, Ruth Benzacar Gallery. She studied in Switzerland, and exhibits internationally, in the United States, Europe and Argentina. In her series *Ajuar para un conquistador* (Trousseaux for a conquistador) (figure 75), Girón made knitted versions of a large number of objects from Patagonia, both of the animate and inanimate environment. Her work criticizes the land-taking process in the Argentine South, following the Campaign of the Desert in the late 1870s. The subsequent transformation of Patagonia (especially in the Andean areas) into a tourist idyll, was accompanied by the complete suppression of indigenous people and, having forced them into reservations, the

Figure 75 Mónica Girón *Ajuar para un conquistador* (Pullover for American Stork, merino wool and buttons), 1993. Courtesy of the artist.

conquest and appropriation of their lands, which resulted in a general amnesia among the "white" population,[15] who put forward their official history in the museum of Bariloche on which this work of Girón is based.

When I observed in our conversation that her work is more about the natural environment and does not make direct reference to the Mapuche, Mónica Girón replied:

> No, because my direct experience of the territory is that of an empty space. I worked with that topic, with "emptiness," that is with the absence of what is not there. I did not try to revive what is absent but I wanted to make evident this emptiness. The birds are not there, so I worked with the absence of birds. With the torsos [for the knitted trousseaux, A.S.] I used my own torso which is a western torso, and thus commented by implication on the absence of indigenous bodies and autochthonous trees. And with my other work *"De frente" tierras de la Patagonia* [figure 76], the gloves are made from earth, but do not have an exact reference, only that they are human, but ambiguous, and as gloves, they are western. It is like an appropriation starting from the recognition of an absence. Because I grew up without knowing. For example, in primary school, they told the history of Patagonia as a virgin territory.

Girón has been teaching a private art-theory class in her studio twice a week since the early 1990s, where young artists attend to learn about the latest tendencies in Europe and North America. The class also functions as what art teachers in Buenos Aires refer to as *clínica* ("clinic"), a workshop to which students bring their work, which is then discussed and criticized. Girón reads

Figure 76 Mónica Girón *"De frente" tierras de la Patagonia* (earth, stone, various materials), 1995. Courtesy of the artist.

from authors (in art theory, philosophy, and cultural studies) and translates them in the class. She asked me in our conversations whether I had read Homi Babha's *Nation and Narration,* which she used in the class. Girón's example is indicative of the mediating role artists and art critics have in *importing* and *disseminating* models of thought from Europe and North America, such as the current trends in postmodernism to what is still perceived as the peripheral art world of Buenos Aires.

Globalization then is a multistranded, multidirectional process by which local elements get transformed and transported to a larger, international audience, as we have seen with the work of Ximena Eliçabe and Anahí Cáceres, but also where international models are adopted in local contexts, as Mónica Girón's example demonstrates. There exists then a parallel or contemporaneous process of appropriation both from indigenous and international sources (the latter somewhat substituting what were once the European models for Argentine artists). Obviously, there is also the increasing penetration of the global art world by commercial actors, operating from local centres, such as the galleries and Websites (for example, www.latinarte.com) which have been discussed in chapter three.

The important issue here is to emphasize how both individual artists, and more powerful commercial players (galleries, museums), now occupy the spaces of mediation between local and global levels.

In these new spaces of mediation, filled both with the multimedia practices of contemporary artists in Argentina, and with more "conventional" genres

(such as painting and sculpture), any message "originated," or circulated by indigenous cultures gets transformed, both in terms of form and content, whilst at the same time reaching a wider and more diverse audience, than has been previously the case trough exhibitions and catalogues. Artefacts, symbols, and indigenous narratives are taken out of the context where they were first created (I prefer this expression to the essentializing term "original," as explained in chapter two), and invested with new meaning. As Xavier Inda and Renato Rosaldo have put it more generally for the inverse process of global forms entering local cultures, so too, local forms enter global spaces, where they become "customised, interpreted, translated and appropriated," according to the (local) "condition of reception" (Inda and Rosaldo 2001: 16). However, any presumed "original" meanings (see above) that are transformed, changed, altered, and made completely different still trigger the effect that *a new discourse* about indigenous O thers is opened up, whereas before, at least in Argentina, there existed mostly denial and oblivion with regard to indigenous cultures.

So if we conceive of artworks as commodities, they would share with commodities the characteristic to "mediate in the encounters between culturally distant others" (Inda and Rosaldo 2001: 3). New opportunities are also opened up by globalization, and paradoxically, as Cáceres indicated in the earlier quote, also allow to question globalization from within, rather than to refocus on a romanticized image of indigenous people.

Globalization and the Technologies of Appropriation

Clearly, in the practices of the artists reviewed in this book we can discern a number of different technologies of appropriation (consisting, as we recall from chapter four, of both strategies and techniques) which allow us to construct a typology. This typology is not meant to be exhaustive and hermetically closed, but open to further research findings.

In the first instance, we can distinguish between *direct* and *indirect* appropriation, direct meaning that artistic research and practice involve the face-to-face contact with indigenous communities, or in the case of past cultures the first-hand participation in archaeological excavations or visits of archaeological sites. Obviously, there are different degrees of engagement with the subject involved which include private and public (institutional) study or research, collaborations with anthropologists and archaeologists. *Travel* to archaeological sites and to visit indigenous communities, ranging from short trips to extended stays (some of which parallel, in depth and degree of scholarly profundity, anthropological and archaeological fieldwork), is the most common technology of appropriation. In addition to the appropriation of indigenous culture such travel also involves the appropriation of indigenous space (often as an intrusion which has to be negotiated as we have seen in chapters six and seven). However, direct contact with indigenous people and communities can also be established without distant displacement. In fact, some artists also meet members of these communities in their home cities, such as Teresa Pereda (who met with members of the Kolla community in

Buenos Aires), and Gaby Herbstein (who collaborated with representatives of indigenous communities in Buenos Aires). Travel involves physical and temporal displacement, underscoring the cultural (and temporal) difference perceived and created through appropriation. Thus travel is also related to the appropriation of space,[16] albeit temporarily (though conceptually space might be claimed much longer than the actual duration of the travel). In a wider sense then, we are also dealing here, as mentioned in chapter two, with an appropriation of time and history (for which Fabian 1983), when the Pre-Columbian past of Argentine indigenous cultures is claimed by contemporary artists (who descend from Europeans) as *lo nuestro* or "ours."

The *indirect* technologies of appropriation involve all practices where contact with indigenous people (past and present) is mediated through third media and parties, and include photography, sketching/drawing, writing, expressive media such as performance and installation, and all content mediated through the Internet, as well as the collecting of artefacts. Whilst the indirect technologies can all be practised through intermediaries, that is, books, photographic sources, exhibition artefacts, "primitive" art dealers, museum curators, and so forth, they can also be part of the apparatus of the direct technologies, that is, they can be employed through travel and other first-hand contact with indigenous people as described above.

It should be pointed out that these *appropriation technologies* are not fundamentally different from those employed by artists who are mainly inspired by European, North American, or in fact models of the international art world. This is for the simple reason of shared training, which does not take place in separate spheres and institutions for artists inspired by indigenous cultures. With very few exceptions, such as the institutions featured in chapter four, in Argentina there are no schools, museums, film or art academies dedicated exclusively to the teaching of indigenous cultures—further reflection of the hegemonic culture in which indigenous people remain marginalized (albeit with greater opportunities for expression after the end of the last military dictatorship in 1983).

Further important determinants of the nature of appropriation are the material constraints and frames of reference which condition the artistic processes, and determine in some ways the closeness or distance to the indigenous subjects. This is seen very clearly with the production of the cinema movie *El Camino* in chapter six, where the sophisticated technical equipment, complex production processes, and a big crew had a different impact on the indigenous community (and different implications for the type of their representation) than would have been the case with for example a small team of documentary film-makers.

Therefore, it has been essential in this book to show how artists conceptualize appropriation, that is to say, how they view their strategies to incorporate difference into their work, and, finally, how they construct proximity and distance do their subject, and how this influences the process of appropriation. Arguably, with those strategies which employ a higher degree of abstraction, a greater recognition of difference takes place, since these,

conceptually speaking, refute the idea of one-to-one transferral or assimilation. Similarly, in those artistic traditions that do not put themselves into a legitimizing context there is an explicit degree of reflexivity (in the construction of otherness) and quest for the cognitive experience of otherness through individual research strategies which do not serve an ideological paradigm, such as the classic varieties of "indigenism" (e.g., Franco 1970, Marzal 1993, Gutiérrez 1999). On the other hand, artists also express appropriation in the idiom of identity, a newly constructed belonging in Latin America—what was other becomes now *lo nuestro*, or "ours."

We have also observed, through the examples provided in this book, that appropriation, and subsequent "indiginization" and globalization of indigenous cultures are politically and economically uneven processes. The "power geometry" as Inda and Rosaldo (2001: 12) call it, still defines which routes the "cultural stuff" transformed in theses encounters will take. In chapter three, we have seen how the hierarchies of the Buenos Aires art world determine to a large extent who is recognized with success and who is not, and how this success is channelled to an international art world. Other chapters, especially four, five, and seven, have demonstrated how the appropriating agents, as visual artist (Teresa Pereda), film-maker (Javier Olivera), or photographer (Gaby Herbstein), are in a much more powerful and advantaged position with respect to the subjects they are dealing with.

Challenges of Practice: The Outlook for Anthropology

This book has not just been about artists and artworks in the process of globalization. A strong case, specially in chapter four, six, and seven, was made for a change in the anthropological research practice on art. Because the focus has been on practices, it is advocated that anthropologists leave the preferred and customary position as observers of material practices, but instead participate in these very practices. These material and bodily practices[17] are essential to understand the work of appropriation and artistic practices more generally. Only when anthropologists express materially (albeit in limited ways) creativity, and artistic practices are inscribed into the work of the anthropologist, can we arrive at a better understanding of the processes involved in appropriation and artistic practices.

In this sense, practical engagement with artists' practices can provide fresh impetus to the study of art worlds, which so far has been dominated by studies *of* artists rather than *with* artists (Schneider 2004c), and lead to a fuller appreciation of the participant side of the ethnographic method. These studies will still be situated in concrete art worlds, a proper understanding of which, rooted in urban anthropological research as developed in this book, for instance in chapter three, is necessary to locate artists within the art system.

Whilst the examples from my own fieldwork in this book show different degrees of engagement with artistic practices, ranging from punctual and short-term intervention in the film project (chapter six) to full participation

in the materially creative process in the ceramics class (chapter four), future collaborations between artists and anthropologists could evolve in a wide variety of media (installations, video art, and multimedia to name but a few). New forms of research and (re)presentation could be possible in such collaborations, especially in order to capture the enormous wealth and variety of sensorial data gathered during fieldwork.

We can think here of an emerging field of practice which includes ethnographic modes of appropriation and representation and which is explored by different actors, both artists and anthropologists, who bring different skills and methodologies to the projects.[18] However, it is not the disciplinary differences which will define the rules of engagement with the other (after all, the subjects and partners for our research and representations), in an overlapping and changing set of practices, but rather differences in power, economic status, and cultural identity.

Appendix I: A Note on Methodology, or the Challenge of Artistic Practices

In terms of methodology, an emphasis on process (individual artists) rather than final product or result (i.e., artworks) represents a considerable challenge for ethnographic research. How to observe the process of artistic creation, let alone the discourses and actions of identity construction, which are not easily tangible and accessible?

Anthropological fieldwork was carried out in Buenos Aires for one year from October 1999 to September 2000, and for a month and a half in November/December 2001.[1] Because of the guiding interest in the processes of appropriation, I intended both to interview artists and to observe their working practices. However, it proved to be more difficult than I had expected to observe artists. Mostly, the single artist's work is still solitary in the studio. Whilst one can hang around for some time, for instance, after an interview or after being shown work in the studio, it is less feasible, or almost impossible to be present when artists "work"—unless one is also involved in the process. This insight, that is to participate in the making of artworks, provided my way forward on several occasions, for example, when working in a ceramics studio, when casting extras during a film shoot, and when accompanying an artistic field-trip—all of which are discussed in the respective chapters (four, six, and seven). Rarely, have anthropologists opted for participation in the artistic process. It is still a novelty for anthropologists to cross borders into that direction and take on artistic practices. For instance, Schneider and Wright (2006) advocate strongly the engagement of anthropologists with artistic work.

During fieldwork, I employed a great range of methodological tools to get answers to the research questions, and tackle the variety and richness of empirical data.[2] My ethnographic approach was "multisited,"[3] involving fieldwork locales in Buenos Aires, as well as in Patagonia and in the Andean province of Jujuy, where I accompanied artists on their fieldtrips. Rather than restricting myself to any one method, I found great strengths in the combination of several. Given the focus of my research on the appropriation of indigenous cultures among artists, the emphasis was on qualitative methods rather than quantitative ones. I conducted a considerable number of

prearranged interviews with artists, critics, and gallery owners which, with the interviewees' consent, have been recorded on tape. Interviews were open-ended and unstructured, following the course of the conversation rather than any pre-formulated questions. Key topics discussed in all interviews were the appropriation of indigenous cultures, the artists' motivations, and their career paths. Participant observation was carried out during these interviews, and also at openings and during visits in galleries, museums, and other exhibition spaces, as well as during the week-long art fair *Arte BA* in May 2000 (see chapter three). The arranged encounters and interviews were agreed upon with artists at the places of their best convenience, and would take place at their homes and in their studios, in cafés or restaurants, at art fairs, in galleries, at art schools, and also at my home. The majority of encounters took place in the homes and studios (or a combination of the two when the artists' studio was also at the place of his or her residence), and this variously allowed me a different kind of insight into their "world," than I would have had in a café or other public place—although in some instances, a first meeting in a public place could be followed up by an invitation to visit at home and/or the studio. Some visits to artists' homes and studios allowed me to make deductions as to artists' social status, their interests and preferences in the art world (e. g., through the kind of works by other artists on display) and wider cultural tastes (indicated, for example, by furniture, books, and food). In other instances, especially with more established artists, studios or the showrooms in their homes were more arranged as display cases for their work, similar to gallery rooms, which would not allow any more insight into their life-worlds. There was no established pattern to the interview situations at home and in the studio (and where the two overlapped, see above), although on a number of occasions a conversation, with drinks, and sometimes food offered, would be followed by a showing of the artworks, and accompanied by specific explanations (but the reverse order was also possible).

Intensive participant observation was carried out by attending classes for graphic and textile designers in Pre-Columbian Art, directed by Professor César Sondereguer at the architecture faculty of the University of Buenos Aires, as well as during visits to the studio classes of Juan Maffi, a Buenos Aires sculptor who also teaches at the national art academy, Ernesto de la Cárcova. Participation in the practical work of the ceramics classes of Pre-Columbian pottery in the studio of Mirta Marziali yielded important data on the actual process of appropriation, as did participation in the classes in the arts and crafts classes of the *Escuela Taller Municipal de Artes y Artesanías Folclóricas de Morón* in Greater Buenos Aires (see chapter four).

The research for chapter five, which focuses on the issues of representation of indigenous peoples in both commercial and artistic photography, was based on a number of research strategies. These included both the reception of works (Gaby Herbstein's exhibition and calendar *Huellas* ("Traces")—in which fashion models were dressed as indigenous women), and interviews with the photographer, her assistant, and participating indigenous consultants.

On two occasions the process of artistic appropriation of indigenous cultures was observed in-depth during extended and continuous periods of time during two field expeditions. Both of these resulted from interviewing the artists in Buenos Aires who then invited me to accompany them on their respective projects. Like many other jobs that are centered in the city (company executives, sales representatives etc.), some artists, too, have a mobile side to their work which gets them away from the city temporarily, in terms of production, knowledge acquisition, and consumption of the work they produce: these can be second homes, or studios in the countryside, travel for a specific artistic project (the two cases I was involved with), travel to art fairs, galleries, and museums in other cities and abroad to show their work.

The first of these was the shooting of the Argentine feature film *El Camino* (dir. Javier Olivera, Argentina 2000), in the Mapuche reservation of Ruca Choroi in the Patagonian province of Neuquén, which I was able to follow in April 2000, courtesy of the kind invitation by director Javier Olivera (see chapter six). The second opportunity to observe artists' work at close quarters consisted in accompanying the artistic field trip by visual artist Teresa Pereda, in order to document the celebrations around the winter solstice and the feast of St. John in Jujuy province in the Northwest of Argentina, in June 2000 (see chapter seven).

I kept a fieldwork diary throughout my stay in Argentina, which recorded observations and impressions on daily activities interacting with my research subjects and other Argentines. In respective chapters, I use edited extracts from the diary entries to provide both ethnographic detail and to give a vivid illustration of the fieldwork process.

Selection of Artists

My aim was to interview a sufficiently large number of artists in order to arrive at some generalizations regarding their practices of appropriation. However, the theoretical emphasis of my approach is based on the processes of artistic appropriation, rather than the finished artwork. Therefore, at the centre of my concern was not the reputation or standing of the artists in the art world, but their artistic practice. To put it differently, interviewing a student at the Buenos Aires art school, Pridiliano Pueyrredón, was as valuable for my research as interviewing an internationally established artist. Obviously, I would take differences, in terms of standing in the art world and position in terms of career, into account—but they would not deter me from choosing somebody for interview, if the motivations, practices, and also the work (in that order) were of interest.

This sometimes provoked vehement protest by some art critics, along the lines of "Well, if you chose bad artists [i.e., artists which are not recognized by the art world] then your study will also be bad." Yet this did not discourage me to continue with my unorthodox approach, and to interview and mix with those people I had selected for my research.

At the beginning of my research stay, I consulted with a number of critics, gallery owners, and museum personnel whom I knew from previous periods of fieldwork (cf. Schneider 2000b), explaining my research project and compiling names of possible interviewees. Through these contacts I would also try to attend as many openings of gallery shows, and exhibitions at museums as possible.

Very soon, my initial contacts and interviews led to more names, and this is how I eventually established the "universe" of my research. Unlike in other countries such as Germany, there is no census category for artists in Argentina, and it is difficult to estimate their number. Associations, such as the *Sociedad Argentina de Artistas Plásticos* (SAAP) (founded in 1925, 2.200 members in 2001) are not representative, and estimates which have been mentioned to me in conversations with the personnel at SAAP, spoke of as many as 20,000 artists in Buenos Aires alone.[4]

However, as in my previous fieldwork on Italian immigrants in Argentina, I have been of the opinion that it is better to work with a combination of methodological tools, and adopt an open-ended (and also open-minded) approach to fieldwork than to be in a rigid methodological straitjacket.

Thus, in my original research design I had planned to interview about fifty people but when this number was reached it did not stop me from including more interviewees, and eventually I arrived at over ninety. I made altogether ninety-three taped interviews with artists (seventy-four people),[5] critics gallery owners, museum directors, and curators, and also attended a considerable number of events, such as openings and other gatherings in the art world, during my fieldwork. However, as explained above, the interviews in their recorded versions are just one element of the material. They represent verbal discourses, recorded in the sometimes formal (sometimes more informal) situations of the interview set-up. Yet other observations and practices, such as my participation in Mirta Marziali's ceramics studio are equally, if not more, important as ethnographic records of how the process of artistic appropriation of indigenous cultures and their art works occurs in Buenos Aires.

Fieldwork in the Metropolis

Working with artists across the extensive territory in the metropolis of Buenos Aires (and Greater Buenos Aires) presents a certain logistical challenge and is a time-consuming business. Buenos Aires, of course, was familiar to me from earlier fieldwork in 1988–1989 and 1993 among Italian immigrants (Schneider 2000b: 43–44).

My own expectations of Argentina also had to be adjusted during fieldwork. Though I had carried out a shorter piece of research in 1993 (see Schneider 1996), and had been back very briefly in 1996, initially, I had not fully grasped what the ten years of the Menem administration had meant for Argentina. Thus when I first took a train to the province of Buenos Aires, I was shocked by the sheer number of poor people. Not that in 1988/89 there had not been poor people on the trains, but somehow I sensed the

difference, and the depth of the economic crisis which resulted in ongoing pauperization. Obviously, Buenos Aires had changed (and so had I) during the ten years since my last prolonged fieldwork, and in addition I had a completely different field of enquiry. Yet many of the challenges and problems of urban fieldwork were similar. As in my earlier fieldwork, I carried out interviews all over the city, wherever artists would invite me to their studios. This time, however, there was no preponderance of upper- and upper-middle-class neighborhoods though some artists came from that extraction— but mostly they were of middle-class backgrounds. Also, in terms of gallery and museum visits for participant observation, my excursions were more concentrated in the downtown area of Buenos Aires, the *centro*, and to some degree in the *barrio norte* and *Recoleta*, which are the locations for the main art institutions. In other words, whilst the same urban space, or "city," was the stage for both fieldwork with "Italians" and "artists," the mental maps, of how this city was conceptualized, understood, and used differed considerably among the two "groups" under enquiry.[6]

E-mail and the Internet were added to the telephone as vehicles for data collection, and some information gathering and setting up of interviews were now arranged through these media. In contrast with my earlier work on ethnic identity among Italians and their descendants, artists were generally more open to interviews and having them recorded. This is because interviews (by critics, journalists, curators) are part of the art world and, to a certain degree, most artists are familiar with interviews and writing about art—it is an integral part of their symbolic universe, and something of an accepted social and professional practice. I always asked for the interviewee's consent before using the tape recorder, and only in once case was I refused permission. Significantly, this happened with an indigenous artist from an interior province, whose work was shown at the art fair *Arte BA* (see chapter three). The artist, however, had no objection in me interviewing him without the tape recorder over a cup of coffee (and later using that information), and subsequently also sent me an artist statement and material on his work. I think that during the conversation he just would have felt uncomfortable with a tape recorder.

I made ample use of a stills camera both to photograph artists' work and, less frequently, to document their processes of working, as well as taking photos during gallery and museum openings and on other occasions. In general, after people had been approached for their permission, there was no problem with this procedure. In one instance at an opening, a gallery owner told me that "we would not usually allow people to photograph, but since we know you, it is alright." On another occasion, I wanted to take a general shot of somebody's collection of Pre-Columbian art but the moment was ill chosen, since the collector was busy with some dealers showing her new pieces. She asked me to come back later. The issue of photographic representation during my fieldwork is discussed in more detail in chapter seven.

Whilst these were small set-backs to the course of fieldwork which could easily be remedied, on other occasions my requests for information were

refused, such as when I asked about the investors behind a new Website promoting Latin American arts—"a business secret which cannot be disclosed," I was told by one of the employees of www.latinarte.com.

There were also differences in perception of how my work was regarded among my research subjects. Whilst I had explained that I was doing research on the appropriation of indigenous cultures among Argentine artists, some were of the impression that I was primarily interested in indigenous cultures or their artefacts, not the mediation of these by contemporary artists. For example, once I was given as a gift some archaeological artefacts from Northwest Argentina, the donor assuming that these would be my primary interest, not the work and motivations of the artists who had brought them back from a trip to this area.

It is true that artists, overall, were used to interviews, but interviews of a particular kind and with a particular scope. In the best of cases, artists get some immediate returns from interviews with critics, journalists, and curators—that is reviews, catalogue essays, or exhibitions; or nothing happens in the worst cases. I had to explain that I was not an active player in the art world, nor an art historian, and that eventual publication would be of an academic nature. Given Argentina's peripheral status in the international art world, I was sometimes approached with ideas for exhibitions or contacts abroad. Where possible, I was happy to offer advice, whilst practical arrangements lay outside my possibilities and range of contacts. Some differences in perception and expectations, on both sides, had to do with social etiquette—some of these of mundane nature others more pertinent to the art world, all of which I was not entirely familiar with at the beginning of my stay. For example, when I visited the home of a collector of Pre-Columbian Art after a trip of mine to the north-west of Argentina, I brought some candy of the *Cayate* fruit as a present. It was greatly appreciated, but not really expected. Whilst the collector and his family treated me very well, this was perceived as general courtesy and hospitality, and a more personal present on my part was probably seen as exaggerated.

In another instance, I had interviewed an elderly painter who had a considerable career and track record to his name, and at the end of the interview I asked him whether he would sell to me one of the drawings that I particularly liked. He looked at me with surprise and answered that it was not for sale, implying its private and intimate value to him. This did not hamper our relationship. But somehow I realized that I had crossed a threshold, which the artist assumed I was familiar with, that is, the lack of ability on my part to distinguish between those works which were for sale and those which were not—a capacity I had obviously not yet acquired.

There were also more general comments on my role in the field, such as when one artist at a reception at one of the main gallery owners asked me with surprise: "What are you doing here?" implying that I was everywhere, and that he did not expect me at this social gathering. Or when, on another occasion, at an open-air sculpture show in the Parque Avellaneda, I was

photographing a sculptor at work—he turned round and asked me quite bluntly: "Are you an anthropologist?" On that occasion it felt more like demasking me, and putting the finger on my professional self—could he not have asked whether I was a foreigner, tourist, journalist or else—but how on earth could he have had the intuition to know that I was an anthropologist?

In terms of my fieldwork, I was struck by the relative ease and informality with which people moved in the Buenos Aires art world and with which I could move. For example, through the good offices of a personal contact I was allowed to witness the production of a television interview between several critics and the late Federico Klemm, artist, director of his own art foundation, and benefactor to the arts. Having worked in television and print media in Germany in the 1980s and in the world of ethnographic film in Britain since the 1990s, I know that one is not easily permitted into the professional arena of that world, without press passes, security checks or some other kind of legitimization, even if one is introduced through influential contacts. In Buenos Aires, however, the word of introduction or presentation was enough to get me through most doors, another indication of the personalized nature of the art world discussed in chapter three.

Through more contacts it was not only me who would locate more interview partners, but more people would know about me and my work. This would result not only in me being contacted, because somebody had passed on my name, but also, and surprisingly, people already being aware of my research, before I contacted them. In this way, I was also able at times to establish who would know whom in the Buenos Aires art world. Whilst, generally, it was true that most people knew each other or of each other, a few "circles" (as it was expressed to me) existed at the same time. These were not only circles in terms of different artistic preferences or choices, but also in terms of social class (see also chapter three).

Appendix II: Structure of the Buenos Aires Art World (in 1999/2000)

(see also chapter three)

Public Institutions

Museo Nacional de Bellas Artes (MNBA) (National Fine Arts Museum)
Centro Cultural Recoleta (CCR) (Recoleta Cultural Centre)
Museo de Arte Moderno (MAM) (Modern Art Museum)
Centro Cultural Borges (CCB) (Borges Cultural Centre)
Centro Cultural San Martín (CCSM) San Martín Cultural Centre
Palasis de Glace

Private Institutions

Museo de Arte Latinoamericano Buenos Aires—Colección Costantini (MALBA)
Fundación PROA
Fundación Klemm
Espacio Gieso

Galleries

("established" galleries)
Ruth Benzacar Gallery
Rubbers
Diana Loewenstein
("young" galleries)
GARA

Institutions Featuring Work by Artists Working with Indigenous Appropriations:

Art Schools
Escuela Nacional de Bellas Artes "Pridiliano Pueyrredón,"
National Art Academy "Ernesto de La Cárcova"

National Art School "Belgrano"
Centro Cultural San Martín (CCSM) San Martín Cultural Centre
Instituto Nacional de Antropología y Pensamiento Latinoamericano
(INAPL)
National Anthropology Institute
Museo Etnográfico (Ethnographic Museum)
Museo Luis Perlotti

Notes

Chapter One Introduction: The Paradoxes of
Identity in Argentina

1. I have recently offered a comparative analysis of artists in Argentina and Ecuador (Schneider 2004a).
2. For some recent work on these processes, see also Inda/Rosaldo (2001).
3. In Uruguay's case most prominently, Alicia Haber; see (Haber 1996).
4. For this term in the Latin American context, see Radcliffe/Westwood (1996: 19).
5. Cf. Arrom (1954).
6. Mintz (1996: 301, quoting Friederici 1960: 219–220).
7. See also (Quijada 1997: 1).
8. In a more general sense, all cultures are of course hybrid (see Friedman 1997, 1999).
9. Cf. (Mason 1990).
10. Cf. Reina (1973: 4, n.3).
11. Cf. Archetti (1999, 2001).
12. See Balmori/Oppenheimer (1979).
13. See Szuchman (1994: 5).
14. Szuchman (1988: 8–9), Brown (1994: 258), for regional variations Reina (1973: 249), Scobie (1988: 140).
15. Cf. Pérez Amuchástegui (1988), Prieto (1988).
16. Cf. Pérez Amuchástegui (1988: 440), and Reina (1973: 71) for rejection of European origins among second generation immigrants.
17. See also Sebreli (1964: 42).
18. The postcard Che Guevara sent to his father in Buenos Aires is reproduced with Spanish and English translation (by "TUF," but no explanation of acronym) in a bilingual American underground magazine *The Underground Forest/La Selva Subterranea* # 6, p.22, published in Portland, Maine in the late 1980s. There is no indication of the year of publication but other items in the text indicate that it must be 1989, or shortly thereafter. I am grateful to Dr. Richard Appignanesi for having supplied this item to me.
19. On Irish migration to Argentina, see Korol/Sábato (1981).
20. See for example, on the road protests (*piqueteros*) Epstein (2003), and on Argentina's foreign debt Soederberg (2003), also Tedesco/Dinerstein (2003).

21. Obviously, such evaluations will also depend on the political position of the person, and his or her support or implication with the previous military regime.

22. For some recent anthropological work on the Tango, see Savigliano (1995), Taylor (1998), Carlini (2003), and the review article by Schneider (1998a).

23. Literally, "ours," meaning "what is ours" and "our heritage" in the wider sense.

24. A part of that collection was shown in 1996, together with works by contemporary Argentine artists inspired by Pre-Columbian art (Elizabeth Aro, Oscar Paez, César Paternosto, Alejandro Puente) in Giessen, Germany, in a show entitled "Argentinien: Ursprünge und Erbe" (Argentina: Origins and Heritage). The exhibtion on Zapotec art at the MNBA was entitled "Los hombres de las nubes: Arqueología Mexicana Zapoteca y Mixteca" (2000).

25. Artistic copyright, too, is in its infancy in Argentina, but a proposed copyrights bill should bring benefits to artists (Quadri 2000).

Chapter Two Theoretical Foundations: On Appropriation and Culture Change

A first version of this chapter was delivered at the Biannual Conference of the German Society of Anthropologists (DGV), Heidelberg, October 3–7, 1999. Parts of this chapter have been published in different form in Schneider (2003a, 2006).

1. Lowie (1937), Harris (1968), Mühlmann (1984), Gingrich (2002: 230); see my more extended discussion below in the section *Appropriation, Cultural Change and Globalisation.*

2. For recent critical assessments of the term "culture" in anthropology, see Wimmer (1996), Brumann (1999).

3. Cf. Coombe (1993, 1998), Strathern (1996), Ziff/Rao (1997: 1), Brown (1998), Harrison (1999), Benthall (1999).

4. Before culture can be transmitted, there is of course the related issue of "cultural acquisition" (or what in the past was called "enculturation," for more recent approaches, using the insights of cognitive psychology, see Bloch (1991, 1998), Boyer (1993), Hirschfeld/Gelman (1994).

5. On recognition of otherness, see the interesting studies by Kubler (1991, 1996) regarding Western scholars of Pre-Columbian art.

6. On the symbolic appropriation of space by different social groups in Mexico City, see Wildner (2003a, b) and of the Puerto Madero port area in Buenos Aires (see also chapter one), Guano (2003).

7. See note 5.

8. My discussion, relevant to visual artworks, is interested in the process of copying which implies changes of meaning (not those pretending to have the same meaning, that is, fakes on which see Phillips (1986–1987). On virtually identical copies, or counterfeits with yet different values attributed to them by collectors in the world of Rock and popular music, see Jamieson (1999).

9. Cf. also Paternosto (1996: 192), who makes the point more generally, following partly Kubler (1962: 108) that artists across different cultures, and different historical periods can retrieve and recreate meaning through appropriation (although Paternosto does not explicitly discuss the term).

10. In the philosophy of art and art criticism Arthur Danto (1964) first discussed the term in his essay "The Artworld" (see also Danto 1992: 37), where it describes the historically conditioned institutional setting (museums, galleries, dealers, critics etc.) which confers on certain objects the status of art.

 For sociologists in the functionalist tradition of Talcott Parsons such as Howard Becker, but also for system theoreticians, such as Niklas Luhmann, art is a sub-system (*Teilsystem*) of society (Luhmann 1995: 215f., cf. also Sevänen 2001).
11. On Thurnwald, see Melk-Koch (1989).
12. See Clifford (1988), Errington (1994, 1998), Karp/Levine (1991), Price (1989, 1993), Schneider (1993, 1996).
13. For a good summary of present culture concepts and globalization theories in anthropology, see Kreff (2003: 146–153).
14. Cf. Asad (1973), Kuper (1988). On anthropology during the Third Reich, and the roles of specific anthropologists, such as Thurnwald and Mühlmann, see Hauschild (1995).
15. Cf. Haberland (1973), Kramer (1985), Giordano (1997), Heinrichs (1998).
16. On cultural borrowing, see Beals (1953: 623); on *Entlehnung* see Mühlmann (1984: 227).
17. "Piratical appropriation," of course, contains already the concept of *in*appropriately taking from the other, or stealing—the same idea used by many present-day indigenous communities, when protesting against licentious exploitation of their cultural resources by outsiders.
18. See also Inda and Rosaldo (2001) for a recent overview, but with little emphasis on individual agency in the processes of globalization.
19. For some useful discussion of comparative research on contemporary world arts, see Fillitz (2002).
20. Note that I use inverted commas, since most often there is no absolute original, but just a context in which something has been known to be produced for the first time (which might yet be a variation on a previous theme now lost).
21. Ricoeur is inspired primarily by Gadamer's Truth and Method, see Gadamer (1960).
22. Cf. Philosophy of Right, §§ 38–40, 50–60.
23. For which, see such classic writings in economic anthropology, as Mauss (1990) Sahlins (1972), and more recent reconceptualizations, such as Strathern (1989).
24. See also Moore (1990: 94–97).
25. Arguably, our usage of "cultural appropriation" falls under the category of "abstract appropriation" (e.g., as it is present in property rights), and not "concrete appropriation," that is, the material appropriation *qua* extraction of natural resources (for these terms and a full discussion of the "appropriation of nature," see Ingold 1986: 12). See also Spittler's (2003: 19) discussion of appropriation of commodities in the context of consumption studies. Coombe (1993: 249), in her discussion of appropriation, distinguishes between intellectual, cultural and real property, all of which are dependent on the cultural constructions of things and persons.
26. Cf. Coutts-Smith (1991: 28); for creativity in art and anthropology (Lavie et al. 1993, Whitten/Whitten 1993).
27. On the related discussion of "alienability and inalienability" of objects in gift exchanges and European and non-Western encounters, see Thomas (1991).

There is also something to be said about visual artworks being inherently "inalienable" art forms, since they are complete in themselves, and not supposed to be changed in their finite forms, in contrast with theatre and music, where representation varies with performance (cf. Zolberg 1990: 169–171).

28. Maranhão (1986), Crapanzano (1990); Toren (1991: 277) speaks of the "fugitive conservatism" of appropriation in post-colonial situations where, paradoxically, new elements are introduced whilst conserving other elements of a specific culture (her example being tapestry representations of Leonardo's *Last Supper* in Fiji).

29. Cf. Lips (1937).

30. Cf. Moreiras (1995: 3).

31. Camnitzer gives the revealing example of the Cuban painter Amalia Paláez who tells in an interview "about a visitor who, seeing a painting in progress, expressed surprise and admiration about the sudden elimination of black in her work. He interpreted it as an unexpected creative renewal of the artist, while the real reason was that her supply of black had run out and she was unable to replace it (a fact she did not reveal to the visitor)." (Camnitzer 1994: 315–316, referring to Seoanne Gallo 1987 : 192–193).

32. The Argentine anthropologist García Canclini (1995), on the other hand, presented a powerful thesis of understanding Latin American cultures more as hybrid cultures; cf. also other work by Acha et al. (1991), Rowe/Schelling (1991), Yúdice (1992), Chanady (1994), Echevarría (1994), Larraín (1996).

33. Similar to what Claude Lévi-Strauss claimed for the meaning of myth, that is that "a myth" is constituted by all its variants. See also the work by anthropologists on the epidemiology of concepts (Latour 1986, Sperber 1996: 77).

34. Cf. also Thomas (1991), Kramer (1993 [1986]), Taussig (1994), Gell (1998).

35. Cf. Spitta (1995), Trigo (1996).

36. Peter Burke has pointed to the chronology of concepts which have been used to explain culture contact and change: "To place them more or less in chronological order, the concepts run from 'appropriation' (used by the Fathers of the Church about pagan culture before the recent revival of the term by Michel de Certeau), 'borrowing' and 'sinking' through 'influence' (an astrological term) and 'reception' (the original example being the reception of the Roman law), to 'acculturation,' 'transculturation,' 'hybridization' and 'creolization'." (Burke 1996: 188).

37. For recent summaries on the globalisation debate, see Inda/Rosaldo (2001), Hauser-Schäublin/Braukämper (2002), and Kreff (2003).

38. Cf. Chanady (1994).

Chapter Three The Buenos Aires Art World: Sites of Appropriation

1. For sociologists in the functionalist tradition of Talcott Parsons, including systemtheoreticians, such as Niklas Luhmann, art is a sub-system (*Teilsystem*) of society (Luhmann 1995: 215f., cf. also Sevänen 2001).

2. Recently, Plattner also studied contemporary art production in Florence, which occupies only a secondary position to Milan and Rome as centers of contemporary art in Italy, whereas the Florence art world is dominated by mass tourism and a historical interest in Renaissance art (Plattner 2004).

3. The truth of this assertion was brought home to me during a recent research trip (in 2005) to the provincial capital of Corrientes, where upon a visit by a major Buenos Aires curator, most artists in the city where eager to be included in his forthcoming show.

4. The MALBA was opened in 2001 and because of the importance of its collection of Latin American art, and significant temporary exhibitions immediately occupied a leading role among arts institutions.

5. The Fundación PROA is funded by the TECHINT cooperation, an Italo-Argentine steel company.

6. In Florence, as Plattner observed, those galleries which charge artists to exhibit their work are regarded by other gallery owners and artists as corrupting the criterion of artistic quality for selection (Plattner 2004).

7. *Arte al Día*, X, 81, August, 2000, p. 7.

8. Interview with Jorge Glusberg, 03/09/2000.

9. Art institutions were ranked after conversations with art critics, and artists who agreed on which constituted the most important ones.

10. Amalia Fortabat is presiding over one of the largest industrial empires in Argentina, and is also owner to an important art collection.

11. *Asados* are a traditional and central part of Argentine culinary lore. Usually they are held outdoors, the largest and sumptuous ones on the *estancias* (ranches) where whole halves of cows (the rib parts) are stuck into the ground, and entrails, sausages, and black pudding are offered from huge open grills. Smaller versions are held in the backyard of private houses which ideally all have a grill facility (*asador*), or even on the balconies of flats.

12. See Bony (1998), exhibition catalogue.

13. Sadly and unfortunately, Ruth Benzacar died before that opportunity, but I managed to interview her daughter and successor at the gallery, Orly Benzacar.

14. However, I was unable to find out how much it cost, or who paid for it.

15. Marcelo Pacheco, "Colecionismo, política e identidad," *La Nación* May 11, 2000.

16. Bourdieu's terms (Bourdieu 1987) are instructive here, although to my knowledge no full-scale sociological study has applied them to Argentine urban society.

17. Carlos Saúl Menem, Argentine president, 1989 to 1999.

18. English translation published alongside Spanish text in *Pagina12*, February 2000 (programa Cutting Edge Invitational: Cono Sur, Arco, Madrid, 2000) (I have kept the ideosyncracies of the English text).

19. On Javier Olivera's work, see chapter six.

20. See Lóizaga (1999: 15).

21. Cf. Simpson (1981).

22. See his presentation at "Fieldworks: Dialogues between Art and Anthropology," the conference I organised at Tate Modern, London, in 2003 (www.tate.org.uk/onlineevents/archive/fieldworks). On recent trends in contemporary Mexican art, see Gallo (2004).

23. Source: Meca en Arte BA, card distributed at Arte BA, 2000; supplement "Arte BA," *La Nación* May 11, 2000.

24. The *Sociedad Rural*, the association of the landholders and cattle breeders, in the neighbourhood of *Palermo*.

25. On New Zealand white farmers developing claims and sentimental attachment to indigenous lands, see Harrison 1999a/b, also see Thomas 1999.

26. See *8ᵃ Feria del Sol natural y artesanal*, Buenos Aires August 17 to September 10, 2000 (catalogue).

27. Saráchaga is one of Buenos Aires' main auction houses. The others are, according to Golonbek (2001: 118): Galería Arroyo, Banco Ciudad de Buenos Aires, Bullrich—Gaoana—Wernicke (BGW), Naón, Roldán, and VerBo.

28. *Criollo* refers here to descendents of Spaniards in the colonial and early independence period in Argentina, and by implication to the land-holding class (see our discussion in chapter one, and also Schneider 1997, 2000).

29. Peña is an upper-class family name.

30. Benito Quinquela Martín, Argentine painter, 1890–1977.

31. Enrique Larrañaga, Argentine painter, 1900–1956.

32. *Artealdía*, X, 81, August, 2000.

33. On Alberto Delmonte (1933–2005), see Delmonte/Robles (1998), and Ramírez (1992: 352–352).

34. See Ramírez (1992).

Chapter Four Copy and Creation: Potters, Graphic Designers, Textile Artists

1. See, for example, Gow (1991), Morris (1994), Overing (1985), Overing/Passes (2000), Strathern (1988, 1992, 1999).

2. *Instituto Nacional de Antropología y Pensamiento Latinoamericano* (INAPL).

3. See also, more recently, Minar/Crown (2001: 377).

4. See Reents-Budet (1994), one of the few contemporary reference works the workshop participants had access to.

5. Such as the standard work by Quiroga/Ibarra Grasso (1971), and others, for example, Lothrop (1979) as well as catalogues from the *Museo Nacional de Antropología* in Mexico City, and Argentine provincial museums.

6. See Chiti (1997: 134–140).

7. Slip or *engobe* (the French term) is "a creamy dilution of clay, often in a different colour to the body of the vessel, which is used to coat it (often making it waterproof), to decorate it or to join parts together" (Lucie-Smith 1995: 173); see also Chiti (1997: 196–199).

8. Traditionally, prehispanic cultures used stones, such as red basalt or agate, or special types of reed for polishing (Chiti 1997: 241).

9. A lifeless appearance is sometimes attributed by art historians to works drawn from copies, rather than from life. In a recent exhibition on Albrecht Dürer's graphic work at the British Museum (2002) such a distinction was made between two different depictions of a horse.

10. For precedents of how an indigenous ancestry is constructed for the Argentine nation state, see Quijada (1996, 1997, 2000).

11. *Los hombres de las nubes: Archqueología Mexicana Zapoteca y Mixteca*, Museo Nacional de Bellas Artes, November 1999.

12. Fiadone (2001: 17–19) mentions Héctor Greslebin, Eric Boman, Vicente Nadal y Moral, Ángel Guido who all published on the subject.

13. Named after Hipólito Yrigoyen, President of Argentina, 1916–1922 and 1928–1930, when he was disposed by the first military coup.

14. *Ñanduty* is a very fine fabric, originally woven by women in Paraguay, and today is also common in other parts of South America for all kinds of white fine fabric (from the Guaraní word *ñandú*, the South American ostrich).

15. For a detailed description of these and other indigenous and Creole instruments in Argentina, see Ruiz/Pérez Bugallo/Goyena (1993).

16. *Colla, Coya,* or *Kolla* is the denomination given to people in Argentina's north-eastern Andean provinces which had been conquered by the Inca Empire and acquired Quechua as their language. Little Quechua is spoken today, though it still shows its strong influence on the grammar and vocabulary of the Spanish spoken. In the province of Santiago del Estero *Quichua,* a variant of Quechua is still spoken. For a recent assessment of *Kolla* identity, see Occhipinti (2002).

17. In the Mapuche language *Mari Mari* is a generalized salute to people, and in fact an abbreviation of longer forms of salute which specify whether the speaker is addressing men, women, or a general audience.

18. *Pehuén* is the Mapuche word for the *Araucaria* or monkey puzzle tree. Its pine-like seeds are used to make flour.

19. See also chapter two, and the final section of chapter eight.

Chapter Five Fashionable Savages: Photographic Representations of the Indigenous

This chapter was first delivered as a paper to the Radical Anthropology Group's seminar in London in February 2001. I thank Chris Knight and Ana Lopes for having invited me, and the participants for their helpful suggestions in a vivid discussion. I am grateful to Laura Malosetti Costa, Marta Penhos, Julio Sánchez, and Norma Schenke in providing information on bibliographic sources. I also would like to thank all individuals and institutions mentioned in the text who generously made available interview time and helped locating resources for this project.

A different version of this chapter has been published in Spanish in *Mujeres y Nacionalismo en América Latina: de la Independecia a la Nación del Nuevo Milenio,* ed. Natividad Gutiérrez, UNAM: Mexico City (Schneider 2004a, also to be published in Gutiérrez *forthcoming*), and has appeared in article form in *Ethnoscripts,* Schneider (2003b).

1. Cf. Malosetti Costa (1993, 1994), Penhos (1996), Giordano, M. (2005).

2. Cf. Sarasola (1992: 103), Rock (1987: 33), Bernand (1997: 49–52).

3. Cf. Quijada (2000: 60–64).

4. Examples are Juan Cruz Varela's "*En el regreso de la expedición contra los indios bárbaros, mandada por el Coronel D. Federico Rauch*" (1827), and the poem *La Cautiva* (1837) by Esteban Echeverría, cf. Malosetti Costa (1993), Penhos (1996).

5. Johan Moritz Rugendas *El Malón* (dated 1835, Col. Yrarrázaval, Chile) another *Malón* (signed and dated in Munich, 1848), *El rescate* (unfinished oil painting, ca. 1848–1858, private collection, Buenos Aires), Ángel Della Valle *La Vuelta del malón* (1892, Museo Nacional de Bellas Artes, Buenos Aires), Malosetti Costa (1993: 6–18).

6. Malosetti Costa (1993: 1).

7. Malosetti Costa (1993: 2), following Iglesia (1992: 563).

8. Malosetti Costa (1993: 23).

9. The process has been called the araucanization of the pampas, cf. Ortelli (1996) and Quijada (2000: 62).

10. Cf. *El presbítero Francisco Bibolini, cura de 25 de Mayo, parlamenta con el cacique Calfucurá, 1859* or *Invasión de 2.000 indios al Veinticinco de Mayo* (lithograph 0,875 × 0,635 m. Museo de la Patagonia *Perito Francisco P. Moreno, San Carlos de Bariloche,* (Inv. 1669), see Penhos (1999 note 1)).

11. According to Quijada (2000: 69), the Argentine elites considered three options: annihilation, settlement in reservations, and assimilation to the

nation-state. Whilst the last options found most favour in public opinion, de facto the Desert campaign resulted in a combination of the first two, with small remnants of indigenous populations today surviving in Argentina.

12. Cf. Penhos (1996).
13. Cf. Penhos (1996).
14. Cf. Penhos (1996: 5).
15. However, see Hernández (1992), Tessler (1989), Sarasola (1992 chapters VII and VIII), Quijada (2000).
16. Cf. Chapman (1982), and also the revealing photographic documents of a French scientific expedition to Cape Horn in 1882/3, *Cape Horn. Rencontre avec les indienes Yaghan*. Paris: Musée de l'Homme, 1995.
17. Cf. Sarasola (1992: 333–336), Gordillo (2004).
18. Cf. Sarasola (1992: 483–489) for an overview on organizations occupied with indigenous people (state, private and indigenous organizations).
19. Cf. Magrassi (1987), Maybury Lewis (1991), Sarasola (1992). The 2001 census counted so far 286,510 indigenous people—but for some provinces, as well as for the capital city, Buenos Aires, the results still have to be published. (source: *INDEC. Encuesta Complementaria de Pueblos Indígenas 2004.* from www.indec.mecon.gov.ar).
20. No individual sources for the archival photos are given, but a general bibliography is supplied in the acknowledgements section of the calendar.
21. Named after the location in the south of Buenos Aires suburb where the vanquished Quilmes Indians where taken after their defeat by the Spaniards, and which was a Jesuit reduction, see also section 2 of this chapter.
22. *B.A..E.*, section "Buenos Aires Cool," December 7, 1999.
23. Cf. Sarasola (1992).
24. However, just title and author, not place and year of publication are indicated.
25. *Cabecitas negras*, "little blackheads," is the derogatory denomination applied by Argentines of supposed European descent (the majority) to those supposed to be of mixed, or indigenous descent, of the immigrants from the interior provinces, or more recently, from neighbouring countries (for ethnic and racial distinctions in Argentina, see our discussion in chapter one, and Schneider 2000a, 2000b).
26. See Curtís (1907–1930); also cf. Edwards (1992), Theye (1989).
27. On the historical figure of *cacique* Pincén, see Sarasola (1992).
28. Cf. our discussion in chapter one, and Quijada (2000), Bernand (2000), Schneider (1998, 2000).
29. Cf. Penhos (1996b); the important works by Rojas in this respect are *La Restauración Nacionalista* (Buenos Aires, 1909), *Blasón de Plata. Meditaciones y evocaciones de Ricardo Rojas sobre el abolengo de los argentinos* (Buenos Aires, Martín García, 1912), and *Eurindia* (in *obras de Ricardo Rojas*, Vol. 5, Buenos Aires: La Facultad, 1924), cf. also Quijada (1996, 1997).
30. Cf. the section *Extinction and Excotism* at the beginning of this chapter, and Malosetti Costa (1993).
31. *Crónica*, November 2, 1999.
32. *Clarín*, November 21, 1999.
33. *Revista Noticias*, November 6, 1999.
34. *Crónica*, December 14, 1999.
35. *Revista Pronto*, December 15, 1999.
36. *Revista TV Guía*, December 19, 1999.

37. "Ethnic Calendar," *Revista Para Ti* November 26, 1999; "The traces of the past illustrate the New Year," *B.A.E.*, December 7, 1999; "Ethnic Calendar," *La Razón*, December 7, 1999; "Models to photograph the past," *La Prensa*, December 8, 1999; "The photographer Gaby Herbstein renders tribute to the indigenous people," *El Cronista*, December 10, 1999; "Twelve Ethnic Groups and as many months," *La Nación*, December 23, 1999.
38. *La Nación*, November 21, 1999.
39. Cf. Edwards (1992), Stocking (1982), Theye (1989), Penhos (forthcoming).
40. For instance, the painter Andrés Bestard, see chapter eight.
41. Cf. Wolf (1982).

Chapter Six Setting up Roots: On the Set of a Cinema Movie in a Mapuche Reservation

An earlier version of this chapter was first presented at the conference "The Future of Ethnographic" Film, SOAS, December 14–15, 2000. A different version of this chapter has been published in *Visualizing Anthropology*, eds. Anna Grimshaw & Amanda Ravetz. Bristol: Intellect Books (Schneider 2004c).

I thank Javier Olivera and his production company *Aries* for their generous hospitality during the shoot in Patagonia in April 2000. I am especially grateful to Nino di Prima in Sutera (Sicily) for having supplied me with a selection of prints from his collection of photographs he took on the set of Michael Cimino's *The Sicilian* in 1986 (see figure 36).

1. Hyper Realism's critical potential was highlighted by super realism (or hyper realism) and photorealism in 1970s' contemporary art, when painters, such as Chuck Close and Duane Eddy, deliberately and minutiosely "copied" photographs, and sculptors, such as Duane Hanson, cast living people (reflecting on the camera's partial representation of reality, and making the beholder aware of artist's verisimilar additions to reality). For hyper reality as an act of simulated reality, see Baudrillard (1988: 28).
2. Cf. Schneider (1990).
3. Despite myths surrounding them of being Robin Hood-like social bandits, Salvatore Giuliano (1922–1950) and his gang were used by the Mafia and the Christian Democrats against left-wing peasants demonstrating for land reform and occupation of lands. On labour day, May 1, 1947 at Portella delle Ginestre (near Piana degli Albanesi) in the Province of Palermo 11 peasants were killed and 33 wounded in a massacre, when Giuliano's gang opened fire with machine guns (Blok 1974: 205).
4. On the Desert Campaign and its aftermath, see Sarasola (1992).
5. Cf. Quijada/Bernand/Schneider (2000).
6. On appropriation (as an art practice) more generally, see chapter two, and Schneider (2003a, 2006).
7. Although failure at the box office meant it remained on the screen only for one week.
8. For *El Camino*, the core of the crew consisted of director, assistant director (and up to three assistants), director of photography, assistant camera man (plus his assistant), producer, director of production, assistant producer, sound recordist and assistant, art director (and four assistants), make-up artist, director of lighting/gaffer (with two assistants), grip, stills photographer, and a varying number of drivers. To this a varying cast of twenty-four actors was added, two of them young stars in Argentina, Ezequiel Rodríguez (*Manuel*),

known to the Argentine public from the TV sit-com *Verano 98*, and Antonella Costa (*Caro*), who already had some film credits (e.g. *Garage Olympic*).

9. Cf. Thomas (1999, 2001).

10. In the present, the Mapuche are politically represented through federations at the provincial and national level, and locally through an elected *lonko*, or chief, a structure imposed by the Argentine government which is supposed to replace the traditional *lonko* by descent.

11. On Prelorán see McDougall (1998: 133–114), Rossi (1987), Taquini (1994).

12. See, for example, Plattner (1996); two notable exceptions are Moeran (1990) and Graburn (2001). For a more general discussion of the porous borders between contemporary art and anthropology, see Schneider (1996), Schneider and Wright (2006).

13. However, *kultrúns* have been documented with a variety of ornamentation, with only two lines, or none at all; cf. Schindler (1990: 174–179), Pérez-Bugallo (1993: 39–62).

14. Maté (*ilex paraguaiensis*), is a herbal infusion widely drunk in the southern parts of South America.

15. For a comparison between Canadian indigenous feature films and ethnographic film, see also Schneider (1993), and more recently, Ginsburg (2003) and Brydon (2004). More generally, on the borders between fiction and document in cinematic and visual anthropology traditions, see Grimshaw (2001: 71–89).

16. For a recent example involving ethnographic observation and scripted events, by a team of sociologists, artists and documentary film-makers, see Lammer (2002a).

17. Apparently, as Javier Olivera told me in one of our conversations, the reactions were mixed. About forty Mapuche saw the film, were quite reserved and did not follow the story line very much, but reacted positively when they could identify themselves in the film.

Chapter Seven Practices of Artistic Fieldwork and Representation: The Case of Teresa Pereda's *Bajo el Nombre de San Juan*

An earlier version of this chapter was first presented at the Conference of South Americanists in Bonn, November 2–4, 2001.

1. See also the international conference *FIELDWORKS: DIALOGUES BETWEEN ART AND ANTHROPOLOGY*, which I co-organized at Tate Modern, London, September 2003 www.tate.org.uk/onlineevents/archive/fieldworks/.

2. Teresa Pereda works both from Buenos Aires, and from Lincoln in the province of Buenos Aires, where she has another studio and also teaches students.

3. Cf. Portillos (2000).

4. Cf. Pereda (1998).

5. Michel Riehl and Irmas Arestizábal figure as contributing authors of the book and are mentioned on the title page.

6. See, for instance, Sontag (1973), Edwards (1992), Pinney (1992).

7. Cf. Prelorán's film *Imaginero* (1970). For the socially and economically more stratified visual culture of urban Lima and Cusco, see Poole (1997: chs. 7 & 8).

8. Cf. Göbel (1997: 41, 1998: 161–162).
9. *Colla, Coya*, or *Kolla* is the denomination given to people in Argentina's north-eastern Andean provinces which had been conquered by the Inca Empire and acquired Quechua as their language. Little Quechua is spoken today, though it still shows its strong influence on the grammar and vocabulary of the Spanish spoken. In the province of Santiago del Estero *Quichua*, a variant of Quechua is still spoken. For a recent assessment of *Kolla* identity, see Occhipinti (2002).
10. Cf. Vázquez Zuleta (n.d.)
11. Cf. On the Inti Raymi cf. Sallnow (1987: 38) and McCormack (1991: 368–369) on amalgamation with Corpus Christi celebrations after the Conquest. Also, De la Cadena (2000: 157–176) on Inti Raymi celebrations in Cuzco since the 1940s as "invented traditions."
12. For a discussion of the advantages and disadvantages of short-term fieldwork, see Greverus (2001).
13. I did not consult census material on Cochinoca, but one of the local school teachers, *Maestra* Ramona, mentioned that there were 16 families, 48 pupils, approximately 5 people per family, and 80 people altogether, with about 20 old people living in the countryside.
14. For the Cuzco area, Sallnow mentions livestock ceremonies which are celebrated on a domestic basis. For lambs it is St. John, June 24 who is the patron saint of the species (Sallnow 1987: 131).
15. Other terms are *amilante* or *plumudo* ("the feathered one"), cf. Colatarci (1985: 2).
16. Cf. Cabezas/Cabezas (1989: 24–27).
17. Referring to St. John celebration in the North-eastern provinces of Misiones and Formosa, García (1979: 146) also reports that people walk across the glowing coal in their "normal physical and psychic state" and, in their majority, do not get burnt.
18. According to Vázquez Zuleta (n.d.: 44) *corpachar* means to "give the earth to eat," consisting in offering to the *Pachamama* coca, cigarettes, alcohol, and food. The main ceremony of this type is on the 1st of August. Mariscotti de Görlitz (1978: 110) suggests that *corpachar* derives from the Quechua *qorpacha* "host, receive hosts," and the Aymara *k'orpacha* "lost, lodge," see also her detailed discussion of *chayada* or *challa* and rites connected to the *pachamama* (Mariscotti de Görlitz 1978: 102–103, 185).
19. An alcoholic drink made from fermented corn.
20. See Coluccio (1992: 70–77, 1994: 134).

Chapter Eight The Indiginization of Identity

1. Kathrin Wildner (2003 a, b) has recently investigated how the *Zócalo*, the central square of Mexico City, is invested with different social practices and symbolic meaning by various social actors.
2. See Ong (1999: 13f.) for a discussion of diaspora studies in anthropology.
3. See also chapter seven, and for the appropriation of indigenous culture in Australian and New Zealand settler art, Thomas (1999, 2001).
4. See, for example, Penhos/Wechsler (1999), Malosetti Costa (2001).
5. Magrassi and Kusch were influential figures in the anthropologically influenced part of the Buenos Aires art world in the 1970s and 1980s, as I have outlined in chapter one.

6. During the Falklands or Malvinas War in early 1982, the European Union, except for Ireland and to some degree Italy, showed complete solidarity with Great Britain.

7. See Schneider (1996b), Tessler (1989).

8. *Documenta XI* was curated by the Nigerian Okwui Enwezor, see also *Documenta XI* (2002). More generally on postcolonial Latin American and world art, see Mosquera (1996) and Mosquera/Fisher (2004).

9. There have been precursors of digital art in the pre-PC era, namely that promoted by Jorge Glusberg's CAYC in the 1960s and 1970s.

10. There are, of course, no "immaterial" techniques as such in art (a physicial impossibility as only a vacuum is immaterial) only discourses about immateriality, as Wagner (2001: 293–300) has rightly stressed, and this observation equally applies to recent forms of digital art, for which more generally, see Wilson (2002).

11. The *Nguillatún*, sometimes referred by the Mapuche also *kamarikun*, is a religious ceremony of the community which can last over several days, and where every participant makes sacrifices to the supernatural beings and asks for the good fortune of their families (Schindler 1990: 98–105).

12. On the *rewe*, see Schindler (1990: 66–67).

13. Though conceived independently, Cáceres approach bears some resemblance with artists shown at the exhibition *Magiciens de la Terre* curated by Jean-Hubert Martin. Paris: Centre Pompidou, 1989. See also special issue of *Third Text* devoted to the exhibition, and Guy Brett's article therein, "Earth and Museum—Local and Global?, *Third Text*, 6, 1989, pp. 89–96. In a broader sense, these works, including Cáceres" can be termed neo-primitivist, see Varnedoe (1984), Cooke (1991).

14. On the contrast between supposed "immateriality" and materiality, see Wagner (2001: 293–300) and note 10.

15. The processes outlined here, of course, are paralleled in other settler societies, such as the United States, Canada, Australia and New Zealand.

16. There is now a substantial literature on the anthropology of space, for a recent critical appraisal, putting the emphasis on how space is constructed through social relationships, see Corsín Jiménez (2003: 138–139); for a case study mentioned before, Wildner (2003a, b).

17. See, Jackson (1983), and more recently, Herzfeld (2004).

18. For further discussions on this emerging new field between contemporary art and anthropology, see also the international conference *FIELDWORKS: DIALOGUES BETWEEN ART AND ANTHROPOLOGY*, which I co-organized at Tate Modern, London, September 2003 www.tate.org.uk/onlineevents/archive/fieldworks/, as well as *Contemporary Art and Anthropology* (edited by Arnd Schneider and Christopher Wright), Berg Publishers, Oxford (2006).

Appendix I

1. The latter period (in late 2001), however, was overshadowed by the deepening economic and political crisis in Argentina which eventually led to the downfall of the government of President Fernando de la Rúa and the quick succession of three presidents in as many weeks (Ramón Puerta, Adolfo Rodríguez Sáa,

Eduardo Camaño), till the election, by the chamber of deputies, of Eduardo Duhalde on January 2, 2002 who led the government till the election, at the polls, of Néstor Kirchner, on May 18 2003 (see also Sanchez 2004).
2. Kokot (2000: 192–194) emphasizes the different strategies to be employed when dealing with a variety of urban fieldwork situation, characterized by dispersed and geographically mobile groups and individuals.
3. See, also Marcus (1995) and Clifford (1997: 57).
4. Although there is a census category for artists in the 2001 census, the results have yet to be published (see "Clasificador Nacional de Ocupaciones," category "50," "Ocupaciones del Arte," pdf file from http://www.indec.mecon.gov.ar/).
5. Simpson (1981: 245f.) interviewed 48 artists in New York, Ericson (1988: 11) 53 in Stockholm, Freeman (1993: 309f.) 54 mainly in Chicago and New York, and Plattner (1996: xi) 65 in St. Louis.
6. On the city as a stage for social actors, see Schweizer (2000: 324), and on mental maps the extended discussion by Hengartner (2000: 92–101).

Bibliography

Pamphlet and Catalogue Material

Argentinien: Ursprünge und Erbe/Argentina: Orígenes y Herencia. 1996. Giessen: Oberhessisches Museum. (catalogue)

Artistas Plásticos Sudamericanos. 1991. Vicente López (Provincia de Buenos Aires): Museo de la Fundación Rómulo Raggio. (exhibition brochure)

Bony, Oscar. 1998. *El triunfo de la muerte. Oscar Bony en el Museo de Bellas Artes*. (edited by Patricia Rizzo). Buenos Aires: Museo de Bellas Artes. (catalogue)

Cabezas, Marcia/Cabezas, Alfredo. 1989. *Danzas Culturales del Norte Jujeño*. Jujuy.

Christie's. 1998. *The Latin American Sale: Important Paitings, Drawings & Sculpture*. New York: Christie's. (auction catalogue)

Colección Nicolás García Uriburu. 1999. *Arte Precolombino* (texto Alberto Rex González, fotografías Facundo de Zuviría, selección y instalación de obra Joaquín Molina). Buenos Aires. (catalogue)

Delmonte, Alberto/ Robles, Pascual Alberto. 1998. *Alberto Delmonte*. Buenos Aires: Arte Argentino Contemporáneo.

Documenta 11 _ platform 5. 2002. Kassel: Hatje Cantz. (exhibition catalogue).

8ᵃ Feria del Sol natural y artesanal, Buenos Aires 17 August to 10 September, Asociación Amigos del Museo Nacional de Bellas Artes, 2000. (catalogue)

Fondo Nacional de la Artes. 1998. *Memoria*. Buenos Aires: Fondo Nacional de la Artes.

Lang, Nikolaus. 1991. *Nunga und Goonya*. Munich: Städtische Galerie im Lehnbachhaus. (catalogue/book)

Los hombres de las nubes: Arqueología Mexicana Zapoteca y Mixteca. 2000. Museo Nacional de Bellas Artes (MNBA). (exhibition leaflet)

Pereda, Teresa. 1997. *Memorias del Sur: El silencio y la pérdida*. Córdoba: Museo Provincial de Bellas Artes "Emilio A. Caraffa. (catalogue)

———. 1998. *El libro de las cuatro tierras: libro de artista*. Buenos Aires: Studio Graf. (artist book)

———. 1999. *Teresa Pereda*. Buenos Aires: Ediciones Argentinas de Arte: Colleción de Arte Argentino Contemporaneo. (catalogue/book)

———. 2001. *Bajo el Nombre de Juan*. Bogotá: Arte Dos Gráfico Press. (artist book)

Petrina, Alberto. 2000. La arquitectura de la recuperación democrática. *Siglo XX Argentina Arte y Cultura*. Buenos Aires: Centro Cultural Recoleta. (catalogue)

Portillos, Alfredo. 2000. *De la muerte a la vida: retrospectiva*. Buenos Aires: Fundación Andreani. (catalogue)

Rébori, Blanca. 2000. Folklore: De la mano, etnia y globalización. *Siglo XX Argentina Arte y Cultura*. Buenos Aires: Centro Cultural Recoleta. (catalogue)

Squiru, Rafael. 1961. An Introductory Note by Dr. Rafael Squiru, Director of the Museum of Modern Art of Buenos Aires. In: Arts Council. *Modern Argentine Painting and Sculpture*. London: Arts Council. (exhibition brochure)

Telesca, Ana María. 2000. Coleccionismo empresarial, Collecionismo institucional, colecciones de arte contemporáneo, Los jóvenes coleccionistas de la última década. *Siglo XX Argentina Arte y Cultura*. Buenos Aires: Centro Cultural Recoleta. (catalogue)

Vázquez Zuleta, Sixto (n.d.; posterior to 1988). *Bienes Culturals Populares de la Quebrada de Humahuaca*. Humahuaca (Jujuy): Museo Folklórico de Humahuaca. (museum catalogue)

Films and Videos

Javier Olivera. 2000. *El Camino*. Aries (Argentina), 105 mins. (film)

Jorge Prelorán. 1971. *Araucanos de Ruca Choroi*. Universidad Nacional de Tucumán (Argentina), 50 mins. (film)

———. 1972. *Imaginero*. Universidad Nacional de Tucumán (Argentina), 52 mins. (film)

Michael Cimino. 1987. *The Sicilian*. Universal Pictures (U.S.A.), 141 mins. (film)

Ximena Eliçabe. 1996. *Mantos chamánicos*. (video based on performance at Centro Cultural Rojas, Universidad de Buenos Aires), 4 mins.

Websites

http://www.arteuna.com/talleres/Caceres/proyecto2001.htm (Anahí Cáceres)

http://www.calatrava.com (Santiago Calatrava)

http://www.facilitarviajes.com.ar/espanol/jujuymapa.htm (Map of Jujuy Province)

http://www.indec.mecon.gov.ar/ (INDEC, National Statistics Institute, Argentina)

http://www.latinarte.com (internet gallery)

http://www.tate.org.uk/onlineevents/archive/fieldworks/ (conference website)

Books and Articles

Albuerne, Irene/ Diaz y Zárate, Vilma. 1999. *Diseños Indígenas Argentinos*. Buenos Aires: Emecé.

Amselle, Jean-Loup. 1998. *Mestizo Logics: Anthropology of Identity in Africa and Elsewhere*. Stanford: Stanford University Press.

Appadurai, Arjun. 1996. *Modernity at Large: Cultural Dimensions of Globalization*. Minneapolis: University of Minnesota Press.

Archetti, Eduardo. 2001. *El poterero, la pista y el ring: Las patrias del deporte argentino*. Buenos Aires: Fondo de Cultura Económica.

———. 1999. *Masculinities: Football, Polo and the Tango*. Oxford: Berg.

Arrom, José Juan. 1959. "Criollo: Definicion y matices." *Certidumbre de America: Estudios de letras, folklore y cultura*. José Juan Arrom. La Habana: Anuario Bibliográfico Cubano.

Asad, Talal (ed.). 1973. *Anthropology and the Colonial Encounter*. New York: Humanities Press.

Ascher, Robert. 1961. "Experimental Archaeology." *American Anthropologist*, 63, 793–816.

Bakhtin, M.M. 1981. *The Dialogic Imagination: Four Essays*. Austin: University of Texas Press.

Balmori, D./Oppenheimer, R. 1979. "Family Clusters: Generational Nucleation in Nineteenth-Century Argentina and Chile." *Comparative Studies in Society and History*, 21, 231–261.

Barkan, Elazar/Bush, Ronald. 1995. "Introduction." *Prehistories of the Future: The Primitivist Project and the Culture of Modernism*. Ed. E. Barkan/R.Bush. Stanford: Stanford University Press.

Barth, Frederik. 1969. *Ethnic Groups and Boundaries. The Social Organization of Cultre Difference*. Oslo: Universitetsforlaget.

———. 1989. "The Analysis of Culture in Complex Societies." *Ethnos*, 54 (3–4), 120–142.

Bateson, Gregory. 1973. "Culture Contact and Schismogenesis." *Steps to an Ecology of Mind*. Gregory Bateson. London: Paladin.

Baudet, Henri. 1965. *Paradise on Earth: Some Thoughts on European Images of Non-European Man*. New Haven: Yale University Press.

Baudrillard, Jean. 1988. *America*. London: Verso.

Becker, Howard. 1982. *Art Worlds*. Berkeley: University of California Press.

Beals, Ralph. 1953. "Acculturation." *Anthropology Today*. Ed. Alfred Kroeber. Chicago: Chicago University Press.

Benedict, Ruth. 1934. *Patterns of Culture*. Boston: Houghton Mifflin.

Bengoa, José. 2000. *La emergencia indígena en América Latina*. Santiago: Ediciones SUR.

Benthall, Jonathan. 1999. "The Critique of Intellectual Property." *Anthropology Today*, 15 (6), 1–3.

Bernand, Carmen. 1998. "Esclaves et affranchis d'origine africaine." *Cahiers Internationaux de Sociologie*, CV, 325–340.

———. 2000. La población negra de Buenos Aires (1777–1862). *Homogeneidad y nación: con un estudio de caso: Argentina, siglos XIX y XX*. Ed. Mónica Quijada, Carmen Bernand, and Arnd Schneider. Madrid: Consejo Superior de Investigaciones Científicas.

Biazzi, Miguel/Magrassi, Guillermo. 1996. *Orígenes Argentina*. Buenos Aires: Corregidor.

Biró de Stern, Ana. 1967. "Supervivencia de elementos mágico-indígenas en la puna jujeña." *América Indígena*, XXVII, 2, 317–331.

Bloch, Maurice. 1991. "Language, Anthropology and Cognitive Science." *Man (N.S.)*, 26 (2), 183–198.

———. 1998. How we think they think: anthropological approaches to cognition, memory and literacy. Oxford: Westview Press.

Blok, Anton. 1974. *The Mafia of a Sicilian Village, 1860–1960: A Study of Violent Peasant Entrepreneurs*. Oxford: Basil Blackwell.

Blum, Volkmar. 2001. *Hybridisierung von unten: Nation und Gesellschaft im mittleren Andenraum*. Münster: LIT Verlag.

Boon, James. 1982. *Other Tribes, Other Scribes: Symbolic Anthropology in the Comparatives Study of Cultures, Histories and Texts*. New York: Cambridge University Press.

Bordas de Rojas Paz, Nerva. 1997. *Filosofía a la Intemperie. Kusch: Ontología desde América*. Buenos Aires: Editorial Biblos.

Bourdieu, P. 1987. *Die feinen Unterschiede: Kritik der gesellschaftlichen Urteilskraft* (French edn. 1979 La distinction: Critique sociale du jugement), Frankfurt/M.: Suhrkamp.

Boyer, Pascal. 1993. "Cognitive Aspects of Religious Symbolism." *Cognitive Aspects of Religious Symbolism*. Ed. P. Boyer. Cambridge: Cambridge University Press.

Brown, Michael F. 1998. "Can Culture be copyrighted?." *Current Anthropology*, 39 (2), 193–222.

Briones, Claudia (ed.). 2005. *Cartografías Argentinas. Políticas indgenistas y formaciones provinciales de alteridad*. Buenos Aires: Antropofagia.

Brown, J.C. 1994. "Revival of the Rural Economy and Society in Buenos Aires." *Revolution and Restoration: The Rearrangement of Power in Argentina, 1776–1860*. Ed. M.D. Szuchman/J.C. Brown. Lincoln: University of Nebraska Press.

Brumann, Christoph. 1999. "Writing for Culture: Why a Successful Concept Should Not Be Discarded." *Current Anthropology*, 40, Supplement, S1-S27.

Brydon, Anne. 2004. "Art, Politics and *Atanarjuat*: Whatever do we do with beauty?" paper delivered at EASA, Vienna, September 8–12, 2004.

Buchloh, Benjamin H.D. 1982. "Allegorical Procedures: Appropriation and Montage in Contemporary Art." *Art Forum*, 21 (1), 43–56.

Bunzel, Ruth L. 1972 ([1]1929). *The Pueblo Potter: A study of Creative Imagination in Primitive Art*. New York: Dover Publications.

Burke, Peter. 1996. "Cultural Studies Questionnaire." *Journal of Latin American Cultural Studies*, 5 (2).183–189.

Brysk, Alison. 2000. *From Tribal Village to Global Village: Indian Rights and International Relations in Latin America*. Stanford: Stanford University Press.

Cáceres, Anahí. 1992. Lectura del Arte Precolumbino: el cerimonial Mapuche del Ngillantún. *Cuadernos de IMAGIN ERA* (Córdoba), 2, 4–23.

Canella, Leticia S. 1990. Construcción de la identidad en un grupo de descendientes indígenas. *Anales del VIIº Encuentro Nacional y Vº Regional de Historia*, 2 (2), 162–165.

Canevacci, Massimo. 1993. *La città polifonica: Saggio sull'antropologia della communicazione urbana*. Rome: Edizioni Seam Roma.

———. 1995. *Sincretismi: Una esplorazione sulle ibridazioni culturali*. Genoa: Costa & Nolan.

Caplan, Lionel. 1995. "Creole world, purist rhetoric: Anglo-Indian cultural debates in colonial and contemporary Madras." *Journal of the Royal Anthropological Institute* (N.S.), 1 (4), 743–762.

Carlini, Sabrina. 2003. "Cada día se ve major." *Todo es historia*, 431, 5–16.

Chapman, Anne. 1982. *Drama and Power in a Hunting Society: The Selk'nam of Tierra del Fuego*. Cambridge: Cambridge University Press.

Colatarci, María Azucena. 1985. "Aproximación a la cosmovisión del hombre puneño." *Pregón* (Jujuy), May 4, 1985, I–II.

Constitución de la Nación Argentina. Santa Fe-Paraná. 1994. Buenos Aires: Producciones Mawis.

Chanady, Amaryll. 1994. "Introduction: Latin American Imagined Communities and the Postmodern Challenge." *Latin American Identity and Constructions of Otherness*. Ed. Amaryll Chanady. Minneapolis: University of Minnesota Press.

Chiti, Jorge Fernández. 1997. *Cerámica Indígena Archeológica Argentina: Las Técnicas. Los Orígenes. El Diseño*. Buenos Aires: Condorhuasi.

Churchill, Ward. 1992. Lawrence of South Dakota: *Dances with Wolves* and the Maintenance of the American Empire. *Fantasies of the Master Race: Literature, Cinema and the Colonization of American Indians*. Ward Churchill, ed. M. Annette Jaimes. Monroe, Maine: Common Courage Press.

Clifford, James. 1988. *The Predicament of Culture: Twentieth-Century Ethnography, Literature, and Art*. Cambridge/Mass.: Harvard University Press.

————. 1997. *Routes. Travel and Translation in the lateTwentieth Century*. Cambridge, Mass.: Harvard University Press.

Coles, Alex (ed.). 2000. *Siting Ethnography*. London: Blackdog Publications.

Colloredo-Mansfeld, Rudi. 1999. *The Native Leisure Class: Consumption and Cultural Creativity in the Andes*. Chicago: University of Chicago Press.

Coluccio, Félix. 1992 [1978]. *Fiestas y Celebraciones en la República Argentina*. Buenos Aires: Plus Ultra.

————. 1994 [1986]. *Cultos y Canonizaciones Populares de Argentina*. Buenos Aires: Ediciones del Sol.

Cooke, Lynne. 1991. "The Resurgence of the Night-Mind: Primitivist Revivals in Recent Art." *The Myth of Primitivism*. Ed. Susan Hiller. London: Routledge.

Coombe, Rosemary J. 1993. "The Properties of Culture and the Politics of Possessing Identity: Native Claims in the Cultural Appropriation Controversy." *Canadian Journal of Law and Jurisprudence*, VI (2), 249–285.

————. 1998. *The Cultural Life of Intellectual Properties: Authorship, Appropriation and the Law*. Durham: Duke University Press.

Cormack, Sabine. 1991. *Religion in the Andes: Vision and Imagination in Early Colonial Peru*. Princeton: Princeton University Press.

Corsín Jiménez, Alberto. 2003. "On space as capacity." *Journal of the Royal Anthropological Institute* (N.S.), 9 (1), 137–153.

Coutts-Smith, Kenneth. 1991. "Some general observations on the problem of cultural colonialism." *The Myth of Primitivism: Perspectives on Art*. Ed. Susan Hiller. London: Routledge.

Crapanzano, Vincent. 1990. "On dialogue." *The Interpretation of Dialogue*. Ed. Tullio Maranhão. Chicago: University of Chicago Press.

Critical Art Ensemble. 1998. "Interview with Group Material." *Interventions and Provocations: Conversations on Art, Culture, and Resistance*. Ed. Glenn Harper. Albany: State University of New York Press.

Curtis, Edward Sheriff. 1907–1930. *The North American Indian*. 20 Vols. Vols. 1–5. Cambridge, MA: The University Press; Vols. 6–20. Norwood, MA: The Plimwood Press.

Danto, Arthur. 1964. "The Artworld." *Journal of Philosophy*, 61, 571–584.

————. 1992. "The Art World Revisited: Comedies of Similarity." *Beyond the Brillo Box: The Visual Arts in Post-Historical Perspective*. Ed. Arthur Danto. New York: The Noonday Press.

De la Cadena, Marisol. 2000. *Indigenous Mestizos: The Politics of Race and Cultures in Cuzco, Peru, 1919–1991*. Durham: Duke University Press.

Directorio de Arte Latinoamericano. 2000. Buenos Aires: artealdía.

Diamond, David D. *The Bullfinch Pocket Dictionary of Art Terms*. 1992. ed. and rev. David D. Diamond. Boston: Little, Brown and Company.

Echeverría, Bolívar (ed.). 1994. *Modernidad, Mestizaje Cultural, Ethos Barroco*. Mexico City: UNAM/El Equilibrista.

Edwards, Elizabeth (ed.). 1992. *Anthropology and Photography 1860–1920*. New Haven: Yale University Press.

————. 2001. *Raw Histories*. Oxford: Berg Publishers.

Epstein, Edward C. 2003. "The Piquetero Movement of Greater Buenos Aires: Working Class Protest During the Current Argentine Crisis." *Canadian Journal of Latin American and Caribbean Studies*, 28 (55–56), 11–36.

Ericson, Deborah. 1988. *In the Stockholm Art World*. Stockholm: Dept. of Social Anthropology (Stockholm Studies in Social Anthropology 17).

Errington, Sarah. 1994. "What became authentic primitive art?" *Cultural Anthropology*, 9 (2), 201–226.

———. 1998. *The Death of Authentic Primitive Art and Other Tales of Progress.* Berkeley: University of California Press.

Fabian, Johannes. 1983. *Time and the Other: How Anthropology Makes Its Object.* New York: Columbia University Press.

Fiadone, Alejandro Eduardo. 2001. *El diseño indígena argentino: una aproximación estética a la iconografía precolumbina.* Buenos Aires: la marca.

Fillitz, Thomas. 2002. "The notion of art: From regional to distant comparison." *Anthropology, by Comparison.* Ed. Gingrich, Andre and Richard G. Fox. London: Routledge.

Fisher, Jean. 1991. "Dancing with Words and Speaking with Forked Tongues," *Third Text*, 14, 27–40.

Franco, Jean. 1970. *The Modern Culture of Latin America: Society and the Artist (revised edition).* Harmondsworth: Penguin.

Friederici, G. 1960. *Amerikanistisches Wörterbuch und Hilfswörtebuch für den Amerikanisten.* Hamburg: Cram, De Gruyter.

Freeman, Mark. 1993. *Finding the Muse: A Sociopsychological Inquiry into the Conditions of Artistic Creativity.* Cambridge: Cambridge University Press.

Freeman, Richard. 2001. "The City as *Mise-en-Scène*: A Visual Exploration of the Culture of Politics in Buenos Aires." *Visual Anthropology Review*, 17 (1), 36–59.

Friedman, Jonathan. 1997. "Global Crises, the Struggle for Cultural Identity and Intellectual Porkbarrelling: Cosmopolitans versus Locals, Ethnics and Nationals in an Era of De-hegemonisation." *Debating Cultural Hybridity: Multi-Cultural Identities and the Politics of Anti-Racism.* Ed. Pnina Werbner and Tariq Modood. London: Zed Books.

———. 1999. "The Hybridization of Roots and the Abhorrence of the Bush." *Spaces of Culture: City, Nation, World.* Ed. Mike Featherstone/Scott Lash. London: Sage.

Gadamer, Hans-Georg. 1960. *Wahrheit und Methode: Grundzüge einer philosophischen Hermeneutik.* Tübingen: J.C.B. Mohr.

Gallo, Rubén. 2004. *New Tendencies in Mexican Art: The 1990s.* New York: Palgrave.

García, Silvia Perla. 1979. "Algunas consideraciones sobre la fiesta de San Juan en Misiones y Formosa. Argentina." *Folklore Americano*, 28, 145–157.

García Canclini, Néstor. 1993a. Transforming Modernity: Popular Culture in Mexico (transl. Lidia Lozano). Austin: University of Texas Press.

———. 1993b. "The Hybrid: A Conversation with Margarita Zires, Raymundo Mier and Mabel Piccini." *The Postmodernism Debate In Latin America* (special issue of boundary 2). Ed. John Berley and Jose Oviedo. Durham, N.C.: Duke University Press.

———. 1995a [1989]. *Hybrid Cultures: Strategies for Entering and Leaving Modernity.* Minneapolis: University of Minnesota Press [*Cultura Híbridas: Estragias para entrar y salir de la modernidad.* Mexico City: Grijalbo].

———. 1995b. "Memory and Innovation in the Theory of Art." *South Atlantic Quarterly*, 93 (3), 423–443.

García-Canclini, Néstor (ed.). 1998. *Cultura y comunicación en la ciudad de México.* 2 vols. Mexico City: Grijalbo.

———. 2000. "From National Captial to Global Captial: Urban Change in Mexico City." *Public Culture*, 12 (1), 207–213.

Gell, Alfred. 1998. *Art and Agency: An Anthropological Theory.* Oxford: Oxford University Press.

Germani, Gino. 1955. *La estructura social de la Argentina*. Buenos Aires: Raigal.

———. 1970. "Mass immigration and modernization in Argentina." *Masses in Latin America*. Ed. I.L. Horowitz. New York: Oxford University Press.

———. 1975. *Autoritarismo, fascismo e classi sociali*. Bologna: Il Mulino.

Gingrich, Andre. 2002. "When ethnic majorities are 'dethroned': towards a methodology of self-reflexive, controlled macrocomparison." *Anthropology, by Comparison*. Ed. Gingrich, Andre and Richard G. Fox. London: Routledge.

Gingrich, Andre and Richard G. Fox. 2002. "Introduction." *Anthropology, by Comparison*. Ed. Gingrich, Andre and Richard G. Fox London: Routledge.

Giordano, Christian. 1997. "I Can Describe Those I Don't Like Better Than Those I do. *Verstehen* as a Methodological Principle in Anthropology." *Anthropological Journal on European Cultures*, 7 (1), 27–41.

Ginsburg, Faye. 2003. "*Atanarjuat* Off-Screen: From 'Media Reservations' to the World Stage," *American Anthropologist*, 105 (4), 827–831.

Giordano, Mariana. 2005. *Discurso e imagen sobre el indígena chaqueño*. La Plata: Ediciones Al Margen.

Göbel, Barbara. 1997. " 'You Have to Exploit Luck': Pastoral Household Economy and the Cultural Handling of Risk and Uncertainty in the Andean Highlands," *Nomadic Peoples* (N.S.), 1 (1), 37–53.

———. 1998. "Risk, Uncertainty, and Economic Exchange in a Pastoral Community of the Andean Highlands (Huancar, N.W. Argentina)." *Kinship, Networks, and Exchange*. Ed. Thomas Schweizer/Douglas R. White. Cambridge: Cambridge University Press.

Golonbek, Claudio. 2001. *Argentine Contemporary Art Market Investment Guide* (bilingual edition). Buenos Aires: Rizzo Patricia editora.

Gombrich, E.H. 1966. "Norm and Form: The Stylistic Categories of Art History and their Origins in Renaissance Ideals." *Norm and Form: Studies in the Art of the Renaissance*. E.H. Gombrich. London: Phaidon.

Gordillo, Gastón R. 2004. *Lanscapes of the Devil: Tensions of Place and Memory in the Argentinean Chaco*. Durham, NC: Duke University Press.

Gow, Peter. 1991. *Of Mixed Blood: Kinship and History in Peruvian Amazonia*. Oxford: Clarendon Press.

Graburn, N. 2001. "White Evaluation of the Quality of Inuit Sculpture." *Inuit Quarterly*, 16 (3), 30–39.

Graebner, Fritz. 1911. *Methode der Ethnologie*. Heidelberg.

Greverus, Ina-Maria. 2001. *Anthropologisch reisen*. Münster: LIT.

Grimshaw, Anna. 2001. *The Ethnographer's Eye: Ways of Seeing in Modern Anthropology*. Cambridge: Cambridge University Press.

Gruzinski, Serge. 1991. "From the Baroque to the Neo-Baroque: The Colonial Sources of the Postmodern Era (The Mexican Case)." *El Corazón Sangrante/The Bleeding Heart* (exhibition catalogue). Boston: The Institute of Contemporary Art/Seattle: University of Washington Press.

———. 2002. *The Mestizo Mind*. London: Routledge.

Guano, Emanuela. 2002. "Spectacles of Modernity: Transantional Imagination and Local Hegemonies in Neoliberal Buenos Aires." *Cultural Anthropology*, 17 (2), 181–209.

Guss, David. 1989. *To Weave and Sing: Art, Symbol, and Narrative in the South American Rain Forest*. Berkeley: University of California Press.

Gutiérrez, Natividad. 1999. *Nationalist Myths and Ethnic Identities: Indigenous Intellectuals and the Mexican State*. Lincoln: University of Nebraska Press.

Gutiérrez, Natividad (ed.). Forthcoming 2007. *Women and Nationalisms in Latin America*. Adingdon. UK: Ashgate.

Haber, Alicia. 1996. Uruguay. *Latin American Art in the Twentieth Century*. Ed. Edward. J. Sullivan. London: Phaidon.

Haberland, Eike (ed.). 1973. *Leo Frobenius: An Anthology*. Wiesbaden: Franz Steiner Verlag.

Hannerz, Ulf. 1992. *Cultural Complexity: Studies in the Social Organization of Meaning*. New York: Columbia Unviersity Press

———. 1996. *Transnational Connections*. London: Routledge.

Harrison, Simon. 1999a. "Identity as a scarce resource." *Social Anthropology*, 7 (3), 239–251.

———. 1999b. "Cultural boundaries." *Anthropology Today*, 15 (5), 10–13.

Harvey, David. 1989. *The Condition of Postmodernity*. Oxford: Blackwell.

Hauschild, Thomas (ed.). 1995. *Lebenslust und Fremdenfurcht: Ethnologie im Dritten Reich*. Frankfurt/M.: Suhrkamp.

Hegel, G.W.F. 1991. *Elements of the Philosophy of Right*. Cambridge: Cambridge University Press.

Heinrichs, Hans-Jürgen. 1998. *Die fremde Welt, das bin ich: Leo Frobenius: Ethnologe, Forschungsreisender, Abenteurer*. Wuppertal: Peter Hammer Verlag.

Hengartner, Thomas. 2000. "Die Stadt im Kopf. Wahrnehmung und Aneignung der städtischen Umwelt." *Kulturwissenschaftliche Stadtforschung*. Ed. Waltraud Kokot/Thomas Hengartner/Kathrin Wildner. Berlin: Reimer.

Herrera, Maria Jose. 1993. "Arte y Antropología." *ARTINF* (Buenos Aires), 17 (85), no page numbering.

Hernández, Isabel. 1992. *Los indios en la Argentina*. Madrid: MAPFRE.

Herzfeld, Michael. 2004. *The Body Impolitic: Artisans and Artifice in the Global Hierarchy of Value*. Chicago: University of Chicago Press.

Heymann, Daniel and Kosacoff, Bernardo. 2000. *La Argentina de los Noventa: Desempeño económico en un contexto de reformas*. Buenos Aires: Eudeba/CEPAL.

Hirschfeld, L.A. and S.A. Gelman (eds.). 1994. *Mapping the Mind*. Cambridge: Cambridge University Press.

Iglesia, Cristina. 1992. La mujer cautiva: cuerpo, mito y frontera. *Historia de las mujeres en Occidente*. Vol. 3 *Del Renacimiento a la Edad Moderna*. Ed. Duby, Georges y Perrot, Michelle. Madrid: Taurus.

Imaz, J.L. de. 1965. *Actitudes y opiniones de la clase alta de Buenos Aires*. Buenos Aires: Investigaciones y Trabajos del Instituto de Sociología.

———. 1968. Los que mandan. Buenos Aires: Editorial de la Universidad de Buenos Aires.

Inda, Jonathan Xavier and Renato Rosaldo (eds.). 2001. *The Anthropology of Globalization: A Reader*. Oxford: Blackwell.

Jackson, John L. Jr. (2004). "An Ethnographic *Film* flam: Giving Gifts, Doing Research, and Videotaping the Native Subject/Object." *American Anthropologist*, 106 (1), 32–42.

Jackson, Michael. 1983. "Knowledge of the Body," *Man* (N.S.), 18, 327–345.

Jamieson, Mark. 1999. "The Place of Counterfeits in regimes of value: an anthropological approach." *Journal of the Royal Anthropological Institute* (N.S.), 5 (1), 1–11.

Jeffery, Patricia/Jeffery, Roger. 2000. "Bollywood in Bijnor? Making an Open University Film in in Rural North India." *Visual Anthropology*, 13, 149–168.

Kokot, Waltraud. 2000. "Diaspora, Lokalität und Stadt. Zur ethnologischen Forschung in räumlich nichtbegrenzten Gruppen." *Kulturwissenschaftliche*

Stadtforschung. Ed. Waltraud Koko, and Thomas Hengartner/Kathrin Wildner. Berlin: Reimer.

Korol, J.C./Sábato, H. 1981. *Cómo fue la inmigración Irlandesa en Argentina.* Buenos Aires: Editorial Plus Ultra.

Kramer, Fritz. 1985. "Empathy. Reflections on the History of Ethnology in Pre-Fascist Germany," *Dialectical Anthropology,* 9, 337–347.

———. 1993 [1986]. *The Red Fez: Art and Spirit Possession in Africa.* London: Verso.

Krauss, Rosalind. 1989. "Retaining the Original? The State of the Question." *Retaining the Original: Multiple Originals, Copies and Reproductions.* Ed. National Gallery of Art, Washington. Studies in the History of Art, Vol.20. Hanover and London: University of New England.

Kreff, Fernand. 2003. *Grundkonzepte der Sozial- und Kulturanthropologie in der Globalisierungsdebatte.* Berlin: Reimer.

Kroeber, Alfred. 1917. "The Superorganic." *American Anthropologist,* 19. 163–213.

Kubler, George. 1962. *The Shape of Time.* New Haven: Yale University Press.

———. 1991. *Esthetic Recognition of Ancient Amerindian Art.* New Haven: Yale University Press.

———. 1996. "Aesthetics since Amerindian Art before Columbus." *Andean Art at Dumbarton Oaks.* Ed. Elizabeth Hill Boone. Washington, D.C.: Dumbarton Oaks Research Library and Collection.

Kuper, Adam. 1988. *The Invention of Primitive Society.* London: Routledge.

Kusch, Rodolfo. 2000. *Obras Completas.* Vol. 1. Buenos Aires: Editorial Fundación Ross.

Lammer, Christina (ed.). 2002a. *doKU: Wirklichkeit inszenieren im Dokumentarfilm.* Vienna: Turia + Kant.

———. 2002b. "Horizontal & Vertical Penetration: The 'Flesh and Blood' of Image Fabriction in the Operating Theatres of Interventional Radiology." *Cultural Studies,* 16 (6), 2002, 833–847.

Larraín, Jorge I. 1996. *Modernidad, razón e identidad en América Latina.* Santiago de Chile: Editorial Andrés Bello.

Latour, Bruno. 1986. "Visualization and Cognition: Thinking with eyes and hands." *Knowledge and Society: Studies in the Sociology of Culture Past and Present,* 6, 1–40.

Lavie, Smadar, Kirin Narayan, and Renato Rosaldo (eds.). 1993. *Anthropology/ Creativity,* Ithaca: Cornell University Press.

Leach, James. 2000. "Situated connections. Rights and intellectual resources in a Rai Coast society." *Social Anthropology,* 8 (2), 163–179.

Lenton, Diana and Mariana, Lorenzetti. 2005. "Neoindigenismo de necesidad y urgencia: la inclusion de los Pueblos Indígenas en la agenda del Estado neoasistencialista." *Cartografías Argentinas. Políticas indgenistas y formaciones provinciales de alteridad.* Ed. Claudia Briones. Buenos Aires: Antropofagia.

Lienhard, Martin. 1997. "Of Mestizajes, Heterogeneities, Hybridisms and Other Chimeras: On the Macroprocesses of Cultural Interaction in Latin America." *Journal of Latin American Cultural Studies,* 6 (2), 183–198.

Lips, Julius. 1937. *The Savage Hits Back.* London: Lovat Dickinson.

Loewenthal, David. 1985. *The Past Is a Foreign Country.* Cambridge: Cambridge University Press.

Lóizaga, Patricio. 1999. "Destacada presencia argentina en ARCO 99." *El Grito,* April, p. 15.

Lothrop, S.K. 1979. *Los tesoros de la América Antigua: Artes de las Civilizaciones Precolumbinas desde México al Perú.* Geneva: Ediciones Destino.

Lowie, Robert. 1937. *The History of Anthropological Theory*. New York: Farrar and Rinehart.

Lucie-Smith, Edward. 1995. *The Thames and Hudson Dictionary of Art Terms*. London: Thames and Hudson.

Luhmann, Niklas. 1995. *Die Kunst der Gesellschaft*. Frankfurt/M.: Suhrkamp.

MacClancy, Jeremy (ed.). 1997. *Contesting Art: Art, Politics and Identity in the Modern World*. Oxford: Berg.

McDougall, David. 1998. *Transcultural Cinema*. Princeton: Princeton University Press.

Magrassi, G.E. 1987. *Los aborígenes de la Argentina: ensayo socio-histórico-cultural*. Buenos Aires: Ediciones Búsqueda.

McGee, W.J. 1898. "Piratical Acculturation." *American Anthropologist*, 11, 243–249.

Malosetti Costa, Laura. 1993. "El rapto de cautivas blancas: un aspecto erotico de la barbarie en la plastica rioplatense del siglo *XIX*." Paper presented at the XVII Coloquio Internacional de Historia del Arte: *Arte, Historia e Identidad en America-Visiones comparativas*. Instituto de Investigaciones Estéticas de la Universidad Nacional Autónoma de Mexico and Comité International d'Histoire de l'Art. Zacatecas, Mexico, September 22–27, 1993.

———. 1994. *El rapto de cautivas blancas: un aspecto erotico de la barbarie en la plastica rioplatense del siglo XIX*. Buenos Aires: Facultad de Filosofía y Letras.

———. 2001. *Los primeros modernos. Arte y sociedad en Buenos Aires a fines del siglo XIX*. Buenos Aires: Fondo de Cultura Económica.

Maranhão, Tullio. 1986. *Therapeutic Discourse and Socratic Dialogue*. Madison: University of Wisconsin Press.

Marcus, G. 1995. "Ethnography in/of the World System: The Emergence of Multi-Sited Ethnography." *Annual Review of Anthropology*, 24, 95–117.

Marcus, G. and F. Myers (eds.). 1995. *The Traffic in Culture: Refiguring Art and Anthropology*. Berkeley: University of California Press.

Mariscotti de Görlitz, Ana María. 1978. *Pachamama Santa Tierra: Contribución al estudio de la religion autóctona en los Andes centro-meridionales*. Indiana, supplement 8. Berlin: Gebr. Mann Verlag.

Marzal, Manuel M. 1993. *Historia de la antropología indigenista: México y Perú*. Barcelona: Anthropos.

Mason, Peter. 1990. *Deconstructing America*. London: Routledge.

Mauss, Marcel. 1990 [1923–1924]. *The Gift: the Form and Reason for Exchange in Archaic Societies*. London: Routledge.

Maybury-Lewis, D. 1991. "Becoming Indian in Lowland South America." *Nation-States and Indians in Latin America*. Ed. G.Urban/J.Sherzer. Austin: University of Texas Press.

Melk-Koch, Marion. 1989. *Auf der Suche nach der menschlichen Gesellschaft: Richard Thurnwald*. Berlin: Reimer.

Minar, C. Jill and Patricia L. Crown, 2001. Learning and Craft Production: An Introduction. *Journal of Anthropological Research*, 57 (4), 369–380.

Minh-ha, Trinh T. 1994. "Speaking nearby." *Visualizing Theory: Selected Essays from V.A.R. 1990–1994*. Ed. Lucien Taylor. London: Routledge.

Mintz, Sidney. 1995. "Enduring substances, Trying Theories: The Caribbean Region as *oikoumené*." *Journal of the Royal Anthropological Institute* (N.S.), 2 (2), 289–311.

———. 1998. "The Localization of Anthropological Practice: From Area Studies to Transnationalism." *Critique of Anthropology*, 18 (2), 117–133.

Moeran, Brian. 1990. "Making an exhibition of oneself: Theanthropologist as potter in Japan." *Unwrapping Japan: Society and Culture in Anthropological Perspective.* Ed. Eyal Ben-Ari, Brian Moeran, and James Valentin. Manchester: Manchester University Press.

Moore, Henrietta. 1990. "Paul Ricoeur: Action, Meaning and Text." *Reading Material Culture.* Ed. Christopher Tilley. Oxford: Blackwell.

Moreiras, Alberto. 1995. "Restitution and Appropriation in Latin Americanism." *Journal of Interdisciplinary Literary Studies,* 7 (1), 1–43.

Morris, Brian. 1994. *The Anthropology of the Self: The Individual in Cultural Perspective.* London: Pluto Press.

Morse, Richard M. 1988. *New World Soundings: Culture and Ideology in the Americas.* Baltimore: Johns Hopkins University Press.

Mosquera, Gerardo. 1992. "Presentación." *Ante América* (exhibition catalogue), Bogotá: Banco de la República.

———. (ed.). 1996. *Beyond the Fantastic Contemporary Art criticism from Latin America. Cambridge, Mass.* London: MIT Press/inIVA.

Mosquera, Gerardo/Fisher, Jean (eds.). 2004. Over here: *International Perspectives on Art and Culture,* Cambridge, Mass.: MIT Press.

Mühlmann, W.E. 1984. *Geschichte der Anthropologie.*Wiesbaden: Aula Verlag.

Nash, June. 2001. *Mayan Visions: The Quest for Autonomy in an Age f Globalization.* London: Routledge.

Occhipinti, Laurie. 2002. "Being Kolla: Indigenous Identity in Northwestern Argentina." *Canadian Journal of Latin American and Caribbean Studies,* 27 (54), 319–345.

Ong, Aihwa. 1999. *Flexible Citizenship: The Cultural Logics of Transnationality.* Durham, N.C.: Duke University Press.

Ortelli, Sara. 1996. "La 'araucanización de las pampas: ¿Realidad histórica o construcción de los etnólogos?" *Anuario del IEHS* (Tandil), 208–225.

Ortiz, Fernando. 1947. *Cuban Counterpoint: Tobacco and Sugar.* New York: Knopf.

Overing, Joanna (ed.). 1985. *Reason and Morality.* London: Tavistock.

Overing, Joanna and Alan Passes (eds.). 2000. *Love and Anger: The Aesthetics of Conviviality in Native Amazonia.* London: Routledge.

Paternosto, César. 1996 [¹1989]. *The Stone and the Thread: Andean Roots of Abstract Art.* Austin: University of Texas Press.

———. 1999. *North and South Connected: An Abstraction of the Americas.* (Essay and Exhibiton Catalogue). New York: Cecilia de Torres, Ltd.

———. (ed.). 2001. *Abstraction: The Amerindian Paradigm.* Brussels: Palais des Beaux-Arts.

———. 2006. "No Borders: The Ancient American Roots of Abstraction." *Contemporary Art and Anthropology.* Ed. Arnd Schneider/Christopher Wright. Oxford: Berg.

Penhos, Marta. 1996a. "Retratos de indios y actos de representación." *Memoria del 4º Congreso de Historia de la Fotografía en la Argentina.* Buenos Aires: CEP.

———. 1996b. "Actores de una historia sin conflictos. Acerca de los indios en pinturas del Museo Histórico Nacional." *Estudios e Investigaciones. Instituto de Teoría e Historia del Arte "Julio E. Payró."* No. 6, Buenos Aires, F. de Filosofia y Letras, U.B.A.

———. 1999. "Representación e identidad comunitaria. Calfucurá y Bibolini frente a 25 de Mayo." *Epílogos y prólogos para un fin de siglo.* Buenos Aires: CAIA.

———. 2005. "Frente y perfil. Una indagación acerca de la fotografía en las practicas antropológicas y criminológicas en la Argentina a fines del siglo XIX y principios del XX", Marta Penhos, Carlos Masotta, Mariano Oropesa, Sandra Bendayan, María Inés

Rodríguez Aguilar, Miguel Ruffo y María Spinelli, *Arte y Antropología en la Argentina*, Buenos Aires: Fundación Telefónica/Fundación Espigas/FIAAR.

Penhos, Marta and Diana, Wechsler (eds.). 1999. *Tras los pasos de la norma. Salones Nacionales de Bellas Artes (1911–1989)*. Buenos Aires, Ediciones del Jilguero, (Archivos del CAIA 2).

Pérez Amuchástegui, A.J. 1988. *Mentalidades Argentinas (1860–1930)*. Buenos Aires: Eudeba.

Pérez-Bugallo, Rubén. 1993. *Pillantum: Estudios de Etno-organología Patagónica y Pampeana*. Buenos Aires: Búsqueda de Ayllu.

Phillips, David. 1986–1987. "Introduction." *Don't Trust the Label: An Exhibition of Fakes, Imitations and the Real Thing*. London: Arts Council.

Pi Hugarte, Renzo. 1993. *Los indios de Uruguay*. Madrid: Editorial Mapfre.

Pinney, Christopher. 1992. "The Parallel Histories of Anthropology and Photography." *Anthropology and Photography 1860–1920*. Ed. Elizabeth Edwards. New Haven: Yale University Press.

Pinney, Christopher and Thomas, Nicholas (eds.) 2001. *Beyond Aesthetics: Art and the Technologies of Enchantment*. Oxford: Berg.

Plattner, Stuart. 1996. *High Art Down Home: An Economic Ethnography of a Local Art Market*. Chicago: University of Chicago Press.

———. 2004. "Contemporary Art in a Renaissance Setting: The Local Art System in Florence, Italy." *Paper at EASA 2004*, Vienna, September 8–12.

Poole, Deborah 1997. Vision, Race, and Modernity: A visual Economy of the Andean image world. Princeton: Princeton University Press.

Powdermaker, Hortense. 1950. *Hollywood: the Dream Factory: An Anthropologist looks at the Movie-Makers*. Boston: Little, Brown & Company.

Price, Sally 1989. *Primitive Art in Civilized Places*. Chicago: University of Chicago Press.

———. 1993. "Provenances and Pedigrees: The Appropriation of Non-Western Art." Imagery and Creativity: Ethnoaesthetics and Art Worlds in the Americas. Ed. D. S. Whitten and N.E. Whitten. Tucson: Arizona University Press.

Prieto, A. 1988. *El discurso criollista en la formación de la Argentina moderna*. Buenos Aires: Editorial Sudamericana.

Quadri, Andrea. 2000. *Creación artística y legislación: Notas para Artistas Visuales sobre la Ley Argentina de Propiedad Intelectual*. Buenos Aires: Editorial Dunken.

Quijada, Mónica. 1996. "Los 'Incas arios': historia, lengua y raza en la construcción nacional hispanoamericana." *Histórica*, XX (2), 243–269.

———. 1997. "Ancestros, ciudadanos, piezas de museo: modelos antropológicos y construcción nacional en la Argentina decimononica." *Modèles européenes en Amérique Latine. XIXème siècle*. Ed. A. Lamparière et al. Paris: Editions du CNRS.

———. 2000. "Indígenas: violencia, tierras, y ciudadanía." *Homogeneidad y Nación. Con un estudio de caso: Argentina, siglos XIX y XX*. Ed. Mónica Quijada, Carmen Bernand, and Arnd Schneider. Madrid: Colección Tierra Nueva e Cielo Nuevo, Consejo Superior de Investigaciones Científicas.

———. 2002. "Repensado la frontera sur argentina: concepto, contenido, continuidades y discontinuades de una realidad espacial y étnica (siglos XVIII–XIX)." *Revista de Indias*, LXII, 224, 103–142.

Quiroga, Urna/Ibarra Grasso, Dick Edgar. 1971. *Argentina Indígena y Prehistoria Americana*. Buenos Aires: TEA.

Radcliffe, Sarah and Sallie, Westwood. 1996. *Remaking the Nation: Place, Identity and Politics in Latin America*. London: Routledge.

Ramírez, Mari Carmen (ed.). 1992. "Re-Positioning the South: The Legacy of El Taller Torres-García in Contemporary Latin American Art." *El Taller Torres-García: The School of the South and its Legacy.* Ed. Mari Carmen Ramírez. Austin: University of Texas Press.

Redfield, R. Robert, R. Linton, and Herskovits, M. 1936. "Memorandum for the Study of Acculturation." *American Anthropologist,* 38, 149–152.

Reents-Budet, Dorie. 1994. *Painting the Maya Universe. Royal Cermaics of the Classic Period.* Durham, N.C.: Duke University Press.

Reina, R. Ruben. 1973. *Paraná: Social Boundaries in an Argentine City.* Austin: University of Texas Press.

Ricoeur, Paul. 1981. *Hermeneutics and the Human Sciences.* Cambridge: Cambridge University Press.

Rock, David. 1987. *Argentina 1516–1987: From Spanish Colonization to the Falklands War and Alfonsín.* London: I.B.Tauris.

Rojas, Ricardo. 1958 [1930]. *Silabario de la decoración americana.* Buenos Aires: Losada.

———. 1993 [1924]. *Eurindia* (2 vols). Buenos Aires: Centro Editor de América Latina.

Rossi, J.J. (ed.). 1987. *El cine documental etnobiográfico de Jorge Prelorán.* Buenos Aires: Ediciones Búsqueda.

Rowe, William/Schelling, Vivian. 1991. *Memory and Modernity: Popular Culture in Latin America.* London: Verso.

Ruiz, Irma, Rubén, Pérez-Bugallo, Héctor Luis, Goyena. 1993. *Instrumentos Musicales Etnográficos y Folklóricos de la Argentina.* Buenos Aires: Instituto Nacional de Musicología "Carlos Vega."

Sahlins, Marshall. 1972. *Stone Age Economics.* London: Tavistock.

Sallnow, Michael J. 1987. *Pilgrims of the Andes Regional Cults in Cusco*: Washington, D.C.: Smithsonian Institution Press.

Sanchez, Omar. 2004. "Argentina's Landmark 2003 Presidential Election: Renewal and Continuity." *Bulletin of Latin American Research,* 24 (4), 454–475.

Sarasola, Carlos Martínez. 1992. *Nuestros paisanos los indios.* Buenos Aires: Emecé.

Savigliano, M.E. 1995. *Tango and the Political Economy of Passion.* Boulder: Westview.

Schindler, Helmut. 1990. *Bauern und Reiterkrieger: Die Mapuche-Indianer im Süden Amerikas.* Munich: Hirmer.

Schneider, Arnd. 1990. *Emigration und Rückwanderung von "Gastarbeitern" in einem sizilianischen Dorf,* Frankfurt/M.: Peter Lang.

———. 1993a. "The Art Diviners." *Anthropology Today,* 9 (2), 3–9.

———. 1993b. "Inszenierte Mythen: Indigener Spielfilm als Dokument und Fiktion." *Fernsehen und Ethnologie* (ed. Gerd Becker). *Mitteilungen des Hamburgischen Museums für Völkerkunde,* NF., 23, 177–180.

———. 1995. "Moderne, Urbanität und Masseneinwanderung an der Peripherie: Das Beispiel Buenos Aires." *kea: Zeitschrift für Kulturwissenschaften* (Bremen), 8, (1995), 125–148.

———. 1996a. "Uneasy Relationships: Contemporary Artists and Anthropology." *Journal of Material Culture,* 1 (2), 183–210.

———. 1996b. "The Two Faces of Modernity: Concepts of the Melting Pot in Argentina." *Critique of Anthropology,* 16 (2), 1996, 173–198.

———. 1998a. "Tales of Terror and Tango." *Anthropology Today,* 14 (6), 1998, 16–17.

———. 1998b. "L'alterité dans l'Argentine moderne." *Cahiers Internationaux de Sociologie,* CV, 241–260.

Schneider, Arnd. 1998c. "Refracted Identities: Argentine Images of Europe." *Anthropological Journal on European Cultures*, 7 (2), 1998, 39–57.

——. 1999. "Appropriation, Contemporary Arts and Globalisation: Some Issues for Future Research." *Ethnoscripts*, 1 (1), 81–84.

Schneider, Arnd. 2000a. "Discourses of Ethnic Distinctions in Contemporary Argentina." *Ideology and Discursive Practices: Spain and Latin America*. Ed. Francisco Domínguez. Peter Lang: European Academic Publishers, Berne/New York.

——. 2000b. *Futures Lost: Nostalgia and Identity among Italian Immigrants in Argentina*. Oxford Berne/New York: Peter Lang European Academic Publishers.

——. 2000c. "Sites of Amnesia, Non-Sites of Memory: Identity and Other in the Work of Four Uruguayan Artists," *Siting Ethnography*. Ed. Alex Coles. London: Blackdog Publications.

——. 2003a. "On 'Appropriation': A Critical Reappraisal of the Concept and Its Application in Global Art Practices." *Social Anthropology*, 11 (2), 215–229.

——. 2003b. "Fashioning Indians or Beautiful Savages: The Case of Gaby Herbstein's *Huellas 2000*." *Ethnoscripts*, 5 (2), 2–33.

——. 2004a. "Indias a la moda: el caso de 'Huellas 2000'." *Mujeres y Nacionalismo en América Latina*. Ed. Natividad Gutiérrez. Mexico City: UNAM.

——. 2004b. "Rooting Hybridity Globalisation and the Challenges of Mestizaje and Crisol de Razas for Contemporary Artists in Ecuador and Argentina." *Indiana*, 21, 95–112.

——. 2004c. "Setting up roots, or the Anthropologist on the Set: Observations on the Shooting of a Cinema Movie in a Mapuche Reservation, Argentina." *Visualizing Anthropology*. Ed. Anna Grimshaw and Amanda Ravetz, Bristol: Intellect Books.

——. 2004d. "Fieldwork and Artistic Practices: The Case for Collaborations." Paper at EASA Conference, Vienna, September 8–12.

——. 2004e. "Acts of Empathy." *Impressions (and Other Images of Memory)*. Ed. Rimer Cardillo. New Paltz (NY): Samuel Dorsky Museum of Art/SUNY New Paltz. (catalogue)

——. 2006. "Appropriations." *Contemporary Art and Anthropology*. Ed. Arnd Schneider and Christopher, Wright. Oxford: Berg Publishers.

Schneider, Arnd and Christopher, Wright (eds.). 2006. *Contemporary Art and Anthropology*. Oxford: Berg Publishers.

Schwartz, Hillel 1996. *The Culture of the Copy: Striking Likenesses, Unreasonable Facsimiles*. New York: Zone Books.

Schweizer, Thomas. 2000. "Nachwort." *Kulturwissenschaftliche Stadtforschung*. Ed. Waltraud Kokot, Thomas Hengartner and Kathrin Wildner. Berlin: Reimer.

Scobie, J. 1988. *Secondary Cities of Argentina: The Social History of Corre intes, Salta and Mendoza*. Completed and edited by S.L. Baily. Stanford: Stanford University Press.

Sebreli, J.J. 1964. *Buenos Aires, vida cotidiana y alienación*. Buenos Aires: Ediciones Siglo Veinte.

Seoane Gallo, José. 1987. *Palmas reales en la Sena*. Havana: Editorial Letras Cubanas.

Serbin, Andrés. 1981. Las organizaciones indígenas de la Argentina. *América Indígena*, XLI (3), 407–437.

Sevänen, Erkki. 2001. "Art as an Autopoietic Sub-System of Modern Society: A Critical Analysis of the concepts of Art and Autopoietic Systems in Luhmann's Late Production." *Theory, Culture & Society*, 18 (1), 75–103.

Sieder, Rachel (ed.). 2002. *Multiculturalism in Latin America: Indigenous Rights, Diversity and Democracy*. London: ILAS & Palgrave.

Simpson, C.R. (1981). *SoHo: The Artist in the City*. Chicago: University of Chicago Press.

Silverstone, Roger. 1985. *Framing Science: The Making of a BBC Documentary.* London: British Film Institute.

Soederberg, Susanne. 2003. "The international dimensions of the Argentine default: the case of the sovereign debt restructuring mechanism." *Canadian Journal of Latin American and Caribbean Studies,* 28 (55–56), 97–125.

Sondereguer, César. 1997. *Estética Amerindia.* Buenos Aires: Editorial eme.

Sontag, Susan. 1973. *On Photography.* New York: Dell.

Sperber, Dan. 1996. *Explaining Culture: a Naturalistic Approach.* Oxford: Blackwell.

Spitta, S. 1995. *Between two Waters: Narratives of Tranculturation in Latin America.* Houston: Rice University Press.

Spittler, Gerd. 2002. "Globale Waren-lokale Aneignungen." *Ethnologie der Globalisierung.* Ed. Brigitta Hauser-Schäublin and Ulrich Braukämper. Berlin: Reimer.

Stangos, Nikos. *The Thames and Hudson Dictionary of Art and Artists.* 1994. Consulting editor Herbert Read, revised, expanded, and updated edition Nikos Stangos. London: Thames and Hudson.

Stocking, George. 1982. *Race, Culture and Evolution: Essays in the History of Anthropology.* Chicago: University of Chicago Press.

Strathern, Marilyn. 1988. *The Gender of the Gift.* Berkeley: University of California Press.

———. 1992. *After Nature: English Kinship in the Late Twentieth Century.* Cambridge: Cambridge University Press.

———. 1996. "Potential Property. Intellectual Rights and Property in Persons. *Social Anthropology.*" 4 (1), 17–32.

———. 1999. *Property, Substance and Effect: Essays on Persons and Things.* London: Athlone Press.

Szuchman, M. 1988. *Order, Family and Coummunity in Buenos Aires, 1810–1860.* Stanford: Stanford University Press.

———. 1994. "From Imperial Hinterland to Growth Pole: Revolution, Change, and Restoration in the Río de la Plata." *Revolution and Restoration: The Rearrangement of Power in Argentina, 1776–1860.* Ed. M.D. Szuchman and J.C. Brown. Lincoln: University of Nebraska Press.

Taquini, Graciela. 1994. *Jorge Prelorán.* Buenos Aires: Centro Editor de América Latina.

Taussig, Michael. 1994. *Mimesis and Alterity.* London: Routledge.

Taylor, Julie. 1998. *Paper Tangos.* Durham, NC.: Duke Unviersity Press.

Tedesco, Laura and Ana C. Dinerstein. 2003. Guest eds. "Special Section: The Crisis in Argentina: Contrasting Perspectives." *Bulletin of Latin American Research,* 22 (2), 165–230.

Tessler, Mario. 1989. *Los aborígenes durante el peronismo y los gobiernos militares.* Buenos Aires: Centro Editor América Latina.

Theye, T. (ed.). 1989. *Der geraubte Schatten.* Munich: Münchener Stadtmuseum.

Thomas, Nicholas. 1991. *Entangled Objects: Exchange, Material Culture and Colonialism in the Pacific.* Cambridge, Mass.: Harvard University Press.

———. 1999. *Possessions: Indigenous Art/Colonial Culture.* London: Thames and Hudson.

———. 2001. "Appropriation/Appreciation: Settler Modernism in Australia and New Zealand." *The Empire of Things: Regimes of Value and Material Culture.* Ed. Fred R. Myers. Santa Fe, NM: School of American Research Press.

Thurnwald, Richard. 1931. *Die menschliche Gesellschaft in ihren ethno-soziologischen Grundlagen.* Vol. 1. Berlin: Walter de Gruyter & Co.

———. 1932. "The Psychology of Acculturation." *American Anthropologist,* 34 (4), 557–569.

Todd, Loretta. 1990. "Notes on Appropriation." *Parallelogramme*, 16 (1), 24–33.

Todorov, Tzvetan. 1984. *The Conquest of America and the Question of the Other*. New York: Harper & Row.

Tomaselli, Keyan. 1996. *Appropriating Images: the Semiotics of Visual Representation*. Højbjerg, Denmark: Intervention Press.

Toren, Christina. 1991. "Leonardo's 'Last Supper' in Fiji." *The Myth of Primitivism: Perspectives on Art*. Ed. Susan Hiller. London: Routledge.

Trigo, Abril. 1996. "On Transculturation: Toward a Political Economy of Culture in the Periphery." *Studies in Latin American Popular Culture*, 15, 99–117.

Varnedoe, Kirk. 1984. Contemporary Explorations. *"Primitivism" in 20th Century Art*. Ed. William Rubin. New York: Museum of Modern Art.

Wade, Peter. 2003. "Race and Nation in Latin America: An Anthropological View." *Race & Nation in Modern Latin America*. Ed. Nancy Appelbaum et al. Chapel Hill: University of North Carolina Press.

Wagner, Monika. 2001. *Das Material der Kunst: Eine andere Geschichte der Moderne*. Munich: C.H. Beck.

Whitten, Dora and Norman, Whitten (eds.). 1993. "Introduction." in D.S. Whitten and N.E. Whitten (eds.), *Imagery and Creativity: Ethnoaesthetics and Art Worlds in the Americas*. Tucson: Arizona University Press.

Wildner, Kathrin. 2003a. "Eine Ethnographie des Städtischen: Die Metrostation auf dem Zócalo von Mexiko-Stadt." *Ethnoscripts*, 5 (2), 95–112.

———. 2003b. *Zócalo: Die Mitte der Stadt Mexiko*. Berlin: Reimer.

Wimmer, Andreas. 1996. "Kultur: Zur Reformulierung eines sozialanthropologischen Grundbegriffs." *Kölner Zeitschrift für Soziologie und Sozialpsychologie*, 48, 401–25.

Wilson, Stephen. 2002. *Information Arts: Intersections of Art, Science and Technology*. Cambridge, Mass.: MIT Press.

Wolf, Eric. 1982. *Europe and the People without History*. Berkeley: University of California Press.

Woolard, K. 1989. *Double Talk: Bilingualism and the Politics of Ethnicity in Catalonia*. Stanford: Stanford University Press.

Yúdice, George. 1992. "Postmodernity and Transnational Capitalism in Latin America." *On Edge: The Crisis of Contemporary Latin American Culture*. Ed. George Yúdice et al. Minneapolis: University of Minnesota Press.

Ziff, Bruno and Pratima V. Rao. (eds.). 1997. *Borrowed Power: Essays on Cultural Appropriation*. New Brunswick, N.J.: Rutgers University Press.

Zolberg, Vera L. 1990. *Constructing a Sociology of the Arts*. Cambridge: Cambridge University Press.

Name Index

Subject Index